ELEPHANT REFLECTIONS

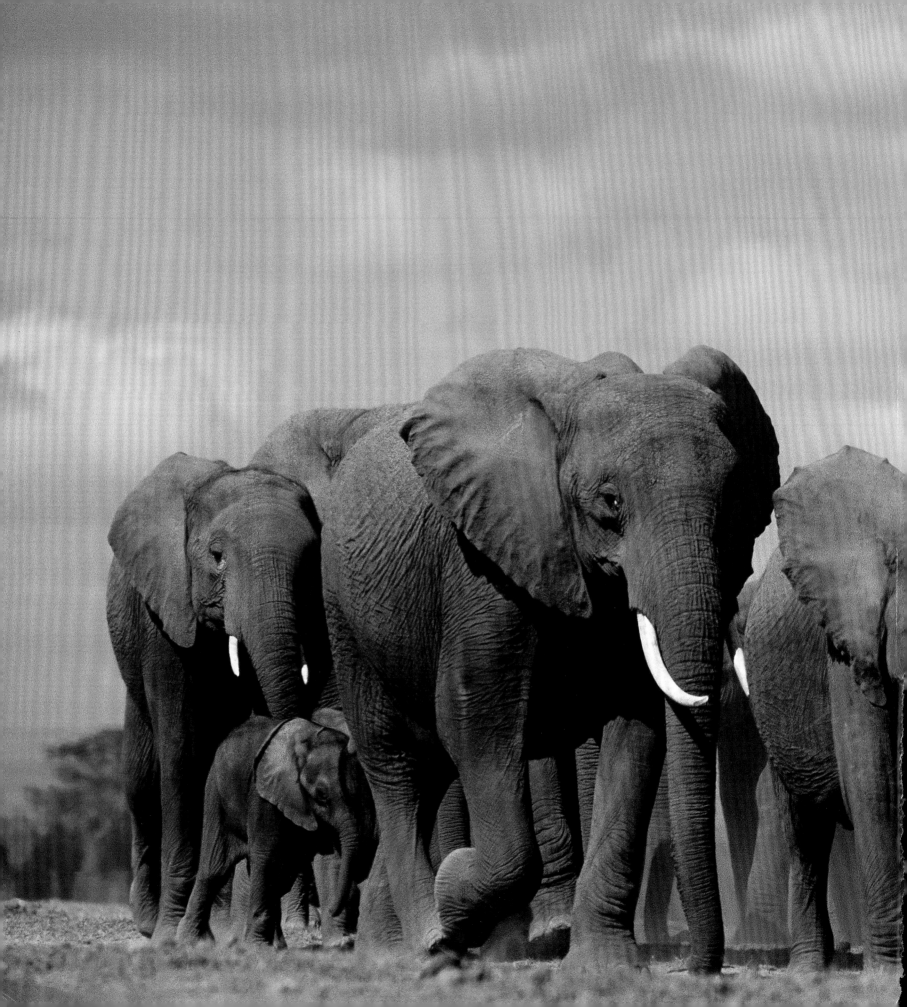

ELEPHANT REFLECTIONS

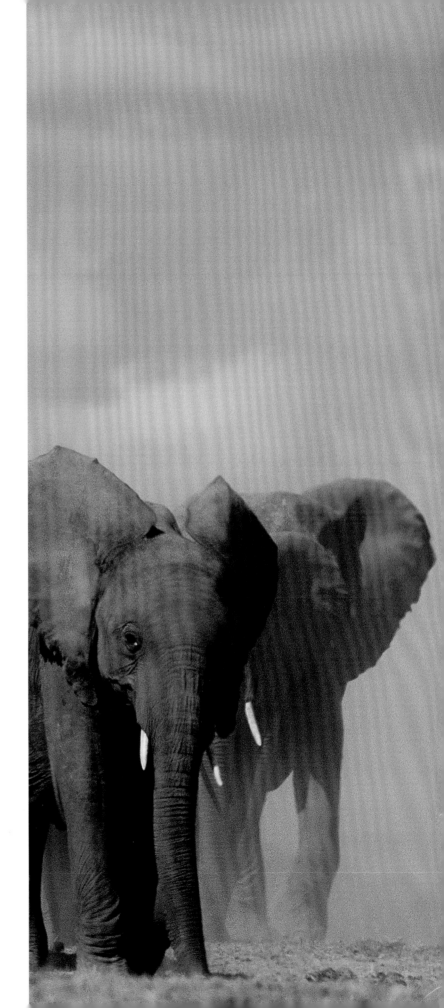

Photographs by **KARL AMMANN**

Text by **DALE PETERSON**

University of California Press

Berkeley Los Angeles London

The publisher gratefully acknowledges the generous support of the General
Endowment Fund of the University of California Press Foundation.

University of California Press, one of the most distinguished university presses
in the United States, enriches lives around the world by advancing scholarship in
the humanities, social sciences, and natural sciences. Its activities are supported
by the UC Press Foundation and by philanthropic contributions from individuals
and institutions. For more information, visit www.ucpress.edu.

University of California Press
Berkeley and Los Angeles, California

University of California Press, Ltd.
London, England

TEXT: 9.5/14.5 Scala
DISPLAY: Interstate
DESIGN AND COMPOSITION: Nicole Hayward
INDEXING: Alexander Trotter
COLOR SCANS AND PRE-PRESS: National Geographic Imaging
PRINTED THROUGH: Asia Pacific Offset, Inc.

Library of Congress Cataloging-in-Publication Data

Ammann, Karl.
 Elephant reflections / photographs by Karl Ammann ; text by Dale Peterson.
 p. cm.
 Includes bibliographical references and index.
 ISBN 978-0-520-25377-3 (cloth : alk. paper)
 I. Elephants. 2. Elephants—Pictorial works. I. Peterson, Dale. II. Title.

QL737.P98A48 2009
599.67—dc22 2008042391

Manufactured in China

18 17 16 15 14 13 12 11 10 09
10 9 8 7 6 5 4 3 2 1

The paper used in this publication meets the minimum requirements of ANSI/NISO
Z39.48-1992 (R 1997) (Permanence of Paper).

In memory of Associated Press reporter Anthony Mitchell,
a valued friend and traveling companion

CONTENTS

FRAGMENTS
85

PORTRAITS
93

BEHAVIORS
123

ASSOCIATIONS
167

PASSAGES
189

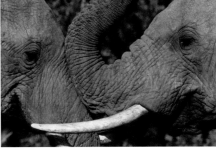

ELEPHANT REFLECTIONS

They emerge from the dark shadows of far trees into the light—a harsh light dropping heavily from above, a tentative, flickering light rising from below—and they descend a bank of mud down to the muddy water. I see more appear at the edge of the trees and stand there, quietly peering out from the shadows as if waiting for their own curtain call.

"There's more coming, so we should have them for quite a while," he says. He rolls down the window, screws the bazooka lens into his camera, and aims the full contraption out the window while stabilizing it by locking the camera base onto a window mount.

The river here is shallow and sand-barred in some places, channeled and pooled in others, and in the channels the muddy water churns and writhes. A strong wind waves the dusty acacia branches above us and whips the green grass around us. The elephants moving into the water on the far bank have now paused, some to drink, others to roll and wallow and splash in a channel and pool. I watch through binoculars. The photographer peers through his camera and its bazooka lens. He continues a running commentary: "Little guy just rolling on top of the bigger guy. . . ." He takes pictures.

Click.

Click.

Click.

It's a few minutes past noon, with the sun overhead making a hard contrast—but it seems as if we have the entire place to ourselves. The few tourists visiting during this lucky, off-season mo-

ment are back at the lodge right now, settling in for the big lunch and long siesta. The photographer: "This kind of setting is hard to beat. It's lunchtime, yeah, but there are four or five calves there." I see brown and swirling water, brown sandy banks, brown elephants getting darker brown and shiny as they—a half dozen from the larger group—roll and cavort and roll some more down in the swirling water. It looks like one big party over there, with a perfect breeze and a half dozen giants frolicking around like fat cherubs. "Good light. . . . No complaints. . . . I mean, you can sense the pleasure and joy they get out of this rolling around and having a good bath."

Click.

Click.

Click.

Sometimes I see nothing but a haunch or a back. I hear an occasional roar and trumpet and the faraway splashing noises of big bodies rolling and rising up. Two of them become almost fully submerged for a few moments. A massive body rises like a whale surfacing and rolls back into the water, trunk snaking up and feet kicking, splashing, kicking. An elephant stands upright and, with a big shake of the head and ears, casts away water like a shower of diamonds. "To fill frames with five or six elephants at this distance is quite nice." And: "Nice, shiny ivory when it's wet."

Click.

Click.

Click.

The wind blows. The grass shivers. The acacias shake. A big female with big tusks—the matriarch, I presume—slowly advances, leading the way, with the rest gradually queuing up and following. I count almost thirty of them, and now I observe a leisurely, splashing procession across the river, with various individuals still pausing to drink, to cavort, to raise trunks up high and splash them down into the water. I see a couple of small babies with flippy-floppy trunks, almost perfect miniatures of their elders, each daintily trying to follow the moving tree trunks that represent mom's legs. These babies have a bouncy walk, bright eyes, heads held high, as if they are just so excited, so enthused to have entered this brave new world. The grown-ups wade knee deep through the center channels, where the water slaps and snaps at their stepping feet; I watch one of the babies as she follows the big feet and steps into a deeper part, where she seems, for the moment, helpless, merely a bit of head and a raised little trunk. But this tiny creature is surrounded by the big others, including one directly downstream, and soon enough everyone makes it into shallower water and then, eventually, to the other side—our side, where the photographer and I sit within the steel shell of our car, watching this group slowly, slowly, slowly, slowly move out of the water and ascend the river bank.

Here, before us and around us, they pause to dust themselves with river bank sand, dusty sand, and then several of them stop to rub themselves, the sides of their heads and bodies, against a standing tree. Slowly they walk to and around us, on either side of the car—babies, juvenile males and females, adult females—a few pausing to push at a second tree, to pull away strips of bark,

to get yet another good, long, lingering side rub. I hear low rumbles that seem like swallowed roars. I see legs shaped like logs, ears like giant cabbage leaves. I note a feisty adolescent male who shakes his head, turns our way, shakes his head again while flapping out his ears, and trumpets, thus challenging the vision of us: two pale worms inside the strange, hard nut of a car. "You're too close, my friend, for my lens," the photographer says, and he unscrews the big lens and screws in a second, far smaller lens. "Take this one." But aside from that feisty adolescent, the rest of the group ignores us, passing on one side or the other of our vehicle. Almost all have been dusting themselves, and now as they continue walking they are still dusting—tossing trunkloads of dust, little exploding storms of it, over their heads and backs—while moving around and past us. The finer particles are lofted by the wind and drift through the open windows into the car and our faces.

Sometimes elephants move quickly and sometimes they trumpet or roar or scream vigorously: their more dramatic expressions of existence, the knockout, run-down script preferred by Hollywood. But for me, one of the most surprising things about these animals is their ordinary combination of precisely the opposite: exceptionally slow movement and remarkable quiet. That combination, slow and quiet, can make them seem, somehow, strangely and peacefully ethereal. Ghostly, even. So now, ghostly slow and quiet and relaxed as they are, these vast agglomerations of heaving flesh and shifting skin, these singular specimens of solemn quietude, these harmless great things and miracles of nature, these *elephants* give us barely a passing glance, hardly a curious sniff or subtle turn of the trunk tip, as they move around us like ships. Like a swaying convoy of great gray ships, they move away into the grass and brush and the trees beyond.

THE PHOTOGRAPHS in this book reflect the two African species: savanna elephants *(Loxodonta africana),* found in eastern and southern Africa, and forest elephants *(Loxodonta cyclotis),* found in central and western Africa. Asian elephants *(Elephas maximus)* are a third and final species, and they require their own book of photographs. The African savanna elephant images were taken mainly in the Samburu National Reserve and Amboseli National Park, both in Kenya, with a few additional images from Masai

Mara National Reserve and the Ol Pejeta and Ol Jogi conservancies, also in Kenya. The forest elephant images come from the Dzanga-Sangha Reserve of the Central African Republic and the Wonga-Wongué Reserve of Gabon.

Experts can tell the difference between African savanna and African forest elephants on sight and even, often, from photographs. Savanna elephants are generally bigger and more angular than forest elephants. Savanna elephants tend to have thicker and more forward-pointing tusks; forest elephants' tusks are narrower and more downward-pointing, and their ears are smaller and more rounded. For the nonexpert, though, the easy clues are those of setting. Savanna elephants are creatures of wide-open spaces: grasslands or spotty woodlands, arid scrub or even desert. If you see trees around savanna elephants, they may be part of a narrow gallery lining a river or a thin copse at the edge of a swamp. Forest elephants, by contrast, are creatures of the leafy and shadowy Central African ecosystems: in most circumstances, they are hard to find and even harder to photograph. They may appear in the light and open air in a convenient little patch of savanna grassland or in a small, muddy mineral-lick clearing *(baï)* within the larger forest—the baï of Dzanga-Sangha, for example, where most of this book's forest elephant photographs were taken.

To take their pictures, all you need is time, patience, and the right equipment. Karl Ammann keeps his standard camera bag opened up to allow a quick choice from four different camera bodies—Nikon F4 and F100 plus a pair of Canons, both EOS2—and a variety of lenses that may be screwed on and off the bodies.

He has a 300 mm Canon lens and an 80–200 mm Nikor. These telescopic lenses both include automatic focusing mechanisms, and, to eliminate hand tremor, they are both stabilized by internal gyroscopes. One of his favorites, though, is the bazooka-style 800 mm Nikor, which requires its own backpack for storage and transportation, but which, in his words, "allows you to sit back and pick out almost any detail of any scene in front of you." The lens is bulky, a pain to carry, and it requires a door mount for stabilization. The other lenses, for closer distances, require just a steady hand or, at times, a bean bag propped against the car door. Karl also brings along some additional exotic lenses, such as a wide-angle zoom and a fish-eye, but he rarely uses them.

He prefers to use old-fashioned film rather than digital imaging. Having a slide in his file feels safer than digital storage. In addition, a slide can always be scanned to produce a useful digital copy, whereas digital originals cannot readily be turned into slide copies. He relies almost always on Fuji Velvia 100, which is "very rich in colors, although it is often not fast enough under low light conditions," creating the risk, and sometimes the artistic potential, of blurring from movement.

I HAVE SORTED THE IMAGES according to what I see as their various themes, subjects, and genres. The themes, identified as *Beginnings* and *Passages,* are expressed in the opening and closing sets. The subjects include *Textures, Colors, Perspectives,* and *Fragments,* while the genres are those of portraiture (or *Portraits*) and action (or *Behaviors* and *Associations*). The themes are self-explanatory, I think, but perhaps I should defend my choice of subjects and genres.

Textures. Texture, in elephant photography, is the visual consequence of wrinkles, and wrinkles, in elephants, are a consequence of skin that is up to an inch thick. In response to its own plenitude, the skin bunches and folds and furrows. It bundles over the hinge of the ear. It sags across the torso, as if someone had too casually tossed on a tablecloth or a blanket. On the trunk, that most mobile and flexible of organs, the skin cascades down and settles into a series of horizontally banded wrinkles, like stacked rings. At the forehead, it turns dense and hard and pebbly. In places, an elephant's skin produces a matrix of cracked diamonds, like the crazing of old silt in a dry riverbed, while elsewhere it resembles deeply furrowed tree bark—before the bark has been stripped off and eaten by an elephant. Texture is everything in elephant photography, and some of my favorite images in this collection are almost strictly studies in texture.

Colors. Color is partly a consequence of ambient light. In the forest trying to photograph forest elephants, you curse the shadows. On the savanna, you may be thinking bad thoughts about the sun. The slanting light of early morning or late afternoon on the savanna is better for drawing out essential colors and textures. You can take in more shadow-marked detail of the elephants' bodies and faces. The direct light of the day's middle is much more intense, often too intense. The midday sun can turn into a hot hammer that breaks your subject down into reflective extremes: bright glares and dark burns. At the same time, during the midday hours elephants will often cool off at a water source and become socially active and interesting, and so the photographer begins praying for a cloud to pass over.

In elephant photography color works as both a challenge and an opportunity. The slate gray of elephants is a color more of absence than presence, more an artifact of absorption than reflection. Especially when it appears behind a partial screen in the foreground—say, the bursting greens and browns of a few intervening trees and thorn bushes—the gray of elephants can bleed like watercolor or dissolve like smoke. In certain circumstances, that gray becomes an all-purpose camouflage, a merging color that obscures edge and form and individuality, that turns solid into liquid and shape into muddle into puddle. Gray is nature's disappearing ink, the color of drifting clouds and wavering shadows. It offers the photographer some of the tricks and opportunities of an illusionist's art when the disappearing ink of gray combines with the obscuring effects of puffing dust, of rising mist, of heat distortions in the air. At best, the gray of elephants is a subtle color, and perhaps that quality hands the photographer his or her biggest challenge and chance. An image pulled from inside a moving herd, for example, may become a study in gray at its most refined: a semiabstract expression in monochromatic slabs and slashes, shades and tones, with only drifting hints of the polychromatic world beyond those faintly reflected blues and greens, that light dusting of amber.

Elephant gray normally has a velvet quality, which is to say it lacks sheen. But in the right kind of light, say in the angled light of late afternoon, especially a light that has been splintered and concentrated by reflection off water, the gray of elephants may turn metallic. A sheen emerges, and now we begin to see not gray but pewter or platinum or bronze.

In fact, a quick look at the photographs in this book may convince the looker that elephants are anything but gray. We find ourselves captivated instead by creatures who display a complex if localized spectrum of color. We see magnificent animals who sometimes look as if they have emerged whole from the magnificent landscape that surrounds them, who have taken on the colors of the earth itself: ocher and tan and brown, gold and saffron,

laterite red and clayey cream yellow. New light shows new things. A sun near the horizon turns a sky orange and an elephant orangey. Sunlight passing through the hairs on an infant's head shows them to be brown, blond, red. But the elephant earth colors are not so much an effect of light as of earth. Elephants love to wallow in mud and spray themselves with muck and dust. These behaviors feel good, obviously, but they also bring practical benefits such as reducing skin parasites, soothing skin irritations, and providing an extra layer of protection from the sun. For the photographer, the benefit is aesthetic. The result is as if the elephant has decided to put some color into that gray, to dab on a little makeup for the camera, and you see a golden adolescent passing through the gold-colored mud wallow of a Central African baï or a tan-toned matriarch tossing clouds of tan dust as she showers herself in public.

Perspectives. Some of the African forest elephant pictures in this book show an elevated perspective, which is a consequence of the photographer being perched on the higher-than-elephants observation platform at the Dzanga-Sangha baï. The images of African savanna elephants are mostly marked by a lower-than-elephant perspective, which is an artifact of the photographer taking pictures through an open window from inside the protective confines of a car on the East African savanna.

Savanna means variety and perspective: a far horizon, a sweep of sky and earth, a world of light open to the eye and the camera. Photographic close-ups are also possible. Elephants will walk up to your vehicle. They will parade slowly past in a long, loping queue, while you may be—within the profile of your vehicle and behind the reflective surfaces of glass—disguised, effectively invisible. But the savanna also calls out for romantic long-shots, where at a distance you can take in the whole elephant family as a single coherent group. At a greater distance you see those far-off, creeping pachyderms merge with the landscape and the weather, and they are simplified and abstracted, transformed into lonesome profiles and cryptic symbols at the horizon: five-legged mushrooms or dark, round-backed spiders. Distorted by the heat-rippled air, they begin to float and take on the hallucinatory appearance of mythic beasts stepping into eternity.

Fragments. Showing texture, color, and perspective is mainly a technical problem, a comparatively simple exercise in focus, depth of field, shutter speed, film choice, and the like. Composing portraits and capturing action are matters of aesthetic choice and good fortune combined with dogged patience and nerve. But communicating scale is a more complicated matter.

To be sure, communicating scale is part of the normal miracle of photography. By what means do we allow a static and two-dimensional pattern only a few inches high and wide to represent in our minds a dynamic, three-dimensional reality that may be ten or twenty or fifty times larger? The photographer captures a tiny reflection or echo of light and presents it to the public preserved as a pattern of chemicals distributed over paper and frozen in time. It is an obscure magic, photography is, and a practiced deceit that we accept. With elephant photography, however, that deceit and our acceptance of it are all the more remarkable. How extraordinary to be moved by photographs of an alien species we know so little about, whose perceptual and mental experiences are so far removed from ours, and whose single most obvious aspect—giant size—is, through the photographer's art, collapsed so radically. Photographs of elephants must somehow convince us that the original, living subject is not 4 or 5 inches high, as we see it, but rather 9 or 10 or 13 feet high, as reality has it.

In short, photographs of elephants must not only evoke texture and color, and not merely capture portraits and reveal behaviors, they must also imply dimension and mass. They do that through perspective, and they do it through fragmentation, by presenting one piece or part at a time. There will always be conflict between form and detail in photography. If we want to see detail, we cannot fully discover form. If we want form, we miss detail. With elephants as photographic subjects, this normal conflict becomes an essential one, and the photographer becomes, in turn, each of the six blind men touching an elephant in six different places and describing six different beasts.

Portraits, Behaviors, and *Associations.* The portrait and action genres in photography rely heavily on subject and opportunity. In the photography of elephants, these genres often divide, as elephant society does, by gender.

Elephant herds are ordinarily based on matriarchal families, each family consisting of related adult females and their young of both sexes. A photographer approaching such a group may first focus on the charismatic babies and playful youngsters. Elephant babies are goofy innocents, angels from a much heavier universe improbably waving floppy tubes at the ends of their faces. But the

herd itself, a family as small as two or three individuals or an associating group of families with anywhere from forty to as many as a hundred or more elephants, is a compelling subject. The oldest and biggest female of any family usually rules as the matriarch, a position acquired not by brute force or through battle but rather through natural happenstance and group consensus, probably in part as a natural response to that particular female's greater age and superior social and environmental knowledge. The matriarch serves as the group's mediator during social conflict and its central defender in times of danger. She can be expected to know how to avoid danger and where to find good food and reliable water, so during the group's daily movements and seasonal migrations she leads and the rest of the family follows, often in single file—offering the photographer a dramatic opportunity for what I think of as the *processional queue* photograph. And when the family group reaches, say, a cool, rippling river and stops to drink, individual members may spread out along the bank, all of them facing the same direction and thereby presenting themselves gathered, in a relaxed composition, for what I like to consider the *family portrait*. When the family perceives a threat, though, the adult females may tighten around or in front of their vulnerable calves and become a maternal wall of tusks and trunks, a great mountain range of heads and legs, an intimidating female fortress—yet another opportunity for the photographer.

Male and female elephants have very different interests from the start. Even in the earliest months, males play more roughly than females do, and by the time they are about four years old, males are more independent, while females of the same age have already begun to assist the mothers of their family group in watching after the babies. By the time they reach adolescence, around the age of fourteen, males have left their family group and begun wandering by themselves or in a loose association with other males, entering a bachelor society where one is ranked by size, strength, aggression, and testosterone level. Adolescent males still weigh less than adult females and are less than half as big as adult males, so during the first years of bachelorhood the males test one another's strength and aggression in play fights and trunk wrestling. They may also follow older mentors, fully adult males who have entered the serious male-against-male competition for the opportunity to mate. If the photographic drama offered by females is often found within the extended spread of a coherent family group, the photographic drama offered by males tends to more solitary and competitive behaviors, ranging from playful jousting and wrestling among young adolescents to the occasional all-out battles between full-grown bulls in musth.

Big bulls ordinarily have a Mount Rushmore kind of grave monumentality: that broad face bonily expanded at the forehead and again around the tusks; those enormous and sometimes cracked or broken tusks; the rough, weather-beaten texture of the skin. But a big bull in musth has become, as the other elephants recognize, a dangerous contender. For that puny character with the camera he is at once very compelling, in a photographic sense, and, in most other senses, decidedly uncompelling.

Here is where the car comes in. An adult elephant of either sex can seriously beat up a car, crushing it like a tin can from the top down or stabbing with a tusk right through the door, but you may still be better off inside that car than outside. When driving close to a large bull, Karl always looks for a fast getaway route to either side. And if two bulls in musth have come together in conflict, Karl remains especially wary of the loser, who will often let out his frustration by attacking anything handy, such as a nearby car. During his more than twenty years of photographing elephants, Karl has been chased many times, although most of those chases have been playful feints or mock charges. One particular male in Samburu, however, charges him routinely. This bull seems serious, and the charges may indeed be serious. "He comes out of nowhere, and I had one close encounter where I had no escape route in front so had to back up a high river bank. The back wheels went up the edge of the bank, and for a moment I stood on two wheels. If the car had turned over I would have been in trouble. But I dropped back on all four wheels and was able to accelerate on the grassy plain on top of the bank."

Karl Ammann describes himself as a member of the "hands-on, close-up" school of photography, and for really close-up or inside shots of a moving herd he sometimes uses a remote triggering device. "I always hope for a herd to move at a steady pace across an open plain, allowing me to set up a camera with a 16 mm fish-eye lens on the ground and then let the herd trigger the camera with the remote device. It is a hit or miss affair," he adds—though when the luck hits, that remotely triggered fish-eye can yield remarkably intimate portrayals—I consider them *interior studies*—pictures taken at a stepping-foot perspective from in-

side or at the very edge of a moving group. Yet, again, even laying out that camera and remote trigger can be risky. "Where I still do a lot of missing is in estimating the speed with which an elephant herd moves toward me. Often they are on top of me before I am ready and moved off to a safe distance."

IF THE FUNCTION OF ART is to open our eyes and allow us to see the world freshly, the best of this book's elephant reflections— the photographs—can, I believe, likewise inspire a new reflection on old things. They can remind us of the beauty in strangeness and of the splendid strangeness, the vast improbability of (to quote the seventeenth-century English poet John Donne) "Natures great master-peece, an Elephant / The onely harmlesse great thing." And so the photography of elephants becomes an art of found objects and imaginative collage, the visual equivalent of poetic metaphor: a collection of odd pieces wrapped under a wrinkled gray blanket.

Those enormous, slowly flapping ears look, when seen alone, like huge, dark beach umbrellas. Those great columnar legs appear, on their own, as tree trunks, the toenails parabolic and big as goose eggs, the foot bottoms as flat and circular as drumheads or dinner plates. Beneath the trunk, there is a mouth shaped like a V, and inside that mouth is a tongue as big and soft and leathery as a boxing glove. The tail moves like a pendulum, back and forth, back and forth, and it terminates with a hair-tipped painter's brush. The trunk, by far this animal's most restless organ, shifts and flexes, turns and probes, curls and twists at the sniffing end like the head of a large and possibly dangerous snake. Then there is that great lumpy skull, gray the color of old rock, which from the side looks like a massive if strangely misshapen boulder with one eye in the middle.

That eye, surrounded by a swamp's edge of long, pale lashes and brightened by the sun into a rich amber, gives nothing away. We humans are accustomed to primate eyes that follow us as we move, and to faces capable of signaling emotion and intent. So what are we to make of this large toy marble that seems almost vacant or indifferent, staring so incuriously from the midst of that great boulder of a head, and that tends to hide and disappear in the shadows, to avoid showing up in photographs? How to respond to a face that remains stonily flat and motionless, that

signals almost nothing? Elephants have often seemed to me not merely indifferent to our nervous, quick-moving, birdlike, camera- and binocular-carrying presence, but even nearly absent from it. They have seemed, at times, so calm and ponderous as to be living within an entirely different, much slower, experience of time. Surely, in any case, elephants live in a social and perceptual world permeated—defined, even—by an evanescent encyclopedia of smells and sounds far more than of sights. They are not fooled, as we are, by the visual tricks and deceits of the photographer's art.

In spite of such artistic "tricks and deceits," though, we human viewers still expect that the image fairly represents the subject. Such is the essential premise of serious photography, I believe, the unspoken compact between artist and audience. Yes, we may hope to recognize the values of composition and angle, light and texture. Yes, we may appreciate all the technical skills and fancy technology involved in the process of a photographic creation. But we also expect some direct correspondence between the light-cast image on the page and the particular creature who, at one particular moment, caught the light in the first place. Photography has some of the magical quality of figures scratched on a piece of bone or of dreamlike game animals painted in dreamtime on cave walls. Capture the image and you are that much closer to capturing the real thing. That's the promised magic, but it relies on our belief in prosaic representation, our faith in a fair association between image and subject. Thus, unlike in the other visual arts, there are limits to what most people will accept in photography. Consider the digital manipulation underlying some contemporary nature photography. Is it art or bold-faced fakery to add, by pressing a few keys on the computer keyboard, more animals to a herd? To stick in a few dramatic clouds of dust at their feet? To invent raindrops and snowflakes? To insert a clear version of otherwise shadow-obscured eyes?

Good photography depends only partly on the artistic skill of the photographer. It also surely depends on the artistic value of the subject. We look at this collection of elephant reflections not simply to admire the talent and skill of Karl Ammann but also, and even more fully, to reflect on the drama and glamour and mystery of real elephants. If we could hold real elephants in our hands, carry them around, place them on a coffee table, embrace

them and examine them at our leisure, we would. If it were possible, we would prefer the real thing. Instead, we are forced to try to content ourselves with the pictures, these reflections. And if we are content with them, it is because they give us a sense of real elephants seen through a clear lens. What the photograph represents is as important as what the photographer does, in other words, and the subject is as much a work of art as the art itself. The nature photographer's real artistry lies, finally, in his or her ability to reflect, with eloquence, clarity, and honesty, nature's art.

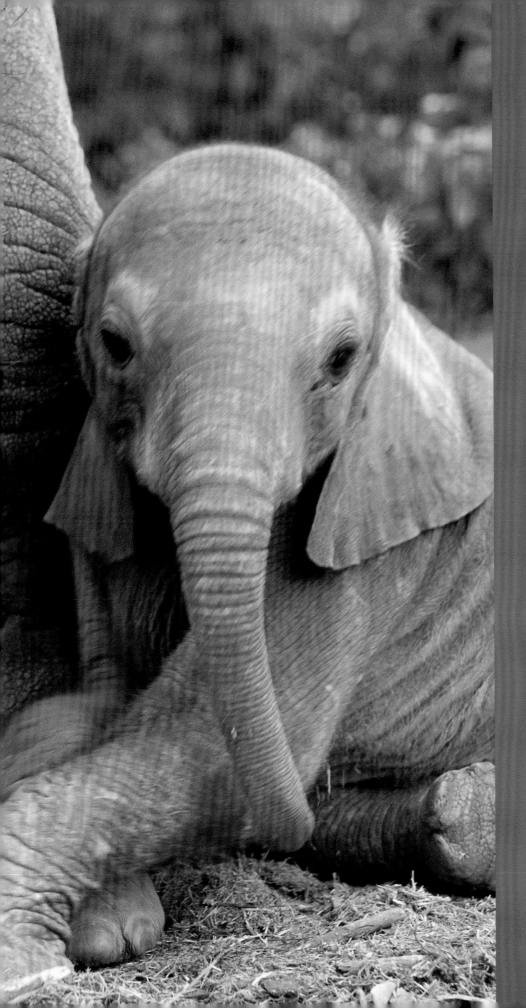

BEGINNINGS

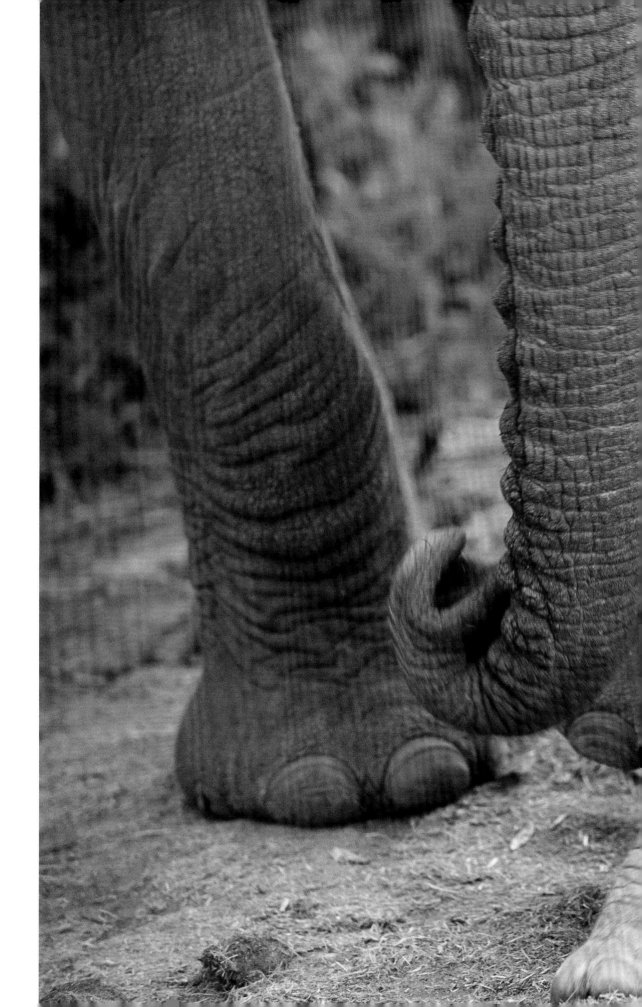

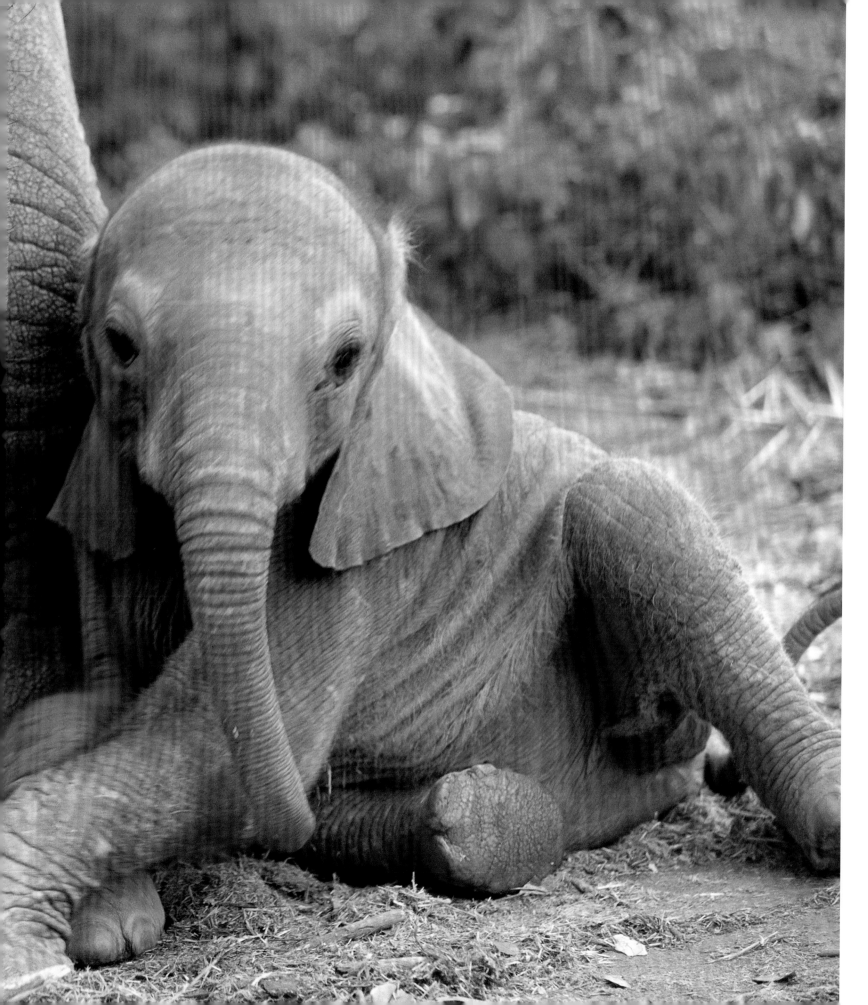

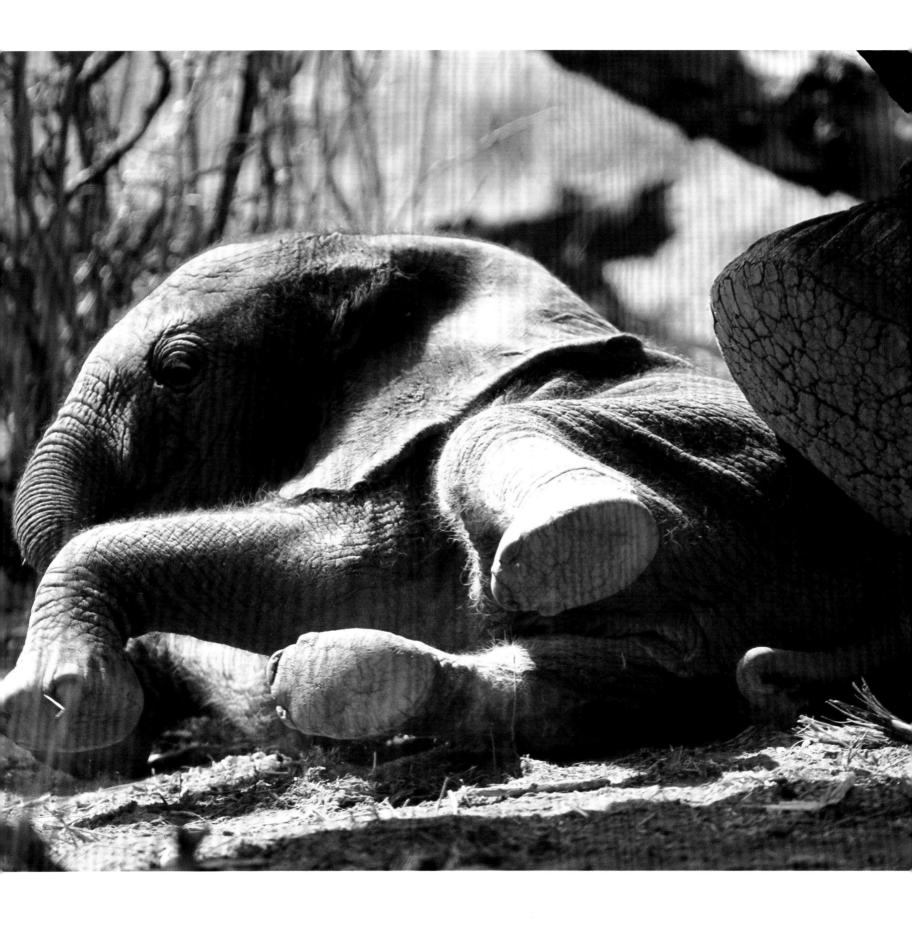

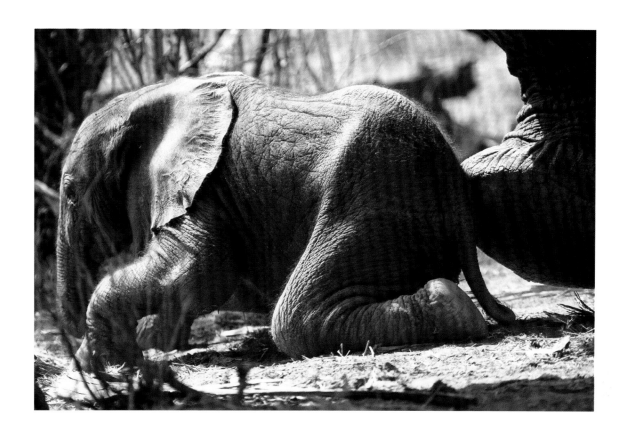

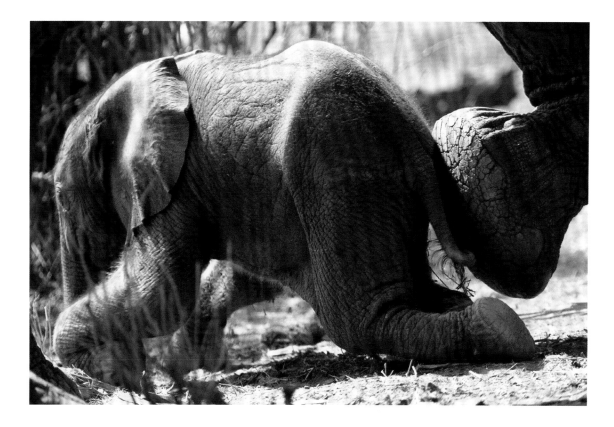

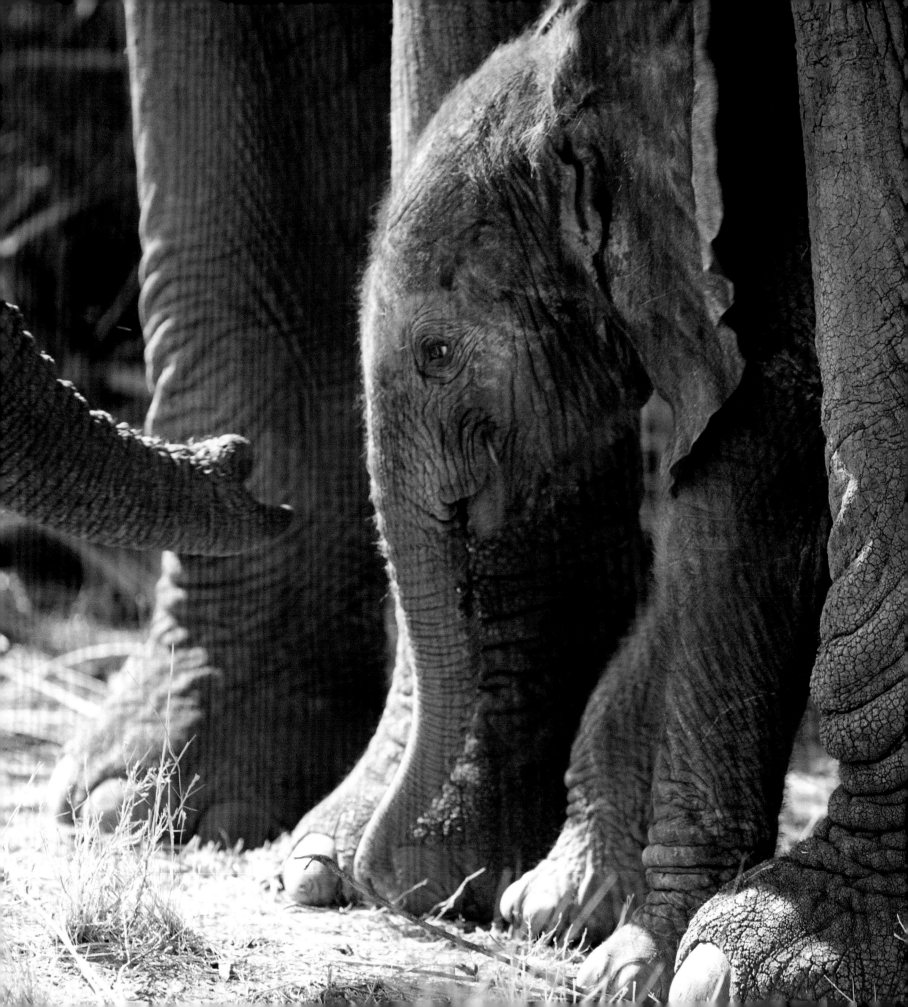

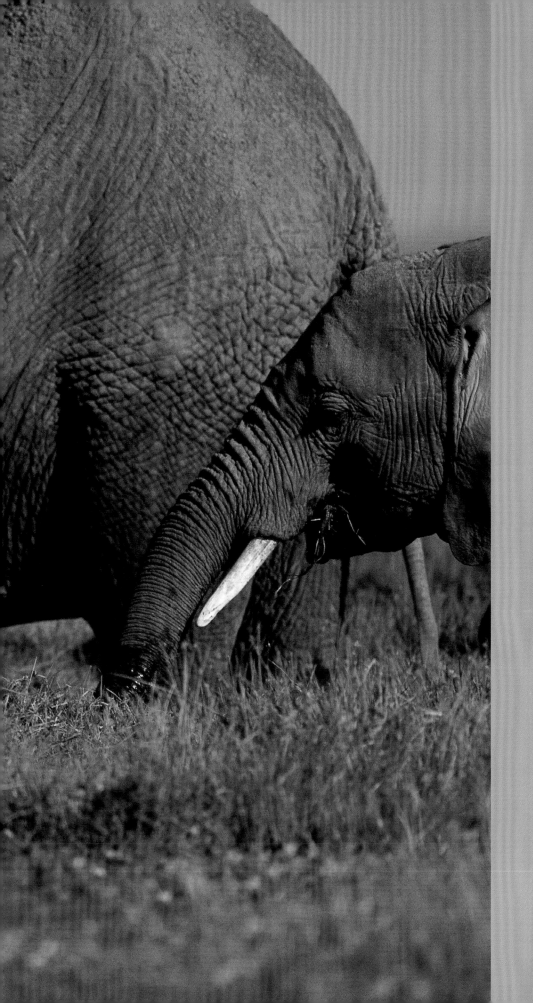

TEXTURES

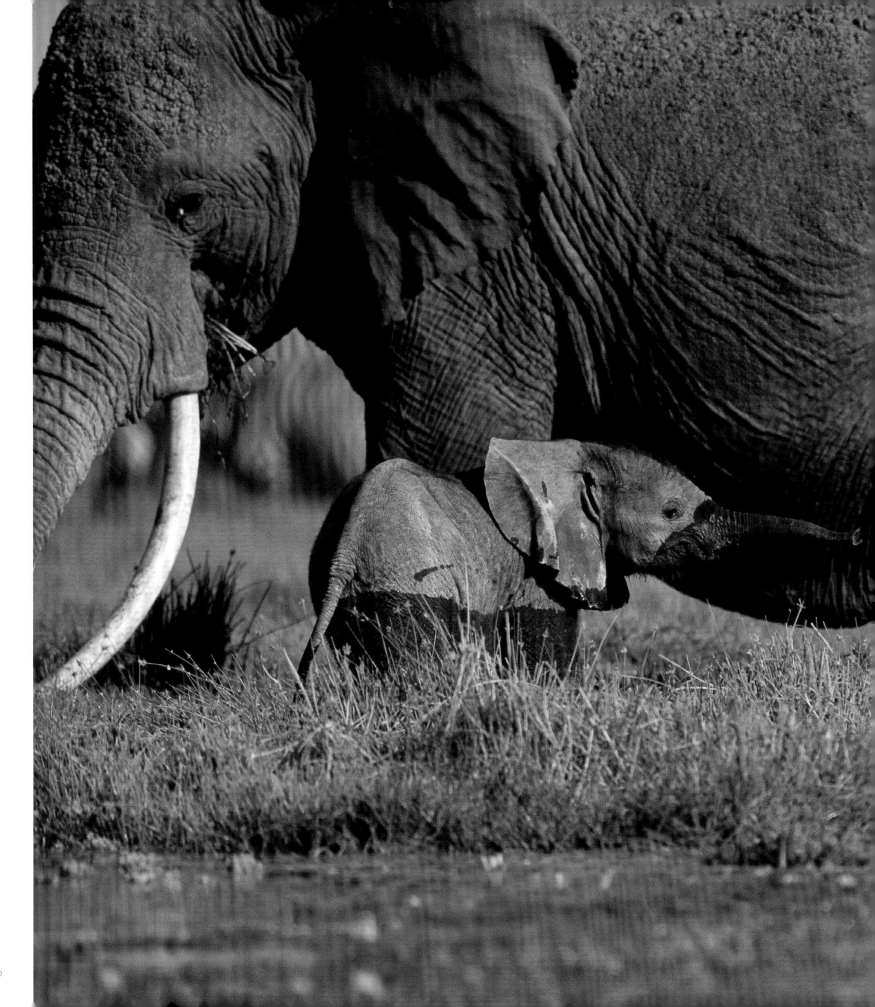

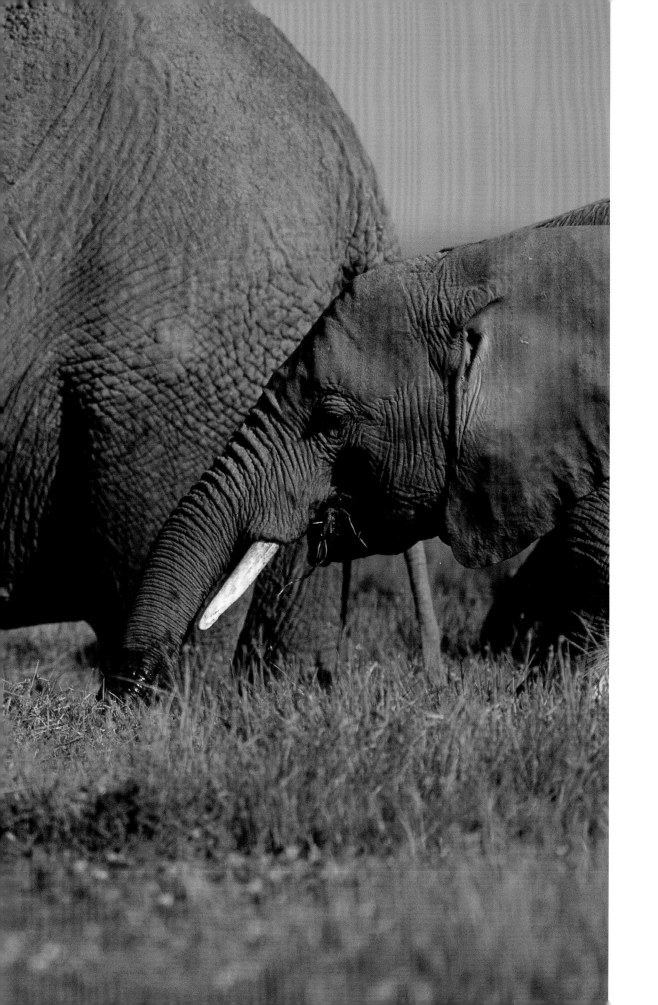

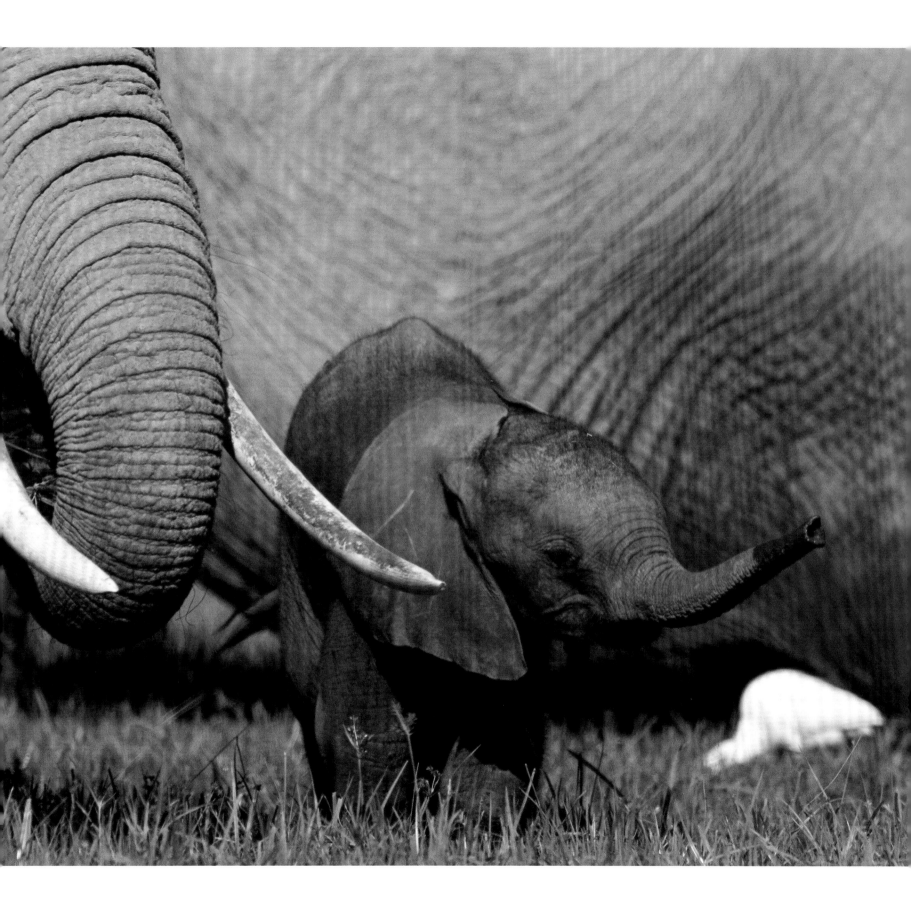

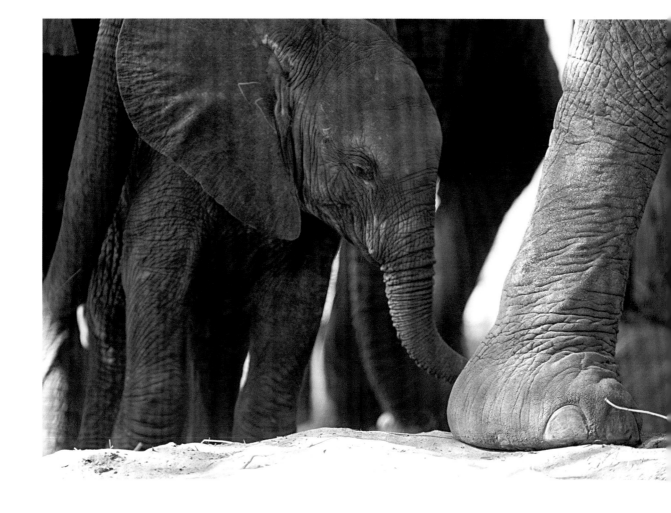

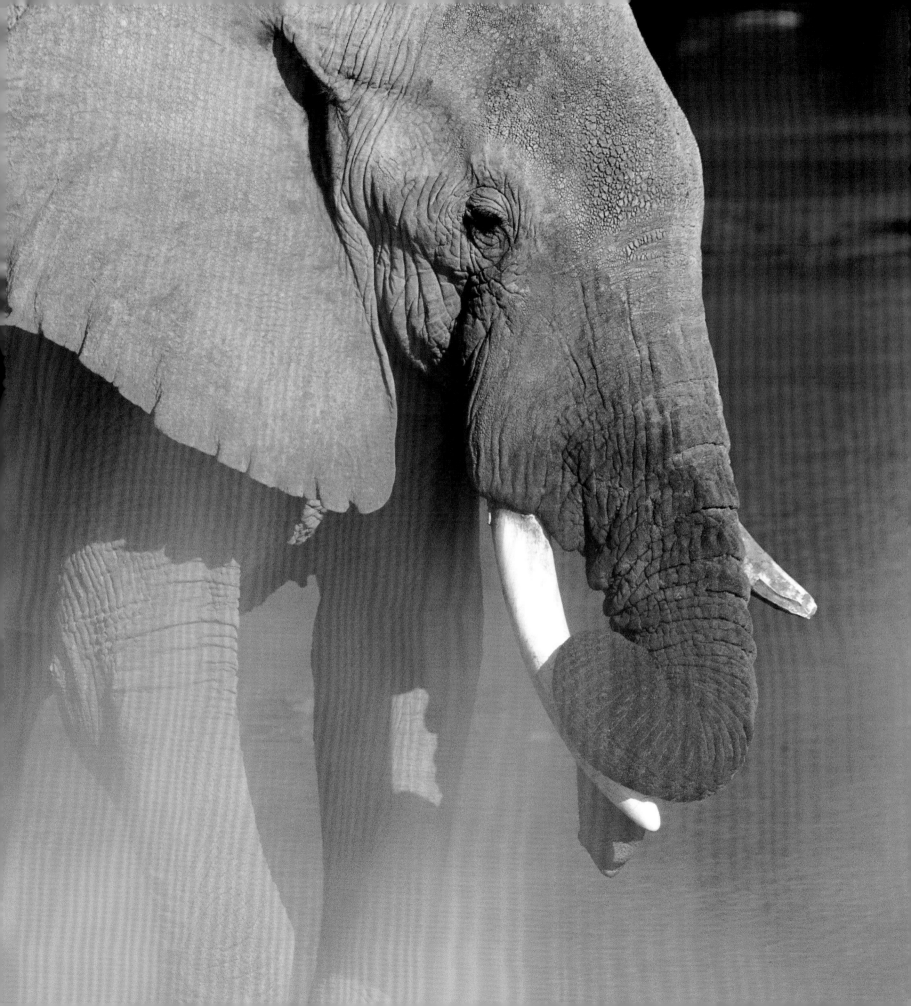

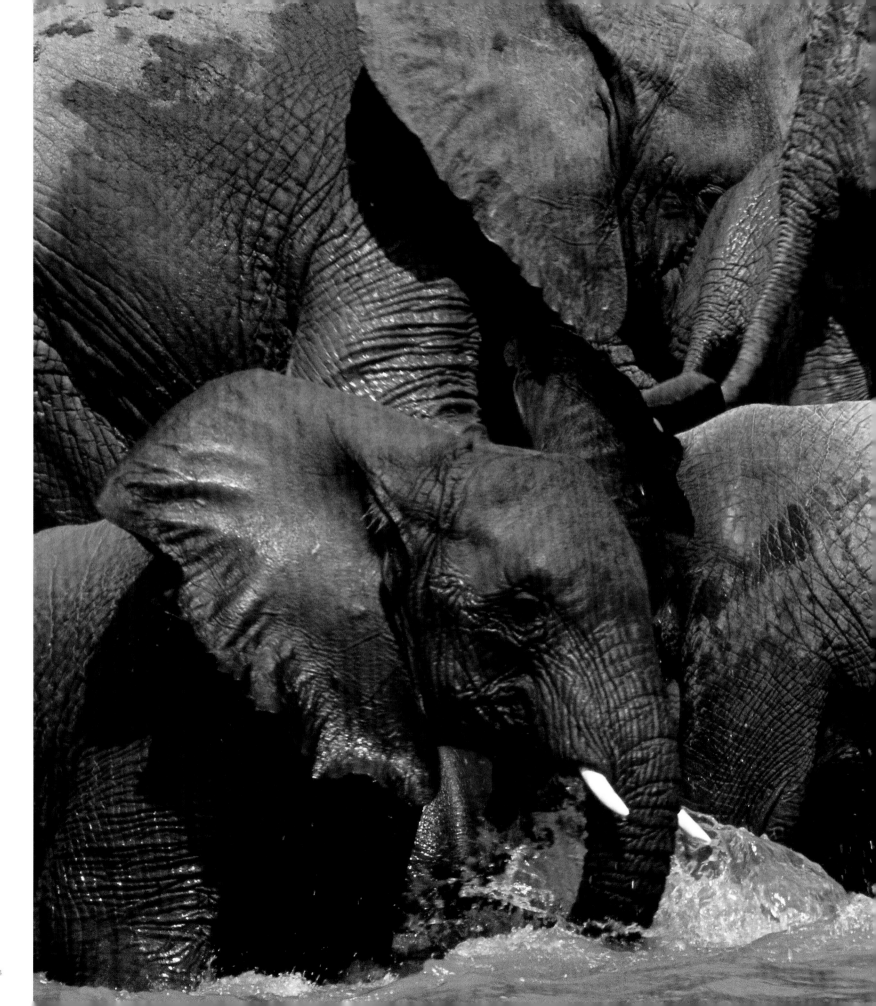

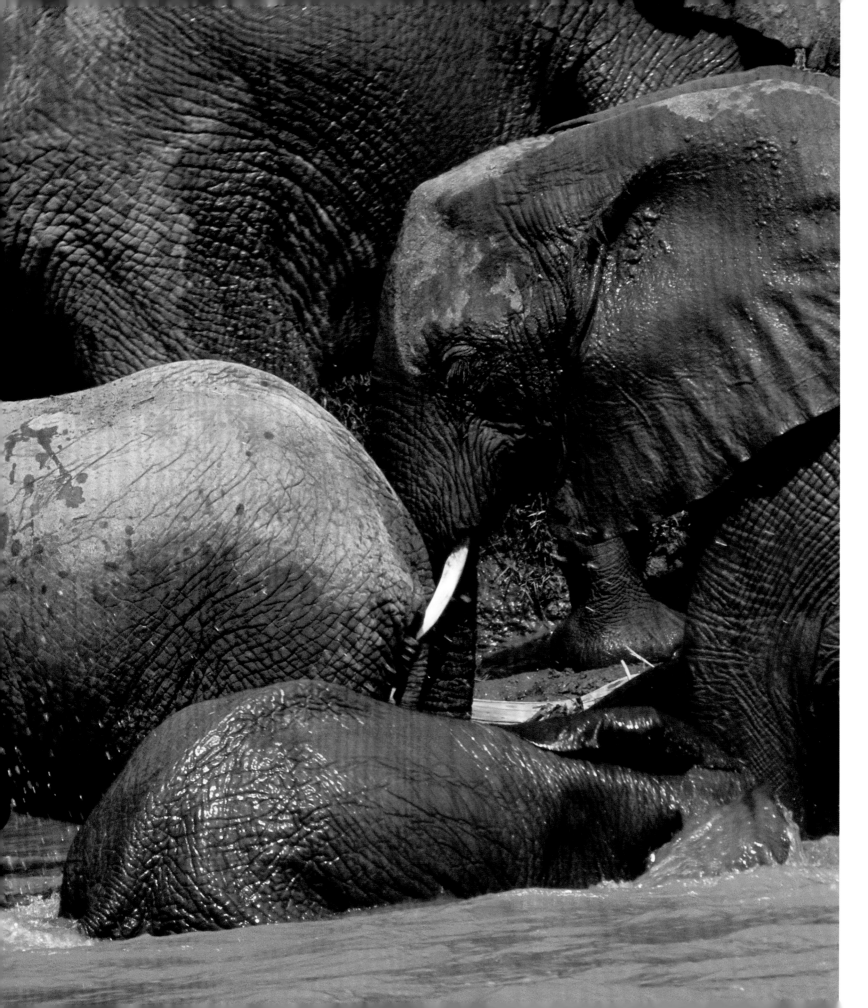

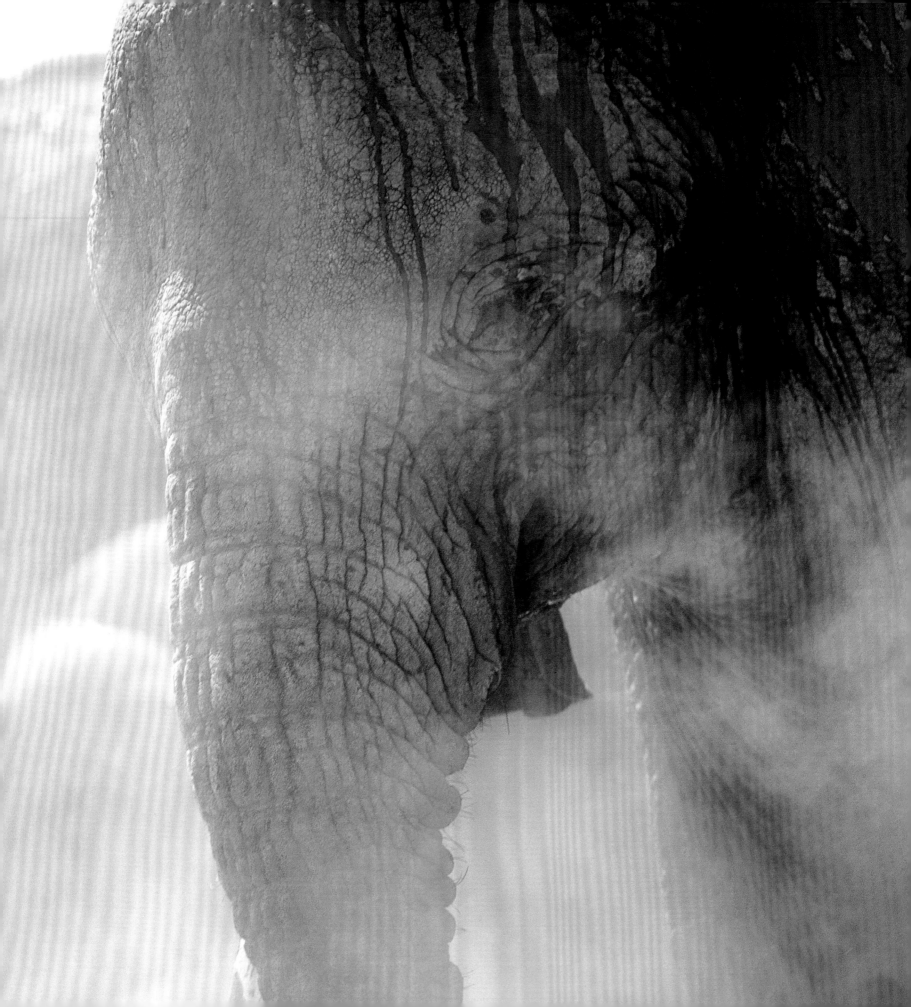

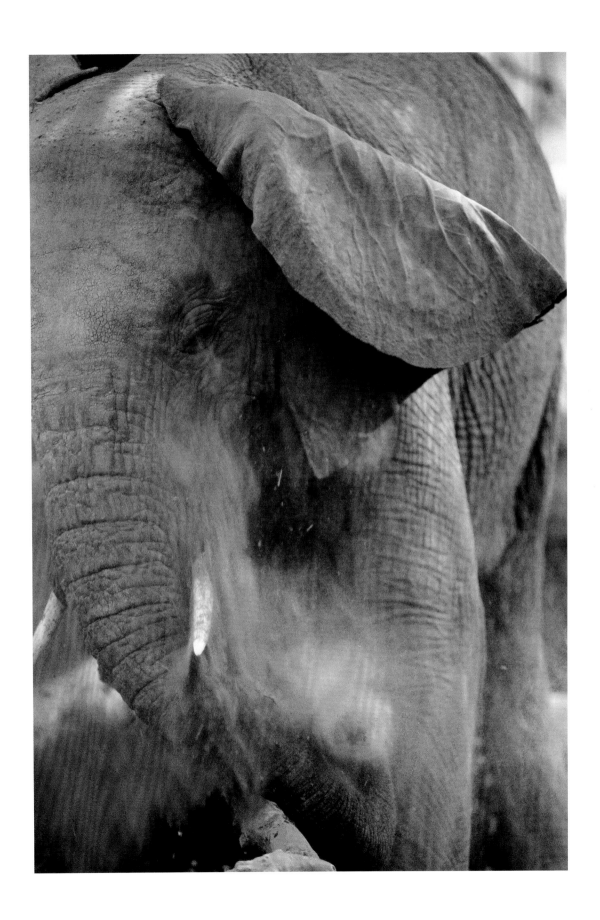

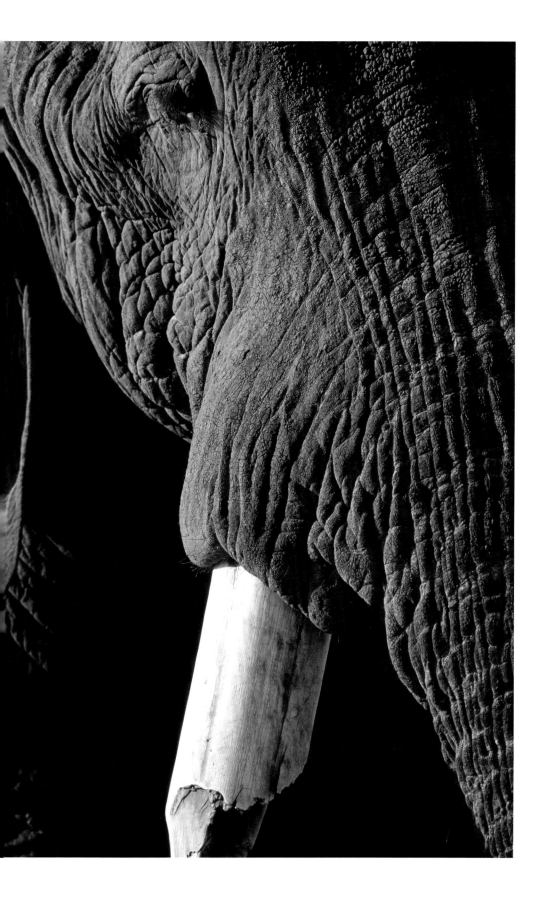

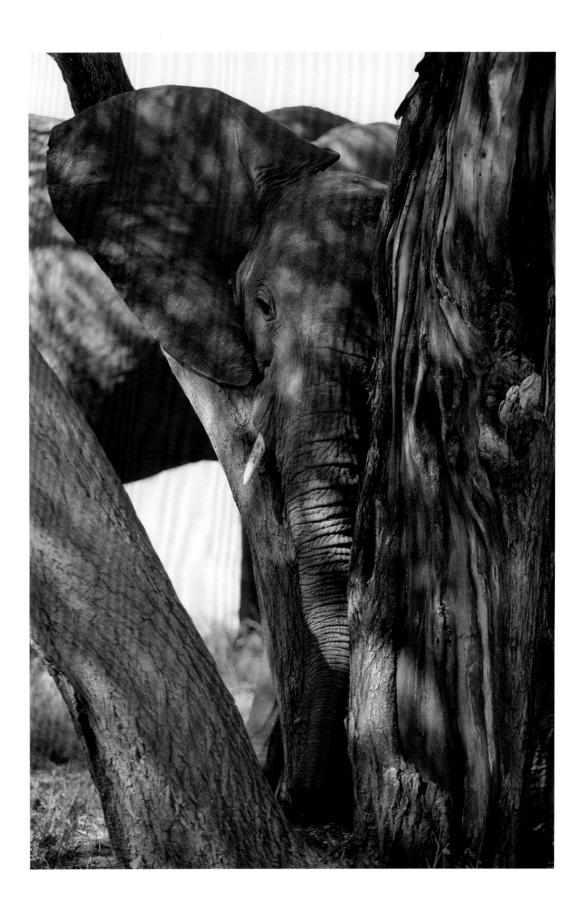

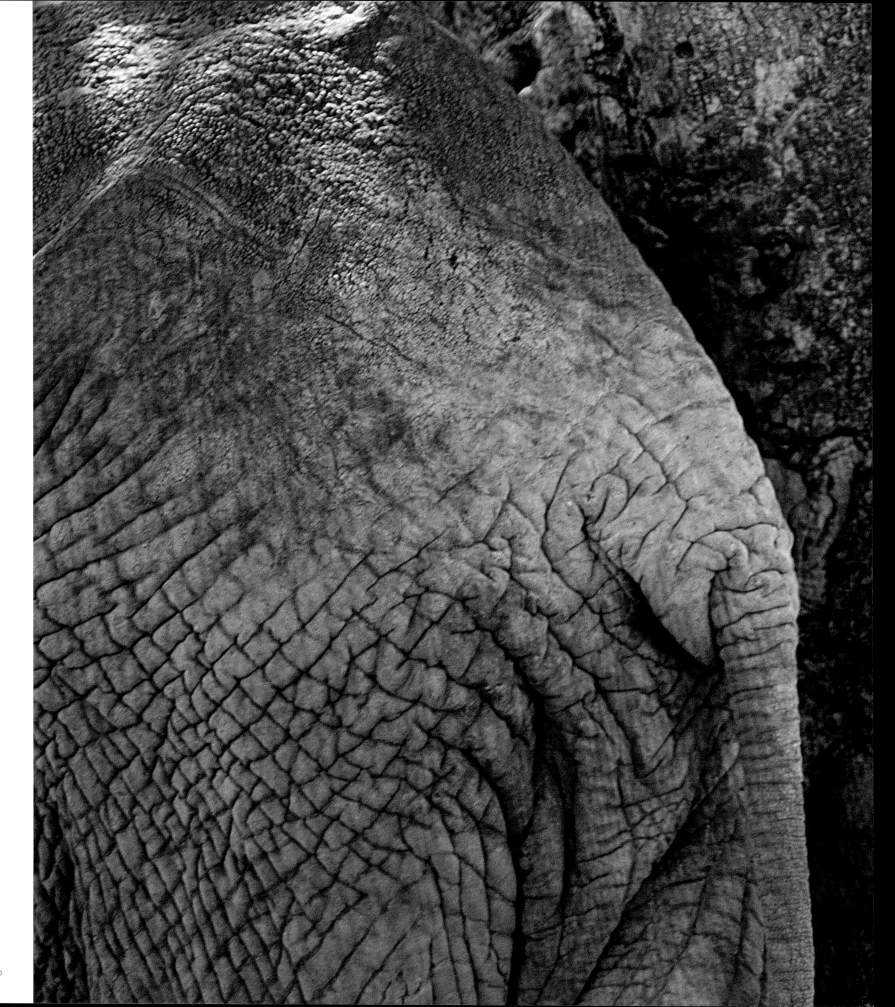

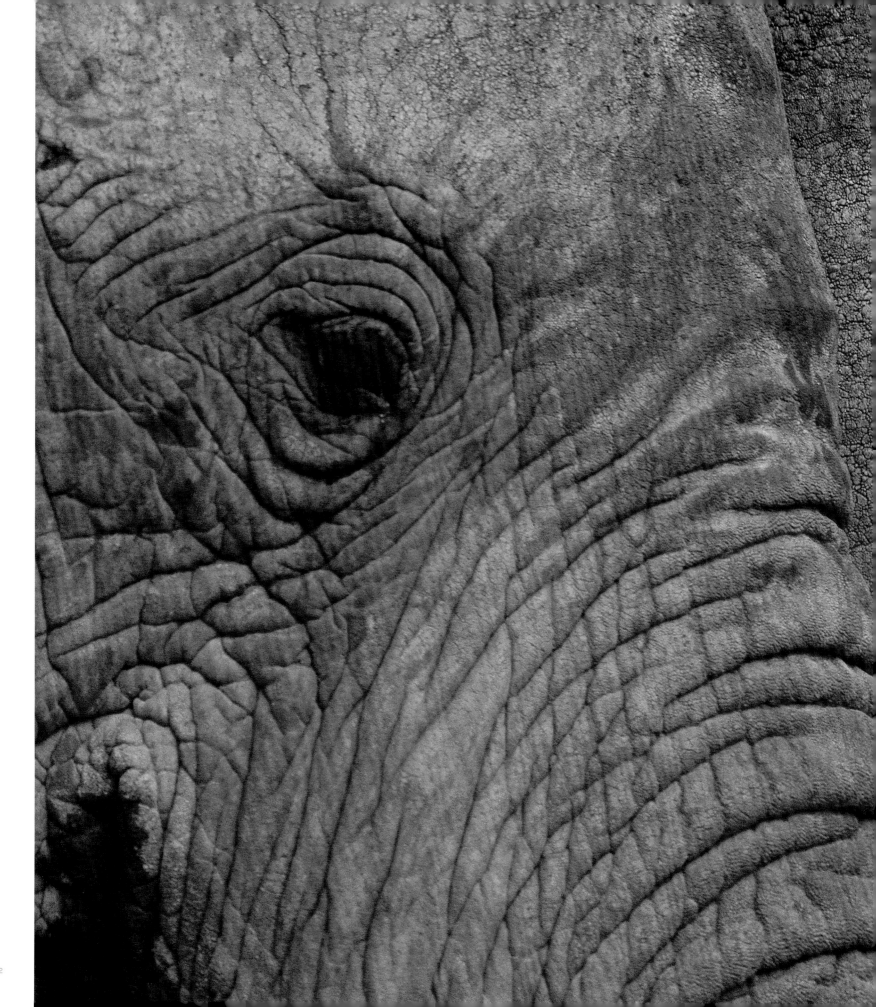

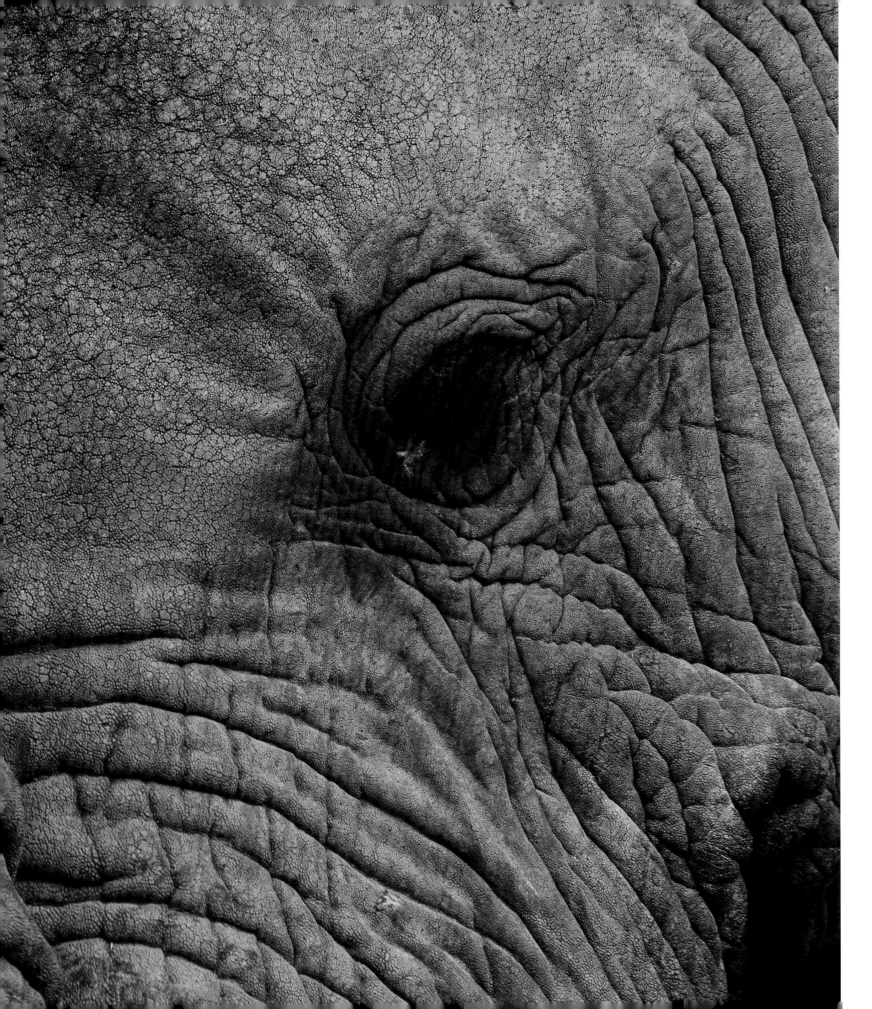

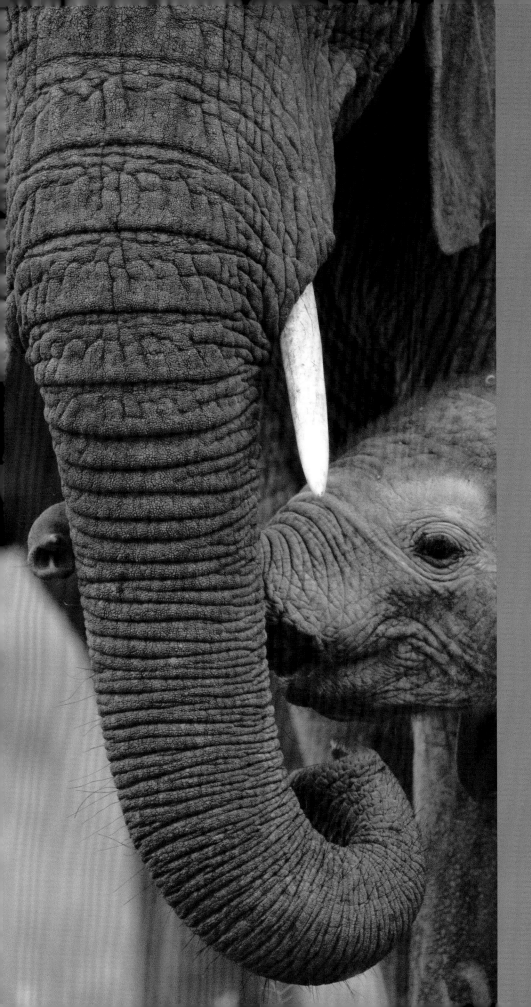

COLORS

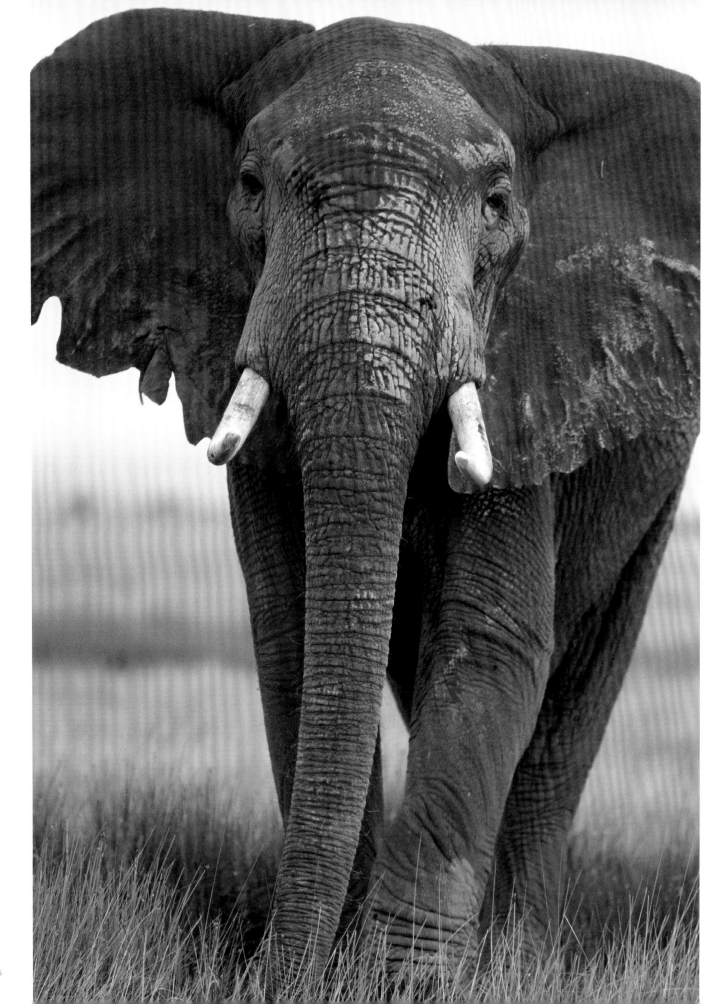

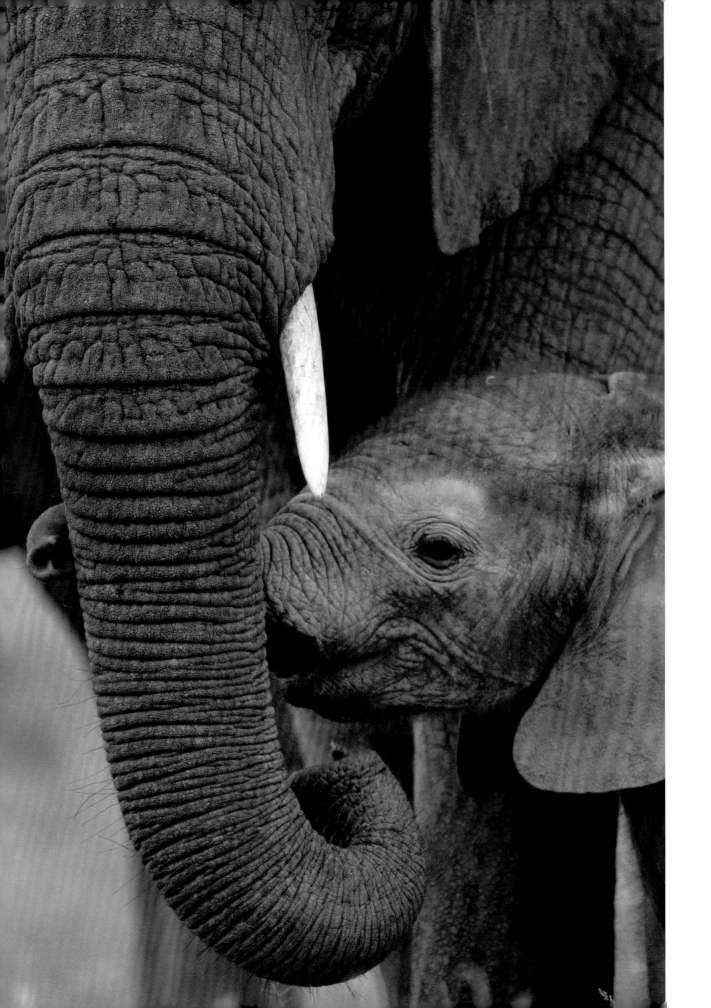

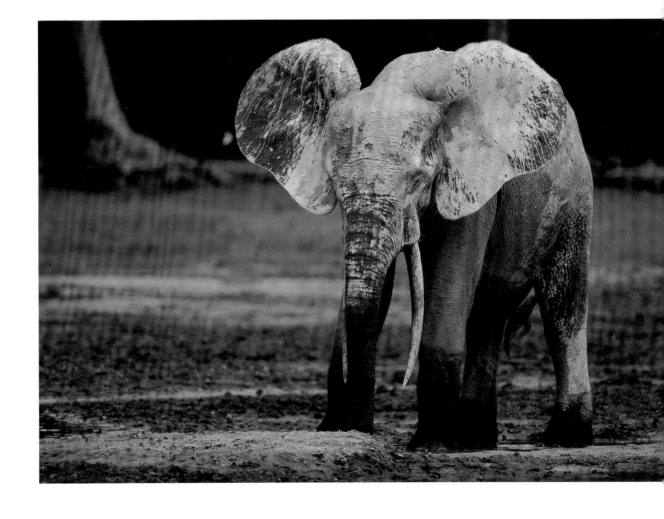

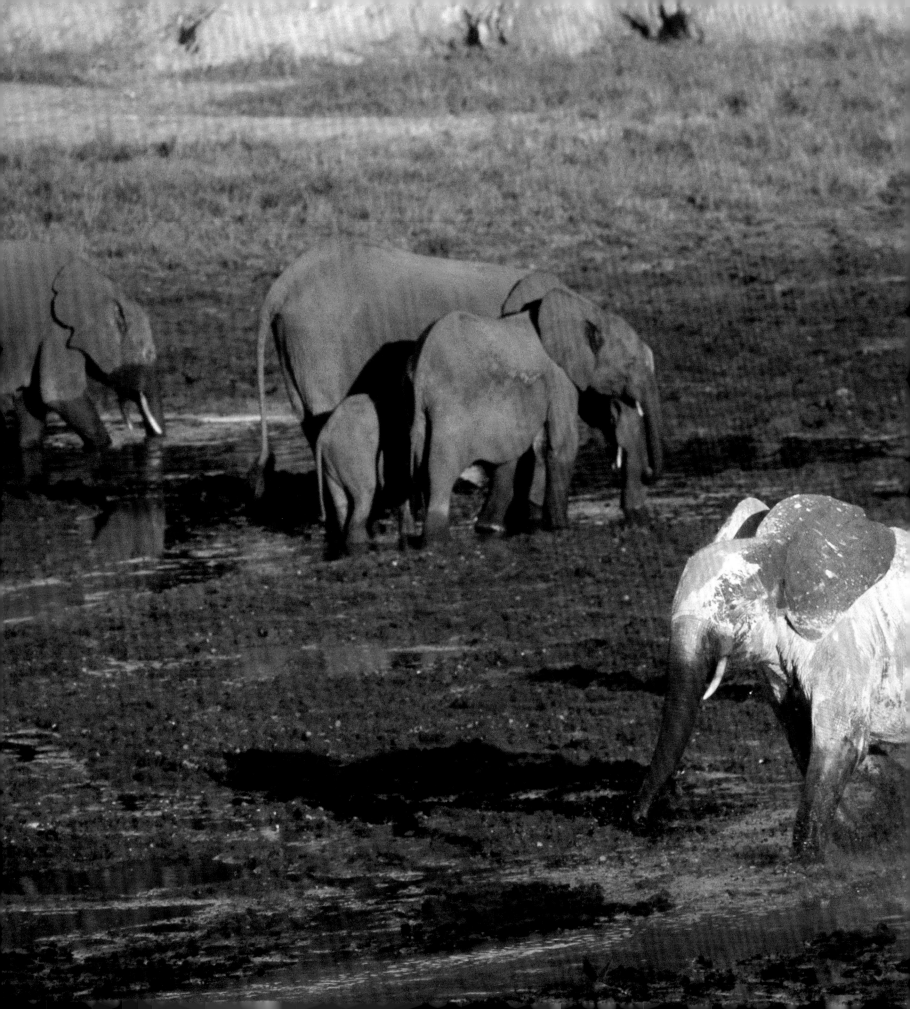

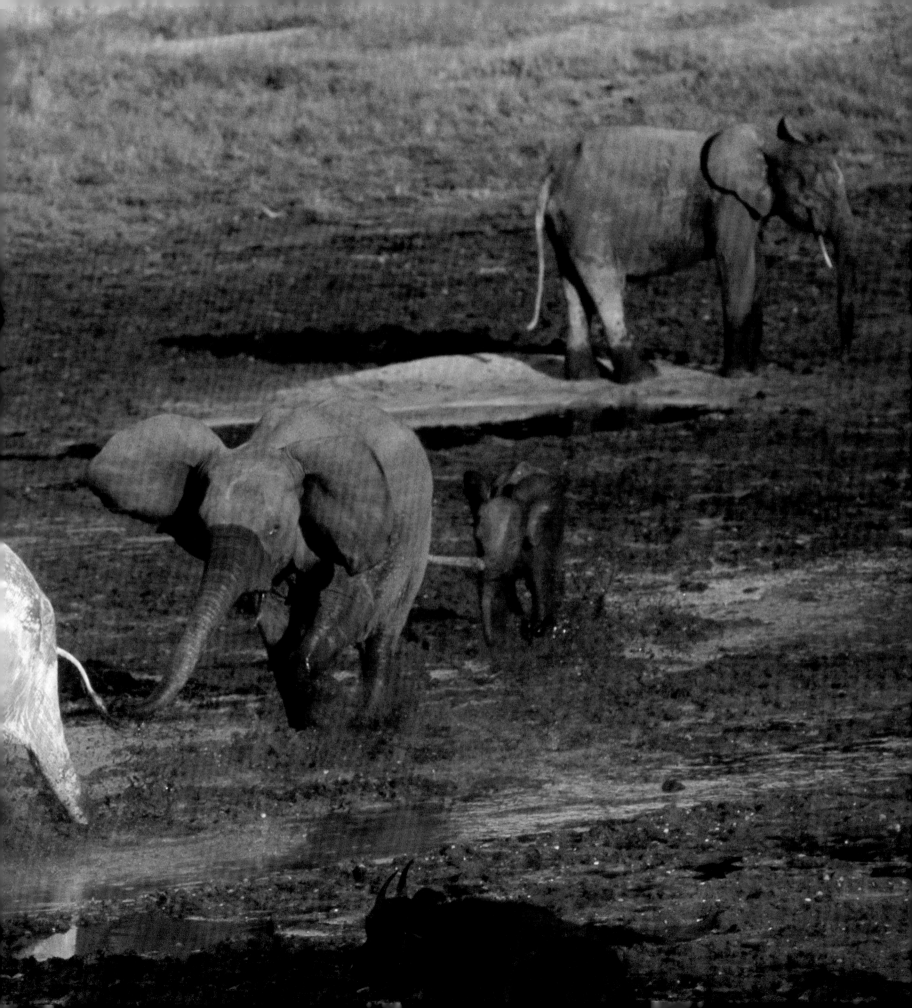

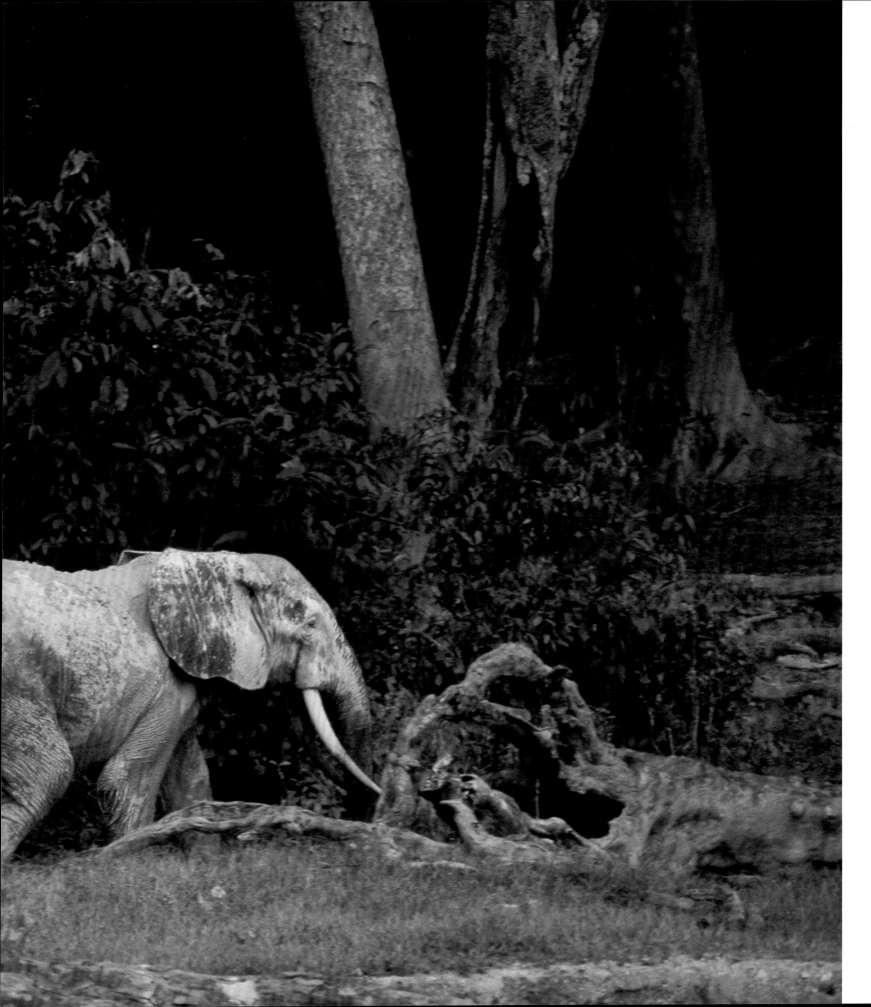

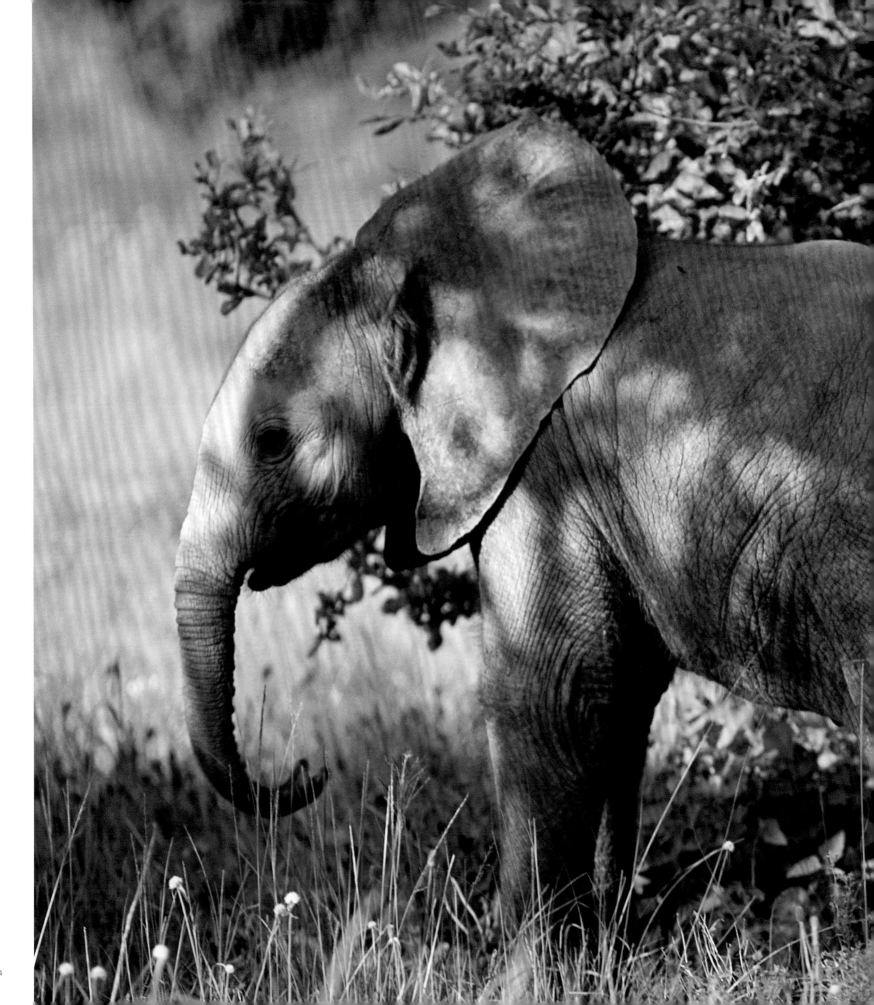

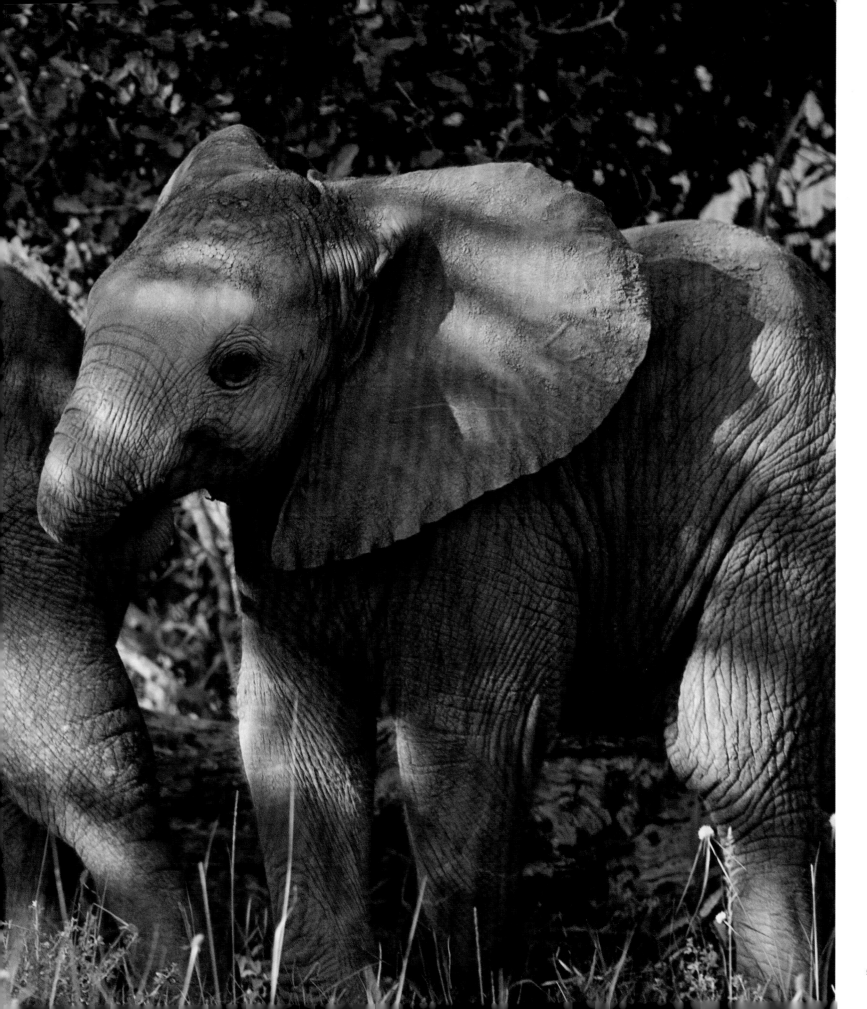

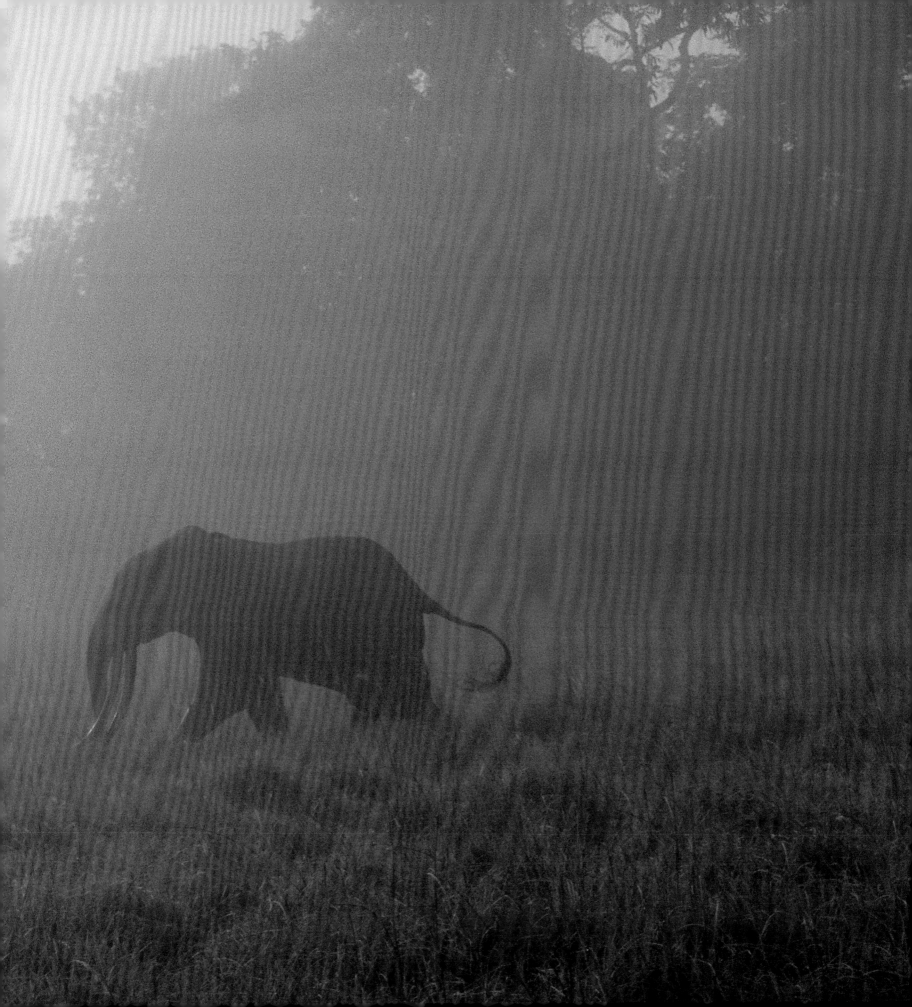

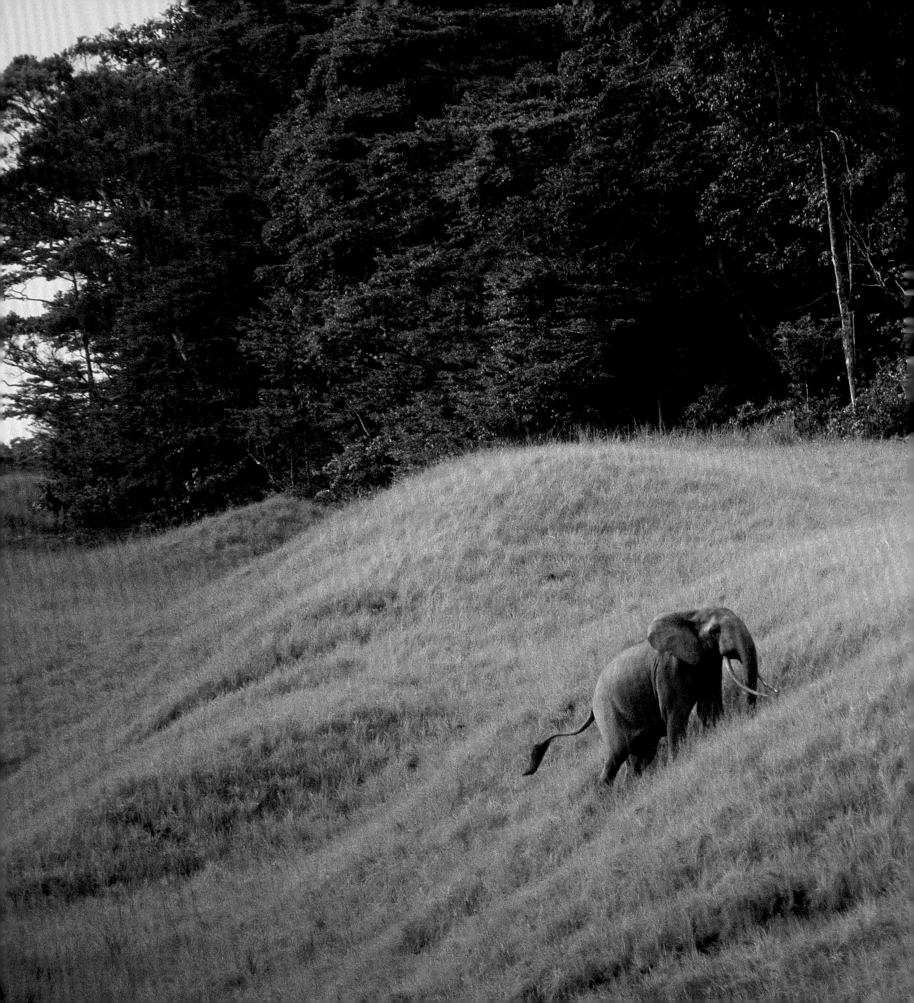

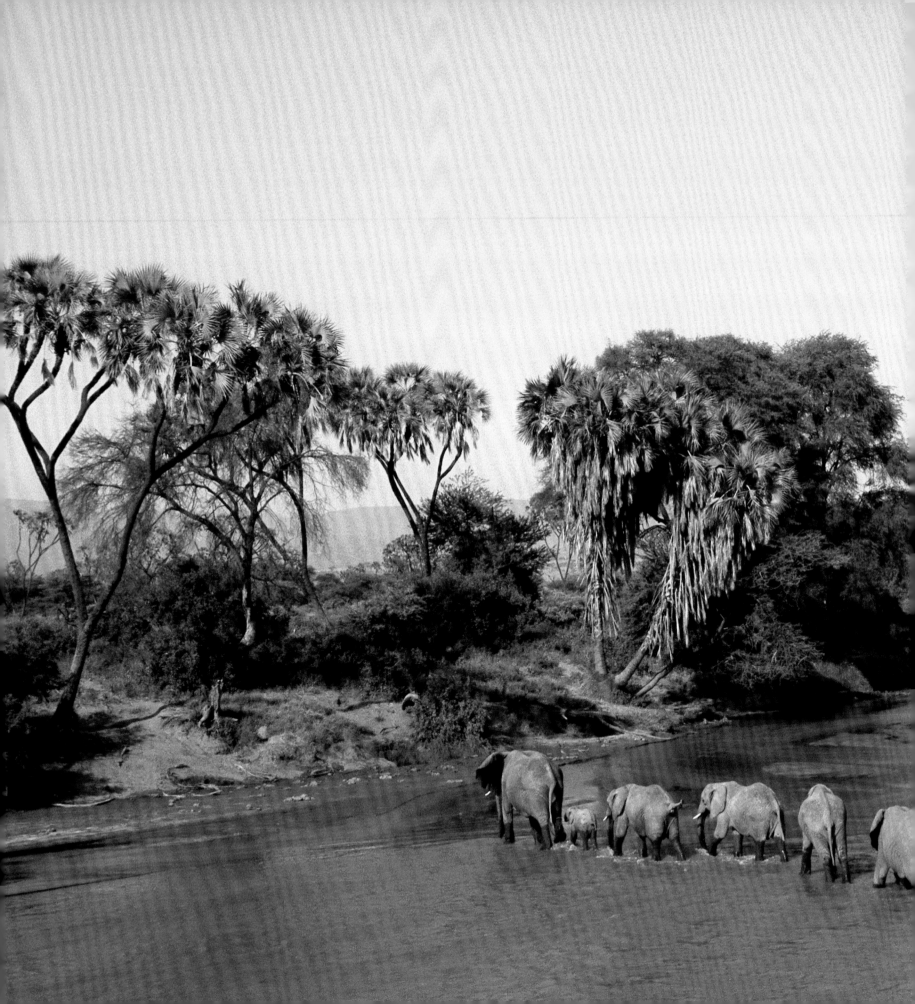

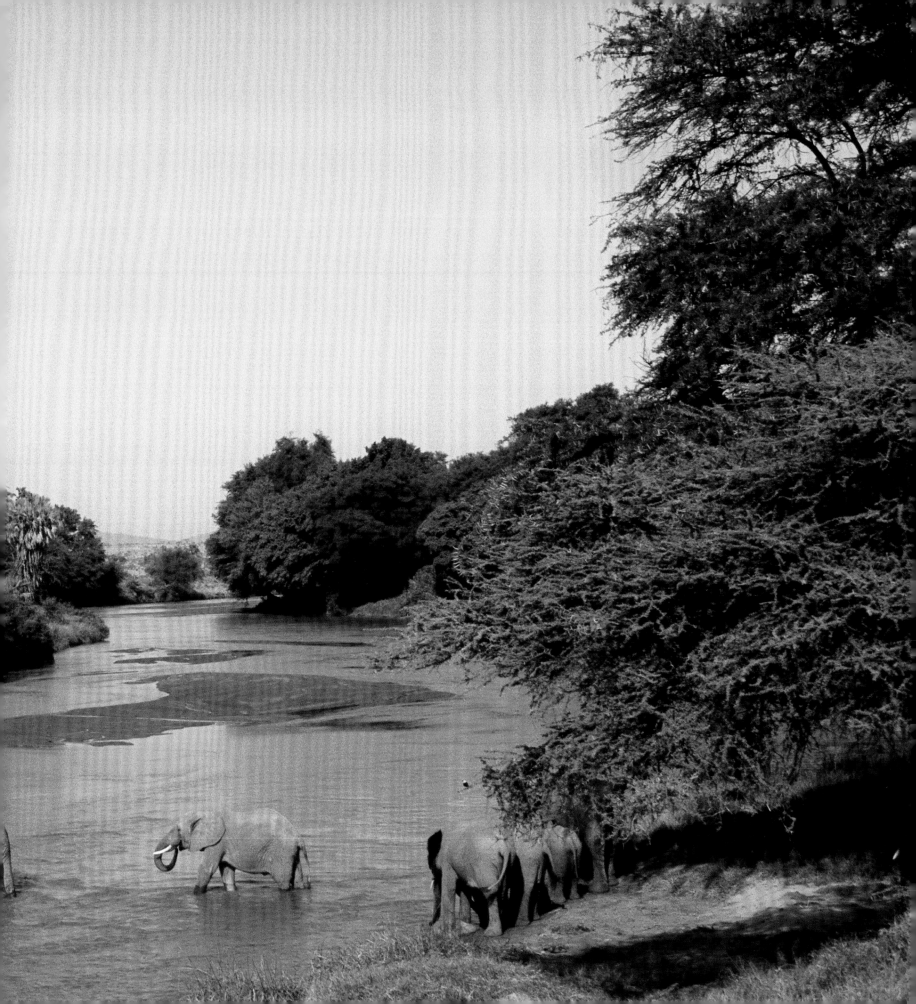

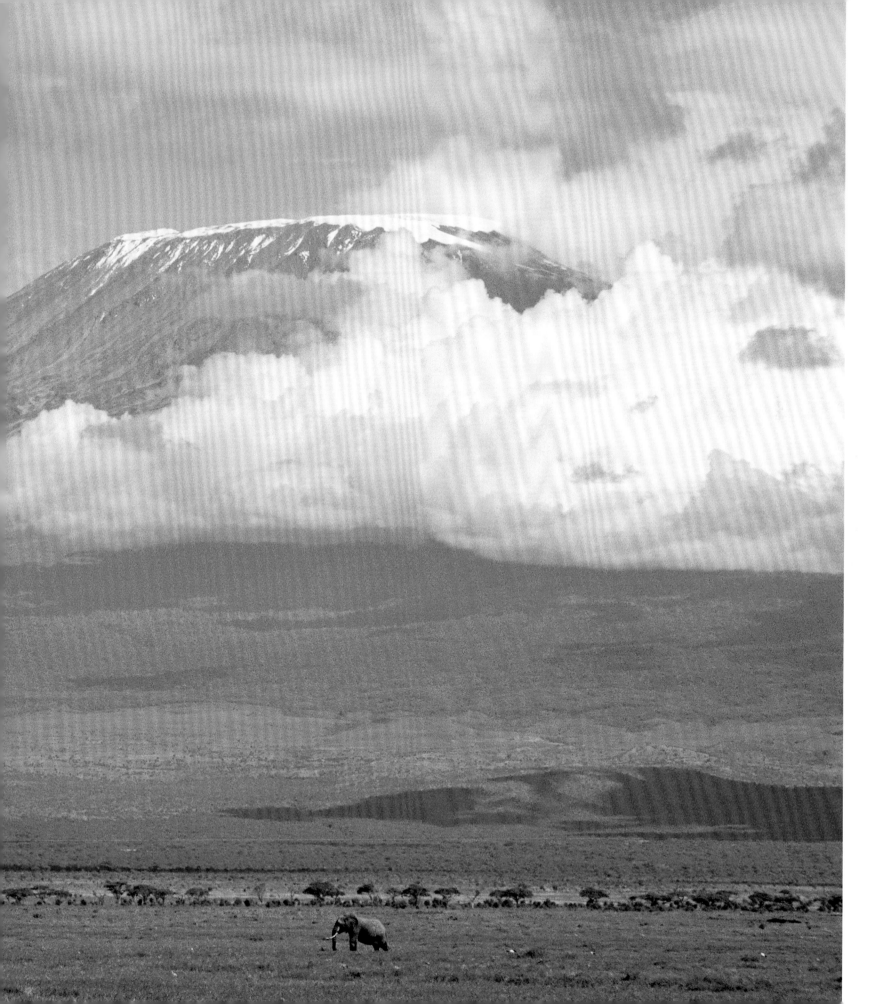

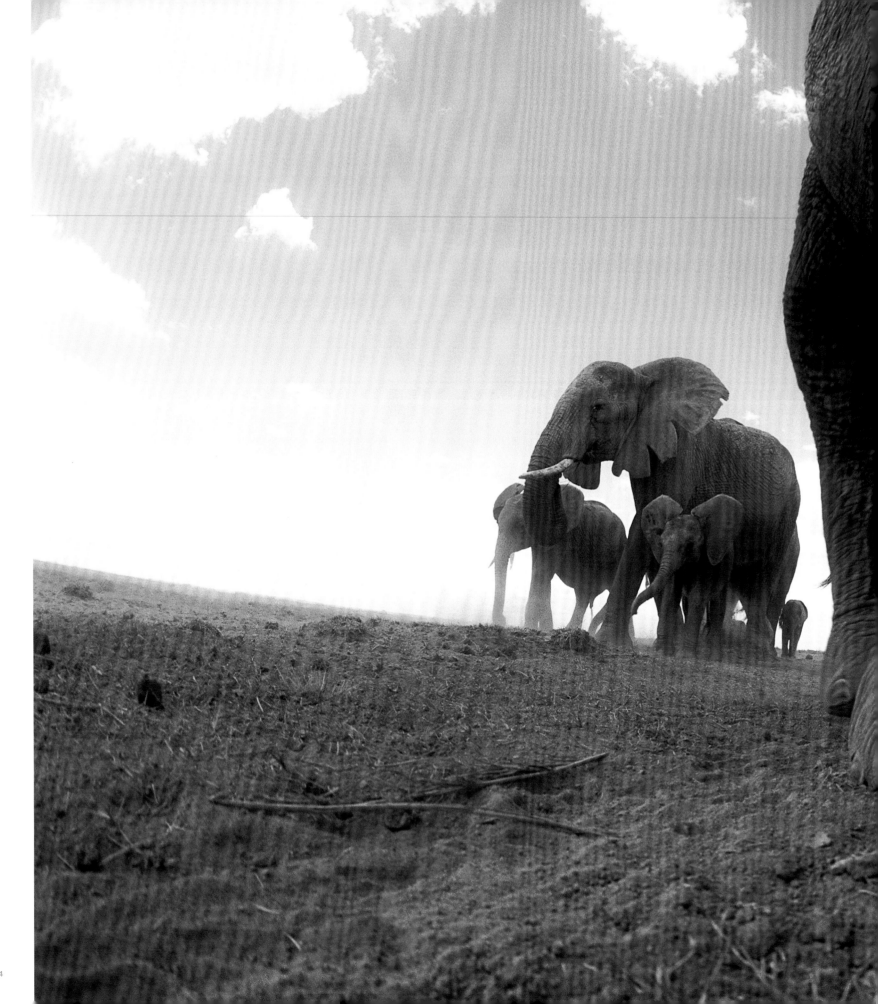

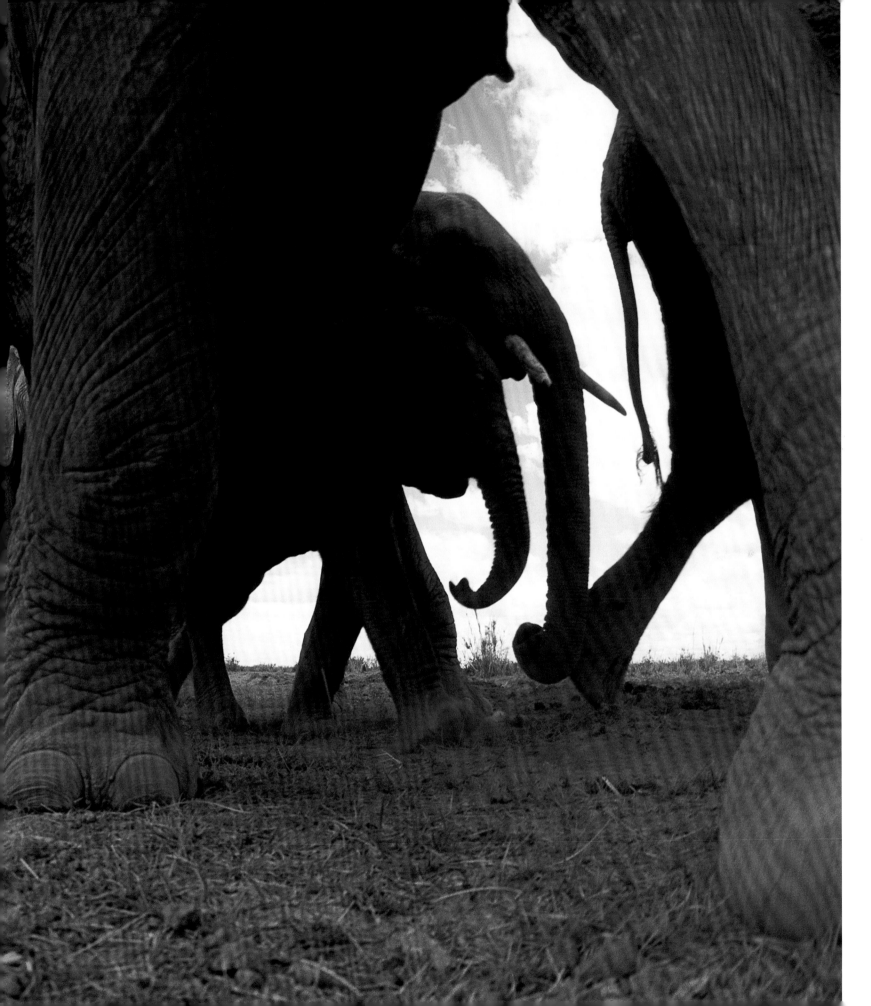

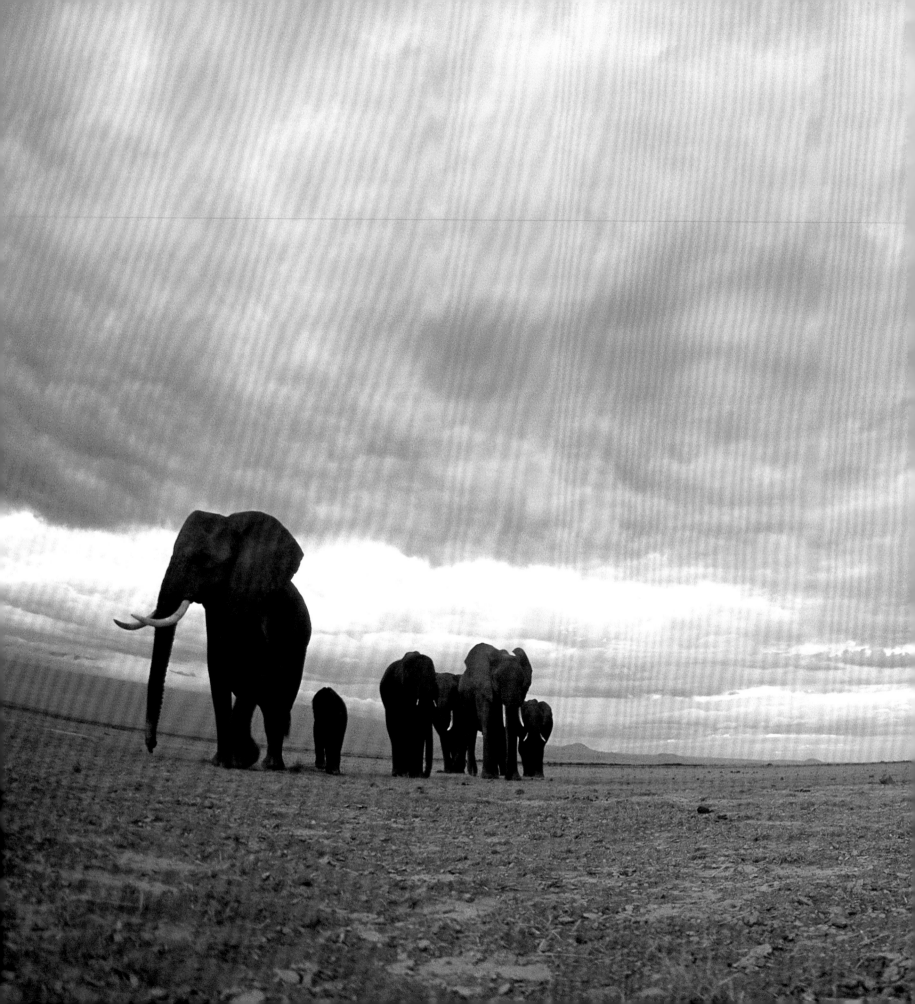

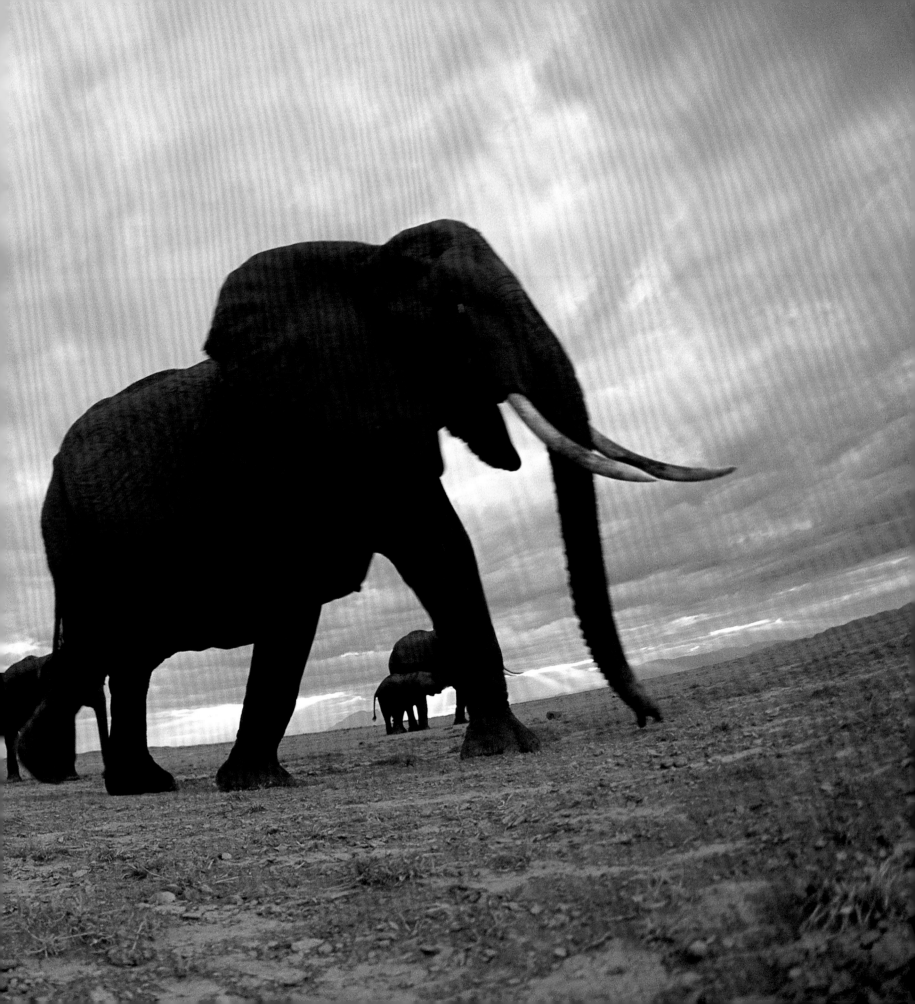

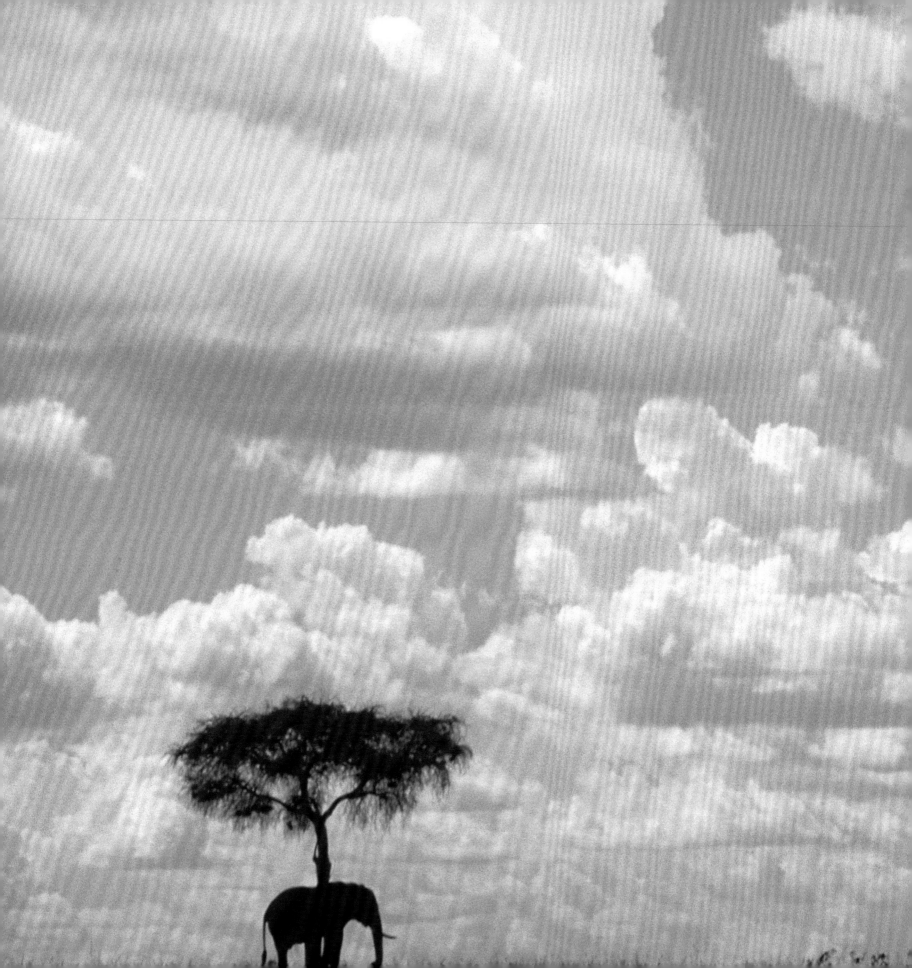

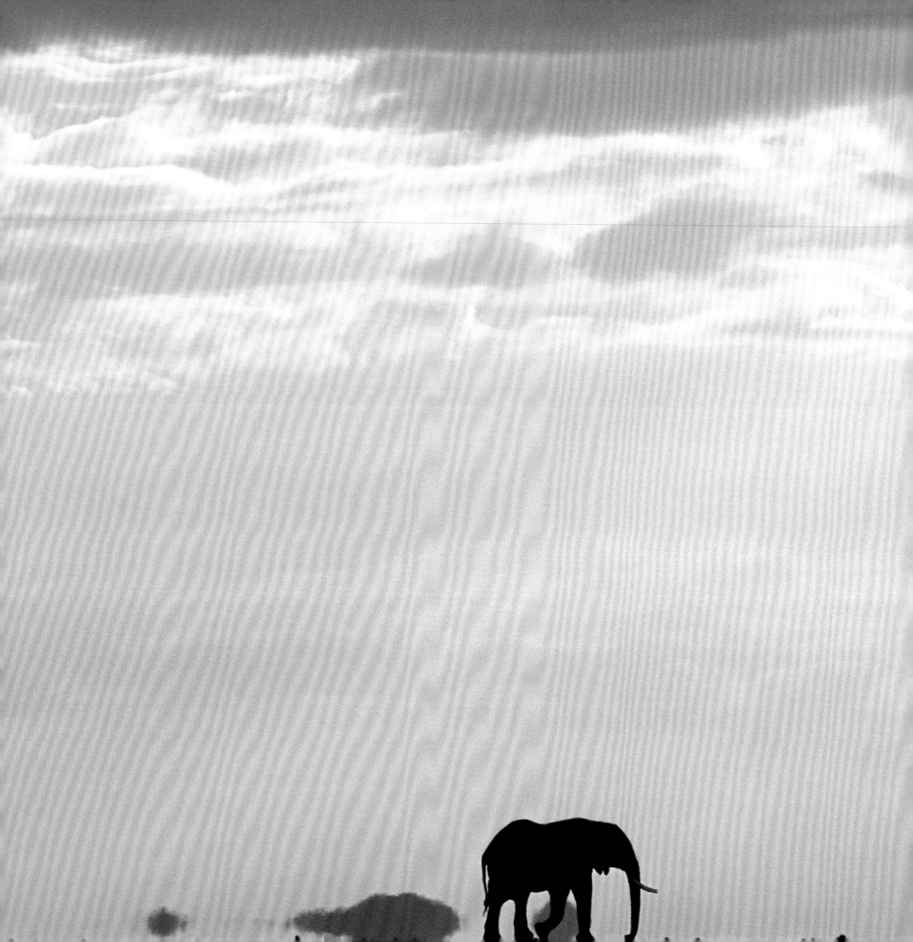

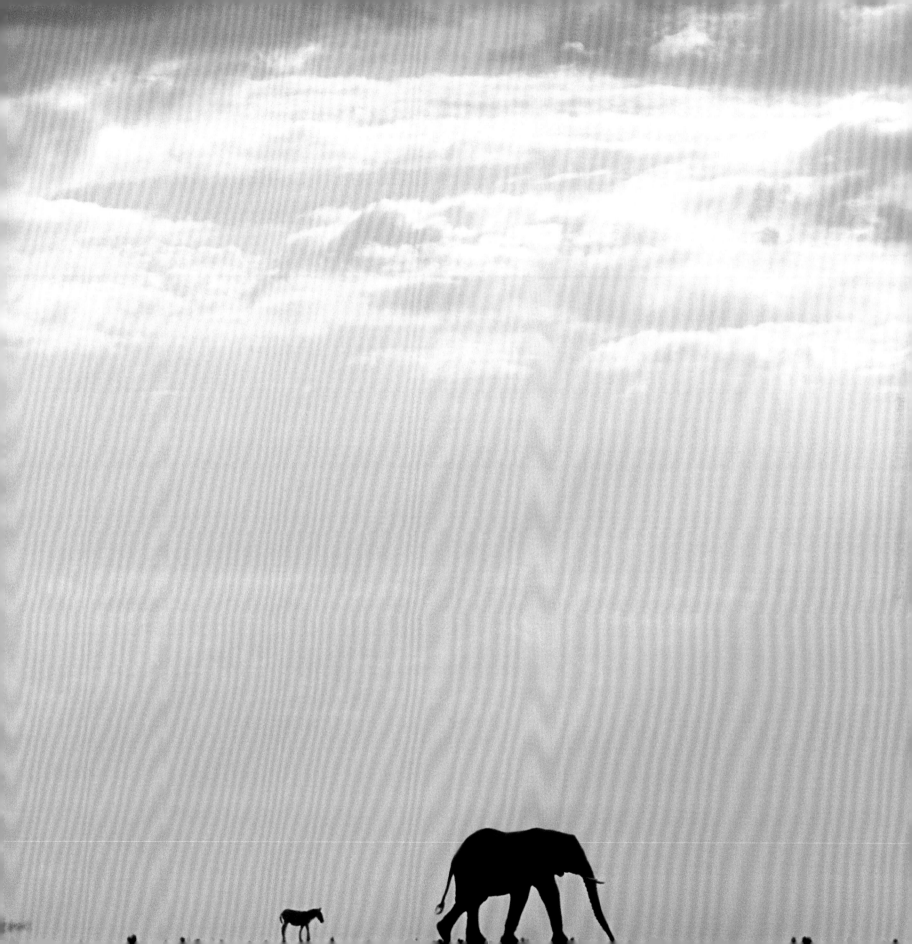

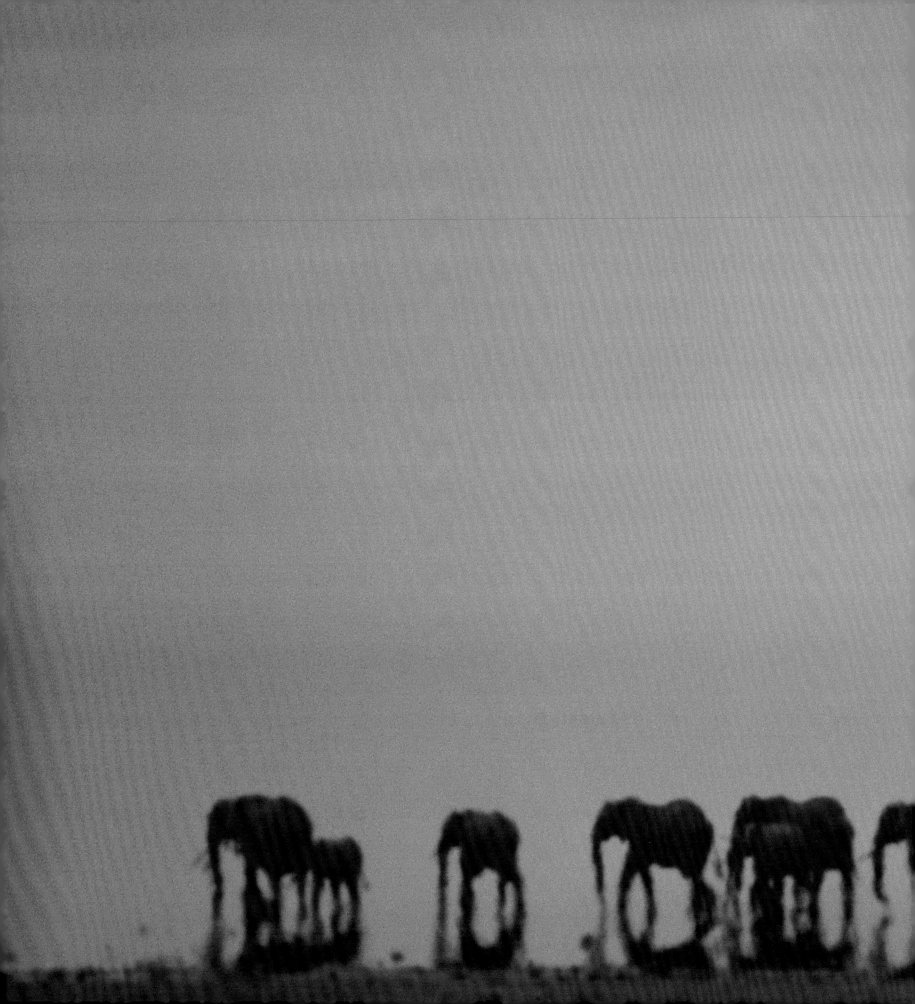

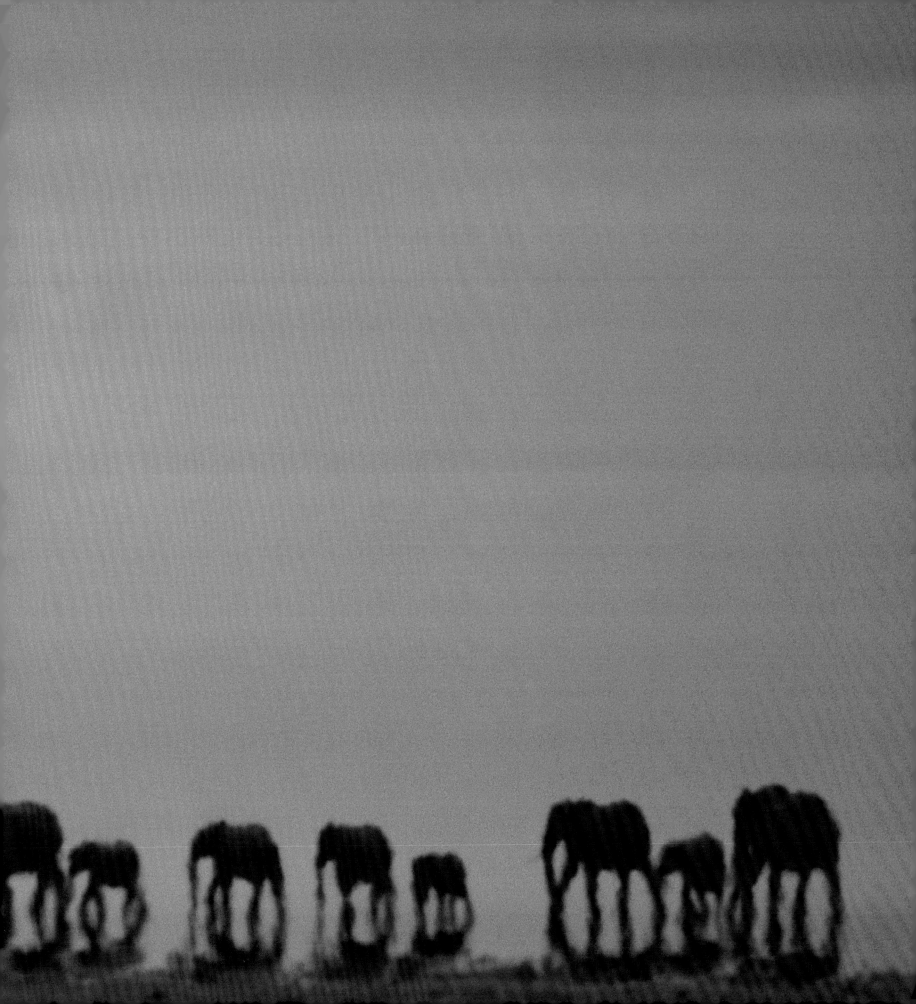

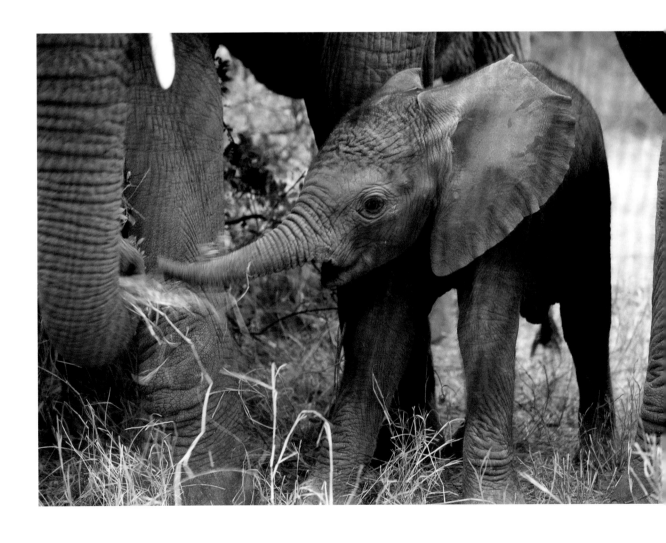

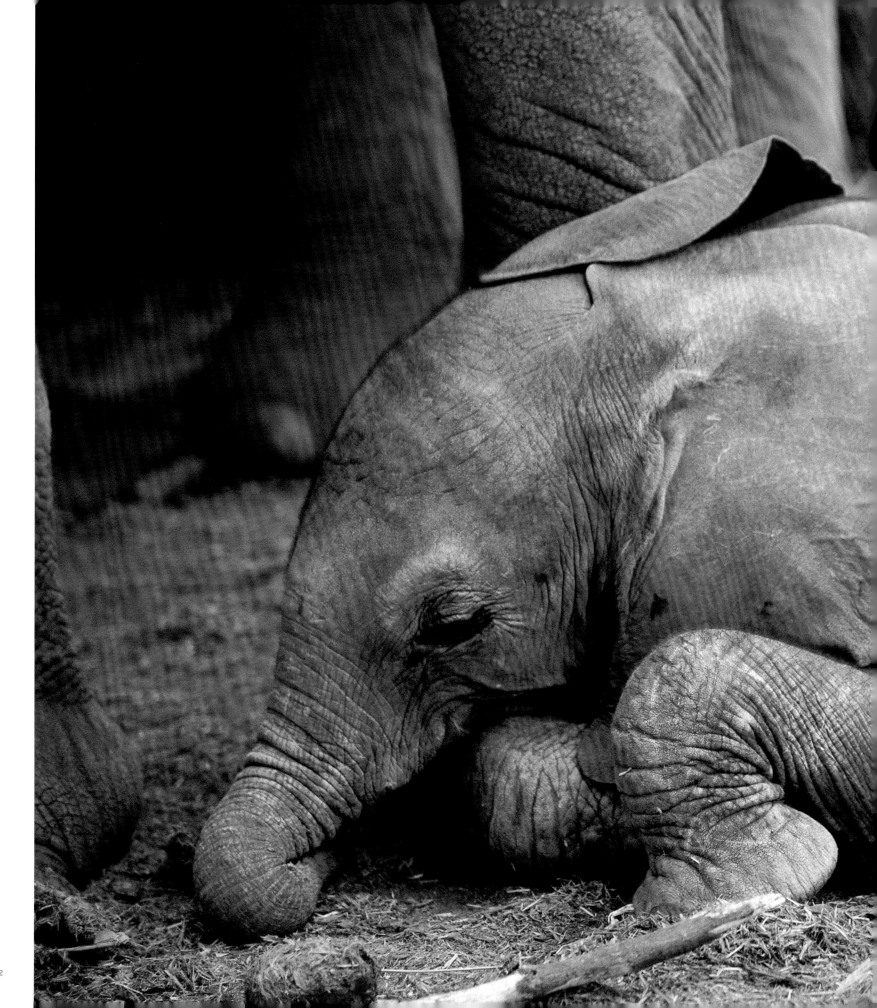

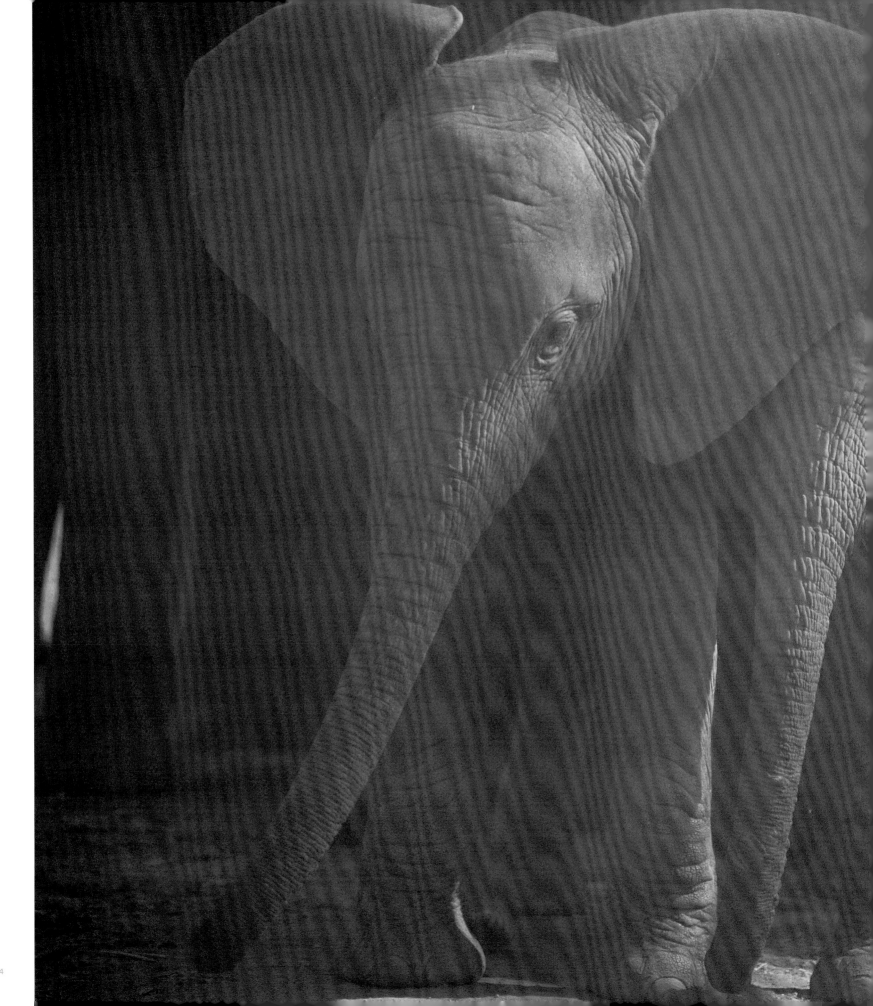

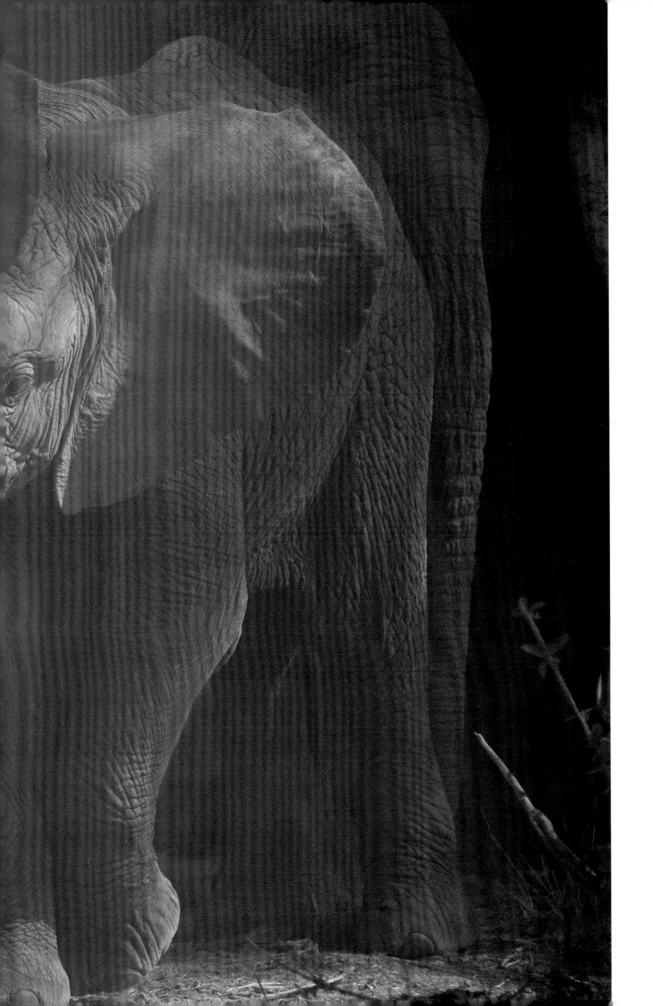

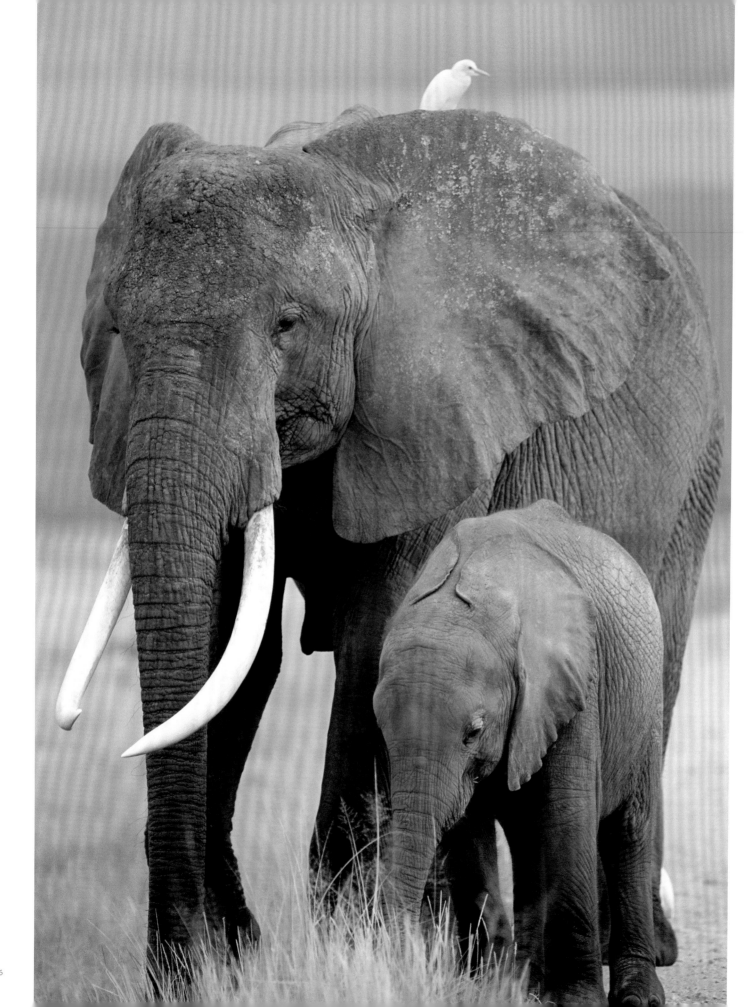

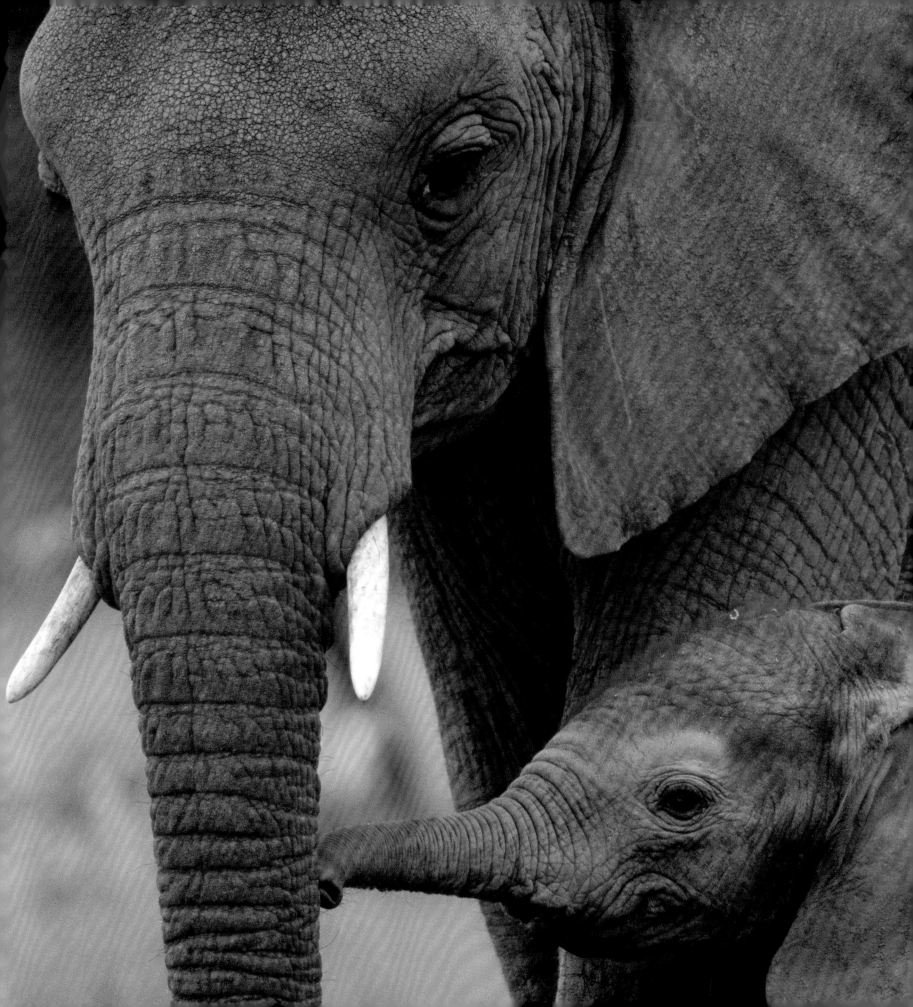

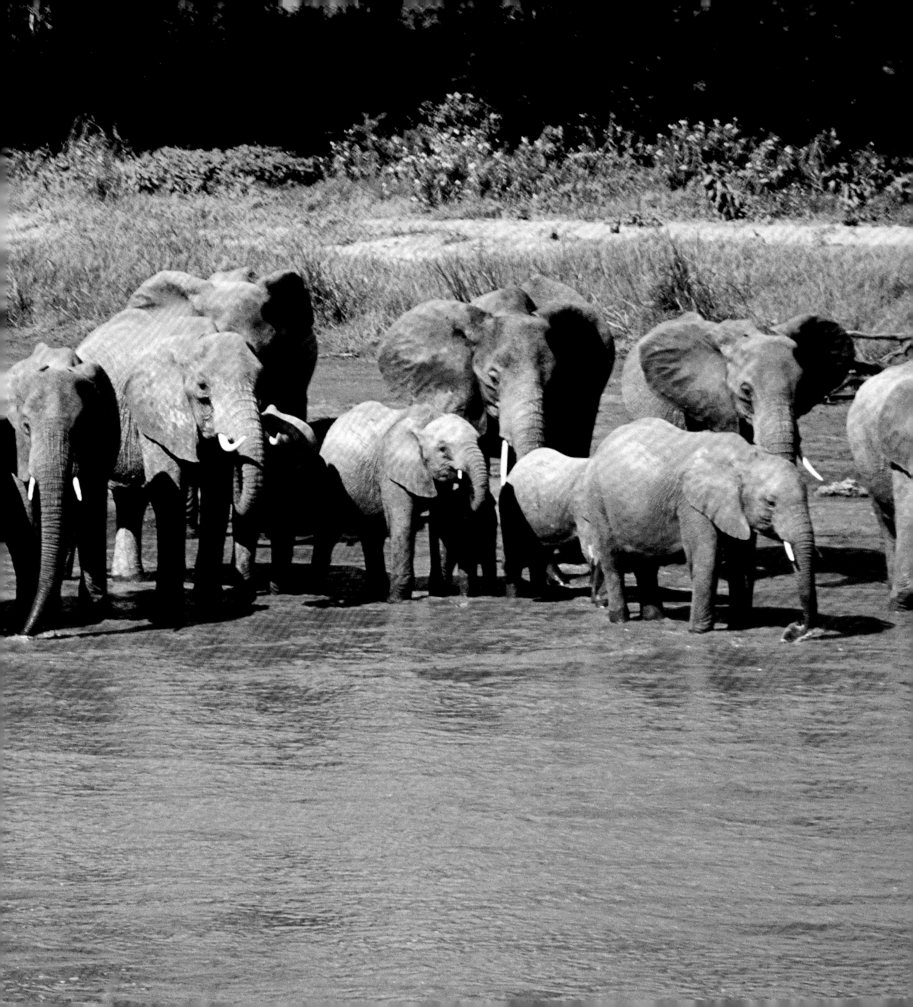

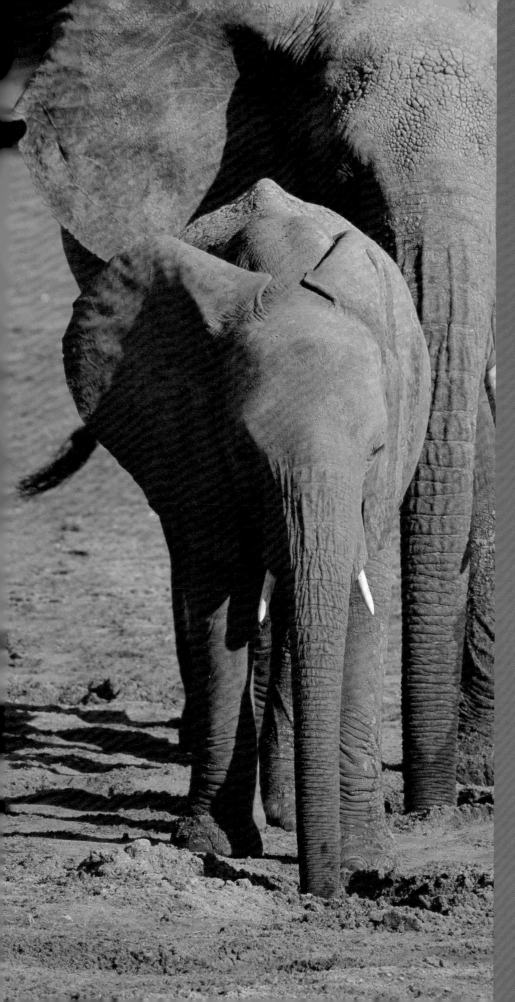

BEHAVIORS

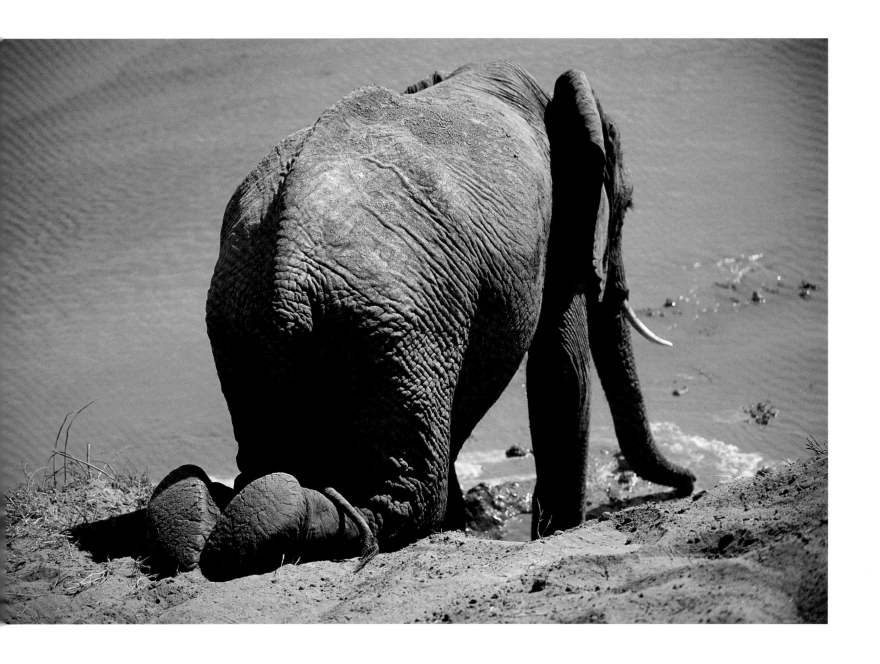

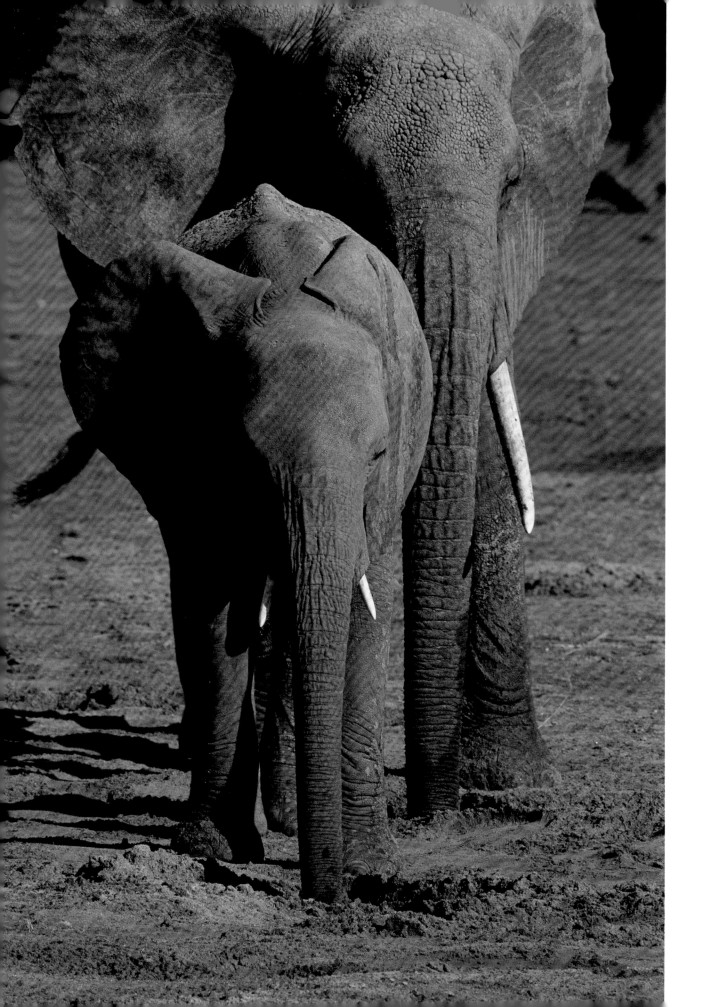

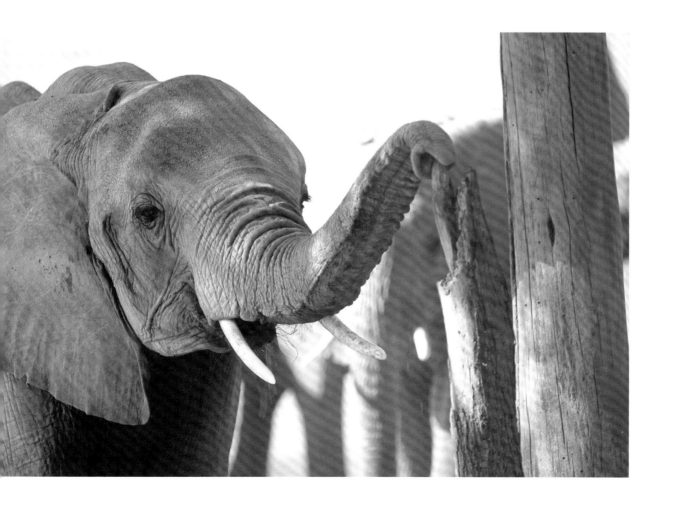

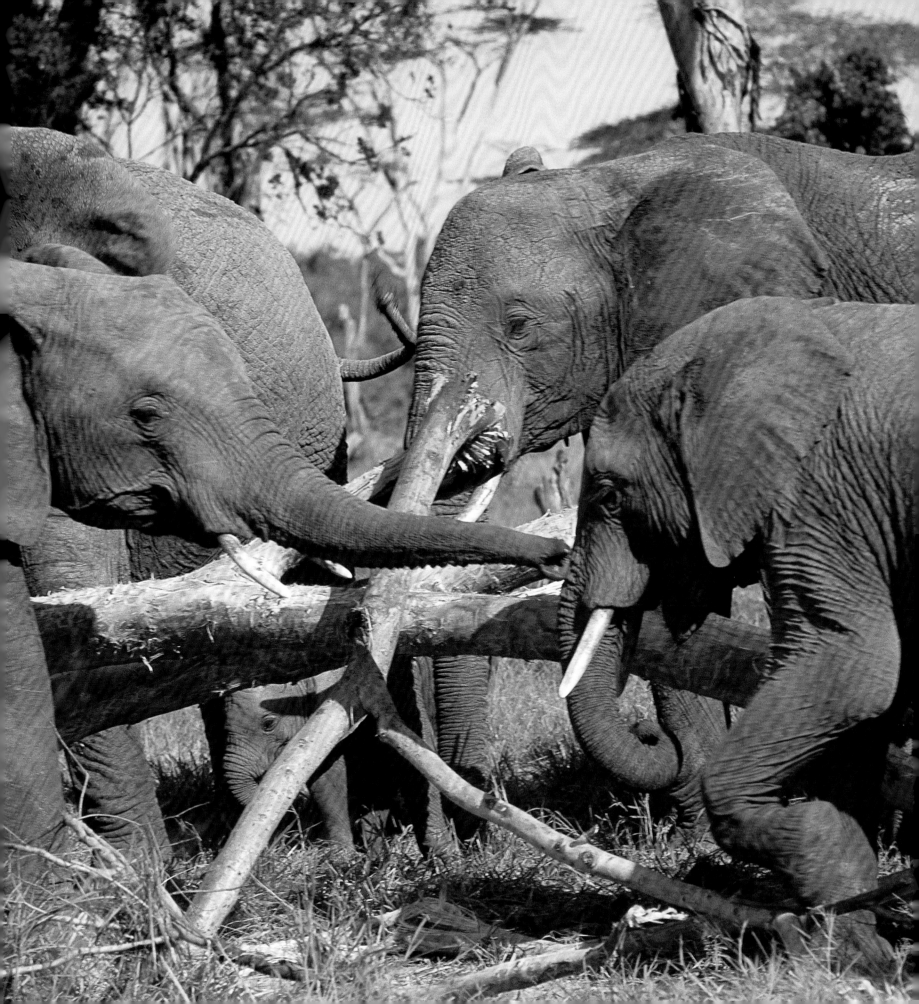

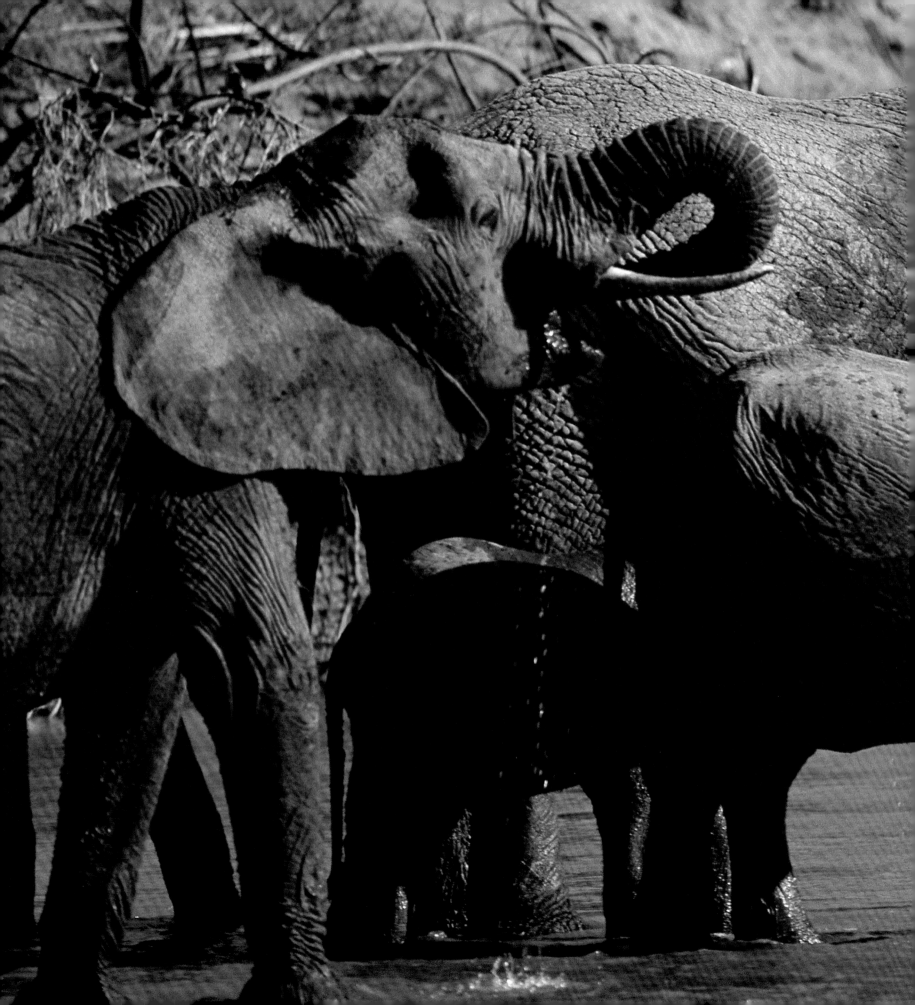

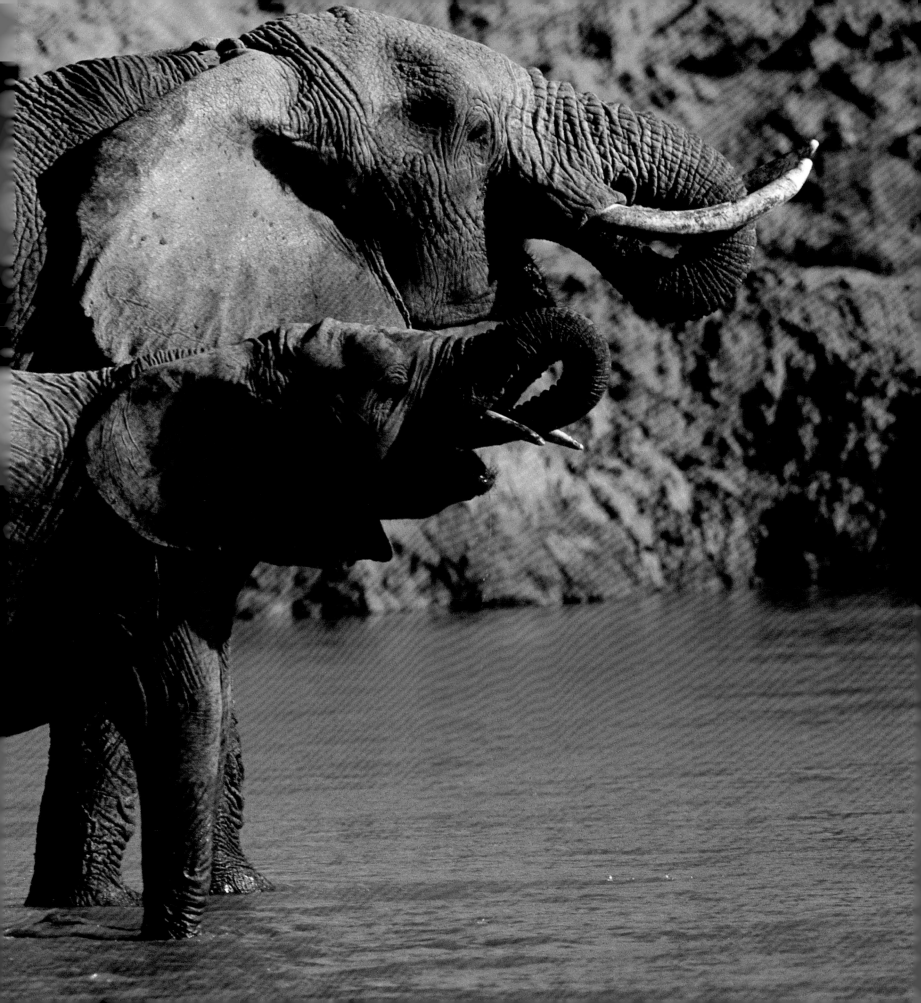

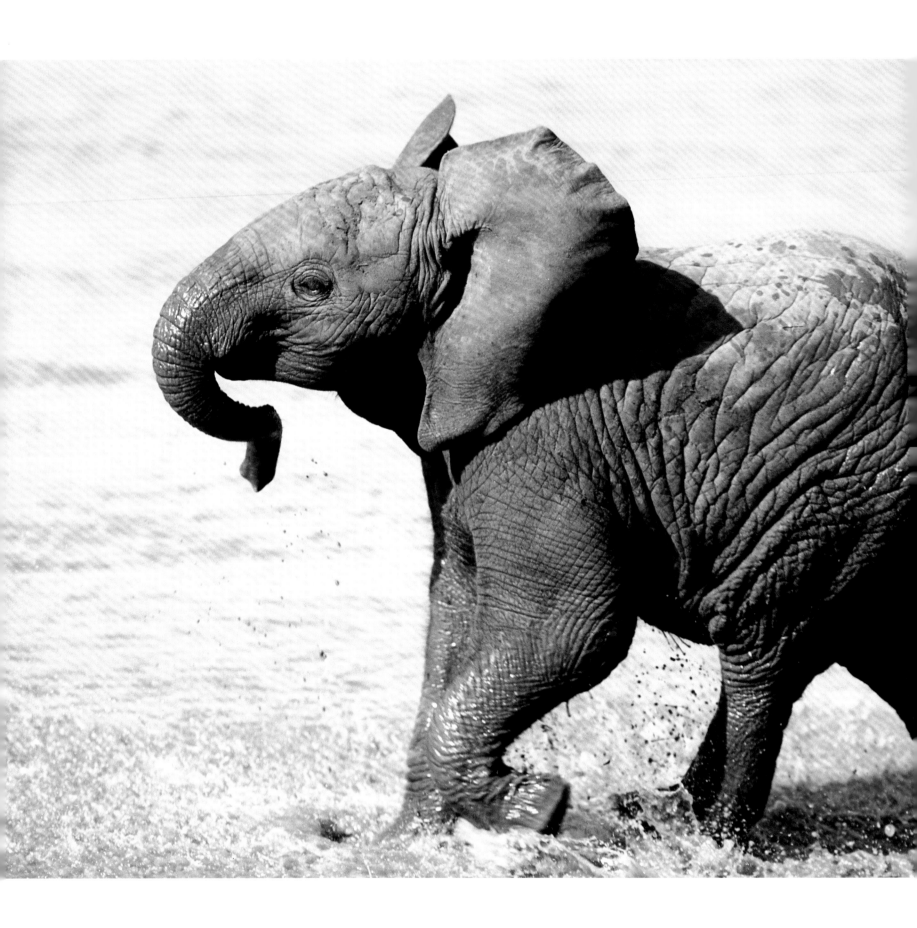

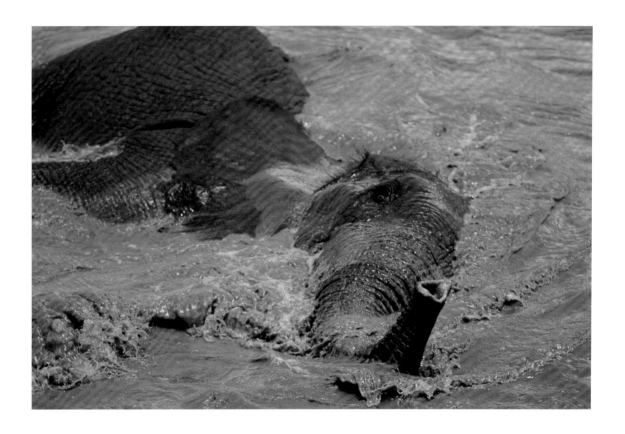

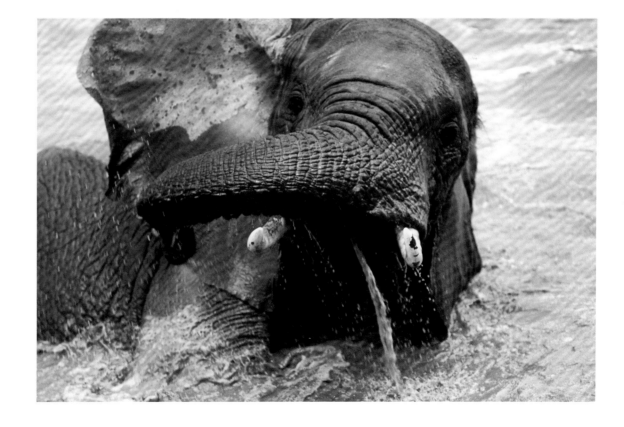

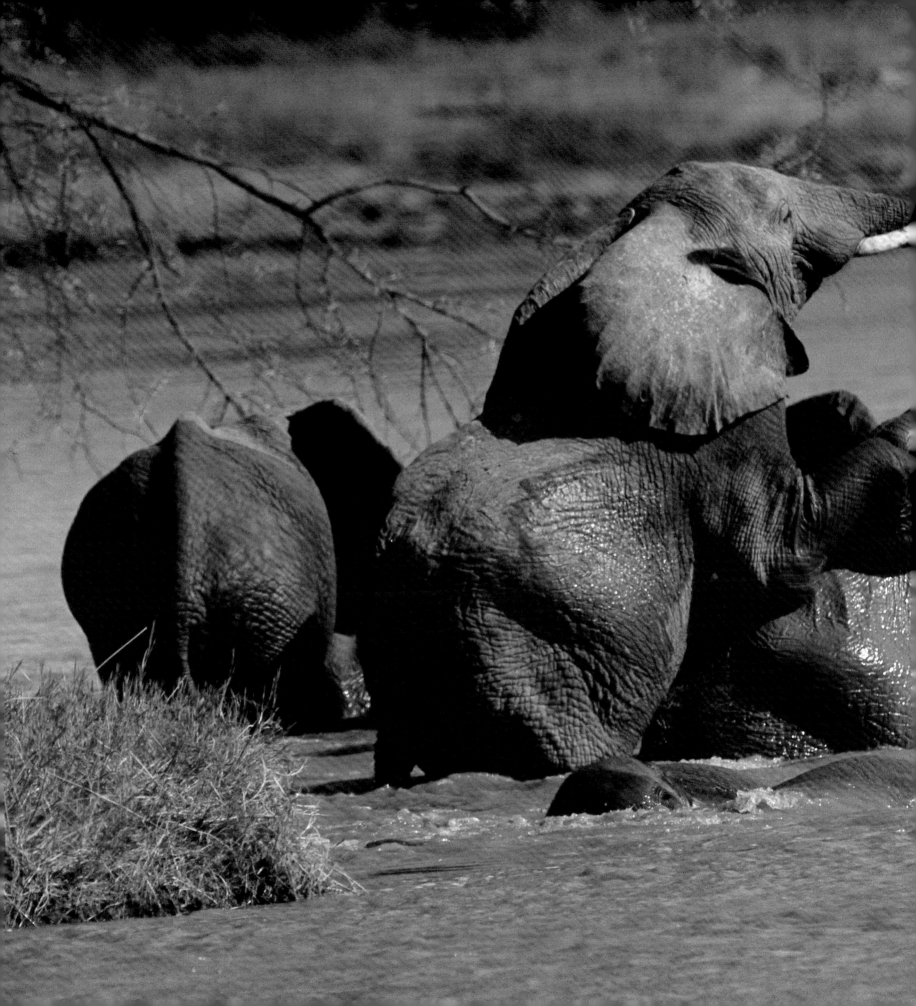

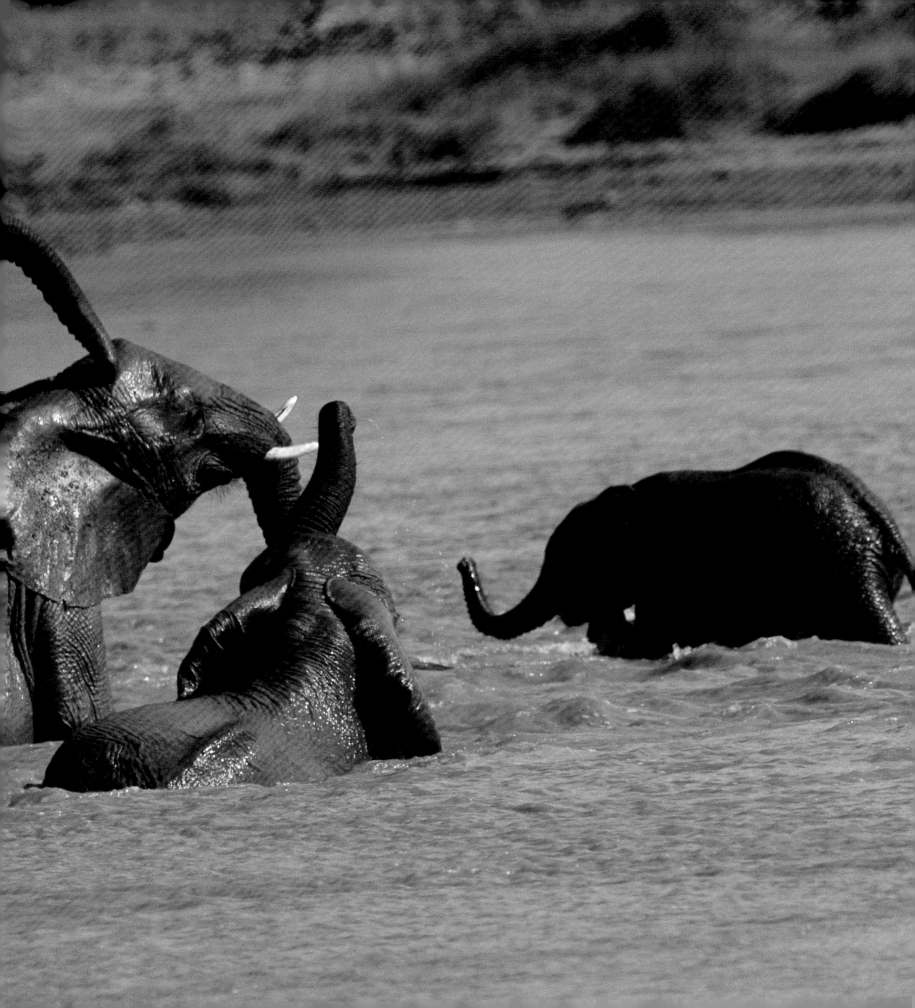

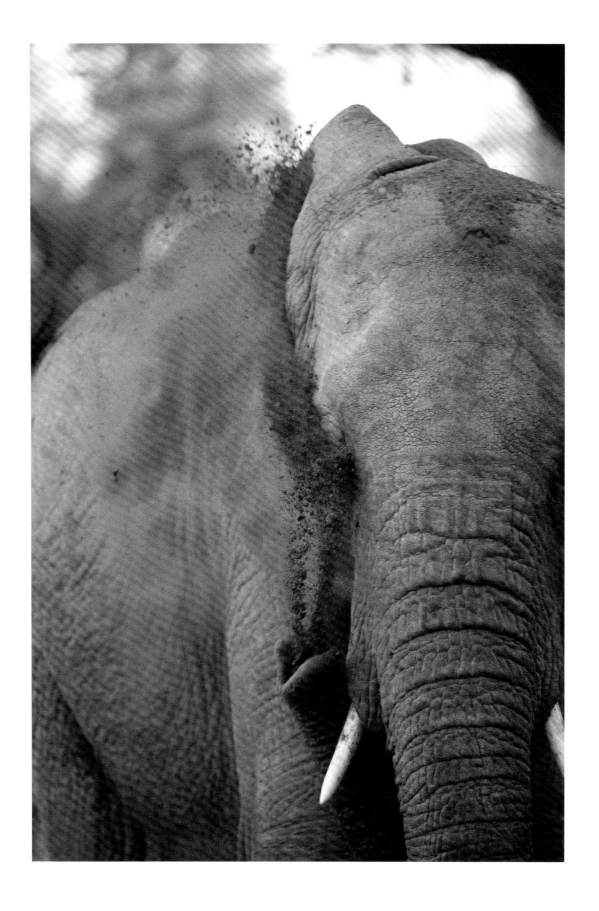

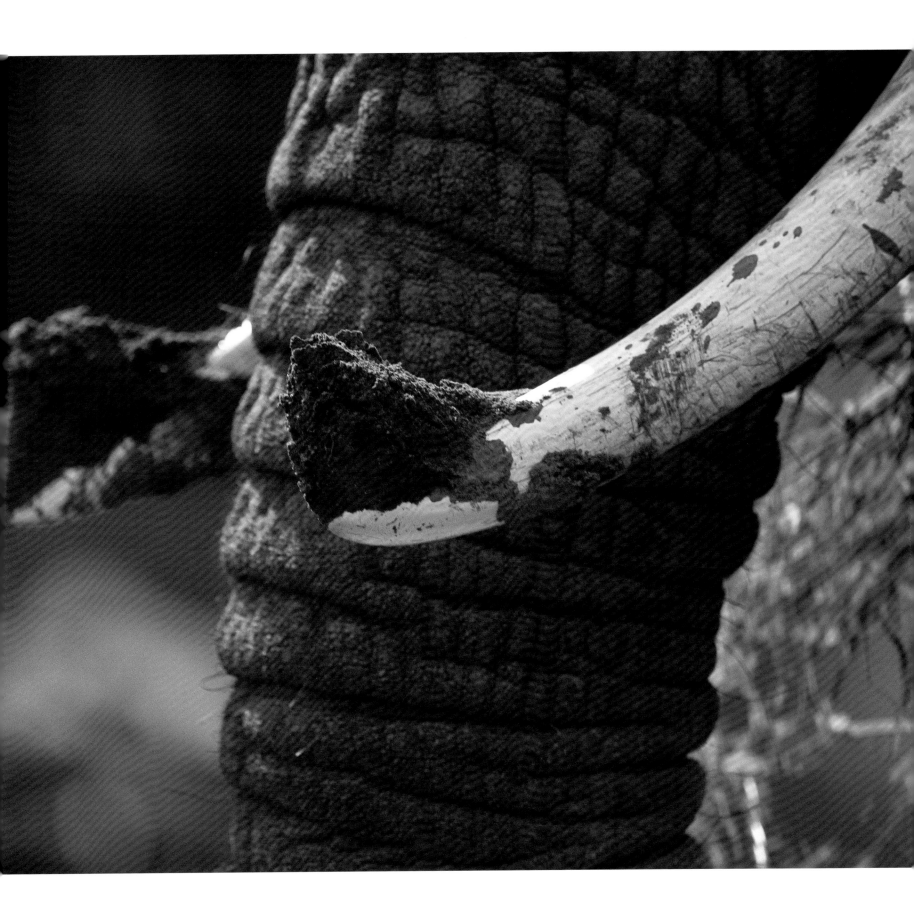

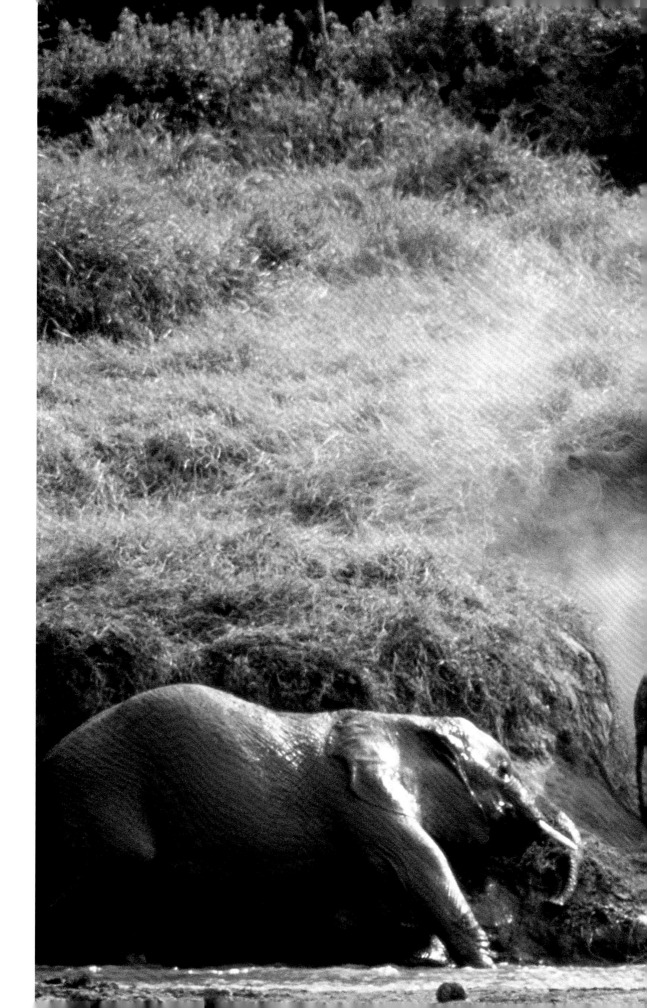

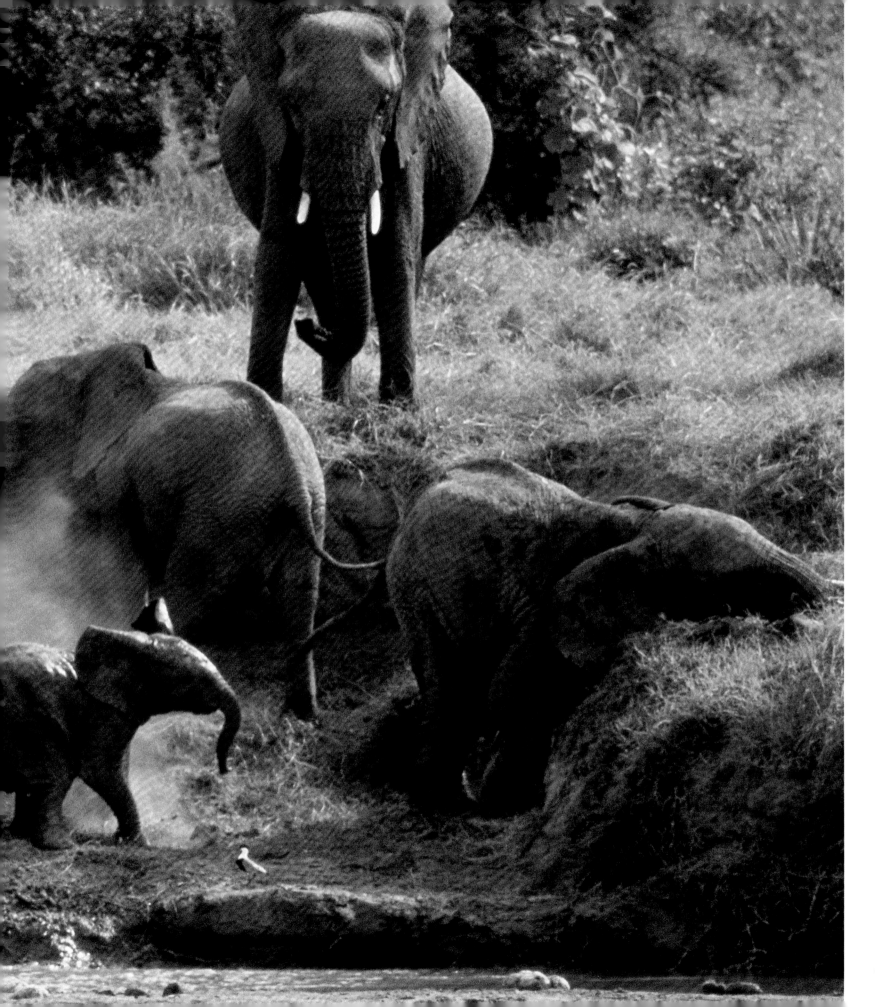

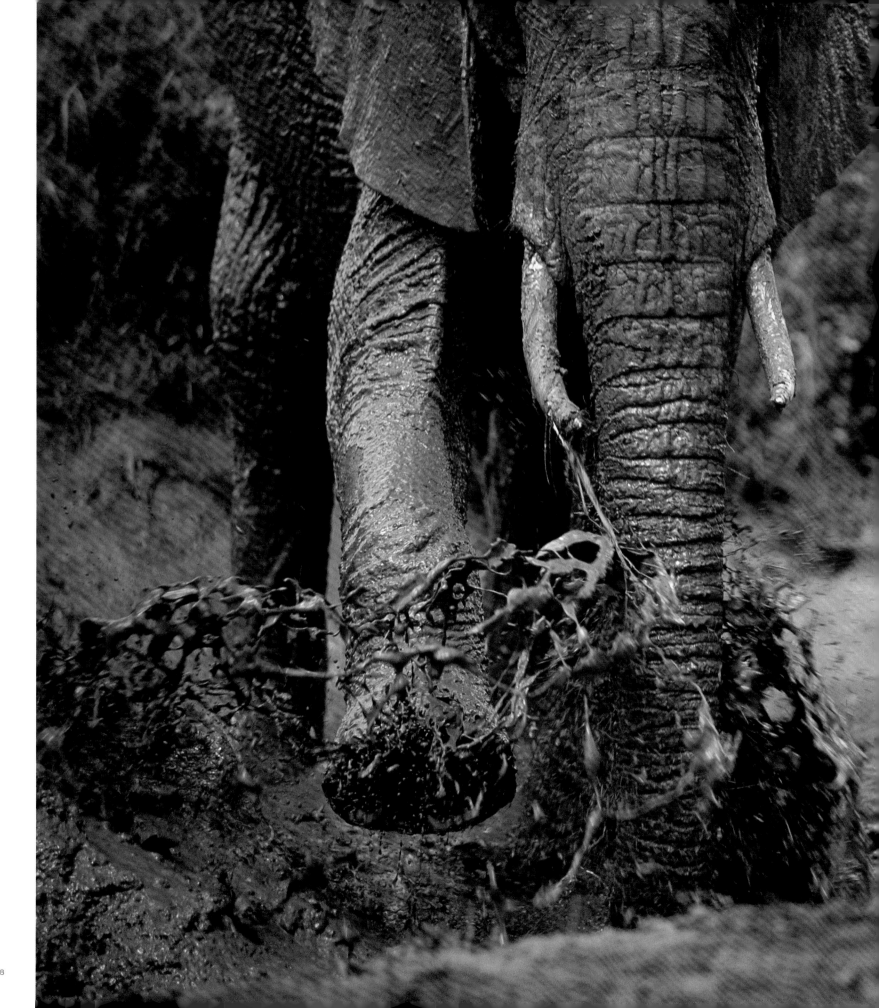

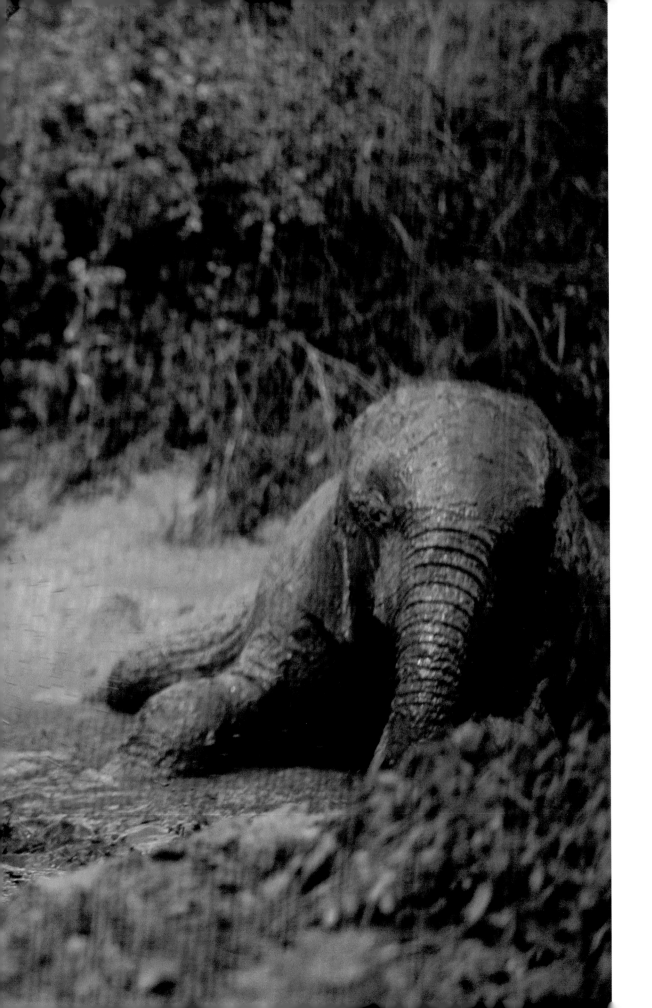

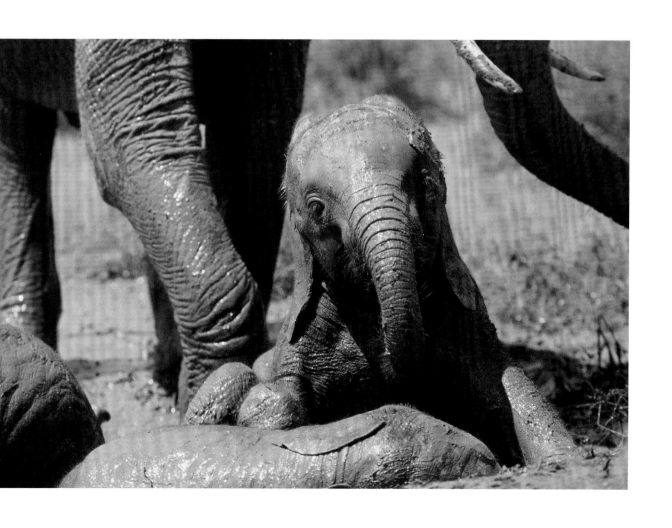

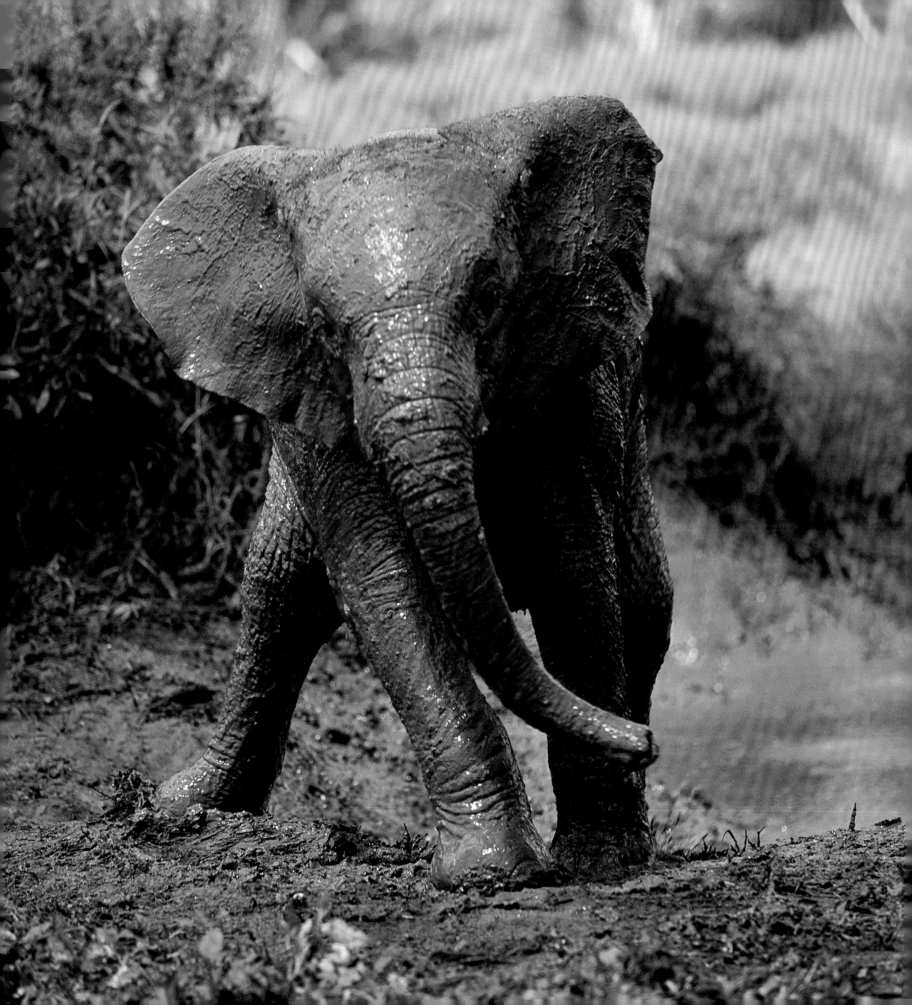

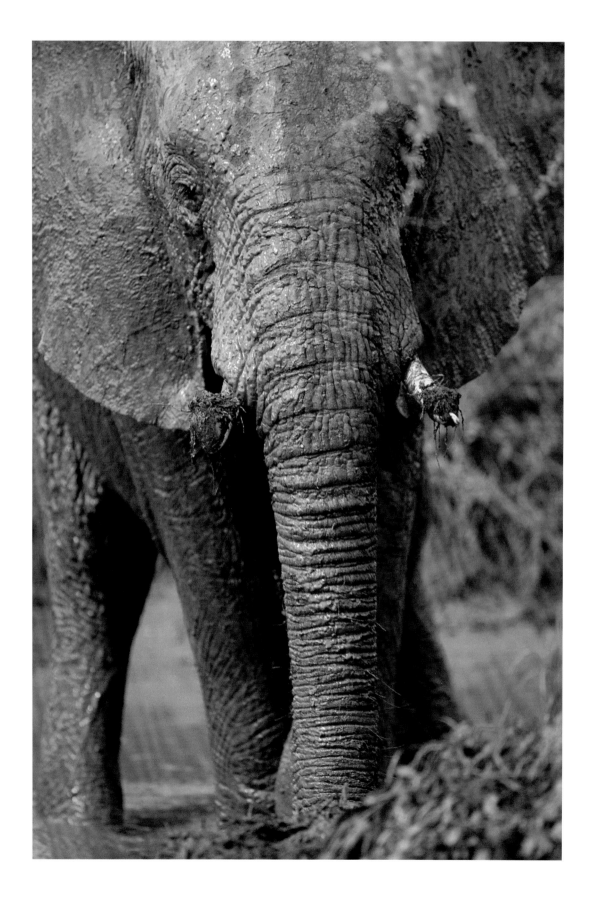

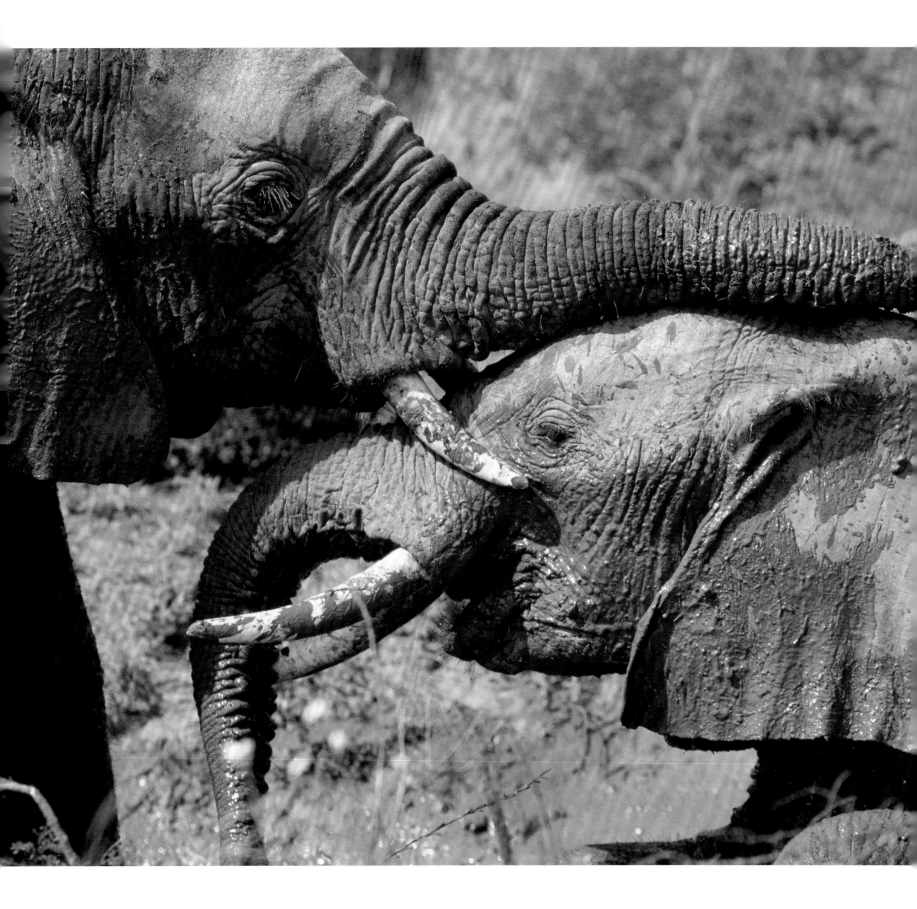

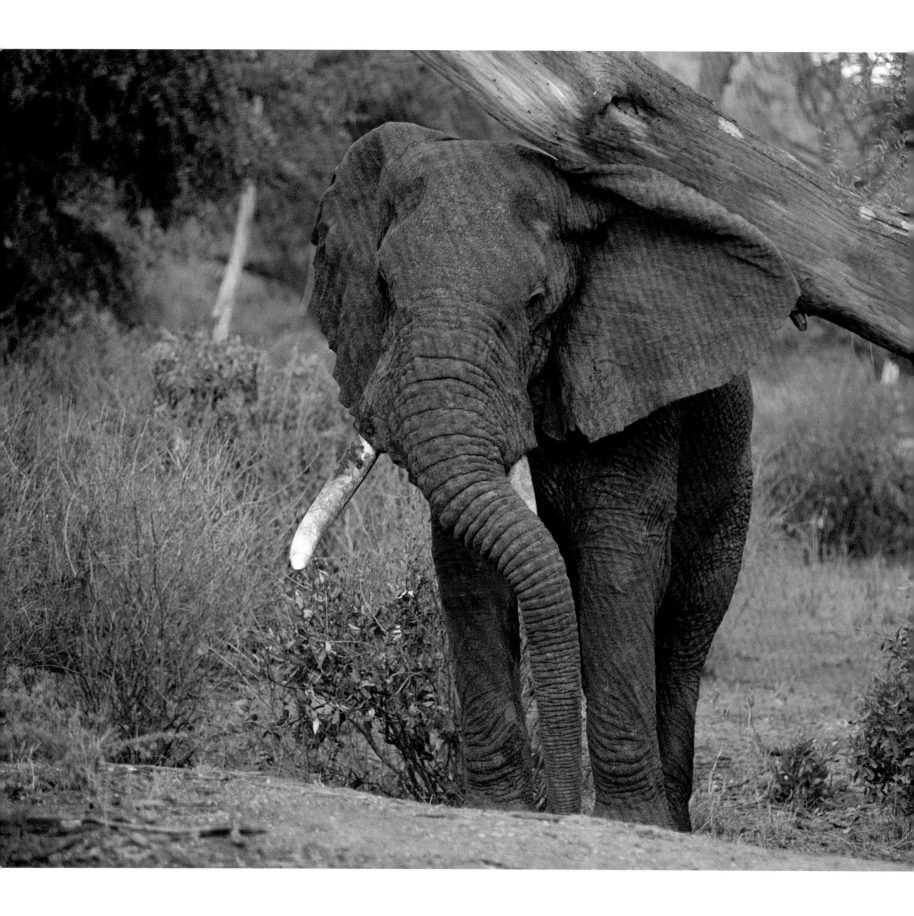

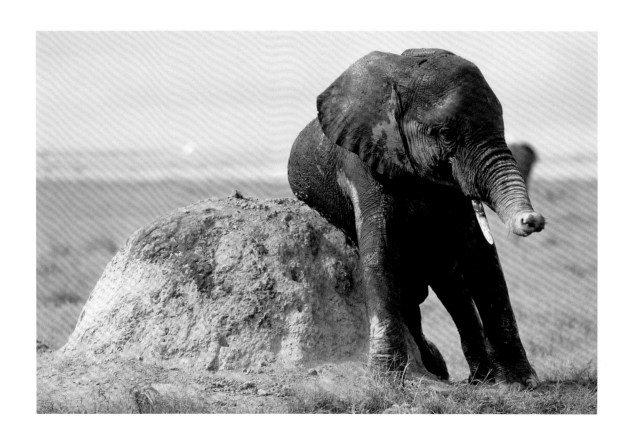

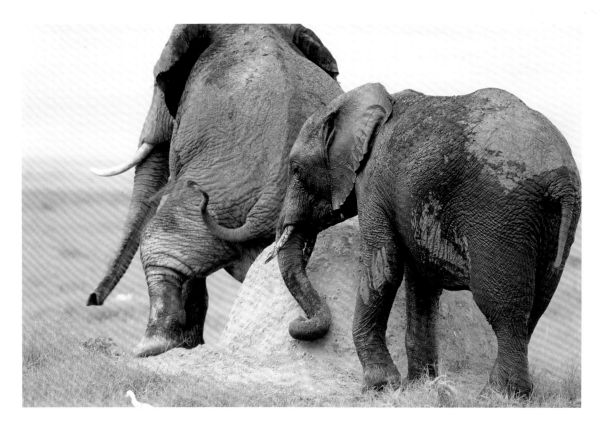

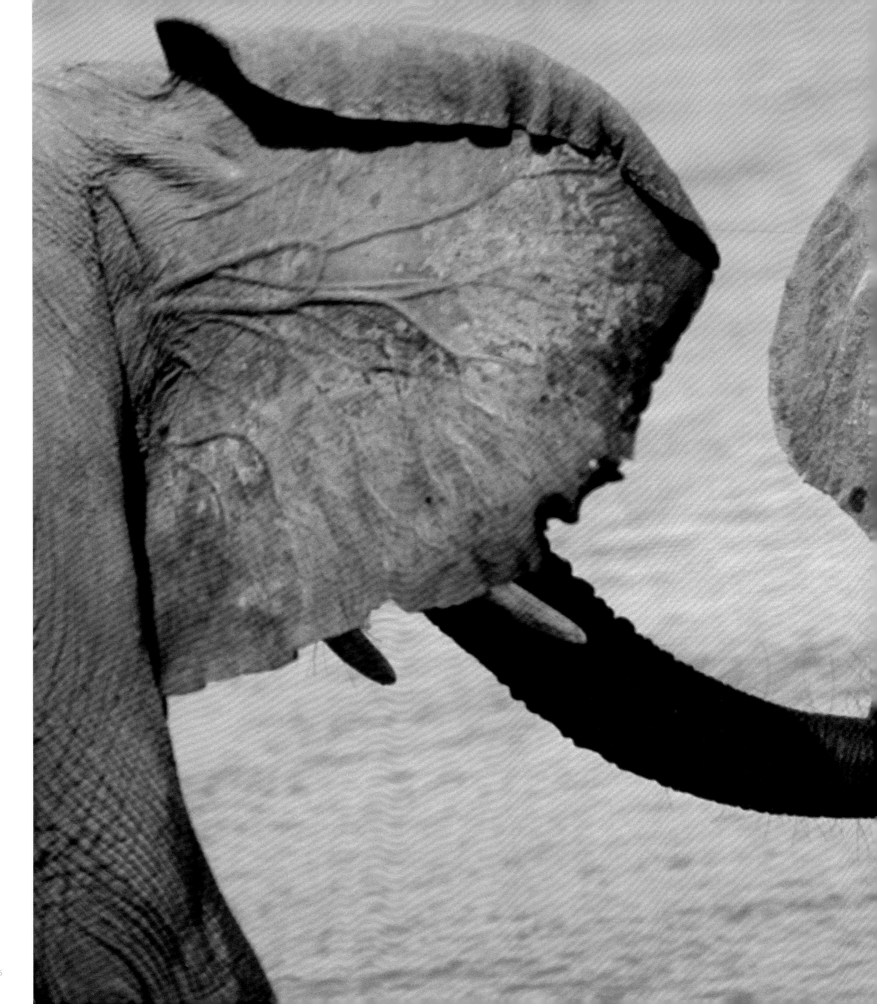

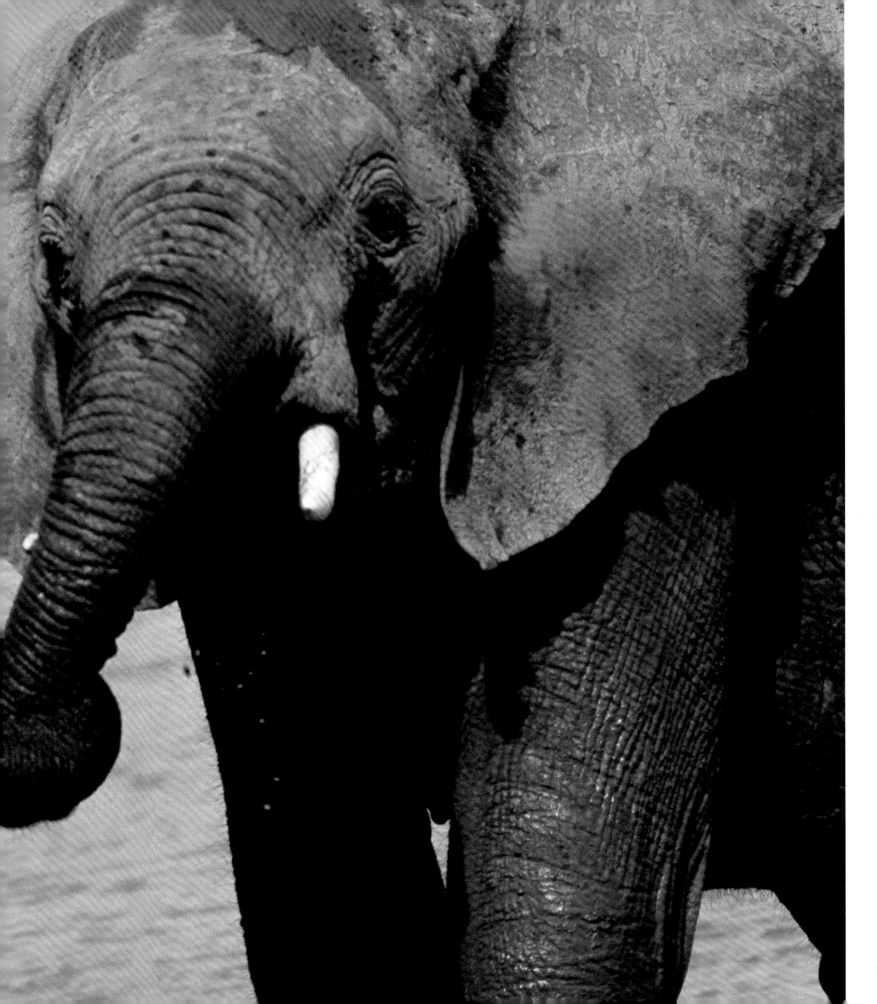

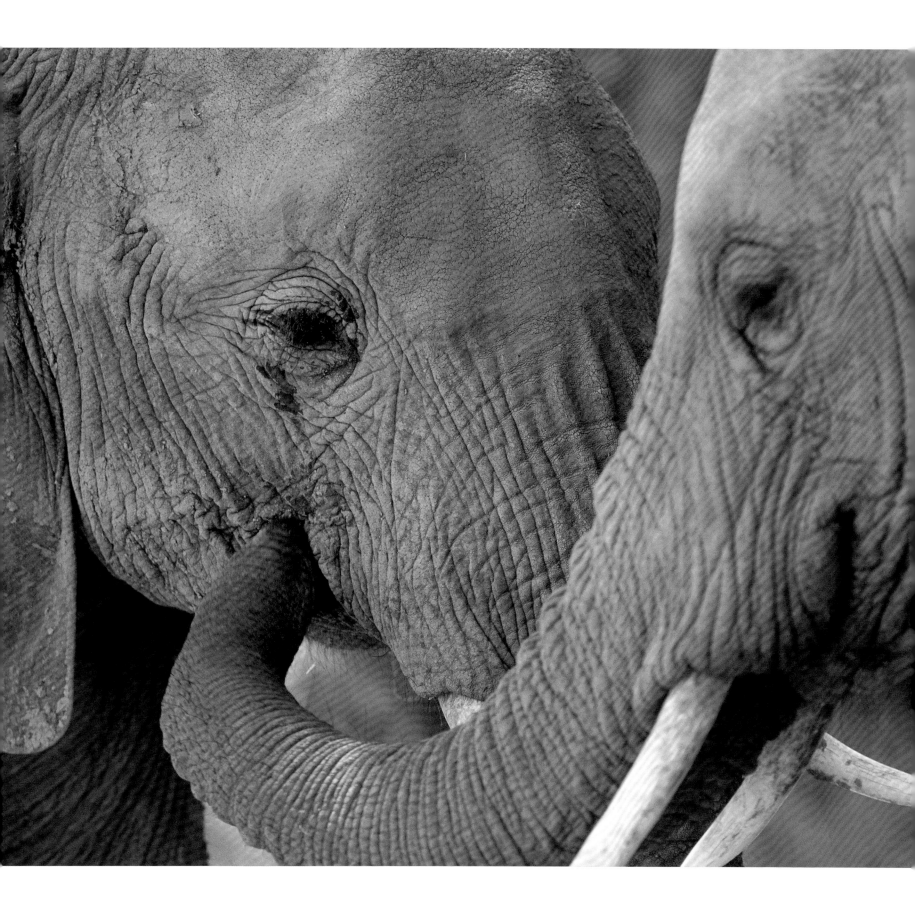

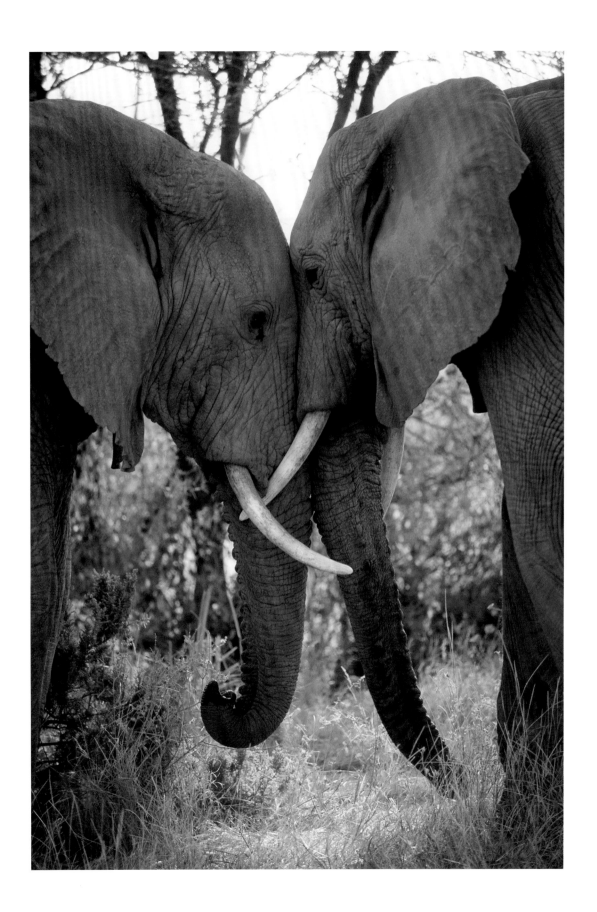

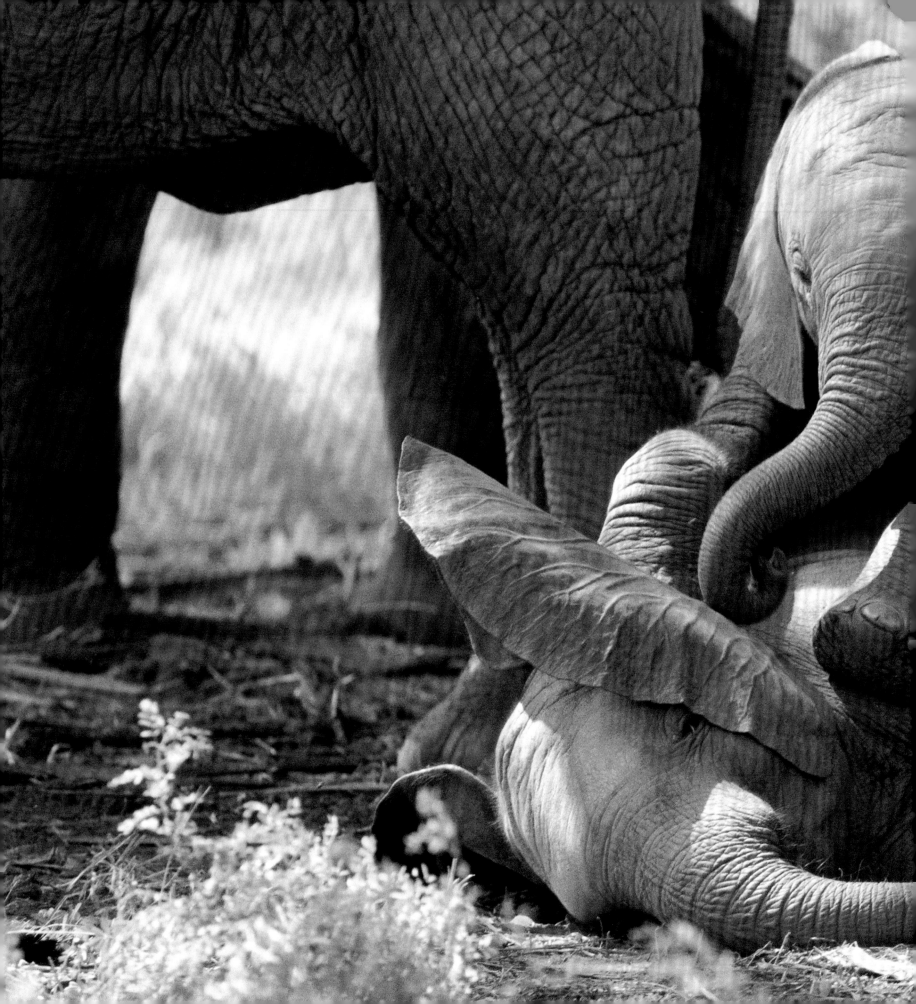

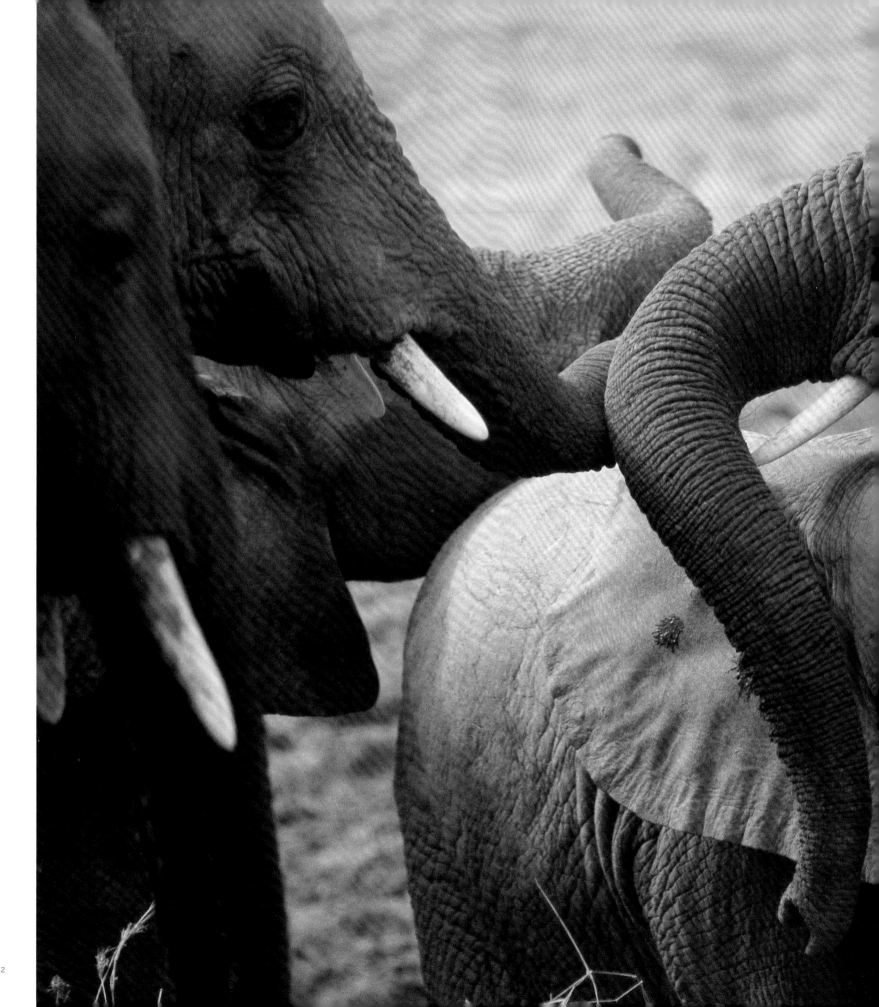

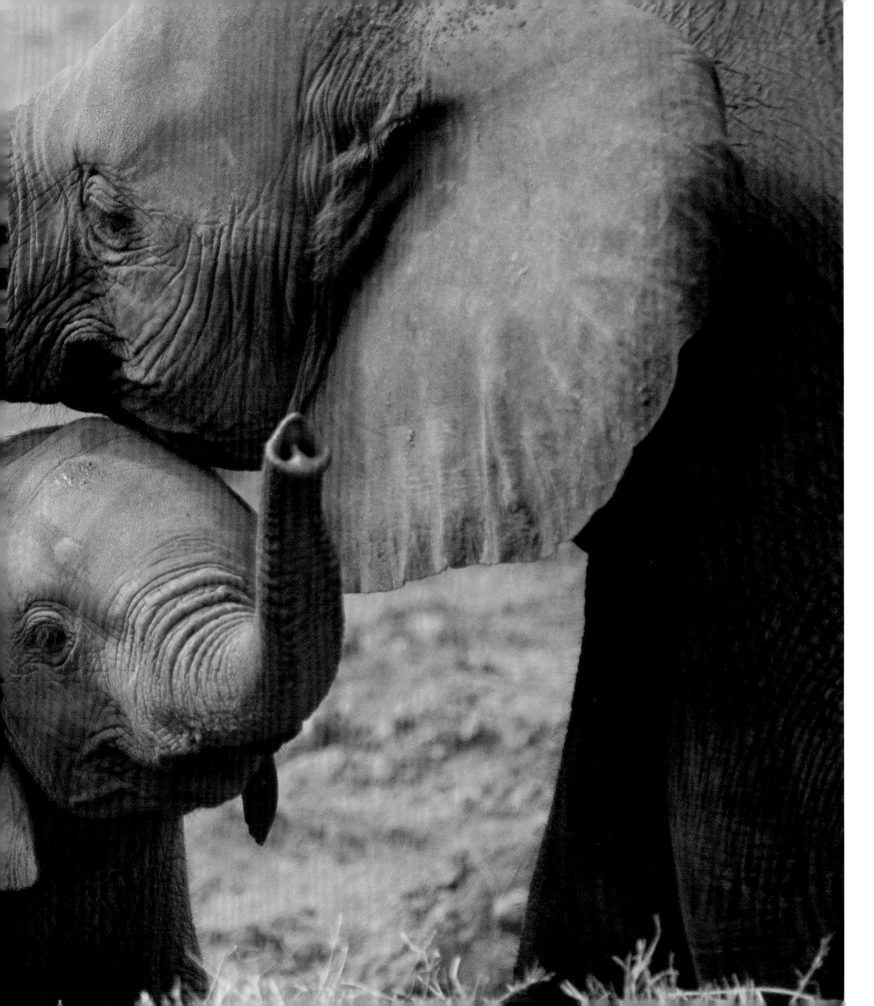

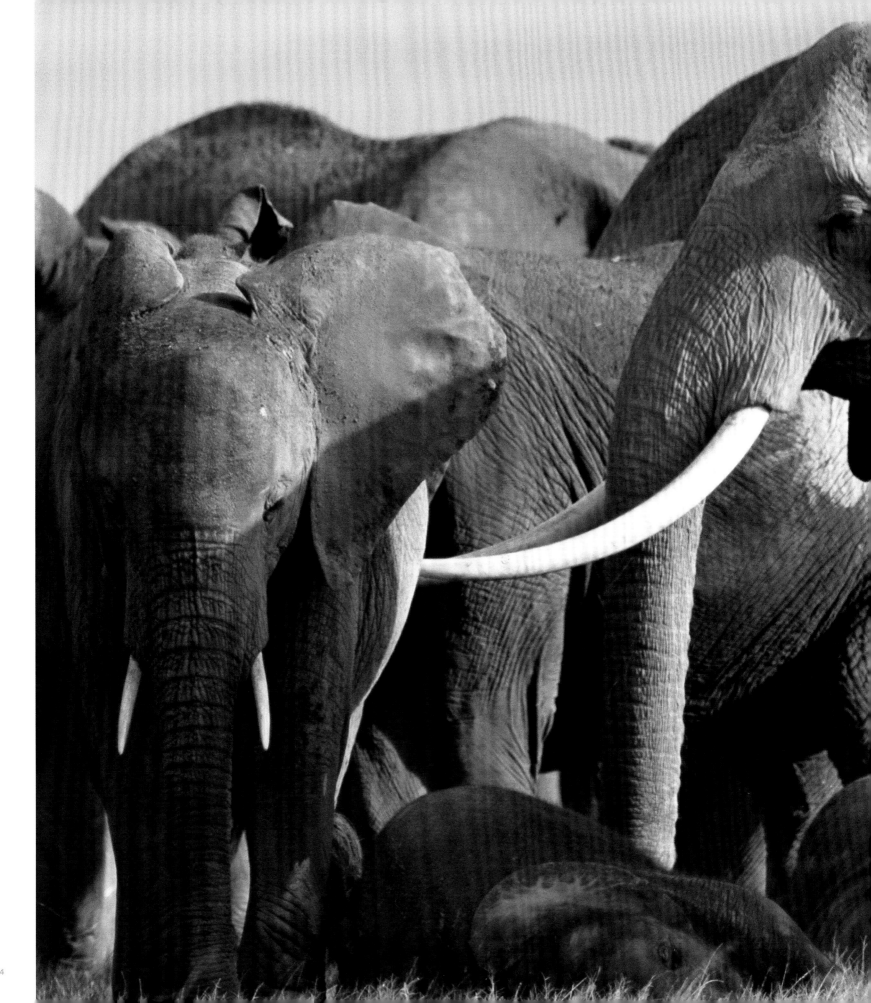

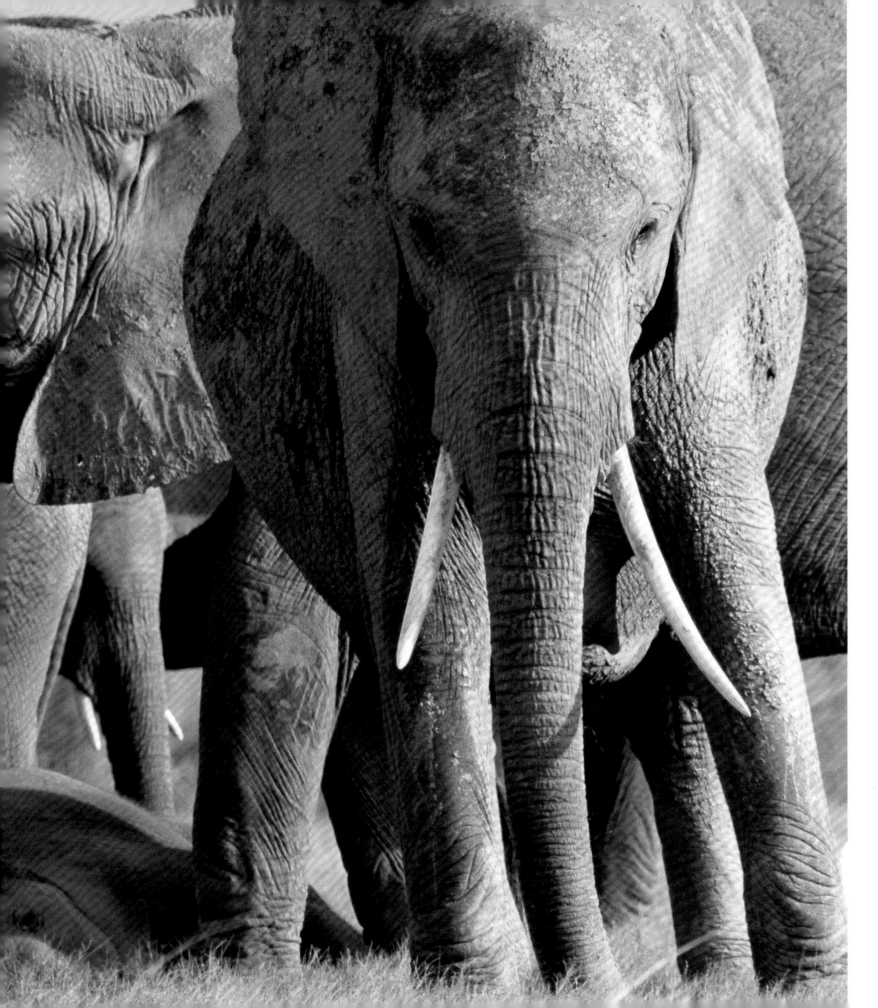

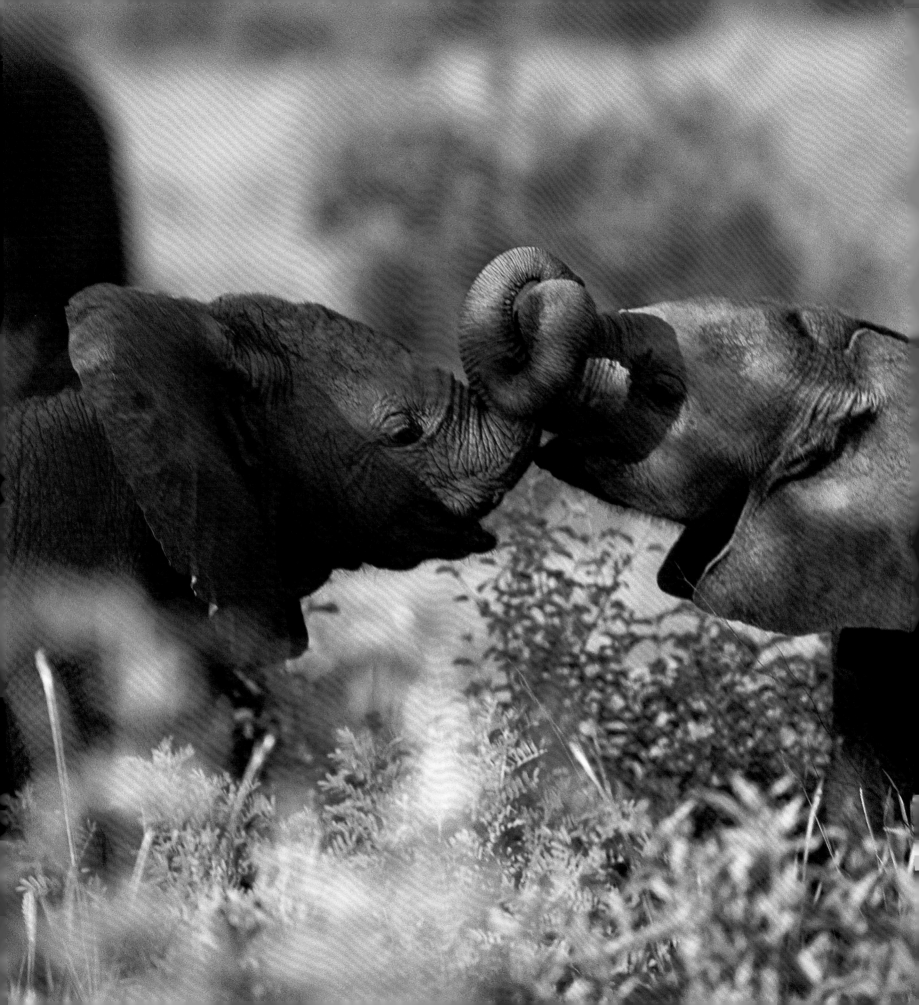

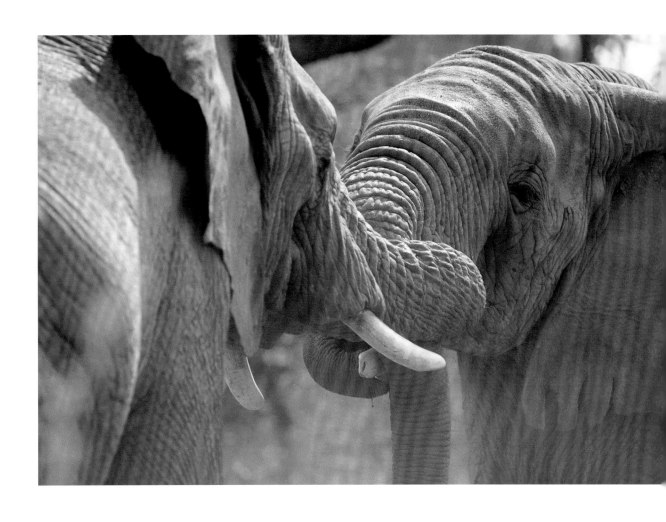

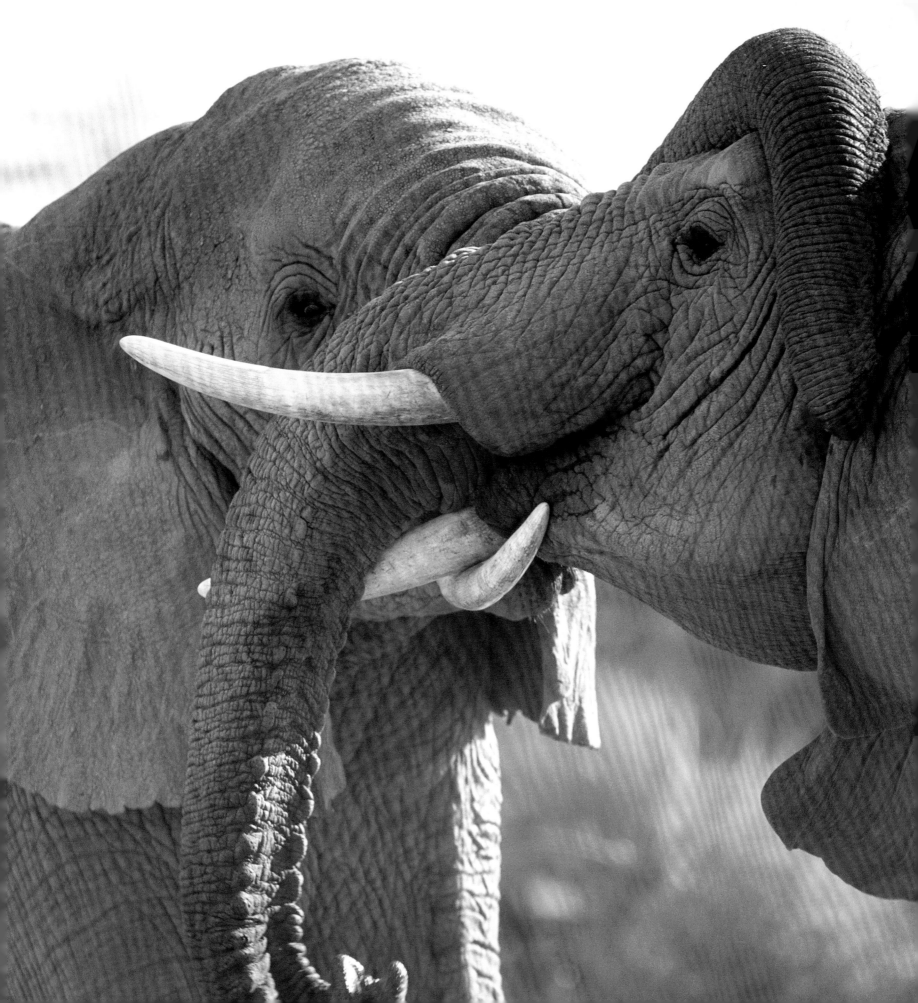

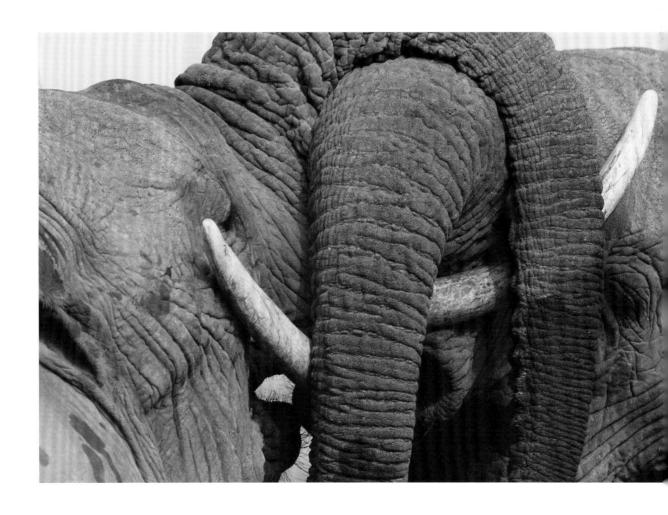

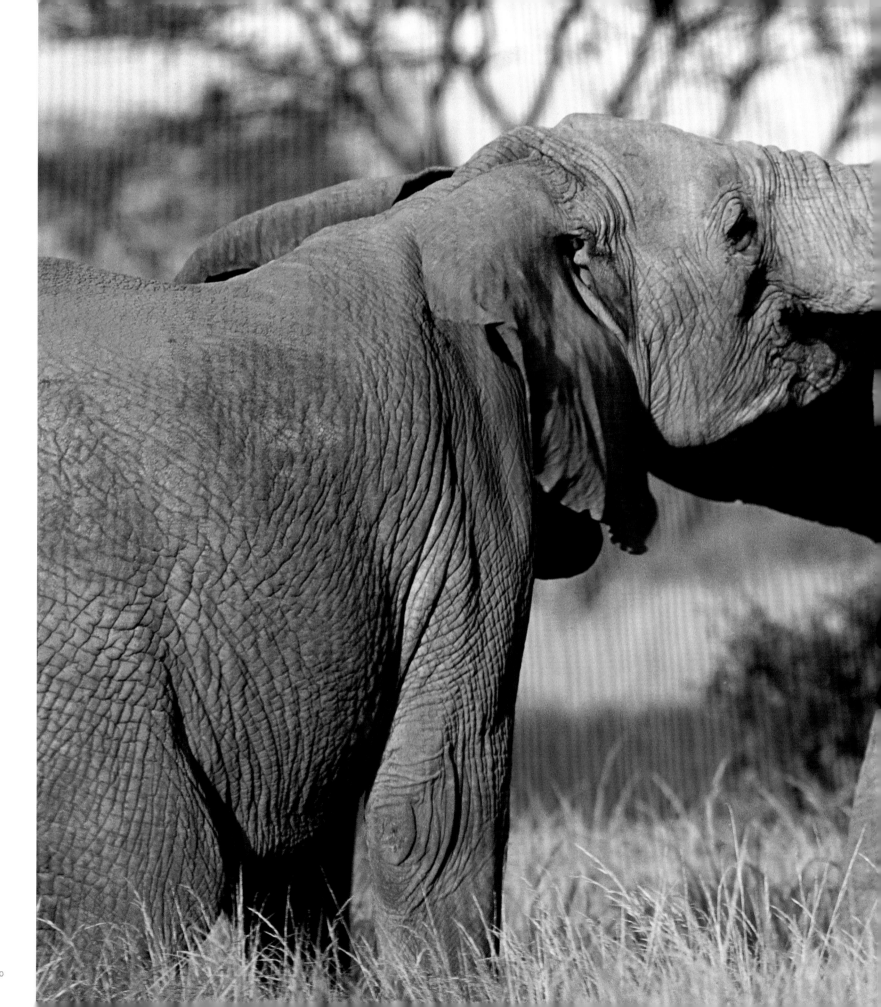

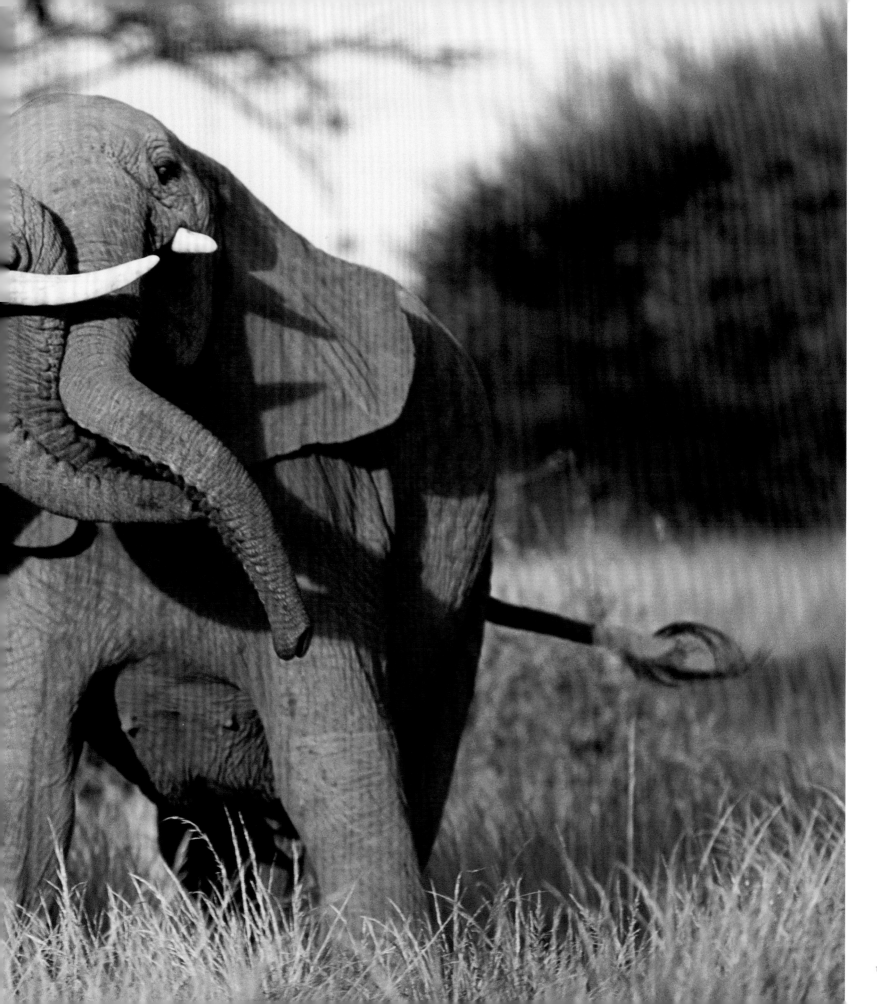

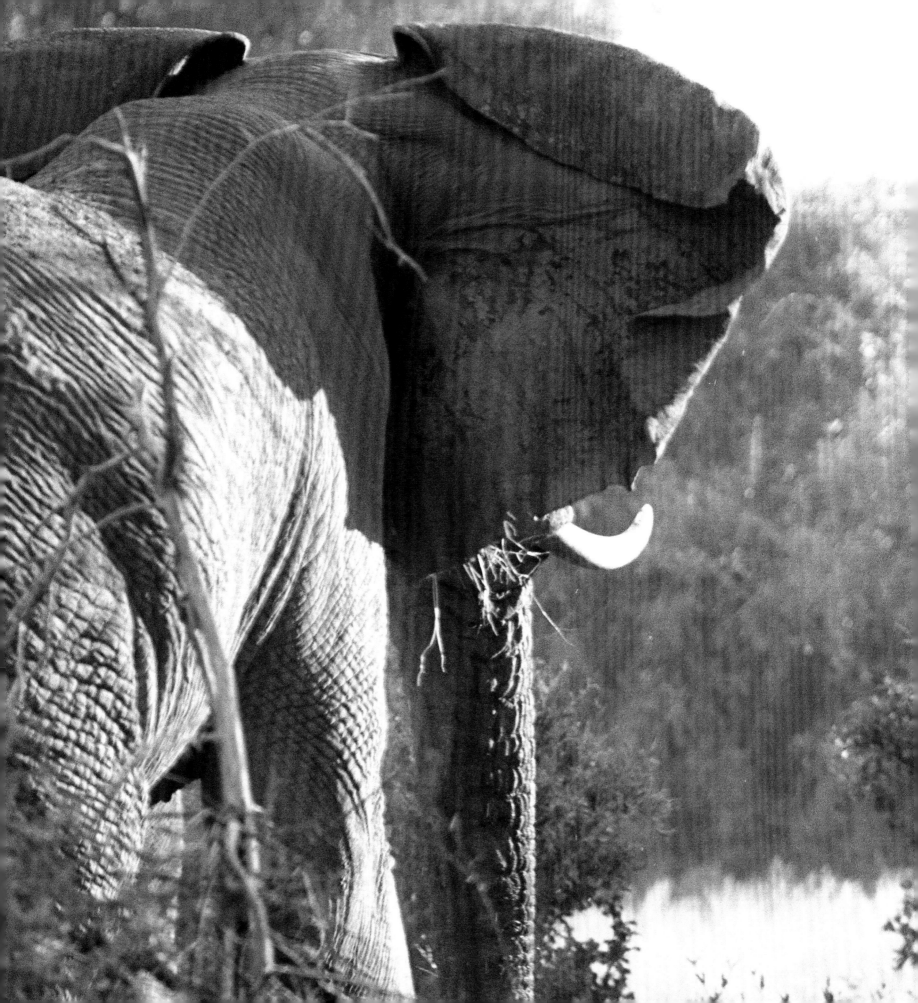

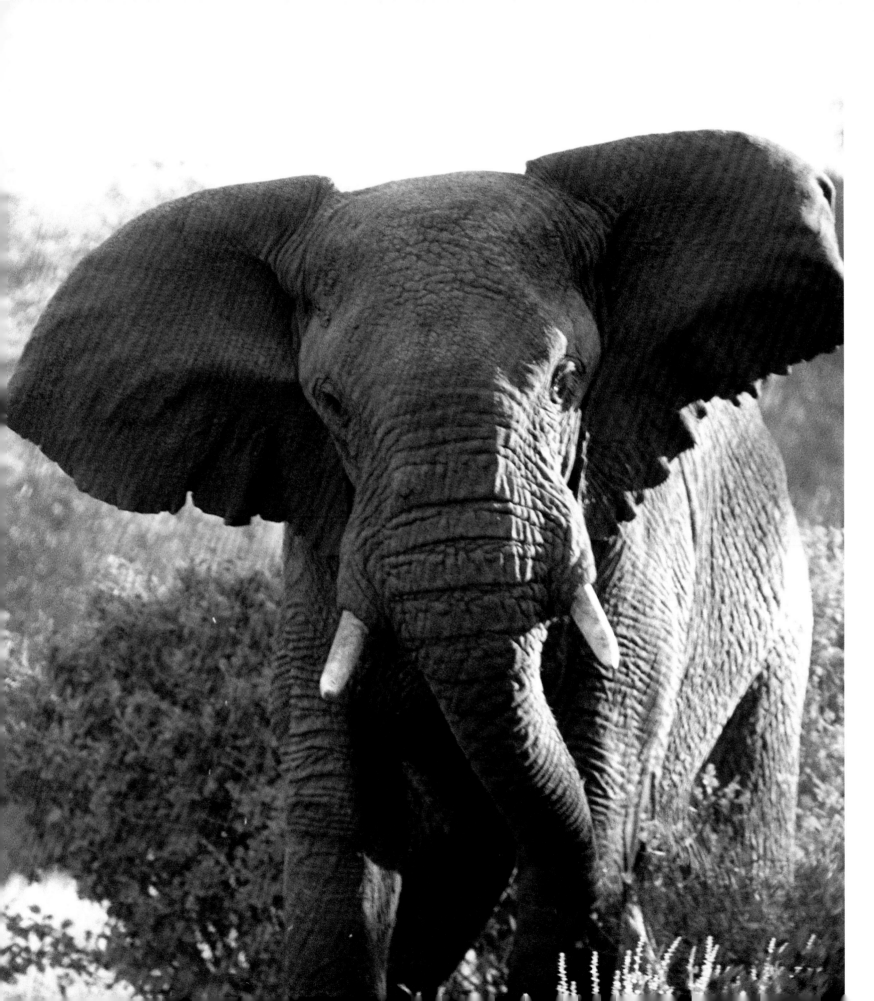

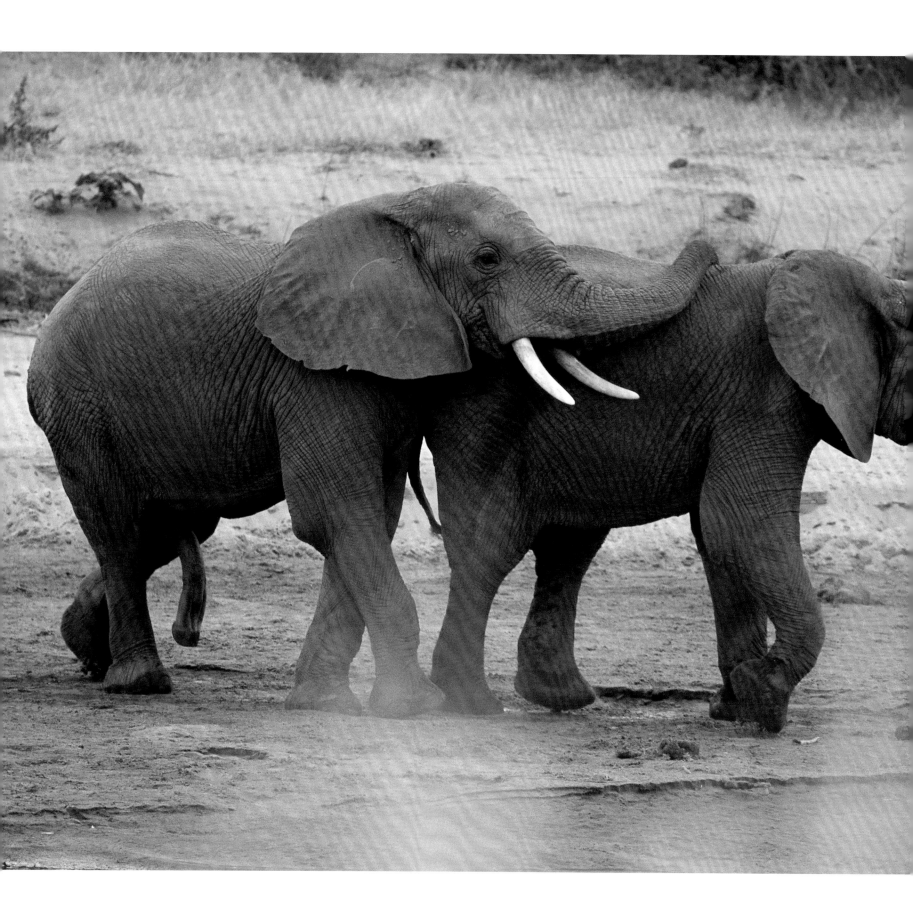

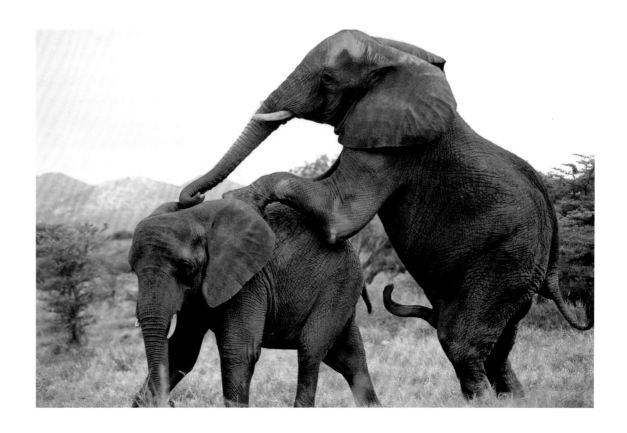

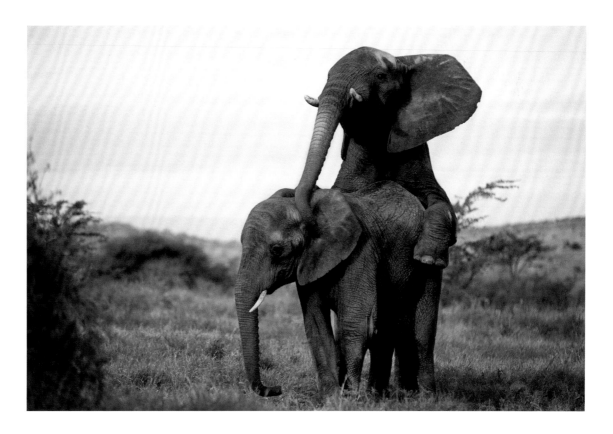

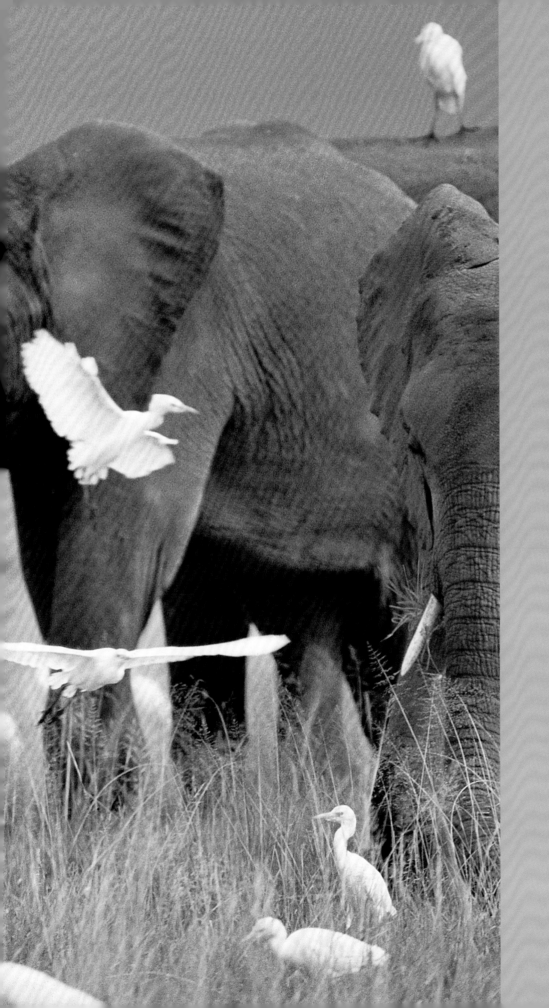

ASSSOCIATIONS

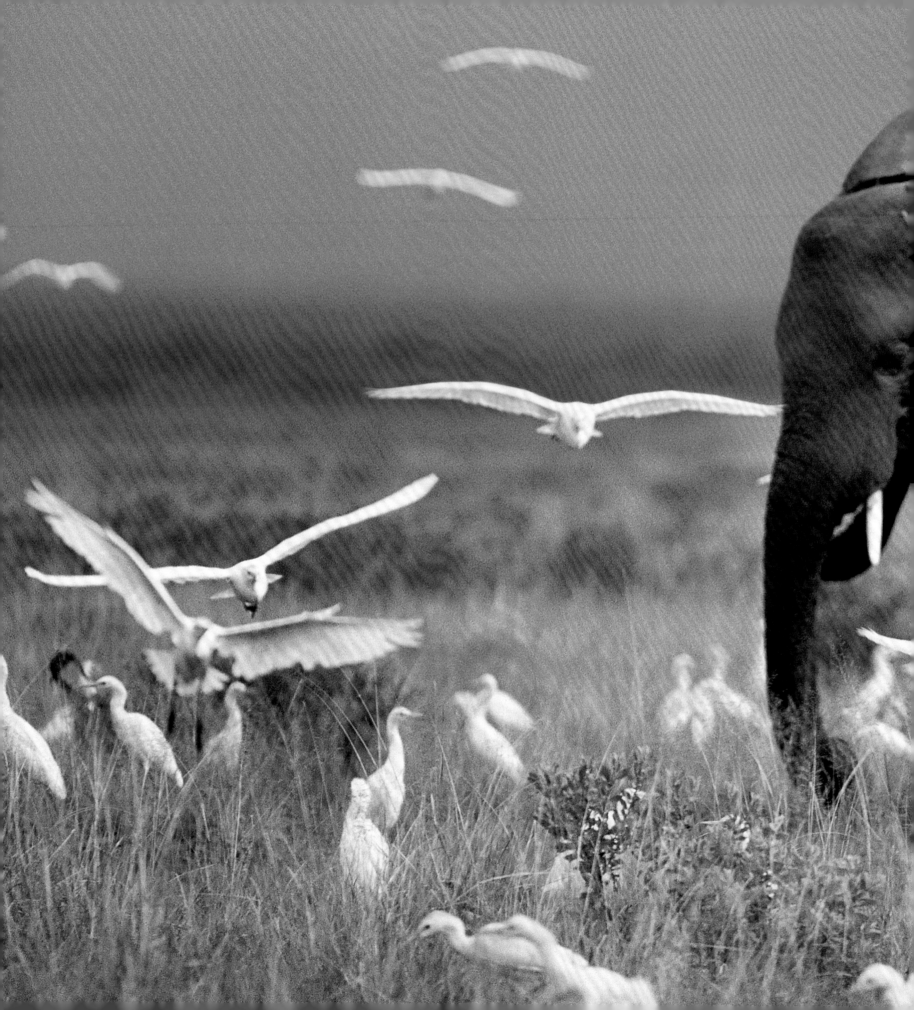

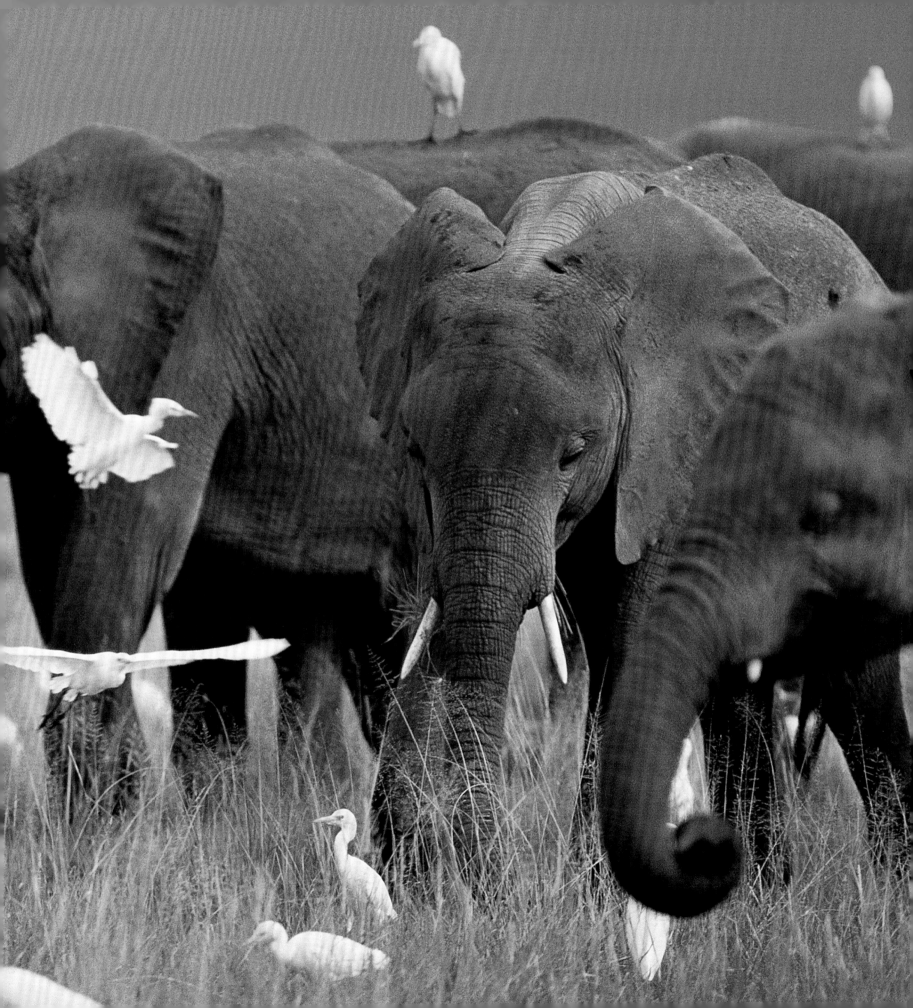

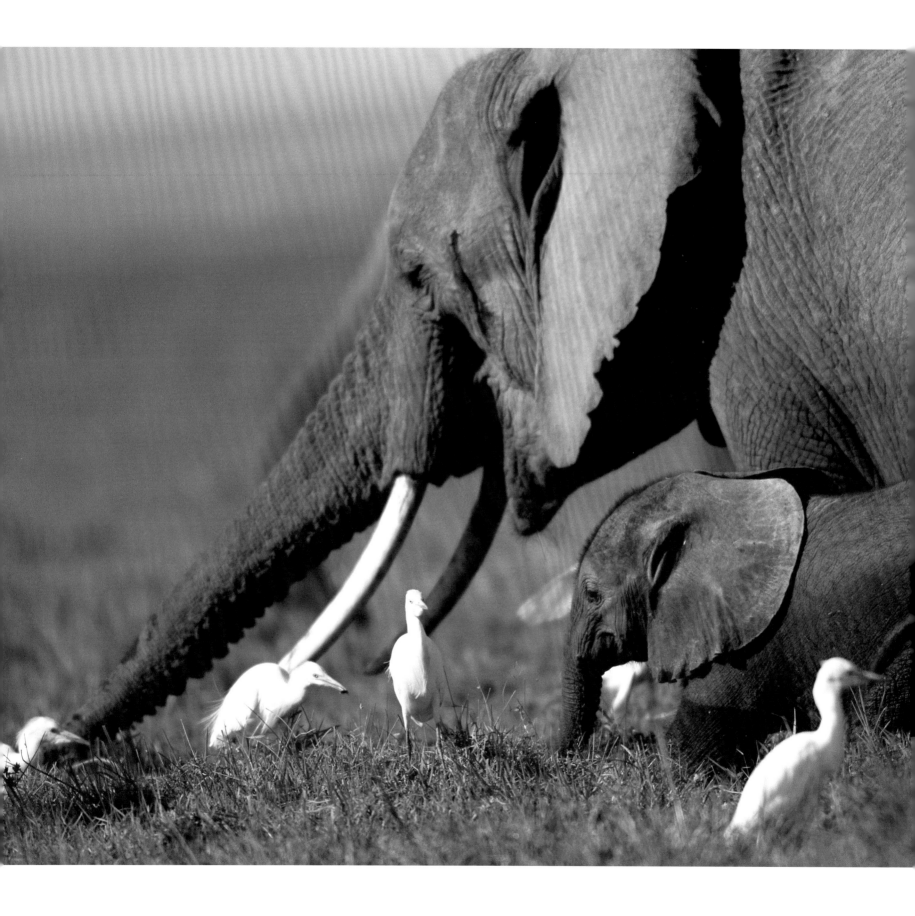

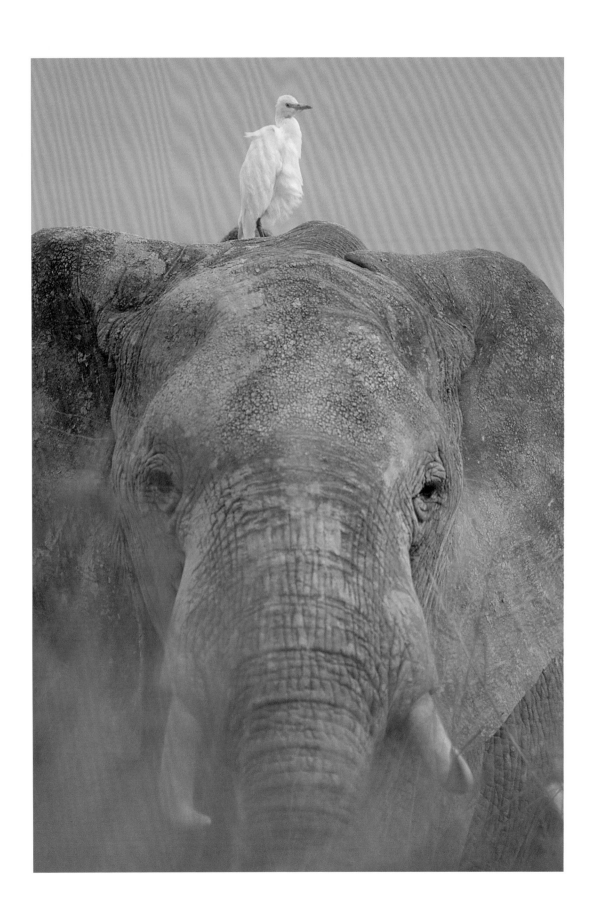

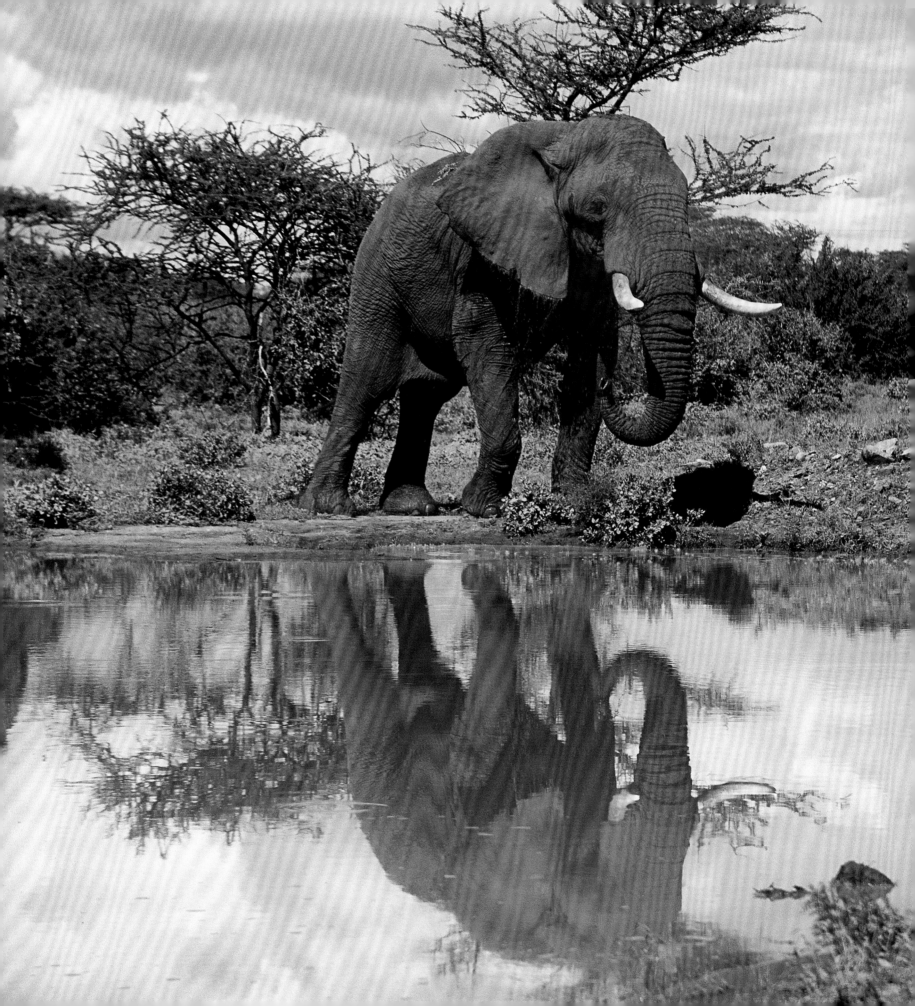

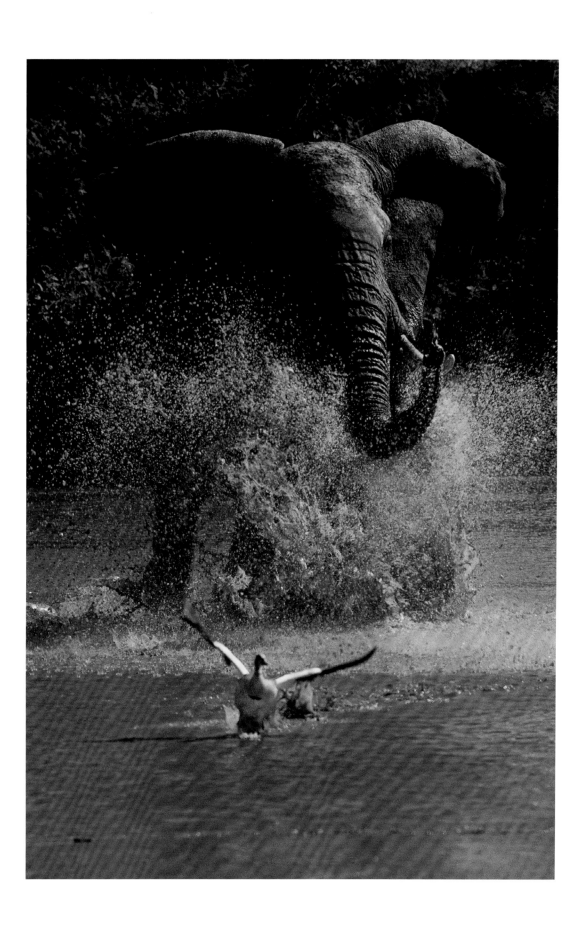

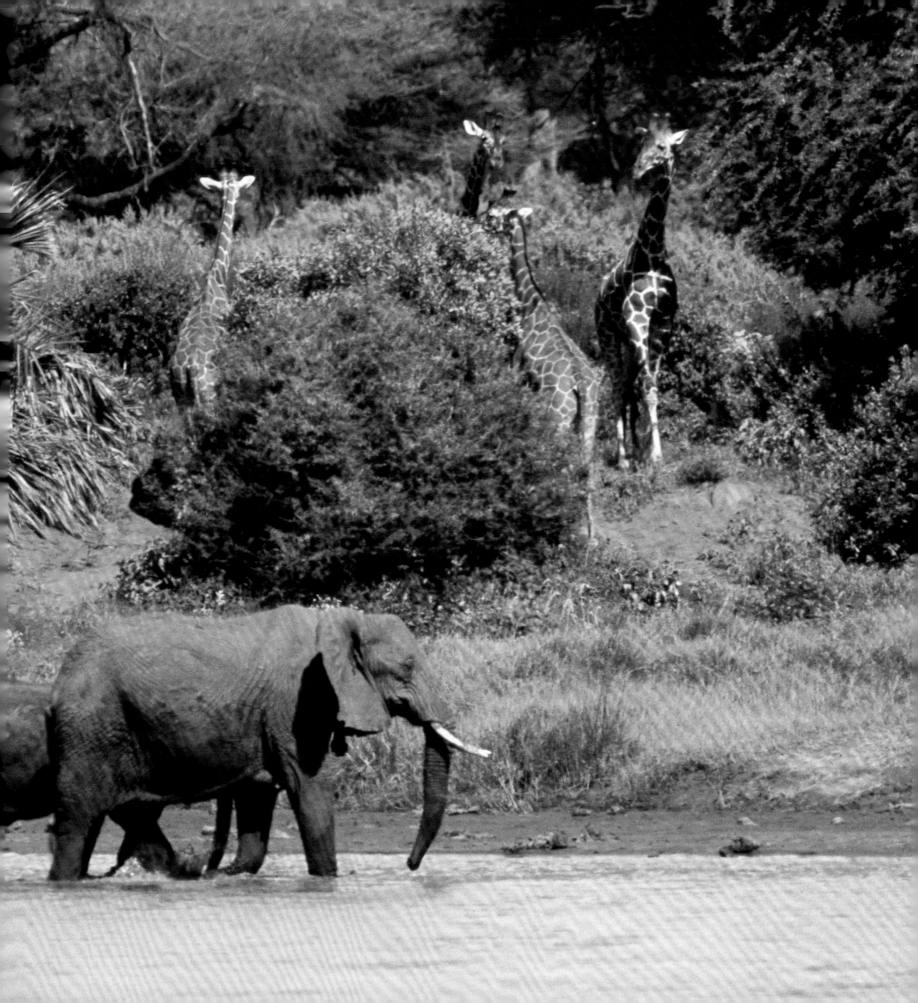

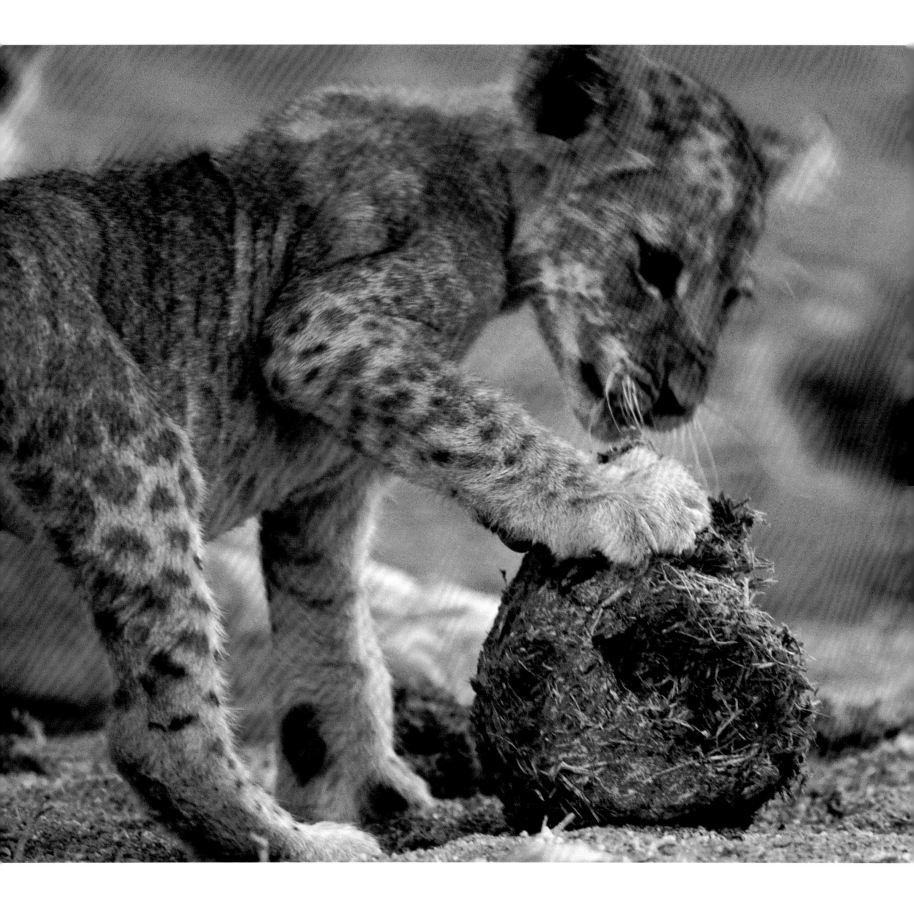

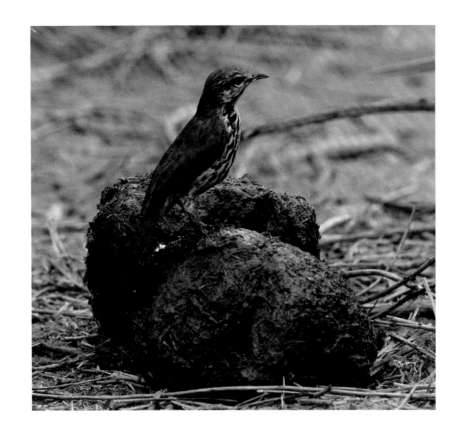

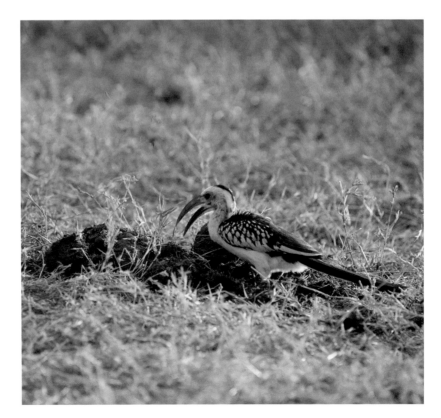

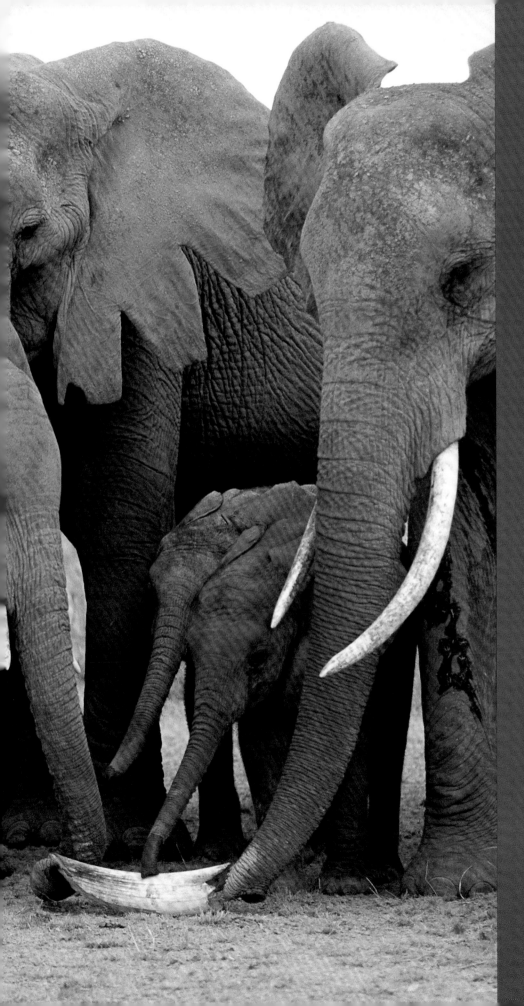

PASSAGES

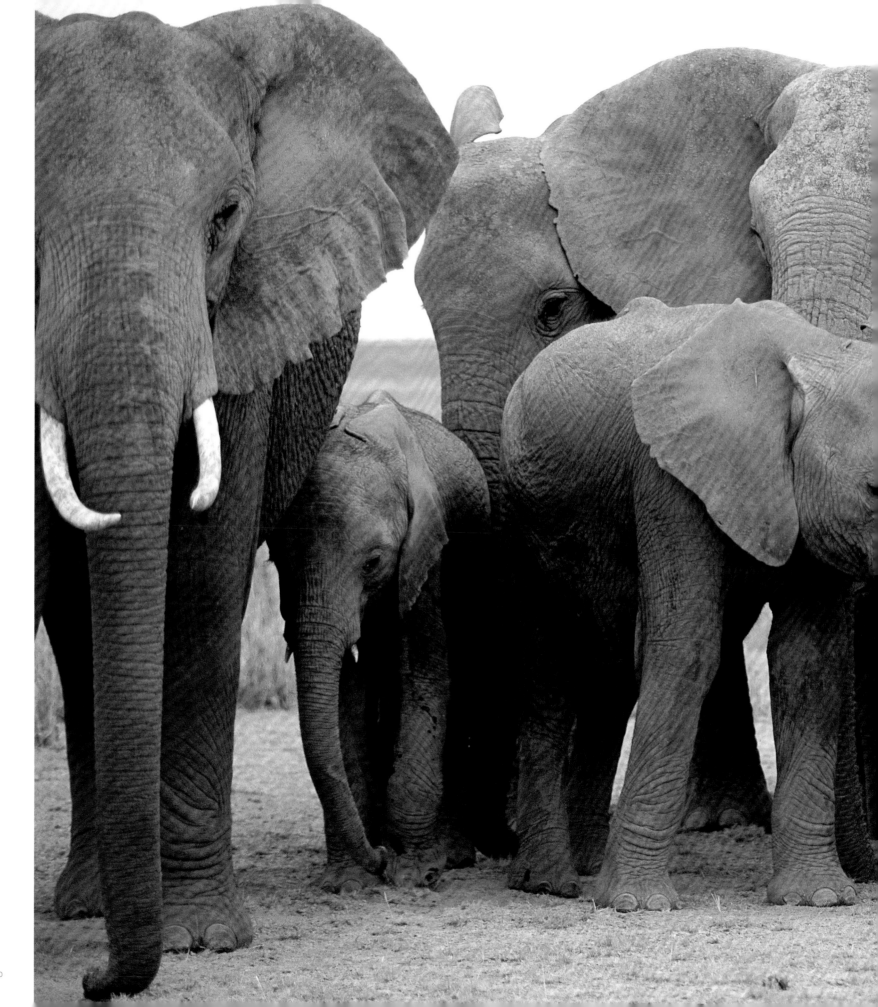

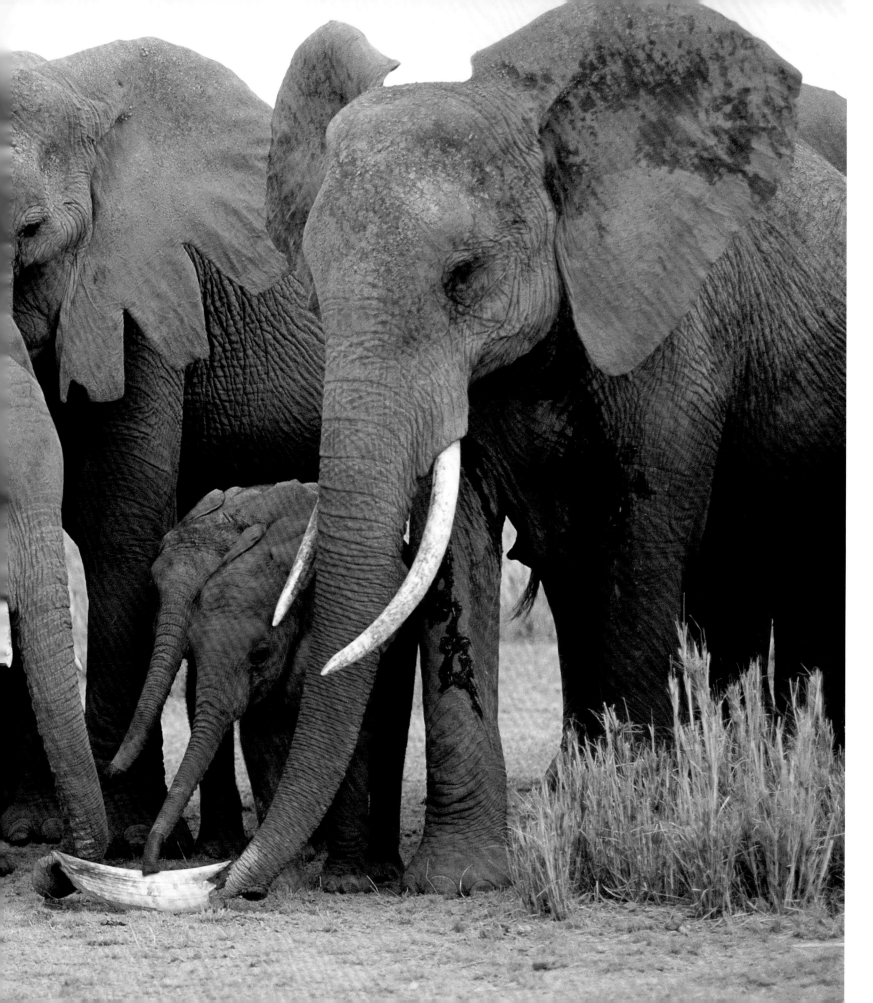

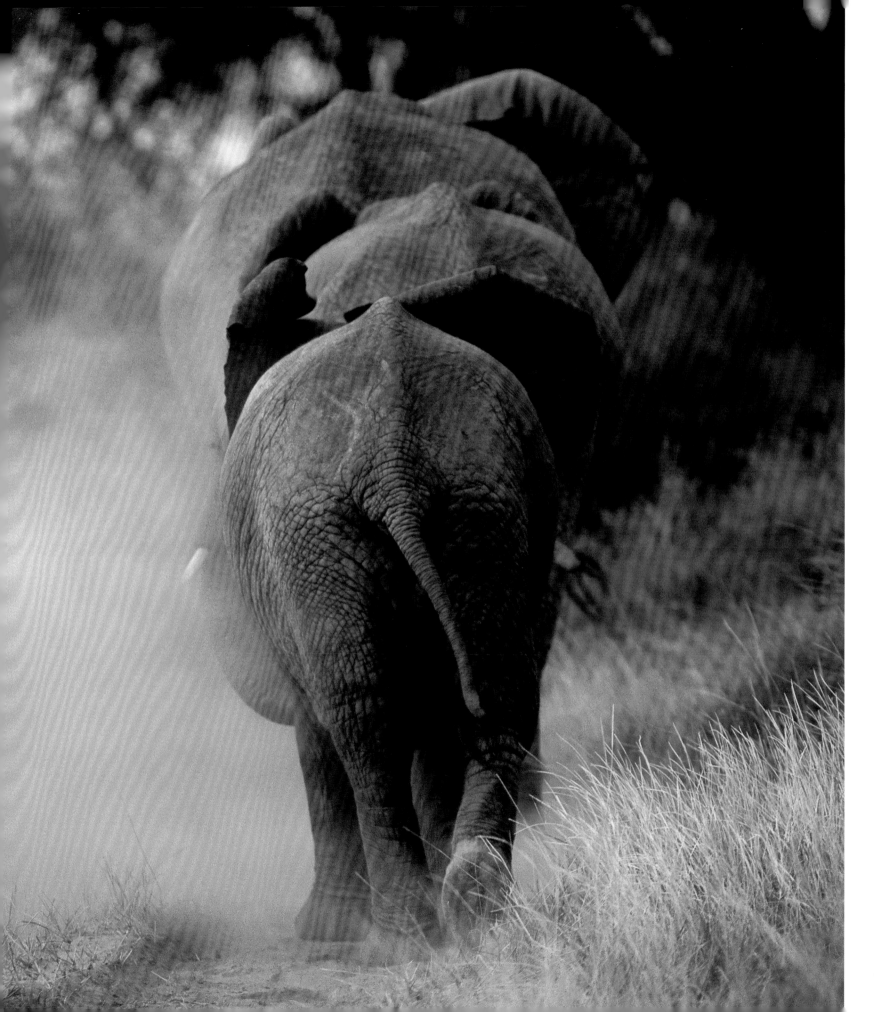

the target they had found was not the one they had been looking for. Boadicea, weaving and foot-swinging in her highly agitated manner, did not dare to come any closer, but found a heavy log on which to redirect her aggression. She picked it up and hurled it with great force. It whizzed past my head and struck the roof of the car.

Another time, Douglas-Hamilton watched the same kin group chase real lions. The elephants charged, "shrieking and bellowing," and the lions fled, growling deeply and furiously, to the safety of a tree.

IN 1967, an American tourist named Cynthia Moss visited Manyara and fell in love with the elephants, so she quit her job at *Newsweek* magazine and signed up as one of Douglas-Hamilton's research assistants. After acquiring some firsthand experience in the art and science of elephant research, Moss went on to start her own project in 1972, within Kenya's 390-square-kilometer (150-square-mile) Amboseli National Park. By East African standards, Amboseli is a comparatively small park, but its richly varied wildlife (including four hundred bird species, thirteen antelope species, and several species of primates, small and big cats, and jackals, as well as hyenas, buffalo, hippos, giraffes, rhinos, wildebeests, zebras, and elephants) gathers on a dramatic stage of alkaline savanna and open swamp with, in the wet months, lush carpets of grass and bush strewn between the two. When the sky clears, the snow-topped cone of Mount Kilimanjaro appears, rising pale and vast above the landscape.

Cynthia Moss intended to learn whatever there was to know about the elephants of Amboseli, and, as Douglas-Hamilton had taught her, she started by identifying individuals. Following his example, she concentrated on the ears, assembling identity files largely based on ear photographs combined with references to tusks and other salient features. She found that once she had mastered the identification by ear, her ability to recognize individuals became automatic and holistic, more like her usual way of recognizing people. As she later wrote, "I got to know the whole elephant: its size, shape, posture, the way it moved, stood, or carried its head." Like Douglas-Hamilton, Moss decided to name her study animals, once she could recognize them readily, instead of assigning them numbers, which had the serious disadvantage

of being hard to remember. Her naming system, however, was more methodical. She chose what were, for her, more easily recalled, common European names, and she embedded in her system the family associations by preferring the same first letters for family member names. Thus, for example, the AA family included eight elephants: Abigail, Agatha, Alison, Alyce, Amelia, Amy, Annabelle, and . . . Wart Ear. (The last was named in honor of a distinctive wart before the alliterative names were bestowed on the rest of the family.)

Moss found the same family structure in Amboseli that Douglas-Hamilton had seen in Manyara, a structure now understood to be universal among all three elephant species: a clear division of sexes, females remaining in their birth group, males leaving at adolescence, and shared mothering and babysitting among females. And she reconfirmed the important leadership role of the matriarch.

Moss also concluded that the elephant families at Amboseli, like those at Manyara, had clear associations with certain favored other families. Douglas-Hamilton had called these larger associations *kin groups*. Moss suspected that these were, indeed, typically larger groups of genetic relatives, but in the absence of evidence, she preferred the more neutral term *bond group* to describe them. She incorporated bond group identification into her naming system. Bond group families shared the same first letter: AA, AB, AC, AD. She observed how significant the bonds between these families were. And she noted the outpouring of emotional expression, in the form of an extraordinary sort of dithyrambic dance, that happens when bond group families reunite after a time apart. In her book *Elephant Memories,* Moss describes a typical *greeting ceremony,* as the family led by a matriarch with large, upcurved tusks, known as Slit Ear, reunited with one of their bond families, led by the matriarch Torn Ear:

> When they were about 50 yards from this group, the upcurved female rumbled—a different, higher-pitched, and louder rumble than the signal the old female gave after they woke. The members raised their heads, lifted and spread their ears, and produced loud, throaty rumbles. At the same time the elephants in both groups began to secrete a clear liquid from the temporal glands on both sides of their faces. More answering rumbles came from the original group and then both started striking

rapidly toward each other. When they were 20 yards apart they broke into a run and came together in a turmoil of earflapping, rumbling, screaming, trumpeting, clicking of tusks together, entwining of trunks, spinning and backing, and urinating and defecating. Their temporal gland secretions were streaming down their faces and they reached their trunks toward each other's glands. The upcurved female pushed through the milling calves and went straight to a large female with a big tear out of her right ear. They lifted their heads together and clicked tusks while entwining their trunks and rumbling deeply.

It is now known that most bond groups are formed out of larger families that have split into separate family groups, but bond grouping also represents a useful system. Bond group families often range out of sight of one another and forage separately, but they stay close enough to maintain auditory contact. This system addresses two contrary problems of elephant life. On the one hand, foraging in densely gathered groups creates competition for the limited resources of food and water. For elephants, such competition can be very significant, since each individual requires a few hundred pounds of vegetation and many gallons of water daily. On the other hand, elephants in small groups are more vulnerable to predators. For elephants, nonhuman predators consist mainly of the collaborative hunters of the savanna—lions, hyenas, and wild dogs. Any of them can successfully kill a temporarily isolated baby elephant. An elephant group often responds to the threat of predators by bunching tightly, calves in the center and adults facing outward, creating a defensive circle protected on the outside by a formidable perimeter of trunks and tusks. The more adults participating in this defense, the more effective it will be: safety in numbers. The conflict between the need for higher numbers in defense and the need for dispersion of numbers in foraging is resolved by the flexibility of bond groups, families that forage separately but move in tandem and maintain auditory contact, ready to rush in and assist one another in moments of crisis.

2

Like Iain Douglas-Hamilton, Cynthia Moss had concentrated on the females, who may have seemed more interesting and were certainly more immediately accessible than the males. Adult fe-

males, after all, constituted the heart of elephant society, while the adult males merely wandered off on their own, then occasionally wandered back, and then wandered off again. Males were hard to watch, hard to keep track of, hard to figure out. It was hard even to recognize them as individuals, since they kept disappearing for long periods. In contrast, females of all ages were openly, even emotionally sociable, and the intricate puzzle of their interactions was richly intriguing. The males seemed dully solitary in comparison, and they only arrived on the social scene when they wanted sex. Or so it seemed. Actually, who knew what the males wanted? The sex life of elephants was still a deep mystery, and the fourth-century B.C. comment of Aristotle that elephants "copulate in unfrequented places" appeared to be as perceptive as almost anything else he wrote. Perhaps these creatures had sex only at night. Maybe they preferred to do it in faraway places while no one was looking.

In four and a half years at Manyara, Douglas-Hamilton saw elephants mating only four times. Even the nature of *estrus*—the heightened state of female fertility and receptivity—was an enigma. Douglas-Hamilton reported observing females seemingly in estrus only ten times during his study. Another elephant scientist from that era, Roger Short, offered a significant monetary reward to some fifty rangers working at a Ugandan national park for anyone who identified an estrous female. Four months passed without anyone claiming the reward. Short himself eventually located a female who appeared to be fertile. At least the males were acting interested. Short watched her for a couple of days and then shot her, cut her open, and dissected her reproductive organs to look for the physiological indicators of estrus. He found nothing.

Cynthia Moss likewise considered the whole problem of elephant sex mystifying. She had seen mating once at Manyara, but after starting her work at Amboseli in 1972, she saw nothing of the sort again until 1974, when, on one lucky day, she saw a female being chased by a dozen males, one of whom caught and mated with her four times. Moss saw no other matings until 1976, when she observed a single instance and twice noticed females who could have been in estrus. She understood only in retrospect that the long dry period in her observations on the subject was a result of a long dry period at Amboseli, a drought during the years 1975 and 1976, which left the elephants stressed by conditions of

near starvation, resulting in infertile females. The females lacked the nutritional surplus to develop estrous cycles, which led them to be less interested in mating: a reasonable response to hard times, since they also could not afford the extra nutritional and energy expenditures that would have been required by pregnancy and motherhood. After the rains came and the drought ended, in 1977, the vegetation returned to its normal lush abundance and the elephants became fat, perky, and sexy. Indeed, Moss observed that along with the rains "came such a profusion of sexual activity that at times it seemed like a bacchanalian debauch." Once she began to see a lot of mating, she became sensitized to the somewhat subtle behavioral signs of estrus among the adult females—a particular wariness, a certain style of walking—combined with the far less subtle signs made by attracted males.

But while the behavior of the females was increasingly understood, that of the males remained as mysterious as ever. What were they doing? Where did they go? How did they deal with one another? What signals brought them back to the estrous females? Moss hired a research assistant named Joyce Poole, a nineteen-year-old American taking time off from undergraduate studies in zoology at Smith College to revisit Africa (where she had lived as a child) and get field experience watching animals. In October 1975, Poole joined Moss in her Amboseli research camp, a small cluster of tents and rough huts at the edge of a shady grove of palm and yellow-barked acacia trees. Moss assigned Poole the task of learning more about the males.

Poole began by updating and expanding the identification files on the males, taking more photographs and developing her own ability to recognize individuals. Soon after she began this new work, though, it seemed as if the male elephants had begun succumbing to a serious epidemic. One day in February 1976, Poole watched a family group wander across a clearing and come right into the grove where the camp was situated. The group included several females who were being shadowed by an enormous male. "I had never seen such a large elephant before," Poole writes in her memoir, *Coming of Age with Elephants*, "nor do I think I have ever seen one as immense since." As the elephants passed by the camp, the young woman was able to look more closely at the huge animal. Since male elephants continue growing almost their entire lives, she knew merely from his size that he was older, around fifty years. But she also thought that maybe he was simply *old*, be-

cause he was incontinent. Poole raised her binoculars for a better look and immediately understood that there was "something terribly wrong" with the big bull: "The constant dribbling of urine had apparently caused the sheath of his penis to turn a greenish color from what seemed to be a nasty fungal growth."

She sighted the same enormous male later that month, and this time she observed not only the dribbling and green-stained penis but also an odd swelling around his temporal glands, which are located midway between eye and ear, and some dark viscous fluid oozing from the glands. Female African elephants in a state of high emotion, expressing, for example, the apparent joy of reuniting with members of their bond group, commonly secrete fluid from their temporal glands—but this was different. Very peculiar. Poole saw the same obviously afflicted male three more times in March, and each time she noted the same syndrome of incontinence, green-stained penis, and swollen and oozing temporal glands. By then she was confident enough of recognizing the giant male, already assigned the number M103 in the photographic identification files, that she gave him a name: Zeus.

It was only a few weeks later that Poole sighted another big bull with the same syndrome. This one was walking at a leisurely pace alongside a group of females, and although he was certainly mature and notably large, he still looked ten to fifteen years younger than Zeus. Wielding an asymmetrically aligned set of long and curved tusks, the new bull seemed vigorous and youthful, making his incontinence even more troubling. It could not have been the result of old age. Numbered M117 in the files, he was now given the name Green Penis. It seemed clear that both Green Penis and Zeus were affected by the same bad thing, and since both males appeared to be sexually active, perhaps their disorder was sexually transmitted, a venereal disease for elephants. Poole and Moss began identifying it as the green penis disease, or GPD.

In September 1976, Poole returned to college in the States. Moss continued with her own research on the females, incidentally noting the pernicious spread of GPD among the males. This alarming malady had been seen in several individuals at this point, although they appeared to recover over time; but as Poole learned when she returned to Amboseli for the summer of 1977, the afflicted males also seemed to behave more aggressively than their healthy counterparts. There had been one recent and memorable incident. Moss had found a large assembly of elephants

on June 2, more than fifty females and their offspring with at least a dozen bulls on the periphery. It was a "quiet, peaceful scene," Moss recalled, with the full group moving at a leisurely pace in the direction of a swamp. The researcher drove alongside, and then pulled her vehicle into a good spot to watch them pass by. One of the bigger bulls approached the vehicle, and she saw that he was yet another victim of GPD, with all the usual symptoms. Distinctively marked by a V-shaped cut out of his right ear and a broken right tusk, he was listed in the identity files as M126. Quite suddenly, he wheeled about and charged. Moss was trapped, without enough time to start the car and pull out of her spot. She could only watch, now paralyzed by shock and alarm, as the six-ton beast rushed right up to the front of the vehicle and then, at about three yards, stopped short, his ears stretched out like a great gray set of warning flags, his massive head looming threateningly over the pale, cringing person inside.

After a few minutes, M126 seemed to lose interest and moved away. Moss started up the car and drove on past the slowly moving line of elephants. After weaving through a maze of trees and bushes until she had reached the edge of the swamp, she turned off the engine once more and settled down to watch the animals as they reached the water. She had been parked there for some time when "suddenly I got a funny feeling in the back of my neck, looked in my rearview mirror, and found it filled with dark-gray wrinkled hide." It was M126, again on the attack. She started the car and was just able to extricate herself from her tight parking spot in the bushes. Meanwhile, M126 was pounding the ground in stiff-legged pursuit, and, as Moss zigzagged through the bushes and trees, he anticipated her moves and tried to head her off. That was unnerving, though once Moss reached a stretch of open land she was able to accelerate and leave the strangely aggressive beast behind.

Shaking from the encounter, she paused to gather her nerve and think. Iain Douglas-Hamilton had believed that it was important not to let the more aggressive elephants, whether male or female, get in the habit of thinking they could dominate you, so in comparable situations he would sometimes try to intimidate them with his Land Rover. Moss looked back at M126, and then she turned around, stepped on the gas, and raced headlong toward the six-ton animal. In turn, he lowered his head, curled up his trunk, folded back his ears, and charged directly at the approaching ve-

hicle. It was elephant versus car, and the former was bigger, better armed, and more single-minded than the latter. Moss swerved away at the last moment. The elephant spun around and gave chase. She accelerated until she had put some distance between herself and M126, and then she turned around, revved the engine, worked up her courage, and bravely tried again. Again at the last moment, she swerved to avoid a head-on collision or a tusk through the windshield, and again the big bull elephant wheeled about and began chasing the car. She raced away from him in earnest now, first straight along a road and then weaving between trees and bushes off the road, until finally, after she had gained sufficient distance, he gave up the chase. She later returned when it was safe to consider the dusty tracks made by her evading tires and to look at the impression made by the tip of M126's probing trunk, which drew its own snaky line following her tire tracks. The beast had been tracking her, she saw—intently, deliberately, intelligently, malevolently following her for almost a half mile. "I found this behavior totally strange, surprising, and not a little creepy," she later wrote. After that incident, she could think of M126 only as the "Bad Bull," which soon became his name.

When Joyce Poole showed up for her summer work at Amboseli in 1977, she heard about Bad Bull and listened to Cynthia Moss's summary of what was known so far about the GPD epidemic, along with the new and distressing hypothesis that it might be associated not only with sexual activity but also with elevated aggression. The picture became even more complicated as Poole checked on the various males she had gotten to know and found a number who, described as having GPD that winter and hanging out with females, were now symptom-free, spending their days resting and feeding quietly, often in the company of other males. Was it possible, Poole wondered, that the males went through their own cycles of sexual activity? The idea was wild enough that she kept it to herself for some time before anxiously revealing it to Moss—who quickly set her straight, explaining that a number of reputable scientists had already studied African elephant reproduction, and not a single one believed that the males passed through sexual cycles.

Back at college in the fall, Poole received regular letters from Moss, who kept her abreast of the latest developments, including the news that two more males had come down with bad cases of GPD. One was named Hulk. The other was Green Penis himself,

who, after seeming to recover, once again had developed the full syndrome.

Poole returned to Kenya over her Christmas break, spending all of January at Amboseli before passing through Nairobi on her way home. In Nairobi she attended a luncheon at the National Museums of Kenya, where she talked with Moss's friend and colleague Harvey Croze, who showed her a recently published article, "Plasma Testosterone Levels in Relation to Musth and Sexual Activity in the Male Asiatic Elephant." Poole casually leafed through the pages until she came to an interesting photograph of a male Asian elephant with the caption "Asiatic elephant bull in musth. The male is fastened to trees by chains around his front and hind legs, and is showing some discharge from the temporal glands behind the eye and a dribble of urine from the penis."

This was a eureka moment. It was instantly obvious to Poole that the green penis disease she and Moss had been seeing and documenting at Amboseli was not some odd viral affliction, not a terrible venereal disease, not a disease at all, but simply the state of musth in African savanna elephants, a condition that had been familiar for thousands of years to professional handlers of Asian elephants. In Asia, mahouts traditionally dealt with musth males by chaining them to trees, severely reducing their food, and, sometimes, giving them treats containing high doses of opium, marijuana, or other sedating concoctions. But no modern scientific observer had so far recognized the phenomenon in African elephants, perhaps because they have been rarely captured or trained in modern times.

After completing her initial research and writing an undergraduate thesis on this remarkable discovery, Poole applied to begin graduate work on the same subject at Cambridge University in England. Her first application was turned down by the university's resident expert on African elephants and elephant reproduction, a distinguished man who condescendingly informed her that musth did not occur in African elephants, and thus her research would be useless. Fortunately, she was later accepted by an animal behaviorist who knew nothing about elephants and therefore was less skeptical about her hypothesis, so she returned to Amboseli in 1979 as a Cambridge University doctoral candidate to examine in greater detail the phenomenon of musth and, more generally, the earthshaking nature of sex among African savanna elephants.

The term *musth* derives from an Urdu word for intoxication.

Indeed, the condition is caused by sharply elevated levels of testosterone, so intoxication is a reasonable way of thinking about it. This periodic surge of male hormones in the male leads to a strange and raging mixture of obsession with females, especially those in estrus, and a suddenly and powerfully increased need to dominate other males. Male elephants begin to experience musth in their midtwenties. Although at first each episode lasts a short time, as the elephants grow older and bigger their musth phases become longer. Males reach their sexual prime by their midforties, when they approach maximum body size and their musth phases continue for a few months each year. The hormonal surge produces psychological changes, which in turn produce a few obvious behaviors; in addition, the surge can be identified in several physiological ways. A pheromone-laden liquid begins to ooze from the temporal glands. The penis begins dribbling a pungent flow of urine, which establishes a scent trail as the great elephant walks. The bull begins to vocalize with distinctive, low-frequency rumbles. He may swagger ominously, head raised and ears spread, swaying his head and tusks heavily back and forth. He paces. He rumbles. He listens for the repulsive responses of other musth males and the attractive responses of estrous females. He begins following the map created by such sounds and their associated smells, moving among the elephant families now, pausing to probe and to sniff with the tip of his trunk the genital opening of each adult female: searching, searching, searching for that very special smell of feminine fertility.

Adult males vie among themselves for access to estrous females, and the condition of musth is an important part of that rivalry, since it makes even a younger and smaller male more competitive, more powerful and aggressive, than a bigger male not in musth. Indeed, the arrival of musth produces a Jekyll-and-Hyde sort of transformation in any male, Poole concluded. As she continued her research, first following and observing the musth males and later trying to collect fresh samples of their urine for chemical analysis, she also found that she and her rumbly research vehicle were often targets, a situation that could be registered in her rearview mirror as a curtain of dust, a wall of skin, a projection of tusk. The most dangerous of the lot was Bad Bull, who during his time of musth in 1980 often left her so shaken that she obsessively dreamed about him at night.

Not long after the most vivid of those dreams, in which she had

a heart-to-heart talk with Bad Bull about the problem of his aggression, Poole imposed on herself a regimen of never following a musth male into a thicket and, in all circumstances, staying at least 50 meters (55 yards) distant. Over time, she also learned to turn off her engine when challenged, an act that usually seemed to reduce tension and deflect aggression. Eventually, she settled into a series of almost ritualized interactions with each of the musth bulls studied. One, RBG, would rumble at her each time she came near. Another, Agamemnon, would approach the car until his front legs touched the bumper; then he would tap at the windshield with his great tusks; and finally, with his eyes turned down to look through the windshield at the little person inside, he would wave his tusks back and forth over the top of the car. Alfred simply leaned over the car while rumbling and stroking the tip of his trunk across the vehicle's hood. Sleepy seemed to indulge in play chases with Poole and her machine; Dionysius and Iain, when in musth, would stand quietly near her, acting "as friends," Poole thought. Only Bad Bull remained predictably unpredictable and perpetually dangerous when in musth.

THE MATING GAME BEGINS when an adult female starts to ovulate and develops the external signs of fertility: a special smell, stance, and style of walking. Her estrous period lasts from four to six days, and even before she's maximally fertile, she becomes a magnet to the previously unaligned males, who turn from their varied and distant interests and begin to move in. Let's imagine that two young males—in their twenties, perhaps—discover her first and, in the usual way, begin chasing her, hoping to catch and mate with her. Young and agile, she flees in a panic through an obstacle course of vegetation and soon leaves the hopeful pair in the distance, returning then to the large gathering of her family and bond group. Several of the females from this assembly greet her with rumbles and trunk probes. Her young calf comes up, reaching up to her mother's mouth with a trunk tip, and then she nuzzles into the breast and begins to nurse. All is well . . . until a third male appears, somewhat older and larger than the first two. He begins examining the vaginal scent of the females in the herd, one by one. As this male moves through the large group, the estrous female, alert and soon alarmed, walks away. She walks with head up, ears spread, peering back over her shoulder at the new male. And he, recognizing the object of his desire, leaves the

others and begins following her, while his penis, until now comparatively small and retracted into an internal sheath, suddenly expands in size and weight and drops heavily down. She pauses, tossing a trunkful of dust across her back, standing at enough of an angle that she can look back. He approaches more closely, and now she simply bolts away, and in the ensuing pursuit they trace an arc that returns her to her family and bond group.

The two younger males are still hanging around that larger aggregation, but they have been joined by two more males. The estrous female now finds herself attended by five eager males, who singly and in small groups pester and pursue her for the rest of the morning. None of the males succeeds in catching her, though. For a couple of hours at midday a high heat settles onto this scene and spreads a quiet torpor over everyone, but later in the afternoon, as the heat begins to dissipate, the harassment and chases begin once more until finally one of the males succeeds in cornering her. He manages to climb up, brace himself, and try mounting her from behind. Protesting with loud bellows, she resists, moving forward, sideways, forward again, while her family gathers around the struggling pair and adds to the commotion with a jumble of rumbles and a chorus of trumpets. In her favor: intercourse is a physically difficult act, partly due to the placement of her genital opening, low between her legs and requiring complex maneuvers by the male. In his favor: an erect penis shaped like an S, for reaching under and up and in, and directionally controlled by independent muscles. Indeed, his penis rises and hardens and begins to seek its target in a mobile, snakelike fashion. But at a crucial moment, perhaps, unable to keep his balance atop the struggling female, the male drops out of position and ejaculates ineffectually to one side, stumbling clumsily away.

When light overcomes darkness at the start of the second day, ten adult males are quietly orbiting, all drawn to the vicinity by this female's olfactory mystique. Yet so far, from her perspective, none of them has demonstrated a comparable mystique. It may seem as if this day will only see a repeat of the unpleasantness of the last, with more harassment and chasing, but she has entered the middle part of her estrous phase now, and is at her most fertile and attractive—and we can imagine that, by midmorning, she hears a peculiarly fascinating deep rumble, a regular sound "almost like an engine far in the distance," to quote Cynthia Moss. Just one of the females in her family rumbles in response, but all of the fe-

males are intrigued and alert. Soon, the deep, long-distance rumbles are followed by the drifting arrival of a rich and acrid odor, the unmistakable molecular signature of a bull elephant in musth. For the females, that scent is at once disturbing and exciting.

Finally, he appears, rumbling and swaying grandly, an enormous creature even by elephant standards, twice the size of the females, perhaps two-thirds of a meter (2 feet) taller than any of the other males, massively broader and heavier, and wielding a monumental set of tusks. His temporal glands are swollen and oozing fluid, producing dark stains down the sides of his face. His penis is dribbling urine, darkening the insides of his rear legs. He carries his head high and waves his ears slowly in a manner that fans the scent from his temporal glands into the air. The many females in this grazing aggregation, now alert and attuned, greet the new arrival with rumbles, and as he moves among them, some turn around, backing up in his direction, while others stretch out their trunks to smell and greet. Three females approach this great animal, one urinating right in front of him, another rubbing herself against his flank, a third standing boldly in his way, but the gigantic musth bull ignores them all, having already located his prize. She may be half his age, young enough to be his daughter perhaps—but since elephants are averse to close inbreeding, she is most probably not his daughter (or sister). She walks away with head up and ears spread, turning just enough to look back and keep an eye on him. He moves in her direction. She continues walking away, faster now, but he easily catches up and lays his heavy trunk across her back.

She stops. He moves the end of his trunk onto the top of her head, and then, using the leverage of his trunk and head against her head and back, he draws his massive torso forward and up until he has placed his front legs onto her back, carefully shifting and balancing the bulk of his weight onto his own hind legs. His penis is now hard, 1.25 meters (4 feet) long, and curled into the usual S shape, and it seems to take on a life of its own, turning, rising, seeking the obscure entrance to an enticingly fertile center. The probe passes her own engorged clitoris, 45 centimeters (18 inches) long, enters, and is soon buried for almost its entire length. She, filled with a strangely pleasurable sensation now, cooperates, backing into his pressure, her legs spread, and they maintain that fragile association for perhaps three-quarters of a minute. It ends with an ejaculation and a gushing withdrawal,

whereupon the female bellows deeply and powerfully. On hearing the distinctive sound, her entire family rushes over, and, in a remarkable chorus of excitement and, seemingly, of celebration, they rumble, scream, and trumpet. Their own temporal glands ooze fluids of emotional excitement. They flap their ears and touch with their trunks, sometimes reaching to the female's mouth and sometimes her genitals—while she continues vocalizing with a distinctively low and pulsating rumble for another several minutes, periodically using her trunk to examine the musth bull's gradually retreating penis and to sniff the small puddle of semen beneath it, spilled and seeping into the ground.

For the remainder of the day, through the night, and for the day and night following, the pair stay tightly close to each other, he attracted to her sexual state, she to his but also to his power and protective presence. They mate again after dawn the next day, and as before, immediately after the mating her entire family rushes over for an excited display. And once again, after the mating, she vocalizes in her distinctive postcopulatory rumble. By now well over a dozen bulls have migrated into the vicinity, drawn by the sounds and smells, attracted by the estrous female, yet cautioned off and maintaining their discreet behavior and distance because of the musth bull. With him nearby and on guard, she is no longer pestered and chased by the less desirable males, and thus she can relax once more and resume eating and drinking. She and he have entered a *consortship,* an exclusive if entirely temporary relationship based on mutual interests and merging behaviors. "The movements of the males around an estrous female were like a beautifully choreographed dance in slow motion," Joyce Poole has written, describing the physical dynamics of consortship. "If the female took a step, her consort immediately took a step after her and all of the younger males moved out of his way. If a young male approached the female, she would move toward the musth male, soliciting guarding behavior from him."

That satisfactory relationship is all too fleeting, however. As the female cycles into the final day of her fertile period, her olfactory attractiveness declines, and the big musth bull gradually loses interest. Finally, on her last day of fertility the big bull simply ambles away, still fully in musth and now searching for another prime female in estrus. With her giant protector now gone, the female is once more fully vulnerable to those less attractive males who continue hanging around the periphery of her bond

group, kept there by persistent hope. She is now chased by several of the remaining males, even trapped and mated by one, before her estrous phase ends entirely. The return to normalcy must be a relief, because it's a return to a steady, familiar life within the family, a return to nursing her own calf, eating delicious grasses and forage when she's hungry, drinking when she's thirsty, wallowing and bathing and all the other activities that give meaning and pleasure to an elephant's life—although she is now quietly shifting into another transitional stage, a pregnancy, which ends twenty-two months later with the birth of a gorgeous 115-kilogram (250-pound) elephant in miniature.

Elephant sex has, by now, been seen many times in many places by many people, but the end result of all that sex—birth—is still only very rarely witnessed. Joyce Poole was among the first to record such an event, which she recalls in *Coming of Age*. She observed an ordinary gathering of eighteen elephants at Amboseli one morning, part of the T bond group consisting of two families, one led by the matriarch Teresia and the other by Slit Ear. The elephants were standing between the edge of a swamp and a small forest of palm and acacia trees. Teresia's daughter Tallulah, Poole noticed, was behaving oddly, dropping down to her knees and urinating in a steady, slow dribble. Poole then saw the bulge beneath Tallulah's tail and suddenly realized that she was about to give birth.

Poole reached for her camera, but as she did so the elephant moved behind a screen of trees and vegetation. Poole located her again, now lying down on her side; the researcher left her car and quietly moved closer. The elephant raised herself up, looked at the person, and disappeared once again, deeper into the clump of trees. Poole found Tallulah a few minutes later, standing quietly above an interesting package on the ground, a small baby still inside the amniotic sac and not moving. The mother tentatively prodded the unmoving object with a front foot, whereupon something inside kicked and the package shivered. The mother leaned over, gently poked with her tusks, and then cut the sac open. Within a very short while, several members of her family had begun showing up, rumbling noisily, urinating, excitedly holding their heads and ears up high. Now the mother bent down and, pushing gently with her feet and trunk, tried to bring the baby into an upright position. More females of her family gathered around, expressing tremendous excitement with a steady chorus of screams, rumbles, and trumpets, while fluids from their tem-

poral glands drizzled down their cheeks. Poole, who stood about 15 meters (16 yards) away, could barely see the newborn creature through a shifting thicket of legs and trunks.

After a few minutes, the mother managed to get her baby upright, on all four legs, but the little thing, still very weak and completely uncoordinated, instantly flopped back down. Another two minutes passed. The baby was again prodded into an upright stance, but again she toppled weakly over. It took more than a half hour before she was finally standing on her own—and during this entire time, more and more females had arrived. Some had come from Tallulah's bond group, but others were appearing from normally unassociated families. Altogether, the group excitement was "intense," Poole reports, "and several females dropped to their knees and, with their heads held high in the air, flopped their trunks about and gave me a wild look, the whites of their eyes showing. It was as if, in their excitement, they had forgotten that I was not an elephant and wanted to share their emotion with me."

3

Katy Payne and her husband, Roger, watched and listened to whales for fifteen years. They began in 1969, considering the extended, complex, and ever-changing songs of humpback whales in the northern Pacific and northern Atlantic. From 1971 to 1981, they also studied the behavior and demographics of southern right whales. Sitting on the edge of high cliffs on the Valdés Peninsula in Argentina, they used binoculars to scan the shimmering tablet of the sea for emerging hieroglyphs made by the whales' backs. Sometimes, when the tide was high, the whales would swim right up to the base of the cliffs, close enough that the Paynes could recognize individuals. They would watch those individuals move away, grow fainter, slip beneath the surface, and rise again much farther on, organizing themselves into parallel-swimming pods that faded at the horizon as they embarked on their long-distance migrations across the open sea.

By 1984, the Paynes' long-term joint research on whales had reached its conclusion, just as their marriage was starting to unravel. Katy Payne needed a new project. She was working as an acoustic biologist at Cornell University, and in April she was invited to participate in a symposium in California on animal cultures—learned behavior passed down through generations. While

on the West Coast, she also decided to visit Warren Iliff, the director of the Washington Park Zoo in Portland, Oregon, who invited her to extend her sojourn by a week in order to see his zoo's elephants. The visit was personal, not scientific, something done on a whim. She had always been interested in elephants, knowing that they are complex, very social, and capable of developing lifelong relationships with particular humans, and she was especially eager to see the elephant babies who had recently been born at the zoo.

Payne arrived at the Washington Park Zoo in early May 1984 and was introduced to the elephant staff, who in turn introduced her to three adult female Asian elephants and their three young offspring. As Payne describes it in her book *Silent Thunder: In the Presence of Elephants,* the animals began examining her: "Six trunks reached slightly through the bars, gently surrounding me with whiffing as the elephants decided . . . who I was." She spent the next several days tentatively exploring who they were. She stroked foreheads. Ran her hands down the cascading wrinkles of a trunk. Looked into the murky well of an eye so abstractly large she could never follow its gaze.

Elephants, the keepers told her, could be sedate and restrained but also determined and even vengeful. They were individuals, with distinctively individual personalities. They could also be unpredictable—sometimes dangerously so. The keepers spoke about naive people who thought they knew all there was to know about elephants and then, in a moment of carelessness, were squashed. "They told me about one swaying elephant belly at a time. About elephants' knees in their faces. About dangerous, affectionate, and often inscrutable individuals. The elephants they knew were as full of quirks and idiosyncrasies as an assortment of very weird people."

On her way back home to Ithaca, New York, while buckled into the seat of a transcontinental jet plane, her ears and neck still itching from the insinuating detritus of the elephant house, Payne thought about the elephants. She recalled the stories and warnings of the keepers. She reviewed the antics and manifest personalities of the kept. As she was comfortably recollecting the previous week's characters and events, though, she also became aware of the plane's rumbling and a peculiar pulsation in the air, and then she recalled the feeling she had had among the elephants, on occasion, of "a faint throbbing, or thrilling, or shuddering." That strange, soundless, vibratory purring was, she thought, "like

the feeling of thunder but there'd been no thunder. There had been no loud sound at all, just throbbing and then nothing."

She was perplexed by the sensation. What was it? What did it mean? Her immediate association with the experience was a memory of listening, when she was thirteen years old and singing in a chorus, to the great pipe organ in the Sage Chapel of Cornell University. The organist played Bach's *Passion according to St. Matthew.* As he moved his fingers lower on the keyboard scale, the air around her pulsated. As the sounds became deeper, they became less clear and less audible, and the pulsations slowed down. The vibrations produced by the pipe organ approached a threshold beyond which she couldn't hear them, moving into a realm known as *infrasound,* which is sound, or vibratory activity, low and slow enough to exist beneath the spectrum of human hearing. She thought again of the elephants.

"Is that what I was feeling as I sat beside the elephant cage?" Payne wondered. *"Sound too low for me to hear, yet so powerful it caused the air to throb? Were the elephants calling for each other in infrasound?"*

She knew that at least two species of large, long-lived mammals, blue and fin whales, could communicate over very long distances infrasonically. Was it possible that elephants did something similar? Infrasound is a concept based on human limitation. Vibrations in the air or some other medium, such as water, strike the human eardrum and register in the brain as sound—if, that is, they occur within a limited frequency range. At the lower end of the range, we humans may be fortunate enough to feel the vibrations as, say, odd pulsations in the air or water or the earth, but we fail to hear them as sound. More generally, our limitation means that both very-high-frequency and very-low-frequency vibrations become part of an unheard information environment. Very-low-frequency vibrations, aside from being inaudible to humans, have another interesting quality. They can maintain their integrity over long distances—and the higher the intensity, the longer the distance. Within the range of audible sound, low frequency registers in human perception as "deep," and high intensity registers as "loud." But increase those qualities enough, and both deep and loud vanish. The vibrations become instead unregistered events of very high intensity and very low frequency. Now understood as infrasonic, they have slipped beneath the human-audible surface—and yet can carry information for many miles, even passing through rocks, trees, and other supposed barriers.

Four months later, Payne returned to the zoo, this time accompanied by two old friends, behavioral biologist Bill Langbauer and author Elizabeth Marshall Thomas. Payne also brought a tape recorder, borrowed from a Cornell University colleague, that was capable of registering infrasound. Over the next week, the three people recorded the auditory environment of the zoo's elephant house while simultaneously making timed records of elephant movements, associations, and behaviors. Payne and Thomas—but not Langbauer—occasionally felt the peculiar throbbing in the air, and they took note of those special times. Once in particular, the sensation occurred when Rosy the elephant walked to the end of the large exhibition hall to stand by herself, her face turned to the concrete wall. Both women registered the odd feeling just then, and Thomas thought to run outside to see what was on the other side of the wall. She saw a large male named Tunga, who was loose in a large sand yard and had walked a long distance over to the building, where he now stood directly facing the other side of the wall. The two elephants' heads were 3 feet apart, separated only by the thick concrete barrier.

When Payne returned her borrowed equipment to the Cornell laboratory, she played back the tapes while watching a visual representation of the sounds produced on a spectrograph. She ran the tapes at faster speeds, to raise the sound frequencies. At ten times their original speed, the infrasonic traces became audible as sounds that were, Payne wrote, "condensed and nearly three octaves too high—a little like the mooing of cows. The loudest calls coincided with a period when Liz [Thomas] and I had both sensed throbbing. Two animals had been carrying on an extensive and animated conversation below the range of human hearing. I suppose that they were Rosy and Tunga, calling to each other through the wall."

For years, scientists had studied the many audible elephant vocalizations (trumpets, roars, cries, screams, and so on), finding communications that seemed interesting, possibly sophisticated, but still inadequate to explain baffling observations of long-distance synchronicity. Rowan Martin in Zimbabwe, for example, had radio-tracked female elephants from different families and noted that they would stay within a few kilometers of one another, even while changing directions and covering substantial distances. They moved in a coordinated, even synchronized fashion, almost as if they were communicating over great distances

with . . . what? No one could recall any unusual vocalizations. The separated groups were not in visual contact. Communication by scent was conceivable, but the coordination occurred even when the wind direction was unfavorable. In short, people were hard-pressed to understand or explain what was going on. Iain Douglas-Hamilton once described the mystification these strange observations evoked: "We didn't mention ESP openly, but . . . some of us were ready to entertain the idea that these animals were sending bloody mind waves to each other." But then came the idea that elephants could be communicating through infrasound. Payne's first report on her findings was published in an academic journal as "Infrasonic Calls of the Asian Elephant," while the New York Times summarized for a popular audience the more dramatic version: "Secret Language Found in Elephants." Put that way, the discovery of elephant infrasonic communication with long-distance potential may have seemed extraordinary, the stuff of science fiction. But people who knew elephants were already fully prepared for the idea. It made perfect sense.

IN MARCH 1985, Katy Payne moved her things into a tent in the palm grove of Cynthia Moss's research camp at Amboseli National Park in Kenya. By that time Moss was able to recognize all 650 elephants living in Amboseli. Joyce Poole had finished her nine-year-long study of the males but was still in residence, about to start a new project. A few other scientists were there as well, working on different Amboseli-related projects (baboons, vervet monkeys, and grassland ecology).

Payne had been invited to work with Poole on the problem of infrasonic communication among elephants. She began by listening closely.

She listened through earphones connected to her recorder, which could pick up both audible sound and infrasound frequencies. On one occasion, while sitting in a Jeep with Poole, she was casually approached by a slowly moving herd consisting of a couple of dozen elephants, including one Poole identified as Ulla. "I heard a very soft deep purr," Payne writes, "and looked up into an eye that was looking down into the jeep." As Ulla looked down, she casually dislodged clumps of grass with her feet, in the process stirring up clouds of dust that, drifting through the window, settled onto the two women and Payne's microphone and tape recorder. "That instrument was recording the scuffing

of feet and the thumps of earth on earth as the elephant, having lifted a clump into her trunk, flung it onto the ground; and the crumbling of dry soil on the salty crust, and the grinding of grass and dust between her molars, the growls and farts of her digestion, the scraping of her dry ears against her dry shoulders, many small hums, faint squeals, and faint rumbles."

Along with the recordings, Payne kept a continuous sequence of carefully timed descriptions, assessments, and references, with expert commentary provided by Poole. Those were the "systematic notes," as Payne called them, which were "overlaid [with] musings and questions, arrows, stars, exclamation points, and guesses, guesses, guesses. There was much to be humble about." Among the humbling things was the fact that, as the acoustic analysis would reveal, they were hearing only a quarter of the elephant calls.

Payne describes waking up in the middle of a night, lying still while a bright moon and sharp shadows cast their cryptic calligraphy onto the canvas walls of her tent. Outside, a bluish glow spread across the great open meadows beyond, while the grove of palm trees around the camp was rooted in its own puddling grove of shadows. She listened. "A wave of sound was passing through those trees, a soft low purring. Slowly it became two waves moving down the trees on either side of the clearing, waxing and waning. Close to my tent, a third wave was beginning. Elephants were all around me, calling and answering." If the elephants were calling and answering, though, what were they calling and answering about? Between which individuals did the communications take place? Under what circumstances?

For calls in the audible range, researchers had been working on those questions for some time, and Moss and Poole had begun to establish their own tentative lexicon for many of the elephant calls. There were calls for help, usually made by elephant calves: rumbles, cries, and screams indicating that they were in distress, lost, or hungry or wanted to suckle. There were social calls, including greetings made with bellows, roars, rumbles, screams, and trumpets, and there was a distinctive style of "half-muffled, half-shrieking" trumpeting associated with play. Group coordination calls included attack rumbles, start-moving rumbles, gather-together rumbles, and a rumbling communal exchange considering problems such as where to go next. Being startled or surprised by something novel might result in an alarm trumpet blast or an alarm snort. Females competing with one another made distinctive female dominance rumbles. Males competing with one another were associated with a number of sounds, including the very distinctive musth rumble. In fact, several different calls, largely by the females, punctuated the full sequence of mating: the lone female's estrous call, the grouped females' excited screams as a large male examined each one's reproductive status with his sniffing trunk tip, the collective pandemonium when a family member was being mounted, and the postcopulatory bellowing and chorus.

Payne briefly describes one bravura performance in the postcopulation opera:

Standing alone—truly alone—Flavia now begins to sing her song, a series of deep, loud, arched notes repeated over and over again. Each shuddering rumble rises up out of the silence and expands in volume as it reaches its peak pitch and then descends as it subsides into nothingness. By the third call, other excited voices are joining in, neither in synchrony nor in sequence. Only Flavia's rhythm is repetitive, and her voice, slower and lower and more extremely inflected than the others, is recognizable again and again. Suddenly, she breaks out of the sequence and starts trumpeting in a series of unorganized, brilliant, high-pitched, wheezy, excited sounds. The surrounding elephants blow their trumpets in response. Flavia ear-flaps, and several females urinate thunderously together.

The elephant calls at Amboseli were made predominately by females, a communicatory bias that makes sense because females are the more social sex, the ones who stay together for a lifetime in their stable family groups. Males are the isolated drifters, only occasionally coming together for periods of passing convenience or sociability, or when finding and securing mates. But, as Payne eventually realized after analyzing her recordings, the females were not merely vocalizing a lot more than the males; they were also vocalizing communally, as a chorus, with their individual announcements "buried and immersed in each others' announcements." If one were to create a rough lexicon of elephant calls, in other words, it might make sense to begin translations of female calls with the first-person plural pronoun: *we*. Payne elaborates on the thought: "If I were trying to offer evidence that elephants are self-conscious, I'd mention these observations. I'd suggest that

male elephants have a sense of themselves as individuals, and females have a sense of themselves as members of communities."

At Amboseli, Payne had given herself the simpler task of first determining whether elephants were capable of communicating through infrasound over long distances. Because the distance a sound can travel is, in large part, a function of its frequency and intensity, the very low frequency of infrasound, if combined with a high intensity, can carry for a long way. Frequency, the number of vibrations per unit of time, is usually measured in hertz (vibrations per second), with the low G of a human bass singer registering at about 98 hertz, and 20 hertz being the threshold below which sound is no longer audible to human ears. Payne found that the frequencies of elephant calls routinely dropped well below 40 hertz, often into the infrasonic range, and—for a male's musth rumbles—as low as 14 hertz. Later on, she would record musth rumbles among savanna elephants that reached a frequency of 12 hertz, and among forest elephants, they went down to 5 hertz. Intensity is commonly measured in decibels, and by measuring the strength of calls at known distances from a microphone, Payne found that some of the vocalizations registered as high as 117 decibels. At those intensity and frequency levels, she concluded, elephant calls might persist for kilometers.

But how many kilometers? Finding out precisely how far these sounds carried required more than measuring frequency and intensity, since the answer also depended on other factors, such as the condition of the medium. In this case, the medium was air, which at Amboseli continually shifted between hot and cool, still and turbulent. Atmospheric conditions would certainly affect the transmission of sound. Moreover, even if the elephants could broadcast their calls over long distances, could other elephants hear them? Were the calls meaningful? How could anyone prove it? Even if a number of males arrived from all directions soon after a female had produced her estrous call, for example, how could anyone be certain their arrival was anything but coincidence? How could anyone prove the males were following a trail of sound rather than some other clue, such as the ever-enticing tendrils of scent?

Payne's colleague Bill Langbauer designed an experiment to address these problems and questions. The experiment involved a giant loudspeaker capable of accurately reproducing elephant sounds and infrasounds. The loudspeaker and its asso-

ciated equipment were battery powered and carried around in a vehicle, thus becoming a mobile source of realistic elephant calls. The calls could be produced at particular times and particular distances from a fixed elephant meeting place, such as a watering hole in an otherwise dry environment.

The behavior of the elephants coming to this natural meeting place could be recorded with automatically timed video and audio equipment. This was a double-blind experiment, meaning that the later analysis of those timed recordings was done by people who had no knowledge of when and from where the original loudspeaker calls had been broadcast. The later analysts were merely looking for particular behaviors (such as raised ears, rumbling, standing still, turning in a new direction, moving in that direction) that would indicate that the elephants had perceived a distant sound or infrasound. If their analysis of listening behaviors coincided in a statistically meaningful way with the records of call broadcasting kept by the mobile speaker team, then the scientists would have not only evidence that the elephants were communicating over long distances but also good information on how far and under what conditions those communications were effective.

The sound trials for this experiment took place over three months in 1987 and involved a half-dozen scientists (including Payne, Langbauer, and another acoustic specialist from Payne's whale-song days, Russ Charif) living in desert conditions among skulking, yellow-eyed lions in Etosha, a large national park of Namibia, in southern central Africa. The observation part of the Etosha experiment—the video and audio recording—took place at the top of a platform 5 meters (5.5 yards) high, constructed out of telephone poles and wire and erected some 50 meters (55 yards) from an artificial watering hole kept wet by a solar-powered pump. The conditions were hot and dry, and the water hole was surrounded by a blasted forest of stunted mopane trees, arthritic-looking hardwood plants that, like the Sorcerer's Apprentice's broom, refused to give up. Since it was the only source of water and wallows for some distance, the spot was frequented by many animals: antelope, foxes, jackals, giraffes, hyenas, lions, ostriches, and zebras, as well as elephants.

In *Silent Thunder*, Payne describes one of the experimental tests, starting from the perspective of the observation platform. Two bull elephants, the very large Mohammed and the smaller and younger Hannibal, had arrived at the pool and were drinking

and splashing and mucking about. Then, at 4:45:02, according to the automatic timer on the video camera, both elephants simultaneously lifted their heads. "Out went four ears, spread, lifted, and stiffened. Two bodies froze, all motion stopped. Very slowly Mohammed swung his head around to the left, and slowly back to center, and around to the right, as if scanning half the world for sound. Very slowly Hannibal did the same." After that initial behavior, both bulls turned slowly until they were facing due north, and then set off. They walked north, ignoring the usual animal trail. They stopped after three minutes, froze for thirty seconds, and then began moving again, continuing north until they disappeared at 4:56:00 into the mopane trees.

Later, Payne and her associates on the observation platform learned what Russ Charif and his partner at the mobile loudspeaker had done. After setting up their speaker exactly 1 kilometer due north of the watering hole, the mobile team had broadcast a female estrous call at 104 decibels. The broadcast sound started at 4:45:00, two seconds before the platform team noted listening behavior among the two bull elephants. It ended forty seconds later, at 4:45:40, ten seconds before Mohammed and Hannibal stopped their directional scanning, turned, and set off on their journey north. The mobile team also noted that the pair of elephants had reached the giant speaker thirty minutes later and kept on going, apparently still looking for the interesting female who had made the call.

With data from sixty trials in total, the experiment confirmed that the elephants of Etosha were capable of responding to one another's calls from as far away as 4 kilometers (2.5 miles), which meant their communications could typically cover an area of at least 50 square kilometers (19 square miles). In a subsequent analysis, a team of meteorologists established that certain atmospheric conditions would routinely and radically expand that auditory field. Between dusk and dawn, a shifting dynamic between ground and air heat produced a marked temperature inversion within 300 meters (330 yards) of the ground. This inversion had the effect of concentrating, or funneling, low-frequency sounds rather than allowing them to dissipate upward. As a result, during the darker hours at Etosha, the elephants were theoretically able to call one another from a distance of about 10 kilometers (6.2 miles), which in turn established an enormous potential call area: some 300 square kilometers (115 square miles).

Of course, such analysis has focused on the idea that elephants are listening to one another's infrasound communications through the air, while in fact high-intensity, low-frequency vibrations can travel even greater distances through water and the earth. As later research has shown, elephants listen to one another's infrasonic calls not only with their ears, which catch high-intensity and low-frequency vibrations moving through the air, but also with the bottoms of their feet. The dense, fatty pads on the bottoms of elephants' feet contain specialized receptor nodes, known as Pacinian corpuscles, that enable them to sense vibratory information traveling as seismic waves in the ground.

4

Although the Greek historian Herodotus was never lucky enough to see living elephants during his extensive travels into northern Egypt, he did happen to gaze over the shivering surface of a place that would become famous two and a half thousand years later as a graveyard of ancestral elephants. Located only a couple of days' journey by camel south from Cairo, the place was remarkable as a peculiarly vast sinkhole 1,800 square kilometers (700 square miles) in area, dipping some 50 meters (160 feet) below sea level, and filled with water. The ancient Egyptians called the body of water Lake Moeris, and it covered nearly the entire depression floor and was used as a supplementary source of irrigation water for the Nile Valley during periods of drought.

When the German explorer George Schweinfurth arrived in 1871 at the same spot, the lake had shrunk by four-fifths in surface area. It had also undergone a name change, so that the part of old Lake Moeris still remaining had become Lake Quarun, and the rest of the former lakebed, now exposed, had become an important oasis known as El Fâyum. More significantly, Schweinfurth's written recollections of his travels to the lake and the contiguous oasis described some impressive fossils that the lower water table had exposed in layers of rock around the rim of the great sinkhole.

A number of those fossils were dug up during a turn-of-the-century geological expedition and sent to the British Museum, where the English paleontologist Charles Andrews looked over the remnants of several strange, new creatures, including one he named *Moeritherium*, "the Wild Animal of Moeris," in honor of the original name of the lake. The Wild Animal of Moeris, alive and well some fifty million years earlier, would have been the size

of a pig and the shape of a hippo. Its eyes and ears were set high enough in the head to suggest a swimmer, an aquatic animal. But *Moeritherium* was ultimately identified not as an ancestral hippo but rather as one of the earliest ancestors of modern elephants, a member of the order Proboscidea. It possessed a flexible snout rather than a full trunk, but its teeth included, alongside the more ordinary canines and molars, upper and lower incisors that were enlarged and extended into small but definite tusks.

Andrews's report stimulated an American paleontologist to launch another fossil-hunting expedition into the same region. Henry Fairfield Osborn, a distinguished professor at Columbia College and a dynamic curator at the American Museum of Natural History, was also, in the assessment of one of his research assistants, an unbearable prig: "incredibly pompous, vain, arrogant, conceited, remarkably self-centered, and almost entirely lacking in humility." Those qualities were apparently counterbalanced by talent and energy, as well as some useful connections, such as a friendship with President Theodore Roosevelt. Roosevelt provided Osborn with a compelling letter of introduction to Lord Cromer, the British nabob in charge of Egypt at the time. By 1906, with the help of sixty camels, Osborn and his American associates and a large group of Egyptian workers were trekking south from Cairo, past the ancient source of Egyptian civilization and its dynastic pyramids along the Nile, moving at a camel's pace until they reached the spot that marked the ancient source of elephants. Their first excavations continued for two months, until everyone was overwhelmed by the heat and blowing sand, but by then the team had already uncovered at El Fâyum the bones of three ancestral elephant types.

Thus concluded the sweaty part of Henry Fairfield Osborn's most memorable project, which culminated in a monumental study of elephant evolutionary history titled *Proboscidea,* published as a pair of weighty tomes in 1936 and 1942. In *Proboscidea,* Osborn described more than fifty million years of evolutionary shape-shifting among the tusked and trunked creatures of this earth: a complicated order of mammals that included 8 families, 44 genera, and 352 species. Osborn's original system has been revised and consolidated, and scientists today recognize an order of mammals somewhat simpler than the one the great man first visualized, with 8 families, 38 genera, and a little more than 160 species appearing at one time or another during their long dynastic history.

Since Osborn's early excavations at El Fâyum, the remnants of many other members of the *Moeritherium* genus have been found at other North African sites. These and similar fossils tell us that archaic members of the proboscidean order thrived in warm sea shallows—the fringes of the archaic Tethys Sea, a large extension and confluence of today's Indian Ocean and Mediterranean Sea—and that they fed on soft aquatic plants. The fossils also add to the impression that all species belonging to the order Proboscidea, including modern elephants, are distantly related to the species of two other major mammalian orders, the Sirenia and the Hyracoidea.

Sirenians today consist of two genera that are entirely aquatic and herbivorous, the manatees and dugongs, collectively known as sea cows. Not only are the fossils of archaic proboscideans and sirenians found in the same sedimentary beds, but they also happen to share some distinctive anatomical features, including unusually dense bones, a similar heart structure, and molars that displace horizontally rather than vertically—that is, instead of pressing up from below, new molars migrate from the back to the front of the jaw and push away old, worn, and crumbling teeth. Like male and some female elephants of modern times, male dugongs grow tusks from modified incisors. Also, female elephants and sea cows have a vaginal opening located in the lower abdomen rather than near the anus, and their mammary glands are placed at the chest, whereas most other mammals have milk glands at the abdomen. (As it happens, humans and other primates also share this feature; the globular breasts of elephants are strikingly similar to a woman's full breasts, and the breasts of sea cows may account for that old sailor's yarn about a half-woman, half-fish miracle of the seas, the mermaid.)

Elephants remind people of aquatic animals in other ways. Although not aquatic themselves, elephants are strong and natural swimmers. Elephant embryos also develop, around the third month of gestation, an unusual duct in the kidney called the nephrostome, which then fades at around the sixth month. Nephrostomes ordinarily appear in the kidneys of freshwater fish, frogs, and birds as well as reptiles and mammals that lay eggs—but not mammals that give birth to live young. Their temporary appearance in elephant embryos indicates that elephants may have had aquatic ancestors in the distant past. In sum, there is intriguing evidence that the orders Proboscidea and Sirenia,

and thus modern elephants and sea cows, are linked through a common ancestor that lived during the early part of the Paleocene epoch or even earlier.

Proboscideans may also be distantly related to another order of mammals, the Hyracoidea, represented in contemporary times by squirrel-size, operatically noisy creatures known as hyraxes, found only in Africa. Hyraxes have externalized upper incisors—tiny tusks—and feet that are padded at the bottom, like elephant feet. They walk flat on the soles of their feet, like elephants, and that gives them an elephantine stability and sure-footedness over rough terrain. Unlike elephants, hyraxes also have a cleft in their foot pads, which provides enough suction to enable them to climb vertical rock faces and scramble effectively in the trees.

THE COMMON ANCESTORS that link living elephants, sea cows, and hyraxes with one another died a very long time ago, after which natural selection began sculpting the proboscideans on their own. Nature's art shaped the raw material—the flesh and blood, bone and tooth, as well as the DNA that defined this form over time—and the line developed and diverged, expanding over great time into a highly complex series of lineages that may have been marked by three especially fertile bursts of evolutionary radiation.

Proboscideans started as creatures wallowing in shallows and eating soft aquatic vegetation, but climate change and ordinary opportunism led them, during the first major radiation (from fifty-seven to fifty-three million years ago), to spread geographically and, in adapting to new environments and new foods, to shape-shift. Proboscidean teeth became more specialized, for example, possibly in response to long-term climatic cooling and drying, which led to their vegetable food source becoming increasingly dry and coarse. Canines and premolars disappeared. Molars developed more prominent lophs (ridges across the grinding surface). Proboscideans were already large, but they evolved to become so large that one archaic species was as big as a modern elephant. What accounts for the increased body size? One theory holds that larger size was an evolved response to foods with lower nutritional content. If each unit of food has less nutritional value, an animal must get bigger in order to consume and process enough food to maintain the same level of nutrition.

Some of the species developed larger and rounder incisors that eventually became tusks stout enough to serve as weapons. The tusks may also have served as tools to manipulate, to comb through, or to tear at the early proboscideans' floating aquatic food. And if the tusks eventually became a barrier that made it harder to bring the mouth in direct contact with food, then a flexible snout would have been useful. Modern tapirs also have flexible, actually prehensile snouts, which they use to grab edible vegetation and draw it to their mouths. So one might guess that the proboscidean proboscis first evolved for this purpose, although the number of uses for the snout would have grown as the organ itself expanded and became more flexible. In any event, the order Proboscidea is named in Latinate homage to that strange and powerful organ, the trunk, which is not only its most obviously distinctive feature but also its most creatively functional one.

Considered fully, the proboscideans were triumphantly successful, becoming the most diverse and broadly distributed large-bodied mammal group in this planet's history. In myriad manifestations, these large trunked and tusked animals marched on columnar legs across the globe, and they adapted successfully to the challenges of almost every imaginable terrestrial habitat: from hot and wet tropical forests to seasonally changing woodlands and grasslands to sun-hammered savannas and deserts to frigid arctic tundra. As they adapted to such a plenitude of varied habitats, the genetic groups began to diverge. Some proboscidean bodies grew bigger; others grew smaller. Hair grew or thinned and disappeared. Teeth changed strategic structures and grinding-surface patterns. Tusks expanded or contracted, curled and curved this way and that.

The mammutids (family Mammutidae), for example, evolved into numerous genera and species that moved out of Africa into Europe and Asia, and across a land bridge into the Americas—where they emerged as the American mastodon *(Mammut americanum)*. These magnificent mammutids were roughly elephant size, though often bulkier and hairier. They had large, downward-curving tusks sprouting out of their upper jaws, and their molars were distinctively surfaced by cone-shaped projections of enamel—thus the name *mastodon,* which means "nipple-tooth."

The gomphotheres—an exceptionally diverse collection of "long-jawed" proboscideans—include members of the now-extinct genus *Gomphotherium,* lately revealed in fossils dug up in Kenya and Egypt, distinguished by low-crowned and triple-ridged molars,

tusks growing out of both the upper and lower jaws, and a clearly defined but short trunk. From African origins, individuals from the *Gomphotherium* genus evolved and migrated far enough north and west to leave fossilized remains in modern France and Portugal, while others moved east to leave more of their distinctive fossils in the Arabian peninsula, Pakistan, Japan, and ultimately (having crossed the Bering land bridge) the Americas. Gomphotheres from the *Platybelodon* genus may be the strangest and most memorable versions of this ancient line, having sprouted from their elongated lower jaws a set of wide and flat tusks that together resembled, and may have served as, a giant shovel. Some members of the shovel-tusker species could have specialized in scooping up soupy mouthfuls of aquatic vegetation, while others may have pressed their shovel-tusks to the ground, using them to dig for tubers perhaps, or to the trees, where they used them as a tool for peeling away bark.

The elaborate drama of gomphothere expansion, occurring between twenty-seven and twenty-three million years ago, has been conceptualized as the second big evolutionary radiation for proboscideans, while the third and most recent radiation (occurring around seven million years ago) centers on the drama of the Elephantidae family—the so-called true elephants. Members of the founding genus, *Primelephas,* had both lower and upper tusks. The lower tusks were relatively small, however, and over time they diminished and then disappeared. Most significant, at least in terms of identifying members of this group, was their development of molars with improved grinding and shearing capacities, which gave the Elephantidae access to new varieties of dry and coarse foods and therefore allowed access to new habitats. The working surface of their molars developed transverse ridges made of durable enamel, while directly beneath those hard ridges were softer layers of dentine. As the teeth wore down, the layers of contrasting hardness helped maintain sharp edges and an efficient grinding surface.

The Elephantidae are readily identified by their distinctive molars—rather like slightly rounded bricks with the working side specially designed to grate carrots. The group includes the genus *Mammuthus*—comprising several species of mammoths—and the two genera that include today's elephants. Actually, mammoths resemble modern elephants in many ways, though most mammoth species were significantly larger, and they wielded

heavier and more formidable tusks that bowed out and then in, forming a partial loop. These giant African herbivores eventually migrated into Europe and Asia, and as they spread north, they adapted to new and colder climates.

AT THIS TIME, the overall global climate was becoming colder, and around two million years ago the earth shifted into a climatic phase described as the Pleistocene epoch—the Ice Age—which lasted until ten thousand years ago.

Woolly mammoths represent their genus at its cold-adapted extreme, taking the stage around eight hundred thousand years ago in Siberia. Standing almost 3 meters (some 9 feet) tall at the shoulders, or roughly the size of modern Asian elephants, woolly mammoths were significantly smaller than some other mammoth species, but they possessed the mammoth's huge, bowed tusks, which may have served, among other things, to plow away the snow covering tundra vegetation. Their bodies were shaped to minimize heat loss by reducing wind exposure of the more vulnerable areas, with small ears and rear legs short enough to produce a characteristic, upward-sloping back. Their skulls rose into a single high, bony dome, which anchored the muscles and tendons supporting the tusks, and their backs were humped at the shoulders, where they harbored an important savings account of extra fat. A full layer of fat 8 centimeters (3 inches) thick spread beneath their unusually thick skin, serving as additional insulation from the cold, while the outer layer of skin sprouted an arctic-style fur coat, with a thick, woolly underlayer and a protective overlayer consisting of long, reddish-brown guard hairs.

Woolly mammoths are of too recent a vintage to be preserved as fossils. They are simply not that long gone, having disappeared close to the start of historical time. We know the texture, length, and even the color of their fur coats not from fossils but from numerous freeze-dried fragments found in Siberia, as well as from a nearly intact individual dug out, in 1901, from a Siberian riverbank by scientists from the Russian Imperial Academy of Sciences in St. Petersburg. That particular creature was found near the Arctic circle along the river Berezovka by a local hunter, who first saw a huge, tusked head and part of a humped back that appeared to be struggling to rise out of the dark, frozen earth. The hunter's discovery was soon communicated by telegram to the outside world. Experts from the Imperial Academy hastily or-

ganized an expedition, and by the end of May they had boarded a train for the Siberian town of Irkutsk. After a four-month journey by rail, riverboat, horse, and reindeer, they finally reached the site. By then the exposed parts of the mammoth were in a state of advanced decay, a hunter had taken one of the tusks, and scavenging wild animals had eaten the trunk and chewed away the skin from its head and back-hump.

With winter fast approaching, the team raced to erect a log cabin around the site. They then began thawing and digging away the permafrost, after which they carefully heated, thawed, dissected, and removed the corpse piece by piece, setting each dissected piece back out into the cold to freeze again as a means of preservation. As the scientists soon discovered, one of this creature's front feet was bent in what seemed to be a desperately struggling or pawing gesture, and the pelvis bone was broken in two places. Perhaps the mammoth had injured himself by slipping into a hole or a crevasse. A partially erect penis, measuring 86 centimeters (34 inches) long and 18 centimeters (7 inches) in diameter, suggested death by asphyxiation—perhaps in water or mud or beneath deep piles of snow.

The team continued with their dissection. They removed the skull and the skeleton and cut away the flesh in large sections, finding it to be as red as fresh beef and veined with fat—possibly, some thought, good enough to sample. Thawing, though, turned the meat putrid, so finally only the expedition's dogs were persuaded to eat some. Bits of tundra grass still clung to the lower jaw, and a peek inside the stomach revealed a large amount of still-recognizable food. The creature's coat had a shaggy outer layer of dark auburn guard hairs 20 to 30 centimeters (8 to 12 inches) long, lighter-colored at the belly, and the tail, just slightly longer than the guard hairs, was doubled in length by a final tuft of thick auburn hair.

After three weeks of intense forensic labor, the scientists wrapped up the skin and fur, bones and organs, large samples of the muscle meat, and a big bag full of stomach contents, and transported it all by reindeer-drawn sled to the railway depot at Irkutsk. From there it was sent via refrigerated rail car to St. Petersburg. Back at the Imperial Academy, the stomach contents and portions of the meat were subjected to long-term scientific analysis, while taxidermists reassembled the skeleton, sewed the skin back together, added some missing pieces strategically salvaged from a few other previously discovered mammoth fragments, and at last put the reconstituted proboscidean on public display.

Here was an individual of the very species that had, during a time of elevated ice caps and lowered sea levels only one hundred thousand years from the present, migrated from Asia into North America. From that single episode of migration, woolly mammoths had spread across the cold tundra of northern North America and begun sharing the New World with numerous other proboscidean species already derived from earlier migrations.

The long-jawed gomphotheres had arrived much earlier and were flourishing in North America. Around three million years ago, the two American continents had been connected by a Panamanian land bridge, which the gomphotheres traversed to move deep into South America as well. And around 1.7 million years ago, members of the steppe mammoth species—which were comparatively hairless and notably larger than woolly mammoths—had also trotted from Asia to North America by way of a land bridge across the Bering Strait. Over time those earlier mammoths diverged and dispersed across the relatively temperate middle of the North American continent, spreading as far south as present-day Mexico and as far east as the Atlantic coast, and they evolved to include the Columbia mammoth species, standing some 4 meters (13 feet) high at the shoulders and possessing the typical massive, curling tusks of their genus.

We usually think of the Pleistocene epoch as, rather simply, the Ice Age, but it was actually a time of climatic oscillation, with relatively brief cycles of interglacial warming interspersed with about twenty extremely frigid periods, each lasting roughly one hundred thousand years. These cold periods were severe enough to cause the world's polar ice caps and their glacial fringes to expand and spread far to the south, eventually covering all of Canada and northern Europe and moving into northern parts of what is now the United States. Although it is easy to imagine such severe conditions quickly wiping out many species and thereby reducing proboscidean diversity, in fact the periodically waxing and waning ice caps and glaciers may actually have promoted diversity.

For one thing, new migration paths opened up. As the global ice sheets expanded, for instance, sea levels lowered enough that the Bering Strait became a causeway of dry land, enabling the woolly mammoth to migrate from Asia to the Americas. Even when lowered sea levels merely shortened the distance between

mainland and island, proboscideans would sometimes be able to swim across. During the warming periods, as the seas rose once more, these same pioneers became isolated on their islands. The evolutionary effect of such enforced isolation was to turn them, over many generations, into the several dwarf species that by the late Pleistocene inhabited islands in the Philippine and Indonesian archipelagos, as well as numerous Mediterranean islands, including Crete, Cyprus, and Malta.

One of the Mediterranean species was a type of elephant only a meter or so (3 to 4 feet) tall as an adult. But perhaps the best known of dwarf proboscideans are the former inhabitants of Santa Rosa and some of the other Channel Islands off the coast of California. These islands were never fully connected to the mainland, but the separating channel was narrow enough, at 30 kilometers (19 miles), for a single group of Columbian mammoths to swim across at one particular moment. Those migrants survived on the islands until about twelve thousand years ago, but by then they were only 1.2 to 1.8 meters (4 to 6 feet) tall at their adult height: roughly half to a third of their original height.

In sum, that complex group of modern and near-modern elephants and their ancestors and ancestral relatives, more than 160 species known collectively as the order Proboscidea, were among the most successful large mammals ever to have lived on this planet. They burst into a great variety of tusked and trunked forms, and they migrated, adapted, and thrived in almost every environment on every continent except Australia and Antarctica. The proboscidean lines that became extinct long ago left only their compressed and mineralized remains to be examined; but others died off so suddenly and so recently that we can still dust off their actual bones and tusks and sometimes even thaw out their skin and fur, organs, and blood vessels. Sometimes we can open up their stomachs to consider, as forensic paleontologists, the contents—and thereby to recall, as thoughtful persons, what not so long ago they were chewing and savoring.

WHAT HAPPENED to those recently living proboscideans: the mastodons and mammoths, the various dwarf proboscideans— dozens of different species from around the globe that were still expressed as living, flesh-and-blood individuals, still alive near the end of the Pleistocene, so hauntingly close to the start of historical time?

Humans walked over from Asia to the tip of North America in migrations that occurred as recently as twelve thousand years ago, following the same land bridge route across the Bering Strait that various proboscideans had taken during their own, earlier migrations. Between 11,500 and 11,000 years ago, the distinctively fluted, sharp-edged spear points of the Clovis people (named retrospectively after a town in New Mexico) had been deposited at mammoth kill sites across the North American continent, and by the end of that brief period, the North and South American gomphotheres, mastodons, and mammoths were gone. By the start of historical memory, not a single individual of any proboscidean species remained in the entire New World. A final, remnant population of dwarf mammoths, protected by their isolation on the Wrangel Islands off the northern coast of Siberia, finally died out three to four thousand years ago.

This sudden elimination of a broad array of very large animals was, in fact, part of a larger pattern. Of all the North American mammals weighing more than 40 kilograms (88 pounds), almost three-quarters of the total—around forty species—were wiped out during the late Pleistocene. In South America, three-quarters of all the comparably large mammals went extinct in the same period, while in Australia, nine out of ten large mammal species were extinguished. Around the globe, half the genera of all mammals weighing more than 5 kilograms (11 pounds) and alive at the start of the late Pleistocene have since disappeared.

Was the cause disease? Climate change? Or human activity? The most compelling model is the case of modern elephants, who have shown amazing adaptability to radical changes in food supply and variations in the weather and environment, and have survived droughts, disease, and even long-term climate change. But in a couple of decades, from the early 1970s to the end of the 1980s, a small number of criminal poachers armed with modern weapons and seeking nothing more than elephants' teeth managed to cut the world population of African and Asian elephants in half. Studies of modern elephant die-offs, in the words of the anthropologist Gary Haynes, tell us very clearly that "proboscidean resilience" allows for their "recovery from nearly any environmental stress except human overhunting." The remarkable pattern of late Pleistocene extinctions around the globe implies a similar, though more gradual and more decisive, picture. Effectively armed and skilled bands of human hunters looking for

meat may have, over a few or several thousand years, combined with environmental stresses to kill off many of the world's largest mammals, including most of the recently living proboscideans.

Only in the tropical regions of Africa and Asia, which offer more forgiving climates and more protective forest and woodland environments, did three proboscidean species from two genera—the Asian elephants, and the African forest and savanna elephants—survive from dreamtime into historical time. These are the elephants of our particular moment.

5

Elephants are among the earth's final visitors from the Pleistocene, the last of the giants standing, bereft, at the door of ancient time. Perhaps more than visitors, though, elephants may seem like visitations: aliens from another time and place. They surprise us with their size and intelligence, shape and construction. They impress and, indeed, amaze us with their sheer improbability. We could never invent or even fully imagine one without a picture, description, or memory to start with.

Central to that elephantine improbability is the long stem of flesh, muscle, and cartilage encasing a twin pair of olfactory passages that allows air and floating scent molecules to move from the tip all the way up to an array of scent receptors leading to the brain. It's a nose, a very long nose. As an olfactory organ, a sniffer, this nose is capable of sampling smells directly from the ground or pulling them from the air up to 15 feet above the ground. The same organ can also focus directionally, turning tentatively one way and another, searching and seeking like a periscope on a submarine: an olfactoscope. This nose is said to be five times as sensitive as a bloodhound's—sensitive enough to locate water up to 20 kilometers (12 miles) away. But perhaps this sniffer is most important in locating and identifying other elephants near and far, present and past. Elephants commonly sniff each other on approach, examining one another's face, mouth, temporal glands, trunk tip, feet, and anal and genital regions. Males use it to locate fertile females. Both males and females use it to keep track of a bull in musth, and also to identify friends and family. A nose is a breather as well as a sniffer, of course, and this nose has the capability of being raised and used as the perfect snorkel while its lucky possessor swims, partly or wholly submerged.

With the coordinated operation of some one hundred fifty thousand layered and crossed units of muscle, this same nose is an organ of exceptional flexibility. It functions as an arm with a grasping hand on the end, and it can stroke, push, pull, lift, enwrap, crush, rip, or smash. The grasping hand has a strong, sensitive, fingerlike projection, or in some cases, projections, at the very tip—one finger for Asian elephants, an opposing pair for African elephants—with a precision grip so fine an elephant can pick up a coin or a crumb of cake from a table. The mobile portion of the trunk can also curl and wrap itself around an object, or an enemy, and with varying degrees of power and precision pick it up, move it around, and, if necessary, dash it to the ground. Elephants will push over trees with that trunk or tear down huge branches from a standing tree. They will use their trunks in greeting old friends, meeting head-on or side by side, mutually enwrapping noses and reaching into mouths in a wonderfully intimate cross between a lingering kiss, a warm handshake, and a good face and body sniff. Two young males may wrestle playfully while intertwined at the trunk. Mothers and aunties will reach down with their trunks to reassure an anxious or needy infant or youngster or to draw an awkward baby out of harm's way.

This extraordinary organ is also employed in diverse ways as a communication device. First, as a visual signaler, a semaphore to communicate mood, emotion, and intent. Second, as an auditory signaler, a sound-generating instrument that is always available and can be raised up high and activated with a blast of air. The blast rushes through the nostril passages, causing the twin columns of air and the encasing tubes of muscle and connective tissue to reverberate; the pitch of the resulting sound is modulated by a judicious tightening or narrowing at the tip.

It's also a suction pump used for drinking. An elephant can draw up to 9 liters (16 pints) of water at a time, lift that water with a curl and twist, and spray it into his or her own mouth. And if the elephant should be standing at a water hole or a running river, a place where water is abundant, he or she may lift the trunk's end even higher and turn it into a shower head for cooling down and cleaning up. After an afternoon bath in the river, the elephant may also use that same shower fixture to anoint himself or herself with a layer of soupy mud or fine dust. The mud and dust baths soothe the skin, protect it from sunburn and dryness, and reduce the load of irritating insects and parasites. If water is scarce, that same suctioning trunk can dig a hole into a dry riverbed to reach the water table below and then draw up that liquid elixir.

It's an itcher and a scratcher and a swatter as well, swiping away at pesky pests, tending to any mysterious and concentrated discomforts near an eye or behind an ear. It even on occasion serves as a walking stick and anterior probe. When climbing a steep hill, an elephant may lean forward and press against the earth with the curled back of the trunk, as if to assess the quality of the path ahead or momentarily to shift some of the weight of that great head onto the ground as he or she climbs.

Interestingly enough, for virtually the entire history of the order Proboscidea, trunks and tusks have gone together. Where you find one, expect the other, as if these two seemingly separate and un-related features are, in fact, functionally inseparable, like smoke and fire. Tusks serve as protective guardrails in the proboscidean profile, defending a dynamic organ that is at once essential and vulnerable. The trunk serves as an agile food-grasping organ that can reach beyond the otherwise awkward barrier of the tusks.

Defensive weapons easily turn into aggressive ones in certain circumstances. And if the proboscidean tusks have proven useful in fending off or finishing off predators, they have proven indispensable in the fierce competition among elephant males for access to fertile females. Males with bigger and stronger tusks are more likely to win that contest, and since tusk size is largely hereditary, the competition produces a powerful evolutionary pressure for larger tusks in males. It is possible that females may also have evolved to prefer males with larger tusks, to find the big tusker bulls more enticing or exciting or, perhaps, merely less avoidable. Although both female and male elephants may be harassed by intemperate predators—lions, for example—males wield significantly bigger tusks. Asian females, however, don't have visible tusks at all. They develop, instead, vestigial tusks hidden in their sockets, ones that never fully emerge.

Tusks are teeth, incisors that have over great time and under evolutionary pressure taken on a projective profile. Like an ordinary tooth, a tusk's hard outer husk protects an inner cavity of soft pulp and nerves, making it sensitive to pressure and, in injury, to pain. Instead of having roots, these specialized incisors are embedded for about a third of their length within a cranial socket. Elephants first appear in this world with a set of small milk tusks, which are extensions of the first pair of incisors. The permanent tusks emerge within the first year, developing from the second incisor pair. For African elephants, they peek out from behind the front lip of females when they are about two years old, for males at one and a half years. They then grow continuously, with the male's tusks growing faster than the female's and reaching a much greater weight and length over time. By the end of their lives, African savanna males will have tusks seven times heavier, on average, than those of the average female of the species: 49 kilograms (108 pounds) for the former, around 7 kilograms (15 pounds) for the latter. The record for African elephants is a male tusk weighing more than 102 kilograms (more than 226 pounds), a single tooth heavier than most men and measuring some 3.26 meters (10.7 feet) long. Of course, such great weights create their own limitations and require secondary adaptations, including a change in skull shape for the big bulls, who become notable for their violin-shaped noggins: broadly expanded at the forehead and swollen again around the tusk sockets.

Not merely vital weapons, tusks are also highly functional tools: good for digging up underground water, minerals, and edible tubers. They serve as chisels to pry bark away from a tree, and as crowbars or levers to snap off branches or otherwise manipulate bulky or big objects. They are good things to rest a heavy trunk on, and, being electrical nonconductors, they're useful as well for breaking down or through an electric fence. Just as humans commonly prefer one hand over the other, so most elephants favor one tusk over the other, and typically these appendages will develop a consequential asymmetry. Since tusks continuously grow (and show growth rings, like trees), they can also sometimes (again like trees) grow over or around damage.

While those dramatic, supremely aristocratic incisors are valuable, the stolidly bourgeois molars are essential. These are nature's grindstones, with a working surface of contrasting layers: high ridges of hard enamel superimposed over a layer of softer dental cement. The contrast produces a self-sharpening process as the surface wears down; the ever-sharp surface has been compared to a kitchen grater, one continuously ready to pulverize coarse grasses, rough bark and wood, and so on. (The ridge patterns, incidentally, are another way to tell African from Asian elephants. An Asian elephant's ridges are arranged transversely, across the width of the tooth surface. An African elephant's ridges are set as a row of closed loops that remind some observers of the shape of lozenges, hence the genus name for African elephants, *Loxodonta*—lozenge-tooth.)

Molar teeth are among the most active parts of an elephant's improbable anatomy, generating concentrated friction and undergoing steady damage. They gradually crumble at the forward edge and are periodically replaced by new molars that appear from the back of the jaw and press forward. This horizontal replacement of molars is another distinctive feature of elephant (and ancestral proboscidean) anatomy. In a normal lifetime, the replacement will happen six times, after the initial loss of the milk molars, with each new set larger than the last and marked by an increasing number of ridges. The first working molars appear before the end of the first year. The second molars appear at around two to three years of age, the third between the ages of four and six. A fourth set will have appeared by the ages of twelve to fifteen, to be replaced by a fifth at twenty-five to thirty. The fifth molars remain in service for about two decades, and the final set appears between the ages of forty and forty-five. Old age, therefore, includes the potential of death through starvation, once those final teeth have disintegrated.

Elephants spend as much as eighteen hours a day drinking and eating. They drink up to 225 liters (50 gallons) of water a day, and they eat equivalently gargantuan helpings of food. One study of the stomach contents of several elephants killed in Uganda's Murchison Falls National Park concluded that the animals had been consuming about 4 percent of their body weight per day, which suggests that a full-grown bull elephant will eat around 240 kilograms (530 pounds) of fresh food each day.

It's a lot of food—although, given the size of elephants, not disproportionate. What more fully distinguishes elephants is the impressive diversity of their diets. The plant materials they seek and sever, grind and swallow include vines, twigs, branches, bark, grasses and reeds, shrubs and herbs, seeds and flowers and fruit, tubers and roots. Following elephants in the Sengwa Reserve of Zimbabwe during the early 1970s, Peter Guy identified 133 species of plants being eaten. George McKay, working around the same time in Sri Lanka, listed 88 plant species that were elephant foods; a decade later, Raman Sukumar counted some 112 plant species eaten by elephants in southern India.

Since African forest elephants are nearly impossible to follow, the most promising source of information about what they eat comes from examining what they have lately eaten. Dung confirms that in places and seasons where fruit is abundant, ele-phants consume it abundantly. One study in the forests of the Ivory Coast, for example, found that fruit seeds constitute more than a third of the dry weight of elephant dung, with 29 species of fruits identified during a single month. An examination of elephant droppings in Ghanaian forests found that more than nine out of ten samples included seeds from at least 35 fruit species. A third study in Gabon discovered seeds in more than eight out of ten samples, with 72 fruit species represented, while the minimum total of different plant species (combining fruits and nonfruits) numbered 230.

Most African herbivores have specialized as grazers or browsers, labels that identify whether they eat the grasses at their feet or the bush and tree vegetation at knee and head height. This specialization is not a trivial preference but an evolutionary adaptation that typically affects, among other things, the structure of their teeth and lips. Elephants, however, are both grazers and browsers, and they shift readily from one to the other according to place, season, and the distribution of nutrients. During the wet season at Ruaha National Park in Tanzania, when the grasses are green and nutritionally rich, elephants obtain two-thirds to three-quarters of their diet through grazing. During the dry season, males browse on leaves, bark, and woody material to obtain three-quarters to nine-tenths of their food, while browsing constitutes up to 99 percent of a female's diet.

ELEPHANTS ARE THE LARGEST living land animals. But along with the fact of their prodigious size comes an additional, related fact: an extreme contrast in size between males and females. Males approaching sexual maturity, at around seventeen years old, are already taller at the shoulders than fully mature females. And while both sexes continue to grow well past sexual maturity, females reach their maximum size around the age of thirty, whereas males will continue to grow well into old age. Mature bulls tower over adult females, being almost half again as tall, and they are twice as heavy. For the African savanna species, fully grown males can stand 4 meters (nearly 13 feet) at the shoulders, as compared to 2.7 meters (less than 9 feet) for fully adult females, and they weigh some 6,000 kilograms (13,200 pounds), as compared to the female average of about 2,700 kilograms (6,100 pounds).

Such sexual dimorphism is the evolutionary consequence of sexual competition and sexual selection. In the case of elephants,

intense competition among males for access to fertile females accounts for much of the difference in body size. All other things being equal, bigger males are more successful reproducers than smaller males, thus passing on their genes at an above-average rate and making bigger males more likely to appear in future generations. But female choice also affects the equation. Mating is a complicated process during which females can often destroy, if not the mood, then the act, simply by moving at a critical moment. Perhaps females are impressed—or effectively intimidated—by large males. Elephants don't think in terms of evolutionary logic, obviously, but they don't need to. Any female who favors the larger, more successfully reproducing males is also more likely to pass on her own genes, including any having to do with her taste in males.

So competition among males and selection among females accounts for the extreme size difference—but they do not explain largeness more generally. For this, we look to ecological reasons, particularly nutritional circumstances and strategies. Proboscideans evolved as herbivores specializing in vegetation that is plentiful but coarse, high in cellulose and low in nutritional value. The large bodies of ancestral and modern elephants, which can process great quantities of food, are in part a strategy to compensate for the poor quality of the vegetation they eat. Obviously, the bigger you are, the more you need to eat—but proportionately you need less. A comparison of African herbivore species shows that food intake expressed as a percentage of body mass decreases steadily as the mass increases.

There are other advantages to bigness as well. For example, when predators threaten, a large body, especially one with weapons, reduces the chances of becoming someone else's high-quality food. Yet there are physical limits to how big a body can get, and elephants must surely be approaching those limits.

Consider, for example, the structural and mechanical problems of supporting and moving a body of such great mass. Elephants' legs are built like great columns or posts, and they are positioned directly beneath the torso, supporting the weight efficiently enough that elephants can sleep, lightly, while standing. In the early hours of the morning, they will lie down on the ground, head resting perhaps on a hummock for a pillow, and fall fully asleep, snoring even, for a few hours. Skeletally, these creatures actually stand and walk on tiptoe, but beneath the upwardly

arched bones of the foot lies a dense pad of fat and connective tissue, comparable to the heel of a human foot, that under pressure produces a flat and round base and footprint. As I mentioned earlier, the padding is sensitive to seismic vibrations in the ground, allowing its possessor to sense long-distance, low-frequency rumbles made by other elephants. The padding also enables an elephant to step very quietly, surprisingly so. And finally, the foot pad provides great stability. With the massive torso weight pressing down, the pliant bottom of the foot spreads and adjusts somewhat to the slope of the terrain, allowing the leg to remain vertical and distributing the torso's weight with a confident plumb. No wonder these creatures are so sure-footed, capable of ascending or descending steep and narrow trails and of passing easily through treacherously muddy swamps.

Still, elephants prefer to keep at least three feet on the ground, and they don't leap or trot or run in the style of less ponderous beasts. Their average walking speed is about the same as a person's, around 6 kilometers (4 miles) an hour. And when they do speed up, they're forced to shift into a fast shuffle rather than a gallop or run, keeping their walking gait but increasing its pace. At a maximum speed of 25 kilometers (16 miles) an hour, though, that shuffle is a good deal faster than a person can run.

Another problem with elephantine bigness is a low ratio of surface to weight, which means, in turn, a problem in dissipating excess body heat in hot climates. Giant ear lobes solve the problem in part by exposing more surface area. Like leaves or feathers, an elephant's huge ear lobes are designed by natural selection to provide a high ratio of surface to weight—especially for the African savanna elephants, who with that single set of sail-like organs increase their exposed surface area by one-sixth. There, beneath a comparatively thin layer of skin, the blood flows into a broad delta of veins and capillaries, efficiently presenting concentrated amounts of body heat to the surface and the air beyond. An elephant's ears, in short, function as radiators, capable of dissipating body heat very efficiently, a process that can be significantly sped up by waving the ears and spraying them with water.

THE IMMENSE SIZE of elephants generally is expressed particularly and emphatically with their very large heads. An elephant's skull is massive and looks to the casual observer as solid as a great boulder, although the bone is actually penetrated with a

maze of air cavities. The great size of the skull is necessary in part to anchor and stabilize the trunk and tusks and to distribute their weight back across a short neck to the torso and legs. The air cavities allow the skull to maintain its size with less weight.

The brain cradled and protected by that skull is, at 4 to 6 kilograms (9 to 13 pounds), by far the largest of any land animal, roughly four to five times bigger than yours or mine, and with humanlike complex convolutions in the neocortex. Based on that anatomical observation alone, we can conclude that elephants must be intelligent. But how intelligent? How can their intelligence be measured? Comparing the weight of the neocortex with that of the primitive brainstem provides one sort of measure, suggesting a ratio between complex and simple brain functions. Such a comparison places elephants high on the list of animal species: with a ratio of 104 for elephants, versus 48 for baboons and 14 for wild boar at the lower end, and 170 for humans at the higher. Comparing the ratio of brain to body weight indicates that elephants have a brain operating a body that is some eight hundred times heavier, whereas the human brain operates a body that is fifty times heavier. A third comparison, examining the ratio of a brain's birth weight to its adult weight, indicates how much a brain grows during maturation and suggests some of the importance experience and learning may play in adult behavior. For most mammals this ratio is about 90 percent. In other words, the infant brain for a typical mammal is already nine-tenths of the intellectual package it will be at adulthood. Humans stand at the extreme on this scale as well, with a human baby's brain only around 28 percent of the adult size—but elephants are impressively close to that extreme, with a ratio of 35 percent.

Brain size and the various ratios suggest in a quantitative way what people already intuitively believe: that elephants are among the most intelligent nonhuman animals on the planet. That intelligence may be primarily focused in ways that we don't fully understand or appreciate. But we do understand the more general principle that brains, like everything else in nature, have both benefits and costs, and we do appreciate that nature's art is a very practical art that invariably strives (through the winnowing process of evolution by natural selection) to maximize benefits while minimizing costs. This principle means that we can look at the myriad products of nature's art and ask a few simple, pragmatic questions. What are the costs—and therefore limits? What are

the benefits—or beneficial functions? What is that big brain for? What does it do? And, in terms of an elephant's perceptual, emotional, and psychological experience, what does it mean?

Brains are nutritionally expensive. Pound for pound, they are the body's most profligate energy consumers. Brains, therefore, above all other organs, are pressured by energy economics and evolution to justify their size or be replaced in future generations by progressively smaller, less expensive models. So, why so big?

The old impression that elephants possess an excellent memory has been reinforced by dozens of anecdotes and numerous observations in the field. Certainly, for instance, the matriarch of a family group remembers well the complex and ever-changing ecological and social circumstances of her world. The matriarch typically makes the decisions about where the family group will go to eat and drink, when it will go, and the length of time it will stay there. Her long-term social memory of other individuals and family groups across the territory is important, and it may account for the greater reproductive success of families led by older matriarchs, who have learned more and therefore have superior social knowledge. The matriarch's long-term ecological memory, her recollection of distant sources of food and water and all the other perpetually changing resources, is significant as well. It becomes crucial in times of resource stress, during drought at Amboseli, for example—or in permanently arid lands such as the Namibian desert. Elephants in the Namibian desert can range up to 3,000 square kilometers (1,160 square miles), and they are known to use some drinking pools once a year or less. A matriarch's memory of a complex ecological map of food and water resources in the Namibian desert can easily, during prolonged dry spells, mean life or death to her family group.

Elephants are also capable of responding to novel circumstances creatively. According to one account, trained working elephants in Burma, allowed to roam free at night, would silence their clanging wooden bells by stuffing them with mud before sneaking onto plantations for after-dark crop raids. Other observers have described Asian elephants using sticks as tools to scratch their backs and drive away flies; the elephants would sometimes modify these tools, shortening them or stripping away leaves, to improve their effectiveness.

But many stories told by reliable witnesses suggest that elephants possess not merely good memories and some degree of

cleverness but also individuality, personality, and even, perhaps, self-awareness. They may have at least enough focused sense of themselves, it could be, to commit suicide. A Burmese forestry official named U Toke Gale has written of captured wild elephants who, brought to total despair by the harrowing process of breaking and taming them to turn them into working elephants, would step on their own trunks and obstinately refuse to move, thus cutting off their air and, hence, their lives. The animal is "so bent on suicide that no amount of shouting, swearing and spearing with sharpened sticks of bamboo by the trainers could, in any way, scare him into removing his foot or relaxing its pressure on the trunk."

Scientific research has lately begun to expand more methodically our appreciation of what elephant intelligence and awareness might mean. One experiment with Asian elephants shows that a young female can distinguish between arbitrary drawings and will remember such distinctions up to a year later. Other projects clarify that African elephants can distinguish the different contact calls of up to a hundred other individuals in a population and are capable of identifying the contact call recordings of individual herd members who have been dead for two years. Another experiment demonstrates that African elephants can tell the difference between two human ethnic groups, the Masai and the Kamba, by both their body odor and the color of their traditional garments: a useful distinction because young Masai men still spear elephants to prove their manhood, while Kamba men do not. Yet another recent study suggests that elephants act rather as humans do when confronted with a mirror. In the experiment, three Asian elephants at the Bronx Zoo clearly behaved as if their reflections in the mirror represented not merely members of their own species but actually themselves. They brought food over and ate it in front of the mirror, moved their heads and bodies rhythmically in front of the mirror, placed their trunk tips into their mouths while watching their reflection. Maxine appeared to use the mirror as a way to examine the inside of her mouth and the back of her ear. Happy demonstrated signs of self-recognition by touching, with her trunk tip, a painted spot on her forehead. Since the paint was odorless and tasteless, she must have learned about its odd presence by seeing it as part of the reflection of herself. Such kinds of mirror-induced self-referential behaviors are, in fact, rare among nonhumans, and they indicate a kind of men-

tal awareness that includes not merely consciousness but self-consciousness, a reflective sense of self, an ego.

6

Three elephants living on the Imire Safari Ranch in Wedza, Zimbabwe, had developed a friendship with four black rhinoceroses also kept on the ranch. By "friendship," I mean that the three elephants and four rhinos seemed to know one another and to seek out one another's company. They often walked around together as a single group. The three elephants were named Mundebvu, Makavusi, and Toto. The four rhinos included three adults—Amber, DJ, and Sprinter—and a seven-week-old infant known as Tatenda. Amber was pregnant and due to give birth at any time, so there would soon have been five rhinos.

The Travers family, owners of the ranch, had been breeding black rhinos for twenty years as part of a conservation program to reintroduce members of this highly endangered species into Matusadona National Park, where they had been decimated by poachers seeking rhino horns for sale on the international market. In the Middle East, the horns are carved into decorative handles for men's daggers. In the Far East, they are pulverized and made into a fake medicine supposed to stimulate men's erections. To reduce the likelihood of poaching, workers at the Imire ranch had preemptively cut off the horns of the three adult rhinos. The animals were also individually protected by armed guards and kept at night in individual enclosures. But all of those precautions failed to deter the four criminals who, dressed in army camouflage fatigues and armed with AK-47s, broke into the pens one night in November 2007, attacked and then bound the guards, and shot all three adult rhinos. Reinforcements from the ranch, alerted by the noise, scared away the intruders as they desperately tried to saw off the minor remnants of horn from the dead animals.

The rhinos were buried the next day, with Amber, the pregnant one, being placed alongside her fetus under a towering msasa tree, the very spot where she had been born. Two days later, some of the Travers family brought their three elephants out to the burial site and witnessed an extraordinary sight. It looked as if the elephants were grieving for their former companions. According to Nicola Roche, a member of the Travers family, one of the elephants, Mundebvu, who was herself pregnant, screamed and shrieked and began digging into the grave, apparently intend-

228

ing to reach her dead friend Amber. The other two elephants, Makavusi and Toto, pressed against Mundebvu, seemingly trying to support or comfort her in her anguish. "The elephants were passing sticks to each other," Roche said, "and . . . you could see their tears running down their faces."

Tears? Anguish? Grief? Do elephants really grieve? Are they aware of death? That elephants feel various emotions is, I think, entirely clear. They have bouts of anger or rage. They show signs of joy at being reunited with old friends or relatives, pleasure in companionship, maternal love, and other indications of positive attachment—and, as we will see, elephant attachment can be a powerful thing.

"MANY GREAT ZOOLOGISTS, including Charles Darwin, have thought that animals possess strong emotions," Iain Douglas-Hamilton writes, "and I have little doubt that when one of their number dies and the bonds of a lifetime are severed, elephants have a similar feeling to the one we call grief. Unfortunately science as yet has no means of measuring or describing emotion even for human beings, let alone for animals."

Cynthia Moss has considered the same issue. She describes female elephants who, after losing babies or young calves, become strangely lethargic and sometimes lag far behind the rest of their family as it moves. "I have often wondered," Moss writes, "if elephants experience anything akin to grief when a close family member dies."

Joyce Poole, in *Coming of Age with Elephants*, elaborates on the case of one particular female at Amboseli who had given birth to a stillborn baby. Poole soon recognized the elephant as one named Tonie, part of the family of Tuskless. When the scientist approached her, Tonie was still bleeding and having contractions, but she seemed very "subdued," as Poole phrased it. The elephant stood quietly, continually prodding the afterbirth with her trunk while standing guard over the body of her dead baby. As a pair of vultures watched from a safe distance, the mother pushed against the body with her front feet, rolling it over again and again.

Tonie stood next to her baby all that day, and when Poole returned to the scene the next morning, the elephant was still there. By then the scavengers had gathered in full force; a jackal and more than a dozen vultures lingered nearby. Tonie would charge them. They would retreat, return, and regroup, as the elephant

stood there, facing them and protecting her dead baby, sometimes gently pressing against the corpse with a rear foot. Poole was moved by this scene: "I got my first very strong feeling that elephants grieve. I will never forget the expression on her face, her eyes, her mouth, the way she carried her ears, her head, and her body. Every part of her spelled grief."

What elephants feel may always remain a matter of interpretation, requiring some degree of imaginative and empathetic assessment. What they do in the face of death is more an issue of fact, and the facts have by now been fairly well documented. Elephants will carefully examine a fresh elephant carcass and then try to revive and protect it. Revival attempts mostly consist of trying to push the body upright, as if by doing so they might persuade it to move on its own. At the same time, elephants will commonly stand around as if to protect the carcass, guarding against and even actively chasing off scavengers.

Douglas-Hamilton has described following, in the company of his assistant Mhoja Burengo, elephant trails at the southern end of Manyara, in Tanzania, into an area of steep escarpment. Drawn by the loud bawling of a young elephant, they followed the sound until they came upon the sight of a large female, caught by one hind leg, the rest of her dead body sprawled awkwardly and half dropping down a sharp slope. Three young elephants stood around the carcass. One, the biggest and oldest, bawled vociferously. The second was quiet, standing still, resting his head against what appeared to be his mother's body. The third and youngest was pathetically trying to suckle at her dry breast. As Douglas-Hamilton and Burengo watched, the oldest elephant stopped bawling long enough to kneel down and push, using both head and tusks, against the lifeless mother, attempting to raise her.

Douglas-Hamilton also relays the stories of two seasoned elephant watchers in East Africa, Harvey Croze and Bill Woodley. Croze was a biologist who, in the company of a friend, watched an aged matriarch die over the course of several hours one afternoon in the Serengeti. At first, the two men observed the female falling behind the rest of her family. The whole group waited for her, moved around her and placed their trunk tips into her mouth—a gesture of reassurance, perhaps—and then, as she toppled weakly, they gathered around and tried to keep her upright. A prime bull happened to be moving within the herd that day, and at times

he drove away the others while he tried alone to raise the old female. After she finally died at the end of the day, the family stayed around her corpse for several more hours. The second story, told by Woodley, who had been a warden at Aberdares National Park in Kenya for many years, concerned a female who had been shot. Woodley watched for three days as a number of her family, including adults and young, remained with the body.

Sometimes the attempts at revival and defense of a dead body will be followed, finally, by burial—as if burial is the final protection when all else has failed. Cynthia Moss once found the remains of a young female who had been sick for a long while. At the moment she discovered the carcass, the family led by matriarch Echo arrived in the same place, so Moss was able to step back and quietly observe their reaction. The elephants became "tense," Moss writes, then "very quiet." They moved in "nervously," and then they "smelled and felt the carcass and began to kick at the ground around it, digging up the dirt and putting it on the body. A few others broke off branches and palm fronds and brought them back and placed them on the carcass." Just then, unfortunately, the park warden flew his plane overhead, guiding a group of rangers to the spot so they could remove the tusks for safe storage, and in the process he scared off the Echo family. "I think if they had not been disturbed they would have nearly buried the body," Moss writes.

At one time in his life, Serengeti Park game warden Myles Turner had been a professional hunter, leading groups into the bush in pursuit of elephants. One morning during a safari, one of his clients shot and killed a large tusker who had been grazing peacefully in the company of a half-dozen other elephants. Once the bull fell, the other elephants gathered around his body, protecting it and making it impossible for the hunters to approach. Finally, the men left to have their lunch, returning several hours later only to find that the fallen elephant was still guarded by a single large bull. At last able to scare off the remaining animal, Turner's group approached the carcass and were astonished to discover that it had been partially covered with dirt and leaves, while a large-caliber bullet hole in its head had been patched over and plugged up with mud.

Another burial story has been recounted by Irven Buss, who conducted elephant research during the 1950s in Uganda. One time he tried to dart and knock out an elephant in order to put a collar and radio transmitter on her, but he used, unfortunately, too potent an anesthetic. The elephant keeled over, and before Buss could approach and administer the antidote, the rest of her family had formed a defensive fortress around her body. The female died, and the defending elephants covered her body with grass and branches before leaving.

The most methodical study of elephant responses to a freshly dead elephant was conducted by Katy Payne and her colleagues at the Dzanga-Sangha baï (forest clearing). Located in the southwestern tip of the Central African Republic, Dzanga-Sangha is the site of a forest-elephant research project run by an American scientist, Andrea Turkalo. By the time Payne arrived, in the spring of 2000, Turkalo had been studying the animals for more than a decade, and thus visiting researchers could observe, from a high platform at the edge of the clearing, the behavior of many well-known individuals with well-documented histories.

On June 26 of that year, Payne watched a young calf die, apparently from starvation (her mother had preferentially nursed an older sibling), around 100 meters (110 yards) from the platform. The calf fell and eventually succumbed at a spot some 2 meters (about 2 yards) from a trail used routinely by many forest elephants to go to and from their favorite spa: the multiple water holes, mud baths, and mineral licks of Dzanga-Sangha. For a total of nearly twelve hours, Payne and her colleagues observed and videotaped the responses of 129 elephants as they encountered the calf, both on the day the calf died and on the next day. These were individuals of every age group and of both sexes, and of the total of 129 who walked past, some 128 seemed to change their behavior in response to the dying and then freshly dead animal.

After a careful analysis of the videotape record, Payne identified those changed behaviors as belonging to one or more of five categories. Four-fifths of the behaviors she characterized as "exploratory," and they included sniffing around the body, touching or near-touching with the foot, probing with the trunk, and bringing the tip of the trunk to the mouth after probing. Half of the behaviors included indications of "fear" or "alarm," shown by avoidance, backing off, a tentative approach, lifting of ears or tail, unusual vocalizations (trumpeting or rumbling), and quick retreats after examination of the body. Close to one-fifth included attempts to lift the body, with the visitors using their feet, trunks, or tusks. Protective guarding, where one elephant stood over or next to the

body and tried to drive away others, occurred in about one-seventh of the visits. And finally, a single individual responded to the carcass with aggression: jabbing with a tusk, tearing at the corpse, and even occasionally placing pieces of the flesh into her mouth.

The assault on the body was obviously an extreme response, and the individual responsible, a nulliparous adult female (that is, one who had never given birth) named Miss Lonelyheart by Turkalo, was already notorious for her tendency to behave in bizarrely antisocial ways. She also distinguished herself on this occasion by spending more time at the body than any other individual, a total of 250 minutes. At another behavioral extreme, a young male named Sappho II visited the body five times and tried 57 times to push the calf upright, as if desperately hoping to revive her.

HERE'S A HOPEFUL STORY about positive behavior toward a living elephant, an event witnessed and photographed by Tracey Rich and Andy Rouse at Samburu National Reserve, Kenya. During floods on the Ewaso Nyiro River, the matriarch of an elephant family spent four hours moving up and down the river bank, looking for a safe spot to cross in order to reach fresh feeding grounds on the other side. She made a couple of anxious, tentative forays before at last committing herself and the family to the swirling brown water. The river was deep enough that the great creatures were soon fully immersed, swimming actively and using their trunks as snorkels. But a baby from the herd, overwhelmed by the turbulent water, was soon caught in the current, spun around, and swept helplessly downstream. She was likely to drown. Instead of continuing on to reach safe footing on the other side, the entire herd of elephants turned, entered the deepest part of the raging current, and swam after the helpless baby. Once they had reached her, they gathered around and floated together, still drawn downstream by the current. The baby wrapped her trunk around the trunk of one of the adults, and the elephants then swam together to the far bank and dry land. After climbing up the muddy bank on the other side, the entire group, as if to announce their triumphant arrival and the survival of that baby, broke into an excited chorus of trumpeting that lasted for the next half hour.

Elephants are bound by social and emotional ties that reach well beyond the fundamental attachment of mother and infant. Orphans are sometimes adopted by relatives or even nonrela-

tives. Injured or ill adults may be watched over, even physically lifted up and supported, by others. I vividly recall my own amazement at seeing, in the Samburu Reserve, a large adult female elephant with one bad leg, walking laboriously on the other three, whose slow pace was not merely tolerated but accommodated by the rest of her herd. We can say that these attachments, adoptions, and accommodations are hopeful behaviors. Elephants care about one another. Or, to phrase the idea in terms of evolutionary economics, elephants are invested in one another and can reasonably hope for some kind of return.

Evolutionary biologists are curious about behaviors that seem to have no immediately obvious return, no instantly apparent function. Why do humans feel grief, for example? Even more problematic (since so many people mistakenly believe that humans break all the evolutionary rules anyhow) is the idea that elephants may feel such an emotion. Why should elephants feel grief? How could an inclination to behave in seemingly nonfunctional ways survive the ruthless and eternal winnowing process of natural selection?

It is not that surprising to read Iain Douglas-Hamilton's account of finding three young animals pathetically standing around the dead body of their mother, dependent as they would be on her continued existence, incapable as they must be of knowing what to do once she's gone. Staying with your mother even when she's stopped moving is often a functional behavior, so perhaps those three young animals were not bereft so much as lost and confused. Nor are the tales of elephants defending an elephant carcass and sometimes trying to push it upright so startling. After all, elephants behave similarly toward members of their social group who are merely ill or injured, so their ineffectual response to a dead elephant may simply replicate their potentially effective response to a momentarily incapacitated one—an individual who might, after all, get better and become an important ally.

Far more surprising than the stories of elephants defending and trying to revive a freshly dead fellow elephant, therefore, are those of elephants defending an injured and possibly dying individual of a different species. Colin Francombe, who managed a ranch in Kenya, passed on the following account. One of the ranch workers had been out with a herd of camels when they were met by elephants. The matriarch of the latter group, possibly sensing a threat, knocked the herder down with her trunk and

in the process broke one of his legs. After the camels wandered by themselves back to the ranch that evening, a group of trackers set out to locate the missing herder. They found him the next morning, sitting with his back against a tree and being defended by a single female elephant. The trackers did their best to scare away the elephant, but she chased them off until they finally gave up and returned to the ranch for reinforcements. Francombe, the manager, drove out to the site, and after failing to frighten away the elephant with his vehicle, he pulled out his rifle. As he prepared to shoot, the man with the broken leg called out, telling Francombe to hold his fire. Francombe fired a series of warning shots, chasing the elephant away far enough that he could drive up to the herder. The injured man then explained that the elephant, having knocked him down and apparently seen that he was unable to move, carefully dragged him with her trunk and pushed him with her front feet over to the tree, where he could sit in the shade, and then she stood guard over him for the rest of the day, through the night, and into the next morning. The other elephants had wandered away, but she had remained, one time chasing away a herd of buffalo, regularly reaching out to touch the herder with her trunk. She seemed to realize that he was injured and needed protection.

If we can imagine burial as a form of defense, a way of protecting a body that could, after all, still be alive, then we might see burying one's kin as part of a continuum of relatively predictable behaviors. Once again, though, when the behavior is directed toward not only nonkin but also members of another species, we are left with the implication of a fascinating mental complexity at work.

A Kenyan park services report from 1956 tells of a rhinoceros killed by elephants, then dragged a considerable distance and buried beneath a pile of vegetation. In his book *The Deer and the Tiger,* zoologist George Schaller describes attracting an Indian tiger by tying a live buffalo to a tree. A tiger, accompanied by her cubs, appeared and killed the buffalo, but as the cubs were feasting on the body, an elephant came by. The cats vanished, but then, as Schaller watched, the elephant deliberately broke branches off a nearby tree and used them to cover the buffalo's carcass. Peter Ngande, a cook at Cynthia Moss's research site in Amboseli, observed an encounter between elephants and a lion. The elephants were moving in a group in the direction of the lion, who was trapped, caught in a funneling of the terrain and unable to re-

treat. At last, perhaps as an act of desperation, the lion leaped onto the shoulders of the matriarch, dug into her flesh with his claws, and held on. She reached up with her trunk, seized the lion by the tail, ripped him away, and, using the tail as a convenient handle, dashed him against the ground several times. Having killed the lion, she and other elephants in her group then pulled off branches from a nearby bush and placed them over the carcass.

Other tales have described elephants burying people. One of the pioneers in the movement to protect the Serengeti ecosystem as a national park, Bernhard Grzimek, writes, for example, of a tourist visiting what was then the Albert National Park in the old Belgian Congo (now the Virunga National Park in the Democratic Republic of the Congo). The tourist, hoping for a good photograph, foolishly moved too close to a large bull elephant, who charged. The elephant knocked the man down with a single swat of the trunk and then kneeled on him and stabbed him with a tusk. The rest of the tourist party fled, but when they finally returned, they discovered the hapless photographer's body buried beneath a pile of vegetation.

I SUGGESTED EARLIER that grief has no "instantly apparent function." Of course, it may still be perfectly functional. Perhaps, for example, grief strongly reaffirms social or family bonds at a moment of greatly heightened vulnerability. But one can also imagine that grief is actually a nonfunctional emotion, an evolutionary artifact if you will, a natural holdover or leftover from some other emotion that *is* functional. Grief could be the echo or reflection of attachment: like the painful snap after a rubber band has broken. The gathering effect of the band was useful; the snap effect was not. Or perhaps grief is more comparable to the painful phantom limbs that haunt amputees. If grief is an echo or reflection of attachment, then the fact that elephants form powerful attachments, as we know they do, should be echoed by or reflected in powerful grief. However we parse the evolutionary logic of this strange emotion, though, it seems to me that the place to look for it, among elephants or people or any other intelligent species, is in circumstances when hope is gone—when, in the case of elephants, the carcass is no longer fresh but many days or weeks old and obviously disintegrating: a stinking heap of rampant chemical transition.

Iain Douglas-Hamilton found the remains of a dead elephant

one time—identified, in his naming system, as the fourth of the four Tyrone Sisters—and he kept an eye on it. Some ten days after the elephant's death, her corpse had been reduced to a rank stew of flesh and bones in a bowl of drying skin. Hyenas had chewed away at her feet, and even dragged off some of the foot bones. On the morning of the tenth day, a very large group of elephants appeared from the south, and, as Douglas-Hamilton watched, one of this group, a matriarch he had named Clytemnestra, approached the remains with her family following right behind. Clytemnestra was, as Douglas-Hamilton phrased it, a "fierce inhabitant of the south," with a range that sometimes overlapped that of the Tyrone Sisters, and so it seemed reasonable to believe that she had known the fourth of the sisters. On sighting the scientist's Land Rover, she made a brief gesture of warning—a cast of the head, a flaring of the ears—before continuing on. Then, suddenly, as if she had just caught a scent of the dead elephant, she turned around and, with unmistakable intensity and deliberation, approached the decaying carcass. Douglas-Hamilton describes this event: "Her trunk held out like a spear, her ears like two great shields, she strode purposefully towards the scent, like a mediaeval olfactory missile of very large proportions." The other females in the group followed directly, their heads "suspiciously raised, until they closed around the corpse. Their trunks sniffed at first cautiously, then with growing confidence played up and down the shrunken body, touching and feeling each bared fragment of bone." Of particular interest, it seemed, were the dead elephant's tusks. "Pieces were picked up, twiddled and tossed aside," Douglas-Hamilton writes.

Having noted the response of these elephants to the corpse of the fourth Tyrone sister, Douglas-Hamilton decided to create a rough experiment. When he discovered the rotting carcass of another elephant, he moved the skin, bones, and tusks near a series of watering holes where he knew many elephants routinely came to drink, and then he noted their reactions. "In most cases," he reports, "as soon as they became aware of the bones they showed great excitement, raising their tails and half extending their ears, grouping around and carrying out a thorough investigation, picking up some of the bones and turning others with their feet." This happened in six out of the eight family groups that he observed, whereas the other two walked past without even appearing to notice the carcass.

The lion enthusiast George Adamson writes (in his memoir, *A Lifetime with Lions*) about a bull elephant who had the temerity to chase a colonial official around his own garden in the Turkana region of northern Kenya. Adamson shot the bull near the garden. Some local people were allowed to take the meat that day, and then, as part of the cleanup operation, Adamson had the remnants dragged a half mile away from the scene of the shooting. Elephants appeared that night, carefully examined the carcass, picked it apart, and brought a shoulder blade and a leg bone back to the precise spot where the elephant had been killed.

The stories of live elephants carrying away the bones and often the tusks of elephant remains are, in fact, numerous. Andrea Turkalo once told me that the forest elephants she observes routinely "handle bones long after the elephant has decayed"—up to a couple of years. There's an elephant jawbone at her observation site in Dzanga-Sangha baï that the elephants regularly move. "They'll toss it around. I mean, I think they know exactly what it is," she said.

Cynthia Moss writes that elephants clearly recognize and are invariably fascinated by elephant remains, while they will ordinarily ignore the remains of other animals. When elephants discover an elephant carcass, she notes, "they stop and become quiet and yet tense in a different way from anything I have seen in other situations." They first explore with their trunks, sniff, and then very gradually, with seeming caution, they start touching the bones, picking them up and rolling them around with their trunks and rear feet. Of special interest, Moss notes, are the skull and jawbone and tusks: "They run their trunk tips along the tusks and lower jaw and feel in all the crevices and hollows in the skull. I would guess they are trying to recognize the individual." Even old, completely dry and sun-bleached bones will cause a group of elephants to stop for an inspection, and if the bones have been even slightly moved from an earlier position, the elephants will always touch them and carry them to some new place. "It is a haunting and touching sight, and I have no idea why they do it," Moss writes.

TO TEST SUCH STORIES and observations, Karen McComb, Lucy Baker, and Cynthia Moss gave a series of preference tests to the elephants of Amboseli between July 1998 and January 2000. The researchers would drive up to a known group of elephants, take

certain test objects—in sets of three—from their vehicles, and place the items on the ground at a distance of 25 to 30 meters (27 to 33 yards) from the nearest member of the group. The three objects were placed approximately one meter (a little more than a yard) apart from one another and in a randomized order. Having thus set up the test objects, the researchers would then drive away until they had reached a good position from which to watch and videorecord responses without disturbing the animals.

There were three different preference tests, each using a different set of three interesting objects. In the first test, the objects were an elephant skull, a piece of wood, and a piece of ivory. These were presented over a period of time to nineteen elephant families, with the point of the experiment being to see which object elicited the highest level of interest.

In the second experiment, seventeen elephant families were presented with three skulls: one from a buffalo, one from a rhino, and one from an elephant. Would the elephants show any preferential curiosity about the elephant skull?

The third test presented three elephant skulls to three families who had lost their matriarch at some point during the previous one to five years. The three skulls belonged to those three matriarchs, which meant that each test would provide one of the families the opportunity to recognize and display a preference for the skull of its dead leader. Each family had three trials with this elephant skull experiment, which meant that there were nine trials altogether. Since the skulls were from one to five years old, their flesh was fully rotted away. They had been dried and bleached in the sun and, in addition, were thoroughly washed with a chemical cleanser deliberately to remove any possible scent cues. Under such conditions, would the elephants show a preference for the skull of their deceased matriarch?

In assessing their results, the researchers reviewed the videotape record, and they measured the level of interest as a function of time: the cumulative time individual adults in the group spent smelling or touching the object. An adult was defined as any animal over the age of ten. Smelling was defined as the trunk tip being aimed toward an object while within one meter of it. Touching meant touching with the trunk tip or, in the experiment involving ivory, the foot bottom.

In the first preference test, the elephants showed more than twice the level of interest in an elephant skull than in a piece of

wood. They also showed an almost equally strong preference for elephant ivory over the elephant skull.

In the second test, where the elephants were faced with three skulls, all of about the same size and complexity, they seemed roughly twice as interested in the elephant skull. The other two skulls, from a buffalo and a rhino, elicited almost exactly the same degree of significantly less interest.

Unfortunately, the third and to my mind most potentially interesting preference test, where elephants were given a choice of three elephant skulls—with one of them the skull of their former matriarch—was seriously flawed in both methodology and interpretation. The array of three skulls was meant to test whether elephants ordinarily would be more interested in the remains of their own family member (a matriarch) over the remains of a nonfamily member. The elephants in fact showed no clear interest in one skull over the other two. The researchers interpreted this lack of interest as an absence of preference for the remains of their relative. But, of course, the lack of interest could simply have meant that elephants, when faced with three skulls—one to five years old, cleaned of flesh, sun bleached, and chemically washed to remove any telltale odors—are unable to tell the skull of one individual from that of another. If they could have distinguished the skull of their matriarch, would they have been more intrigued by it? We don't know.

Given the methodological and interpretative flaws of this third test, if we are still curious about elephant attitudes toward the remains of dead relatives, we are forced to return to the less rigorous evidence of unscheduled observation—what people describe, often dismissively, as "anecdotal evidence." The questions are these: Can elephants distinguish the remains of a social partner or family member from those of an elephant they are not particularly attached to? Do they care? Show a preference? Show a curiosity or an obvious fascination or even, perhaps, act in a manner that suggests something akin to reverence? Or show particular behaviors that might suggest the emotion we think of as "grief"?

7

In the 1970s, the price of ivory began to rise.

The market had begun to revive following World War II, as postwar prosperity gave Europeans and North Americans more money to spend on luxury items. In addition, the rapid growth

in international tourism brought new buyers to Africa and Asia who were eager for ivory trinkets, shiny souvenirs of their warm moment in the tropics. Finally, during the late 1960s, trade sanctions imposed on Japan following World War II were lifted, and the Japanese entered the ivory market. Within a couple of decades, they were routinely purchasing some 40 percent of the world's supply. The Japanese concentrated on the harder ivory of Asian elephants and forest elephants from Central Africa, considered best for *hankos* (the traditional signature seals used to individualize checks and other documents), while the softer ivory of savanna elephants, converted into jewelry and trinkets, was sought mainly by Europeans and North Americans, who together were buying another 40 percent of the total ivory supply. Fueled by increasing buying power, mass tourism, and important new buyers from Japan, the demand for ivory surged—and with it the price. In the early 1960s, ivory sold for around $5 or $6 per kilogram. By the late 1980s, a kilogram might sell for up to $250. In response to the rising price, the volume of trade quadrupled, from 300 to more than 1,200 metric tons annually.

To serve that exploding market, poachers organized in gangs and, armed with assault rifles, labored overtime. They were in the killing business, and they were good at their jobs. Whereas 1.3 million African elephants were alive in the 1970s, by the end of the 1980s only around 650,000 still survived. Fewer than 50,000 elephants remained in Asia. In little more than a decade, the world population of elephants had been cut in half.

Kenya's elephants were among the most devastated. At the start of the 1970s, Kenya had close to 170,000 of the creatures, whereas by the second half of the 1980s, six out of seven had been killed. Fewer than 25,000 remained in the entire country. "By 1987," Joyce Poole reports, "elephants were dying everywhere in Kenya. Bloated faceless carcasses were dotted across Lamu, Tana River, Samburu, and Isiolo districts, across Tsavo, Meru, Kora, and Mt. Elgon National Parks, across Shaba, Boni, and Dodori National Reserves, not only singly, but in groups. Whole families were being slaughtered by poachers with automatic weapons who had moved into the very heart of the parks, where they worked with impunity."

In February 1988, Poole was invited by Iain Douglas-Hamilton to join him at Kenya's 22,000-square-kilometer (8,500-square-mile) Tsavo National Park in an aerial survey of the elephant situ-

ation: nine airplanes flying in a coordinated pattern for five days, with observers in the copilot seats counting the living and the dead. Poole was the Dramamine-stabilized observer in Douglas-Hamilton's plane. Altogether, they found a total of 5,363 live elephants and the rotting remains of 2,421. During the late 1960s, that single national park had contained around 45,000 living elephants, so the 1988 count revealed a population decline during two decades that approached 90 percent. The rate of decline in 1988, as calculated from the data, was two to three elephants per day. Moreover, the distribution of the carcasses indicated that poachers were often shooting elephants at close range from inside vehicles driving along park roads—possibly done with the cooperation of park rangers, who were supposed to monitor and control traffic along those roads. The observation that Tsavo elephants were particularly fearful of Toyota Land Cruisers, the standard park management vehicle, reinforced the idea, later confirmed, that a number of Tsavo's rangers had in fact joined forces with the criminal gangs.

Poole returned to Tsavo within a few months to consider the effects of poaching on the survivors. In the eastern half of the park, she found only a small number of elephants over forty years old still alive, and of the ones over fifteen years old, fewer than one-fifth were male. Most of the males had been killed for their larger tusks. Equally distressing was the social composition of the herds. She found only 37 percent of family groups to be "intact," meaning that they were led by a matriarch more than thirty years old, while 3 percent of all groups consisted only of orphaned young. The situation in the western half of the park was even worse, with males accounting for around 16 percent of the adults, only 29 percent of the family groups intact, and 14 percent of all groups consisting entirely of orphans.

In Kenya, elephant poaching had turned into a national scandal by 1988, and since tourism was the country's number one source of foreign exchange, poaching could also be considered "economic sabotage"—strong words uttered publicly in August of that year by Richard Leakey, a Kenyan by birth and, as the director of Kenya's National Museums and an internationally famous expert on human origins, among his country's more influential citizens. Leakey also declared, during an open press conference, that the Kenya Department of Wildlife and Conservation Management (DWCM) had a secret report identifying several of

its staff members who were involved in the trade, and he called on the DWCM director, Perez Olindo, and Olindo's superior, Minister George Muhoho, to release the report and tell the truth. It was a sensational public attack on a government minister and agency at a time when critics of Kenya's authoritarian, one-party system could reasonably think of jail as the most pleasant of possible fates.

Minister Muhoho responded by declaring that the report showed nothing new, and he accused Leakey of showing a "cheeky white mentality." Director Olindo insisted that his department was keeping well ahead of the poachers. Nevertheless, in late 1988 and early 1989, Kenyan newspapers routinely told a different tale, with constant reports of elephant killings and gunfights between rangers and gangs of poachers. Five heavily guarded white rhinos in Meru National Park were slaughtered for their horns. A gang of AK-47-toting poachers attacked and robbed tourists in Tsavo, killing one. On a dirt road between Tsavo and Amboseli, bandits shot up a number of minivans, wounding several tourists and getting away with money, jewelry, and cameras. And so on.

Responding to the many months of bad publicity and the growing threat to the tourism industry, Kenya's president, Daniel arap Moi, announced on April 20, 1989, that Leakey would henceforth be the new director of the Department of Wildlife and Conservation Management. Then, in a private meeting with Leakey (who had been utterly surprised by the appointment), President Moi earnestly promised his full support.

As the paleontologist quickly discovered, however, the department was a wreck. In the field, about 5 percent of the ground vehicles were functional, and only one of the DWCM's eleven planes was ready to fly. Moreover, there was no fuel available to operate the few vehicles that did run. The rangers' uniforms were tattered, their boots were worn or missing, and the guns they carried—World War I–era bolt-action rifles—were pathetically mismatched against the poachers' semiautomatic assault rifles. At the department headquarters in Nairobi, meanwhile, corruption and theft were commonplace, and morale nonexistent. Some people didn't bother coming to work. Those who did come arrived late, did little, and then left early.

Part of the problem was structural. In 1977, the World Bank had granted a $26 million loan to Kenya, but one of the prerequisites was that Kenya combine its National Parks Department with its Game Department in order to streamline operations and save money. The two departments thus became a single entity known as the Department of Wildlife and Conservation Management— which Richard Leakey now headed. This new bureaucracy, unlike the former National Parks Department, operated under civil service rules, making it very difficult to fire anyone. At the same time, all income from the national parks, such as that from the tourist entry fees, now went to the central treasury. It was an arrangement that almost guaranteed the impoverishment of national parks operations. Money went out. It seldom came back.

The one bright spot in this otherwise exceedingly gloomy picture was the ivory. The government maintained a stockpile of approximately two thousand tusks that had been confiscated from poachers and illegal dealers during the previous several years. Ten days after he was appointed director of the DWCM, Leakey was escorted into the ivory warehouse in Nairobi, a dank, windowless building of stone walls, steel doors, and armed guards, where he looked over the treasure. "I walked among the piles, stopping occasionally to lift a tusk and feel its weight," he writes in his memoir *Wildlife Wars* (coauthored with Virginia Morell). "Ranging in hue from pure white to a yellowish brown, they seemed sensuously warm to the touch. Some of the largest ones swept out in arcs over six feet long; they were from males, I guessed. Others were shorter, more delicate in shape, and I assumed that they came from females and younger males." But there were much smaller pieces, too, some small enough to fit in his hand, and he found these distressing indeed. Not only were they the remnants of very young elephants, sometimes mere babies, but they also marked the cold cruelty of the whole business. "Whoever was behind the poaching," Leakey concluded, "was willing to kill every last animal in a herd. These poachers and their backers were ruthless." The sight of all that ivory was depressing—and yet paradoxically hopeful as well, since the government had recently elected to sell the entire lot, worth perhaps two to three million dollars, and had agreed that the money would support DWCM operations in the national parks. Here, at least, was a start on the funding needed to revitalize the parks and assure protection for the elephants.

In the meantime, Leakey recognized that although he could count on President Moi's support, some very powerful people in and out of the government were involved in the trade, and they

might be joined by other very powerful people in resisting change in the parks bureaucracy for a variety of reasons. The political opportunity was strictly limited, in other words, and he would need to show positive results quickly.

In April, on his third day in office, Leakey issued a note of credit from his personal account to advance two months' worth of fuel for park vehicles. He signed another note of personal credit as down payment on eighteen new Land Rovers. A few days later, he submitted a list of the seventy "most obvious transgressors" within the DWCM and had them given early retirement or transferred to other branches of the civil service. In May, he traveled to the United States to meet with donors and soon returned with $250,000 to buy new aircraft, spare parts, and fuel for the parks. In June, a gang of well-armed poachers killed another tourist in Tsavo. In July, after a shoot-out between a gang of poachers and a force composed of five police officers and ten rangers, in which one of the officers was killed, the government finally allowed national park rangers to retire their vintage bolt-action rifles, and President Moi ordered a shipment of three hundred NATO G-3 assault rifles as replacements. The rangers were properly armed at last.

NOW THE BATTLE over the future of Kenya's national parks and elephants began. It was an extended battle fought with guns and stained with blood, and ultimately the rangers, the police, and the nation won. At the same time, however, the full war was quietly being fought elsewhere and by other means. The full war was far more subtle and complex, and it involved the strange human lust for ivory and the market serving that lust. The market: the silent, shifting tectonics of supply and demand calibrated by rising and falling prices and centered on a single commodity, shiny fragments of dentine amusing to people but essential to elephants. The human amusement was considerable, the loss to elephants indelible. And it was the market, not any individual poachers or particular criminal gangs, that remained the biggest and most insatiable consumer of elephants.

Ivory trading at all levels had been legal in Kenya in the early 1970s. You could buy ivory everywhere—in shops, on street corners—just as you could buy gorilla hands shaped into ashtrays or wastebaskets made from elephant feet. The government ended the local ivory trade in 1977, while also prohibiting the sale of other wildlife products. But internationally, beyond Kenya's borders and internal prohibitions, sales in raw ivory continued as before.

In fact, the international market in elephant ivory had ostensibly been regulated since 1975, when an international treaty concerning trade in wildlife and wildlife products first came into effect. That treaty, a set of international agreements voluntarily enforced by member nations and known as the Convention on International Trade in Endangered Species of Wild Flora and Fauna (or CITES), theoretically shielded animals and their body parts from unsustainable exploitation with two protective categories. The highest protection was given to species identified as "endangered" and assigned an Appendix I status. Asian elephants were listed in Appendix I. Species considered merely "threatened," however, received secondary protection and had Appendix II status, which was the category given to African elephants and their body parts. Animals with Appendix II status could be traded, though this trade was supposed to be legitimate, controlled, and rational. By 1985, however, the protection ostensibly offered to African elephants mainly resided in an ivory-export quota system, in which each elephant-range nation could export ivory harvested "sustainably" from its own elephants until its yearly quota was met.

The quota system was a failure for a number of reasons, including a basic one, that the huge open trade in legally acquired ivory (confiscated from poachers and illegal traders or taken through government-sponsored culling, for example) too easily became a pipeline for trade in illegally acquired ivory. Once an elephant was dead and the ivory chainsawed off and toted away, who could know whether the killers were official government agents or unofficial, nongovernmental thugs? The results were the same, and nothing in the ivory marked the difference. Indeed, too often the quota system seemed to beg for illegal trade. Somalia, for example, had only around six thousand elephants, but it set its annual quota at seventeen thousand tusks per year. In addition to the limitations of self-established quotas, the CITES-regulated trade in ivory was further undermined by an international trade continuing through nations that had not joined CITES. Burundi is a good example. This small East African nation exported more than thirteen hundred tons of ivory between 1965 and 1986, yet Burundi had no elephants of its own. All of its ivory was smuggled in from

neighboring countries, making it illegal by definition and, even worse, the product of gangsterized commerce. When Burundi finally joined CITES, it had huge stockpiles of ivory and thus was given a good-faith exemption and allowed to export nearly 90 tons of it in 1986—plus another 110 tons the following year.

In short, CITES's trade restrictions and quotas simultaneously regularized the legal trade in ivory and fostered a system for laundering poached ivory. And by creating categories of legal ivory and providing a cloak of legitimacy for illegal ivory, CITES directly supported the buoyant international market. The price of ivory held steady at around $250 per kilogram (about $550 per pound) in the late 1980s, and in response to that high price the killing continued. Elephants were being harvested into oblivion.

In October 1988, Joyce Poole traveled to Nairobi to observe a meeting of the African Elephant Working Group, a collaboration of specialists—biologists, economists, experts in the trade—and delegates from the import and export nations, all gathered to consider the health of the ivory industry and compile a report on what was known. Iain Douglas-Hamilton had organized a transcontinental survey of elephant populations in February, and the various experts who were members of the African Elephant Working Group and had participated in that survey now gave their sobering reports and the chilling summary. Extrapolating from the current levels of the ivory "harvest," they concluded that elephants in East Africa would reach "commercial extinction" by 1995, and elephants across the continent would face a similar fate by 2015. It was grim news, but Poole noticed that no one seemed alarmed enough to suggest any radical solutions.

Poole opposed the trade in ivory for emotional and ethical reasons. Given what she and other scientists now knew about elephants as intelligent beings with individual personalities, she considered it offensive and immoral to kill them for such trivial purposes as the manufacture of trinkets and objets d'art. In addition to the need to protect individual elephants from such shameful exploitation, there was a much larger and more compelling issue: the ivory trade was driving these animals toward extinction. The CITES regulations governing Appendix II species had failed to protect African elephants, as evidenced by the scientific census showing that populations across Africa had been cut in half over the previous decade or so. The only solution, Poole believed, was to challenge the market.

Such a thing might be done on two fronts—attacking both supply and demand. First, it might be possible to reduce demand by making known the truth about ivory: that it was a commodity soaked in blood. Public opinion might be changed, at least in the West, and because Europeans and North Americans were consuming 40 percent of the world's supply of ivory, a shift in public opinion there might well have a significant effect on total demand. To that end, in fact, Poole and Cynthia Moss had traveled to the United States in September 1988 to find a sponsor to underwrite a public relations campaign that would stigmatize ivory. They sought the support of a number of big conservation organizations. They stopped at the luxurious Washington, D.C., offices of the World Wildlife Fund, for example, only to be told—as Poole later paraphrased the statement—that the ivory problem required "rational" thinking and that the researchers' sentiment that elephants were "complex, highly social, intelligent animals was an emotional Western notion, and one foreign to Africans who, apparently, only understood money." Finally, however, the organization that had been sponsoring elephant research at Amboseli, the African Wildlife Foundation, agreed to back a public campaign against buying ivory.

Changing demand would change the dynamics of the market, in both its legal and its illegal manifestations. But at least as important was the second front of this campaign: reducing the supply by ending the legal trade. That could be done through the CITES treaty. Perhaps African elephants could be moved from Appendix II to Appendix I and thus receive the fullest possible international protection. That would end, or significantly reduce, the legal trade. Of course, there would still be an illegal one, but at least everyone would know that any ivory crossing any border was smuggled. Law enforcement at the borders would become more straightforward. More significantly, the change would stop the laundering of illegally acquired ivory through legal channels. And finally, although reducing only the supply might actually increase ivory prices, a simultaneous reduction in demand, if substantial enough, might ultimately bring the price down and thus make the illegal killing of elephants less profitable.

The mechanism for changing a CITES listing was relatively straightforward. Representatives from a member country had to submit a petition calling for the change and demonstrating, with irrefutable scientific evidence, why it was justified. Costa Mlay,

the director of wildlife for the East African nation of Tanzania, had agreed to sponsor such an appeal. Douglas-Hamilton was assembling the essential scientific data. And Poole began working with Jorgen Thomsen, an expert on the ivory trade, to prepare the full, formal petition. When it was finished, Mlay's office would officially submit the petition on behalf of Tanzania for a vote before the full CITES assembly at its next meeting, scheduled to take place in Lausanne, Switzerland, in October 1989.

By the time he became the director of Kenya's Department of Wildlife and Conservation Management, in late April of that same year, Richard Leakey was aware of these developments. The African Wildlife Foundation's public campaign against the buying of ivory was well under way, and Leakey decided his office would support the effort to move elephants onto Appendix I and thus ban the international trade in ivory. At the same time, though, he was still wrestling with the complicating problem of all that ivory held in the Nairobi storehouse. Indeed, the auction to sell it was already on his calendar, even though, as he soon found out, such an "auction" was by then a formality. The winning bid had already been chosen. The East Asian purchaser was already in the country. He already had a boat waiting at the port of Mombasa to take away the ivory. The deal was done, in short, and the man's check for $3.1 million would surely come in handy. Yet when Leakey looked beneath the surface, he found that even the sale was marked by corruption. The ivory had been undercounted and undervalued, so it would have been bought at an inappropriately favorable price—in exchange, Leakey concluded, for a private deal enriching someone in the government. At least as troubling to him was that the act of selling the ivory would undercut Kenya's position in support of a future CITES ban on ivory sales.

In a burst of inspiration, or perhaps of madness, Leakey decided to cancel the sale and burn the ivory. And the promised check for $3.1 million dollars? Leakey believed that burning the ivory in the open, in a major public event, might reap that much value in public relations, making a grand statement about Kenya's position on the ivory trade and the country's determination to defeat elephant-poaching criminals. More pragmatically, the act could bolster Kenya's tourist industry. Such was the argument he made when presenting the plan to a surprised and alarmed President Moi that May. Leakey argued his case forcefully, however, and Moi had already agreed to support Leakey in any decisions he felt were

necessary to fight the poachers. The public burning of Kenya's ivory stock was set for July 18, 1989, and Leakey announced that Kenya not only would support the movement to upgrade African elephants to Appendix I status with CITES but also would upstage neighboring Tanzania by being the first nation to submit a formal petition.

In mid-July, Leakey served as the chair for a meeting of the African Elephant Working Group in Gaborone, Botswana, which was convened specifically to discuss the plan for upgrading African elephants to Appendix I status with CITES. By then, five African nations supported such a move, but a handful of delegates representing most of southern Africa and led by Rowan Martin of Zimbabwe's Department of Parks and Wildlife Management remained vigorously and vociferously opposed. Martin was an aggressive sort who contributed to the tenor of the meeting by repeatedly describing Leakey as a "bunny-hugger." The southern bloc delegates claimed that they had too many elephants, not too few, and that the only solution to this overpopulation in their parks was routine culling. In order for the culling to work financially, moreover, the ivory markets had to be open and the price of ivory kept as high as possible. By then Leakey's intent to burn the Kenyan ivory was well known, so Martin and his southern African associates topped off their arguments with a mocking reference to that planned event. It was a limerick of their own composition, which they put to music and sang in unison:

> We cheered when they burned the first bra,
> Lady Chatterley was going too far,
> But the whole world mocks
> When ivory stocks
> Go up in smoke in Kenyar.

On July 18, some three days after the contentious Gaborone meeting, Leakey met with President Moi in an open clearing at the edge of Nairobi, where a large crowd of onlookers and media representatives from Europe, Asia, and the Americas had gathered. A crew for ABC television was broadcasting live by satellite to New York and the *Good Morning America* show. At the center of all this attention, Kenya's entire ivory cache, more than two thousand tusks weighing some thirteen tons and worth millions of dollars, had been stacked into a high and broad pyramid supported by a foundation of straw and firewood. The tusks had been

soaked in and then coated with an extremely flammable chemical. A mixture of kerosene and gasoline had been pumped into the straw and wood.

Standing at a podium set before the forest of microphones and cameras, President Moi made his appeal: "To stop the poacher, the trader must be stopped. And to stop the trader, the final buyer must be convinced not to buy ivory. I appeal to people all over the world to stop buying ivory." He placed a lit torch into the straw. The flames leaped. The pyramid swirled with heat and light, and it swelled into an enormous orange-yellow mass that burned hot for three days. Seen by an estimated 850 million people around the world, that symbolic event, combined with the Don't Buy Ivory campaign run by the African Wildlife Foundation, most certainly had an impact on public opinion.

A few weeks earlier, the American president, George Bush Sr., had declared that the United States would no longer import ivory. In July, British prime minister Margaret Thatcher announced that the United Kingdom would join in the ban. In August, the European Economic Community likewise ended ivory imports, while piano manufacturers in Europe and Japan made it clear that they would henceforth use plastic rather than ivory for their keys.

The final victory came on October 17, 1989, at a full membership meeting, or Conference of the Parties, of CITES in Lausanne, Switzerland, where delegates voted on the proposal submitted by Kenya to place African elephants on the Appendix I list. The proposal was upheld by a vote of 76 to 11, with 4 abstentions. Thus (since Asian elephants were already an Appendix I species) all international trade in elephant ivory was effectively banned. The restrictions took effect at the start of 1990, whereupon the price of ivory plummeted to around ten to twenty dollars per kilo. Suddenly, elephant killing and ivory smuggling were no longer profitable enterprises, and the slaughter ended.

The results were unambiguous. In Kenya, for example, once traders stopped buying ivory, the poaching gangs buried and abandoned their caches, many of which were subsequently discovered by the Kenya Wildlife Service (or KWS, a reconstitution of the old DWCM that was now independent from the civil service, making it easier to remove ineffective or corrupt personnel). Kenya had lost more than four-fifths of its elephants between 1972 and 1989, with an average of five thousand killed each year;

by contrast, only fifty-five were shot by poachers during 1990, the first year of the ban. That hopeful pattern persisted for the next decade. In 1998, there were only forty-one poaching incidents in the entire country, and in 1999, only sixty-seven. Kenya's particular case was generally repeated in country after country among the ivory exporters. Following the ban, East African rates of elephant poaching declined, on average, to one-fifth of their previous levels. Poaching levels also dropped in the Central African nations of Chad, Gabon, Zaire, and the Republic of Congo (Congo-Brazzaville). Mark and Delia Owens, who ran a community-based conservation project in Zambia's North Luangwa National Park, noted that some one thousand elephants were being killed annually in the park before the ban. In 1990, they recorded only twelve such killings.

So the ivory ban worked . . . at least for the time being.

8

Richard Leakey's leadership of the reconstituted Kenya Wildlife Service was significantly challenged in the summer of 1991 when, in what may have been an assassination attempt, the engine of the plane he was flying mysteriously failed during flight. He lost both legs in the crash but within a few months had returned to his job, walking on prosthetic replacements.

Meanwhile, the coalition of southern African states was developing its challenge to the ivory ban. The CITES membership meets every two years to review past matters and argue over present ones, and thus the southern states were given a regular series of opportunities to press their case. Finally, at a June 1997 CITES meeting, the southern nations interested in loosening restrictions on the ivory trade were able to form a strategic alliance with a group of nations interested in loosening restrictions on whaling.

At the insistence of Japan, Norway, and Zimbabwe, the critical vote was taken on the final evening of the meeting. Japan and Norway persuaded members to take the vote in secret—a first for CITES. Then Japan, Norway, and a group of Caribbean nations benefiting from Japanese "development aid" voted, in concert with the African bloc, to reverse the protected status of elephants in southern Africa. As a result, the endangered African elephant was arbitrarily, and insidiously, split into protected and unprotected populations. African elephants were returned to Appendix

II in Botswana, Namibia, and Zimbabwe, and those three countries were then allowed to sell off their ivory stockpiles to Japan. (Later, the bloc of southern African ivory nations reciprocated by voting at the International Whaling Association meeting to reverse the protected status of minke whales in the northeastern Atlantic.) Dick Pittman, the president of the Zambezi Society of Zambia, characterized this partial reversal of the international ban as "a triumph for sanity, objectivity, and for recognizing developing countries' ability to take their own decisions on resource management." The combined cache of elephants' front teeth held by Botswana, Namibia, and Zimbabwe, some sixty tons of ivory altogether, was worth more than thirty million dollars at the time.

The southern African challenge to the ban continued, and four years later, the CITES membership, after a contentious debate, voted to authorize Botswana, Namibia, and South Africa to sell another sixty tons of ivory, once again to Japan.

Such votes and nods, deals and sales took place with the approval of some big conservation organizations, such as the WWF, and a few big conservationists, who continued to evoke an attractive vision of "sustainable utilization": elephants and their tusks as a renewable natural resource or agricultural commodity, like trees in a forest, like golden wheat waving in the sun, destined to be utilized wisely by wise humans for wise development. Conservation had become indistinguishable from farming—except that it was going to be very good farming, very smart farming, very wise farming. Harvested sustainably, elephants would last forever, and, because of the inordinate value of their two front teeth, they would be cherished, protected, and maintained by the nations possessing them. The legal trade was therefore justified, and indeed it was part of a legitimate effort to end illegal poaching—which was also harvesting elephants' teeth, of course, but done by the bad guys instead of the good guys. According to this perspective, legal sales would ultimately satisfy legitimate demand, thus driving down the value of the illegitimate supply offered by smugglers and poachers.

Of course, other organizations and experts argued a completely opposite view: that the legal sales not only encouraged the false belief that buying ivory was now morally and pragmatically justified but also actually primed both markets, legal and illegal.

At the CITES Conference of the Parties held in June 2007 in The Hague, Netherlands, the debate over elephants and the ban once again became extremely acrimonious. This time, however, Kenya stood alone among the East African nations in supporting the 1990 ban, while its old ally, Tanzania, now sided with the southern bloc in calling for an end to the ban. Tanzania had its own ivory to sell. The painfully achieved compromise was this: in return for a nine-year moratorium on all further sales, CITES would now approve a single bulk sale of raw ivory registered, as of January 31, 2007, in the official government stockpiles of the southern nations of Botswana, Namibia, South Africa, and Zimbabwe. The precious commodity would once again go to buyers in Japan, although China was now lobbying forcibly for permission to purchase some. All told, the ivory involved was estimated at one hundred to two hundred tons, worth many millions of dollars.

Precisely how many millions it would be impossible to say, since the final exchange—African ivory traded for Asian money measured in American dollars—has not yet taken place as of this writing. Meanwhile, the price of ivory is soaring. It had reached an unprecedented $850 per kilogram by the time of the 2007 CITES conference. And along with that rapidly rising price has come evidence of a rapidly expanding black market, driven in large part by a strong Chinese economy, weak Chinese laws concerning the importation of endangered species and their body parts, and flourishing sales of carved ivory across that country.

It may be true that African elephant populations in a few places, such as Botswana, are also flourishing, but recent police confiscations suggest that the relaxation of the CITES ban and the high prices for ivory in the Far East have combined to set off a new wave of poaching. In June 2002, authorities in Malawi seized 6.5 tons of illegal ivory—more than five hundred whole tusks and some forty-two thousand pieces carved for sale as Japanese signature seals—crammed into a shipping container and addressed to a buyer in Singapore. This was the largest single seizure of ivory since the ban of 1990. A biologist named Samuel Wasser of the University of Washington in Seattle had by the time of the confiscation developed a database of elephant DNA, allowing him (or anyone else) to examine that seized ivory and pinpoint its geographical origin. As it turned out, the ivory came from elephants in Zambia, mainly from that country's South Luangwa National Park. Zambia was one of the southern bloc of nations claiming that, because of good conservation practices, it had stable elephant

populations and was thus justified in voting to end the CITES ban. Officially, the Zambian government reported only 135 elephants killed by poachers during the previous decade. In fact, the ivory in the Malawi seizure represented the deaths of some 3,000 to 6,500 individual animals. That particular confiscation was followed up by investigators, who found it to be one of nineteen similar shipments, all organized by a criminal syndicate with connections stretching from Africa to Japan, Singapore, and China.

Confiscations of illegal ivory reached record heights during 2005 and 2006. Of course, confiscations were the tip of the iceberg of the illegal ivory trade: law enforcement authorities say police seizures around the world represent one-tenth of the full stream of black-market ivory. Based on the quantitative evidence of these seizures, biologist Wasser roughly estimates that current levels of poaching in Africa are now eliminating some 7.8 percent of the world elephant population each year. If true, that rate would mean greater losses now than during the worst of the killing years preceding the 1990 ivory ban. Has another elephant holocaust begun?

RECENTLY, THE GLOBAL PUBLIC has been treated to a steady flow of media reports on human-elephant conflict, leaving some people with the impression that the 1990 ban worked only too well and that there are now too many elephants in the world. Many of these are poignant tales: of elephants in Africa and Asia stealing subsistence farmers' crops or destroying impoverished villagers' huts, elephants on the rampage, killer elephants on the move. And if we are to believe the newspaper reports emerging from some of the southern African nations, their elephants have indeed multiplied rapidly, have in fact outrageously outgrown the national carrying capacity.

But the facts indicate otherwise. The first elephant holocaust of the 1970s and 1980s cut the global herd in half. Seven hundred thousand elephants were killed for their front teeth, bringing an African population of 1.3 million down to 600,000. The most recent transcontinental survey indicates that elephants have never recovered from that slaughter. This 2007 report, compiled with an unprecedented degree of accuracy, documented somewhere between 472,000 and 690,000 elephants alive in Africa: approximately the same number as at the start of the ban seventeen years earlier.

No comparable survey has been done for Asian elephants, and so we are left citing population estimates—of roughly thirty thousand to fifty thousand—that were never very reliable and are now a quarter-century old. Meanwhile, regional reports suggest that elephant populations across Asia have declined substantially over the past twenty-five years. These declines may be partially attributed to widespread habitat loss, but it is also likely that the 1990 ban temporarily shifted some of the pressures of the criminal trade in ivory away from African and onto Asian elephants. Asian elephants have long been vulnerable because of their comparatively low numbers, as well as the fact that only the males have tusks, so ivory poaching multiplies its effects by skewing sex ratios. Since 1990, according to one report, wild elephants have decreased by nine-tenths in Vietnam and Cambodia, by more than half in Laos, and by a quarter in Burma.

But if the global number of elephants has remained approximately the same over the past few decades or has even declined in places, what accounts for the increasingly common stories of human-elephant conflict? The short answer: more people. Since 1980, the number of people living in elephant-range states has doubled. The general sense that humans and wild elephants are increasingly coming into direct conflict is probably accurate. Most often, however, the conflict begins after people—and their villages and plantations and roads—move onto lands that were recently elephant range, forcibly compressing elephants into smaller and smaller areas.

Zimbabwe, a leader in the drive to scrap the CITES ban on ivory, has long argued that the country's overpopulation of elephants represents a serious problem that must be dealt with humanely and intelligently, in ways that will simultaneously benefit the legitimate needs of people. Thus, Zimbabwe has promoted the sport hunting of elephants, in which wealthy people pay handsomely for the privilege of shooting at big, living targets. And thus Zimbabwe has periodically promoted culling as a rational means of elephant population control that happens to include secondary benefits for humans. Culling brings meat to the local people, wastebaskets and wallets to the tourists, and ivory to the strange aficionados who return the favor with hard cash.

CULLING HAS BECOME a management option embraced not only by Zimbabwe but also, at various times in recent years, by most

of the southern African nations with significant elephant populations. Culling means killing or, more specifically, methodically reducing or controlling an animal population by killing individuals.

The idea of culling as a way to control wildlife populations should be seen in the context of the desperate economic and conservation circumstances of Africa in the late twentieth and early twenty-first centuries. Underlying that desperation has been the dynamic pulse of human population growth on the continent, which remains the fastest in the world, with human numbers doubling every twenty-five years. Human population growth has stymied meaningful economic development, since per capita income in Africa is running a losing race, and this rapid increase in people has also produced an astonishingly rapid decline in wilderness and wildlife habitat. In fact, the recent explosion in human numbers around the globe has transformed the world landscape in general, and the African landscape in particular, into a place where wilderness and wild animals are concentrated into smaller and smaller habitat islands, which are then often defined as parks or reserves.

Off these islands, wild animals, especially big ones, come into conflict with humans. On the islands, wild animals, including elephants, are often managed, with the most persistent problem being how to balance the needs and impacts of varied wildlife populations compressed into a limited habitat. Elephants are notorious for their capacity to alter habitat, and in response to such alterations some southern African nations began culling their elephants. As Zimbabwe's Rowan Martin once described the situation, "People . . . are fed so many images of wild Africa, they don't realize we hardly have a single truly pristine area left on the continent and certainly not in Zimbabwe. So we have to manage. But do we manage for what elephants need or for what pleases people? I myself prefer a nice acacia forest with a few elephants over an elephant-blasted landscape, and I'm prepared to knock a few elephants on the head to achieve it."

Such is the ecological justification for culling, which ignores the alternative of elephant birth control (such as darting with PZP, the porcine zona pellucida vaccine). Another justification is economic, which is a farmer's vision, since the animals involved are actually harvested and sent to market. Given the investment and infrastructure costs—of guns and ammunition, helicopters, trucks, labor, gasoline, and so on—knocking a few elephants on

the head would not seem that profitable, but culling operations in Zimbabwe between 1981 and 1988 harvested a crop of some twenty-five thousand elephants, who, after being disassembled into meat, skin, bones, and teeth, were valued altogether at more than thirteen million dollars.

Culling might also seem morally respectable. Martin defended it fiercely. Well-known conservation groups, including the International Union for the Conservation of Nature and the World Wildlife Fund, approved it. In Zimbabwe, the U.S. Agency for International Development promoted it. Academic experts even coined a pair of happy expressions to promote the general idea: "wildlife utilization" in support of "sustainable development." These were potent euphemisms indeed, suggesting that the practice was at once rationally functional ("utilization") and environmentally progressive ("sustainable"). It was actually a politician's vision: wild animals served up to voters as yet another resource available for their consumption. From a similar perspective, one could even imagine some latent justice in the idea. Animals would now be required to support themselves, to pay for their own protection inside parks and reserves. No more freeloading! Moreover, the organized killing of animals for profit could also, it was argued emphatically, add to the general economic well-being of the developing world. The extra income would trickle down, make everyone better off. The poorest villagers living in remote, rural areas would benefit, since if nothing else the culling business could provide killing and butchering jobs for the unemployed. Eventually, one could even imagine, the newly found wealth might even cycle back to the animals themselves. After all, money earned by culling could be used to compensate rural villagers who had lost crops from giant crop raiders, and then, once these people realized that dead animals had a monetary value for the community at large, they would be grateful to the ones still alive and would be less likely to become poachers.

In Uganda, a man named Ian Parker had pioneered what he considered to be the most efficient technique for culling elephants, and he started his own private culling company, Wild Life Services. With a team of hunters on foot, Parker would stealthily approach a family of elephants and then deliberately provoke their attention, perhaps by breaking a stick or coughing or clicking one metal object against another. The animals, startled and then alarmed, would bunch defensively, with the mothers form-

ing a protective circle, their heads and tusks outward, barricading their young behind a palisade of tusks and a wall of flesh. Once the elephants had circled thus, the cullers would spread into a semicircle around them and fire their semiautomatic rifles into the herd. They shot the biggest animals first, and as these elephants fell, the rest would be exposed and confused and milling about. It was easy to kill an entire family in half a minute.

In Zimbabwe, Adrian Read served from the late 1970s into the 1980s as a professional culler of elephants, working on contract. Read's company used a single airplane overhead and, on the ground, a team of six men—three shooters and three gun bearers—who were followed in trucks by another 250 men, the skinners and butchers. Vultures would occasionally follow the plane so thickly that Read's team would have to suspend operations, but normally the pilot overhead would find an elephant family, radio down its location, and describe the terrain and direction of the wind. The three hunters and their gun bearers on the ground would approach on foot, each carrying a NATO 7.62 mm semiautomatic rifle, while the plane would dive in and scare the elephants, driving them toward the waiting hunters. The lead hunter, at the center, would fire first, and then the pair flanking him would join in. Each gun had four rounds in the chamber. Each hunter would fire three bullets, saving the fourth as an insurance policy, and then trade the weapon back to the gun bearer for a loaded replacement. They shot the biggest animals first, firing into their brains or, in the case of a fleeing elephant, into the spine, working swiftly so that the creatures wouldn't have time to orient themselves. Surprised and confused, they died in a chaos of rising dust, spurting blood, and collapsing flesh. With a good team, the killing happened very quickly. One time, Read recalls, they wiped out ninety-eight elephants in less than a minute.

Yes, they would try to save the little ones, calves between eight months and a year old, elephants young enough, perhaps, to adapt psychologically to the trauma and possibly old enough to survive physically without their mothers. These young animals, worth more money alive as zoo and circus animals on the international market, might be captured and lashed to some kind of temporary anchor—the bodies of their mothers, for instance—while awaiting transportation to a game ranch. Then the trucks were called in, the calves were taken away, and the skinners and butchers went to work.

With the occasional exception of the young calves, the cullers killed whole families. It was, they said, by far the most efficient way of doing things. And killing entire families was also, they insisted, the most humane thing to do. It was better not to have elephant survivors, better to eliminate elephant witnesses, given what everyone understood to be the devastating social and psychological impact of surviving a cull, of losing a family, of seeing and hearing and smelling one's own mother and grandmother and other family members cut down.

Most peculiarly, though, no matter how deliberately they tried to work the culls, no matter how successful they were in killing all the elephants, no matter how careful they were to avoid having survivors or witnesses, somehow the elephants in the larger region would know something had happened. After a cull, other elephants would move into the killing area and stay for a while, as if to investigate, and then they would leave and consistently avoid that area for a long time. In Zimbabwe, at least, cullers sometimes slaughtered not only whole families and bond groups but entire associations of elephants in the same large range. The cullers were, as Zimbabwe's Rowan Martin described the case to the biologist and journalist Douglas Chadwick, "very scrupulous in some areas about removing all evidence. Not just the meat, hides, and ivory, but bones, stomachs, everything." But it made no difference. "Still, elephants came in from all over. We wondered, did they hear bullets? Smell something upwind? No, they came from every direction, 360 degrees," he said, adding, "That was before Katy Payne's work. Now we understand about infrasonic communication."

In sum, the proponents of culling championed the practice as not only a practical necessity but also an economic blessing with far-reaching political benefits. Martin once phrased the idea succinctly: "Wildlife is the engine that is driving democratization in Zimbabwe."

9

Unhappily, the people steering that metaphorical vehicle made a wrong turn somewhere, and so Zimbabwe, under the rule of President Robert Mugabe, has become among the least democratic places on the continent. This slow-moving political train wreck has been followed by an economic one, now desperate enough that hungry people in the country have begun turning to

their wildlife as a last-chance source of food. Meanwhile, government representatives slaughtered a hundred elephants to launch the ruling party's feast celebrating Independence Day in 2006. And in the same year, according to an exposé published in *The Zimbabwean,* the government secretly traded a planeload of ivory to China in return for a planeload of rifles, ammunition, antiriot gear, and other military supplies and equipment. The ivory was valued at one million dollars.

In that same eventful year, significant amounts of high-caliber ammunition disappeared from the armory of Zimbabwe's Wildlife Department, a theft that happened concurrently with reports of a surge in poaching along the Zambezi River, which marks the border between Zimbabwe and Zambia. Observers have estimated that as many as two hundred elephants were killed there during 2006, a carnage that the government bizarrely attributed to foreign animal-rights organizations.

On the Zambian side of the river, Doug Evans, the manager of a tourist hotel known as the Chundukwa River Lodge, reported hearing gunshots from the Zimbabwean side, and wildlife officials in Zambia said that Zimbabwe's general economic catastrophe and rampant poaching had caused a striking increase in the number of elephants crossing the river during the dry season. According to Evans, during the dry season maybe a half-dozen elephants used to appear near the lodge, whereas now the dry season allows migrations of as many as three hundred elephants. "We just put up with it," Evans says. "But over the long term, we can't handle three hundred animals. It's just too many." At the same time, 5 kilometers (about 3 miles) inland from the river, human settlements begin, so the elephants really have nowhere to go beyond a narrow strip of land along the river's edge.

It seems that the elephants are voting against Zimbabwe's President Mugabe "with their feet," as a reporter for *Newsweek* magazine conceptualized it, by crossing the river into Zambia, where there's less poaching and rich sport hunters are not allowed. Tourists are likewise entering Zambia in droves, but although that particular migration is good for Zambia, it may not be good for the elephants. In addition to the barrier of settlements immediately inland, along the Zambian edge of the Zambezi there is a growing barrier of tourist lodges and hotels and their protective fences, some of which cut off the elephants' migration routes.

Among the latest tourist hotels to appear in this beautiful place is the Royal Livingstone, a five-star luxury resort built at the start of the new millennium by Sun International within the boundaries of the Victoria Falls National Park. Victoria Falls is where the great river drops down monstrously some 130 meters (around 430 feet) to the so-called Boiling Pot at the bottom before continuing to sweep brightly on its mighty way. David Livingstone, the famed Presbyterian missionary from Scotland, was the first European to see the falls, and he named it after his queen, Victoria; now the grand hotel at the top of the falls has been named after him. The river churns right past the hotel at a rapid clip, and from the hotel's sundeck you can watch the sunset and see where the river is and then where it is not because it has disappeared into the roaring maw of Victoria Falls, at that point revealing nothing but a vast, trembling column of mist that rises to merge with the hovering clouds above.

The river and falls must have been a particularly awesome sight in the spring of 2007, since seasonal rains had swollen the waters to record levels and produced a raging current. In spite of the high waters and powerful currents, though, a few elephants were still occasionally trying to swim across, and on Good Friday, April 6, tourists sipping their sundowners on the sundeck were transfixed by the sight of three elephants trying to cross the Zambezi at the head of the falls.

In the lead was a large bull elephant, weighing perhaps six tons, followed by a pair of smaller animals, one of them male, one female. Kenneth Nyambe, a ranger with the Zambian Wildlife Authority who was stationed at the hotel, recalls that he first heard a commotion on the sundeck at around 4:20 that afternoon. Walking up to the deck, he found a large crowd of tourists cheering at the sight of the brave bull elephant swimming powerfully across the channel. There was a small island behind him. The three elephants had swum from islet to islet in that stretch of the river, and the two smaller elephants were now marooned by the water and their own failed nerve on that final perch, while the big bull was trying to cross the deep and surging channel in front of the hotel. A head waiter at the hotel, Kelvin Ng'andu, also stopped to watch, and as he later told the *Newsweek* reporter, "He almost made it, and we were all cheering."

But at the bank of the river by the hotel was a barrier of steep rocks, augmented by an electric fence surrounding the hotel. Thus the elephant was forced to turn around and try the banks

farther down, where he was caught in the current. He labored for a half hour, swimming, swimming. He would catch a foothold on an outcropping of rocks and attempt to break the grip of the current, to find an open spot on the bank and scramble up the side. "It was a very sad struggle," Ng'andu recalled. "We could all put ourselves in the boots of that animal. Some people were crying, no one was laughing."

The elephant was "screaming piteously" now, while his two smaller companions, still keeping to the safety of their island, called back, but finally, at around 4:55, the great animal's strength failed, and he was overwhelmed, pulled down, and swept over the falls.

The surviving pair eventually tried to swim back to the Zimbabwe side. One made it all the way; the other, people at the hotel could see, stayed on another islet and didn't swim back until Easter Day. That was "the same day that our Lord Jesus died for us," to repeat the pious language of the head waiter, and in a comparable way the big bull elephant "sacrificed for his friends to live. Elephants never forget. I'm sure when they come back this way another year, they'll have a moment of silence for him."

SOMETIMES I LIKE TO IMAGINE that people and elephants are negative reflections of each other. Look at a map. Where you find evidence of people, the dots that represent cities and towns, the squiggles that identify roads, you will not find elephants. Where you find elephants, you will not find people. The map of the elephant world is a negative reflection of the map of the human world. Experts have even quantified this relationship. One set of experts calculated that elephants can survive on a piece of land with at most 15.2 people per square kilometer (40 people per square mile). Another group of experts collectively surveyed a total area of 60,000 square kilometers (23,000 square miles) in the forests of Central Africa, counting and mapping the carcasses of elephants killed by humans. They concluded that forest elephants are "severely threatened" by ivory and meat poaching, which occur in a pattern that neatly reflects the pattern of roads recently bulldozed into Central Africa by commercial loggers from Europe and Asia. The density of poached elephant carcasses decreased steadily as the distance from the roads increased, until, at 45 kilometers (28 miles) from the nearest road, the experts found no more carcasses. That's what I mean by a negative reflection.

Sometimes, though, I prefer to imagine that elephants and people are actually positive reflections of each other. We have a lot in common. We are both predominately hairless mammals, and we both, therefore, are unusually subject to damage from the sun and discomfort from the cold. We are also both very successful species, having become, at one time or another, relatively numerous and routinely dominant, among the most obvious creatures in the landscape. We are both species characterized by surprisingly large brains and good memories, some capacity for calculation and planning, extended childhoods, long lives, impressive communication skills, complex social systems. We both prefer to live in mutually supportive family groups. We both react emotionally upon reuniting with old friends and family members. We both love our children and will sacrifice our own welfare, even our lives, for the sake of our young. We breathe the same air, drink the same water, swim against the same sweep of time, face the same frightful, roaring mystery at the end. We are subject to similar fates, in other words, and we are both swept up in currents more compelling than we expected or have ever before experienced.

We also both have powerful, often powerfully destructive, effects on the world around us, on the environment; and if humans seem more destructive, well, perhaps that's merely the result of humans being more numerous at the present time. In any case, the experts tell us that the large forces now threatening elephants—human overpopulation, human overconsumption, and the several other by-products of human folly, narrow vision, and limited foresight—are the same large forces that ultimately threaten us. Both we and they are in trouble, even though they will likely go over the falls first.

Some of this book's elephant reflections I think of as studies in lonesome splendor. We see a single, far-off figure in seemingly romantic isolation, or a small cluster of shapes in shaded profile or distorted by distance and the lenses of expanding and contracting pockets of air. These can be inspiring, pleasing images, good for enlargement into posters or inclusion in glossy calendars. Yet frequently the lonesome splendor photographs suggest to me not merely dramatic isolation under aesthetically pleasing circumstances, not just deep estrangement on a large stage, but more, a deep strangeness.

We are all familiar with elephants, or we believe we are. But

often that familiarity is a misleading one, an unexamined collection of images reflecting the tame and protected circumstances of zoos or the comforting, often comical stereotypes offered by circuses and popular cartoons, with their Jumbos and Dumbos.

So our common memories of elephants become brittle images of a familiar, predictable, probable creature who, fitted with harness and feathers, showcases not his or her own power and glamour but rather the reigning power and glamour of the handsome man or lovely lady who rides on top. We have grown accustomed to the bigness of elephants kept small. We know the intelligence of elephants trained to do stupid things. We imagine the wildness

of elephants held captive in limited circumstances, kept under control with steel bars and chains, presented in ways that restrain their power and transgress their nature. But to see an elephant, a real elephant, is to see a creature who is not safe, not comforting, not friendly, not limited or restrained. It is to see an intelligent beast, at once sympathetically humanlike and yet utterly removed and supremely indifferent, a creature who quietly mocks our puny size and frantic chatter, who effortlessly defies our stereotypes, who easily challenges our automatic sense of entitlement and superiority, and who should, indeed, caution us, tell us to be careful, keep still, have respect.

NOTES

SECTION 1 On elephants in circuses and zoos: see Alexander 2000; Barnum 1875, 1888; Bartlett 1899; Bedini 1997; Jolly 1976; Scigliano 2002; and Wallace 1959. On elephants in early Asia: see Alter 2004; Gale 1974; and Gröning and Saller 1998. On war and spectacle in the classical era: see Arrian 1958; De Beer 1956; Kistler 2006; Mayor 2000; Scullard 1974; and Toynbee 1973. On elephants shot during the colonial era: see Chadwick 1992; Conniff 1987; Cumming 1857; Martin 2001; Meredith 2001; and Watson 2002. On African and Asian responses to elephants: see Mayor 2000; Sanderson 1962; Scott 1887; and Sukumar 2003. On Ganesha: see Alter 2004; Brown 1991; Gröning and Saller 1998; and Scigliano 2002. On beasties in the bestiary: see Topsell 1607 and White 1984. On natural history since the time of Aristotle (including Greek and Roman): see Aelian 1958, 1959; Aristotle 1965, 1970, 1991; Bigwood 1993; Pliny 1956; Romm 1989; Sanderson 1962; Scullard 1974; and Toynbee 1973. Aristotle may have dissected—or, more likely, had access to information from someone who did—an elephant during the second half of the fourth century B.C. If so, that would have been an Asian elephant. A more recent dissection of an Asian elephant was conducted in the seventeenth century in Dublin, according to Meredith 2001, p. 139. On Perry's study of reproduction: see Perry 1953, 1964. On discovery of the "matriarch" as social center: see Buss 1961. On elephant age determination: see Laws 1966. The Meredith quotation is from

Meredith 2001, p. 140. The Turner quotations are from Turner 1987, pp. 157, 158. I am grateful to Meredith 2001, p. 141, for suggesting the relationship between Turner's comment and Douglas-Hamilton's appearance. The story of Douglas-Hamilton's early work at Manyara is based on Douglas-Hamilton and Douglas-Hamilton 1975 (and supplemented with material from an interview done in May 2007), with the shorter quotations taken from Douglas-Hamilton and Douglas-Hamilton 1975, pp. 42, 60, 94. The average size of an elephant family is from Payne 2003. The extended quotation on responses to an imitation lion's roar is from Douglas-Hamilton and Douglas-Hamilton 1975, pp. 213, 214; the brief quotation following that is from Douglas-Hamilton and Douglas-Hamilton 1975, p. 214. The story of Moss's early work is based largely on Moss 1988 and Poole 1996. The first quotation ("I got to know") is from Moss 1988, p. 30; the extended quotation describing a "greeting ceremony" is from Moss 1988, p. 24; and the later analysis of the usefulness of bond groups is based on Payne 2003.

SECTION 2 The Aristotle quotation is from Aristotle 1970, 2:105, V.2.540a. The material on lack of mating observations by Douglas-Hamilton and Short is from Moss 1988, p. 99, as is the comment about Moss's lucky day. The quotation is from Moss 1988, p. 98. Much of the story of Poole's arrival and early research is taken from Poole 1996, and the quotation about the seem-

ingly very ill bull elephant is on p. 43 of that source. The tale of M126, including quotations, is from Moss 1988, pp. 106–107. Poole 1996 picks up the story of green penis disease, and the critical meeting with Harvey Croze is described on p. 48. The interactions with musth bulls are described in Poole 1996, p. 80. I have paraphrased Moss 1988, pp. 91–98, for my extended tale about the mating game; I have taken the quotation attributed to her from the same source, p. 91. The comment on avoidance of close inbreeding, however, is in Moore 2007; see also Archie et al. 2007. See Hollister-Smith et al. 2007 for additional assessments of the importance of age and musth for successful paternity. Fertile females solicit the presence of older bulls, who are indeed most likely to succeed reproductively; thus, legalized trophy hunting, which concentrates on large-tusked older bulls, may have unfortunate consequences for the larger population, including a reduction in genetically determined tusk size: see Rasmussen et al. 2008. The Poole quotation is from Poole 1996, p. 105; the later story about witnessing a birth comes from the same source, pp. 92–94, with the quotations taken from p. 94.

SECTION 3 I have drawn my description of Payne's early work from Payne 1998 and material from interviews in February and April 2008. The quotations describing aspects of her visit to the Washington Park Zoo and her return flight are from Payne 1998, pp. 17, 19, 20–21; the quoted description of the tape playback is from

pp. 27–28. See also Payne, Langbauer, and Thomas 1986. The Douglas-Hamilton quotation is from Chadwick 1992, p. 69. The extended series of quotations from Payne (listening through earphones in a Jeep) is in Payne 1998, pp. 17–20. The same source provides the quotations about the middle-of-the-night sounds, p. 70; the post-copulatory opera, pp. 83–84; and the rough lexicon, p. 100. Some of the information on elephant call frequencies and intensities, and what they may mean, derives from accounts in Payne 1998, p. 97, and Payne 2003, p. 78. The description of the experimental test at Etosha is from Payne 1998, with quotations and theoretical assessments from pp. 120, 122. On elephant communications through the ground as seismic waves: see Bouley et al. 2007 and O'Connell 2007.

SECTION 4 Scullard 1974, p. 13, refers to Herodotus's travels in Egypt. The story of Henry Fairfield Osborn is told in many places, including Gröning and Saller 1998; Meredith 2001; and Sukumar 2003; all those accounts have influenced mine. Osborn 1936, pp. 47–48, provides a standard description of the *Moeritherium*. The quoted assessment of Osborn's character, provided by a research assistant, comes from Colbert 1996, p. xxvi; and Meredith 2001, p. 133, suggests some of the details of Osborn's early work at El Fâyum. Shoshani and Tassy 1996, p. 337, summarizes the taxonomic changes from Osborn's original system. Sukumar 2003, p. 8, adds the particulars about elephant embryos (including information on the nephrostome) and the implication of an aquatic ancestry that I have used; I have also relied on Chadwick 1992, pp. 24–25. Our knowledge of elephant evolution is complex and changing, and I have found most reviews of that knowledge to be either oversimplified or hard to understand. I have chosen to rely on the concept of three "fertile bursts of evolutionary radiation," provided by Shoshani and Tassy 1996, p. 337, to inform my discussion. I have, though, more particularly relied on Sukumar's several intelligent accounts of evolutionary changes in tooth structure, body size, proboscis development, and so on (Sukumar 2003, pp. 15–19). The material on mammoths, including the account of the 1901 discovery along the river Berezovka, derives from Lister and Bahn 1994, pp. 44–45 and Gröning and Saller 1998, pp. 42–43. Sukumar 2003 provides some nice summaries of the Pleistocene changes in climate and fauna, and I have relied

particularly on his account of the dwarf proboscideans of the California Channel Islands, to be found on pp. 31–33. Gröning and Saller 1998, p. 35, is my source for the material on the dwarf mammoths of the Wrangel Islands. Sukumar 2003, pp. 36, 37, provides many of the facts on the late Pleistocene die-off; the quotation from Haynes is in Haynes 1991, p. 317. "Pleistocene rewilding" is the plan to restore in North America the descendants of large animals present thirteen thousand years ago by translocating contemporary megafauna—such as elephants, camels, cheetahs, and lions—from Africa and Asia. For a useful summary and critique of this plan, see Rubenstein et al. 2006.

SECTION 5 My material on elephant anatomy comes largely from two sources: Sukumar 2003 and Poole 1997. Sukumar 2003 is detailed, thorough, and reliable; I find Poole 1997 useful for its simplicity and succinctness. Sukumar 2003, p. 149, provides the unusual comparison between an elephant's and a bloodhound's olfactory sensitivity. Schulte et al. 2007 gives additional information on chemical production and smell in intraspecific signaling among elephants. Elephant vision, by comparison, is the weaker sense. See, for example, Sikes 1971 and Shoshani and Eisenberg 1982. Poole 1997 describes trunk drinking capacity, p. 36; other trunk uses, pp. 35–36; average and record tusk weights, pp. 32, 70; and progression of molars, p. 31. The statistics on drinking capacity are from Sukumar 2003, p. 198, and Poole 1997, p. 41. Figures on eating come from Sukumar 2003, p. 196, and Laws, Parker, and Johnstone 1975. Sukumar 2003 also provides the details on diet diversity, p. 193, and the facts on browsing and grazing, p. 200. For more details on diet, see Guy 1971; McKay 1973; Sukumar 1990; Merz, as cited in Eltringham 1982 (for the Ivory Coast); Short 1981 (for Ghana); and White, Tutin, and Fernandez 1993 (for Gabon). Poole 1997, pp. 23–24, is my source on African savanna elephant size and sexual dimorphism. I have used Sukumar 2003, pp. 15, 210, for the material on tooth adaptations and body size; Poole 1997, p. 20, provides the fact that elephants can sleep while standing and information about their locomotion styles and speeds. Weissengruber et al. 2006 adds anatomical information on feet. Poole 1997, p. 38, gives details on elephants using their ears for thermoregulation and some of the statistics on brain size, including the ratio of

brain weight at birth versus adulthood. Gröning and Saller 1998, p. 62, adds to the picture, citing the ratios between neocortex and brain stem for various species. Material describing a matriarch's social and ecological memories is largely from McComb et al. 2001, with added information on Namibia elephants from Payne 2003. For the tale of working elephants in Burma stuffing their bells with mud: see Williams 1960, p. 78. On Asian elephants using sticks as tools: see Hart and Hart 1994. On working elephants who commit suicide by standing on their own trunks: see Gale 1974, p. 109. On memory of arbitrary drawings: see Rensch 1957. On memory of the contact calls of other individuals, living and dead: see McComb et al. 2000. On distinguishing between human ethnic groups based on body odor and the color of traditional garments: see Bates et al. 2007. On elephants and mirrors: see Plotnik, de Waal, and Reiss 2006.

SECTION 6 I have taken the story of three elephants, including the quoted comment of Nicola Roche, from Ryan and Thornycroft 2007. The Douglas-Hamilton quotation is from Douglas-Hamilton and Douglas-Hamilton 1975, p. 234; the Moss quotation is from Moss 1988, p. 271; the Poole story, including the quotation, is from Poole 1996, p. 95. Douglas-Hamilton and Douglas-Hamilton 1975 provides the accounts of Iain Douglas-Hamilton's own observations, pp. 234–235, and those of Croze and Woodley, pp. 235–236. Cynthia Moss's observations of the Echo family and her quoted remarks is in Moss 1988, p. 270. Douglas-Hamilton and Douglas-Hamilton 1975 is my source for the stories of Turner and Buss, p. 241; the account of the "most methodical study" at Dzanga-Sangha is based on Payne 2003. The "hopeful story about positive behavior" derives from Rich and Rouse 2004, pp. 58–59; Poole 1996, pp. 162–163, is my source for the story of Colin Francombe. Schaller 1967, p. 274, refers to elephant behavior in India; Payne 1998, p. 64, tells the story of Peter Ngande. Douglas-Hamilton and Douglas-Hamilton 1975 is my source for the Grzimek story, p. 240; the response of elephants at Manyara to a ten-day-old corpse, pp. 236–237; and the rough experiment, p. 238. The Adamson story is from Adamson 1968, pp. 143–144. Turkalo, in an interview in April 2007, described for me the bone examinations and handling of forest elephants. Moss 1988, pp. 270–271, is the source of my quotations about

responses to elephant remains. The experiment on elephant preferences is from McComb, Baker, and Moss 2005.

SECTION 7 The price of ivory is typically cited in dollars per kilogram. Ivory in bulk weight is typically identified in "metric tons," though some writers, including this one, prefer the stripped-down phrasing of "tons" or "tonnes" to mean the same thing. A metric ton is approximately equivalent to 2,200 English pounds, so it is not radically different from an English standard ton of 2,000 pounds. My source for facts and theories on the rising price of ivory in the 1970s is Furniss 2006. The first Poole quotation is from Poole 1996, p. 194, while the account of her work in Tsavo comes from pp. 221–223. I relied on Leakey and Morell 2001 for the early story of Leakey's tenure at Kenya Wildlife, with the quotations from pp. 6, 7, 2, 66. Poole 1996 offers information on the CITES quota system, p. 199; the story of the African Elephant Working Group, p. 211; and the account of her own efforts, shared with Moss, to gain support for a ban and public relations campaign, with the relevant quotation on p. 202. The problem of Kenya's ivory stockpile and Leakey's solution, a bonfire, are described in Leakey and Morell 2001, pp. 42–44; the Martin limerick is quoted from the same source, p. 90; and President Moi's quote is on p. 92. I have taken information on the positive results of the 1991 CITES ban from Owens and Owens 1992,

p. 284, and Furniss 2006, p. 51. For background information on the history of ivory exploitation, see Wilson and Ayerst 1976.

SECTION 8 Payne 1998, describes the June 1997 CITES meeting, pp. 268–271; the Dick Pittman quotation is from the same source, p. 270. The argument in favor of culling is derived partly from Brahic 2007. I have taken information about the 2007 CITES conference from Morell 2007 and Mpinganjira 2007. Loder 2007 cites the rising price of ivory and describes the big ivory seizure in Malawi and the DNA work of Samuel Wasser; see also Kaufman 2007. The most recent trans-African survey of elephants is Blanc et al. 2007. This somewhat confusing report lists population numbers according to the degree of accuracy of the data. I based my minimum on the numbers considered "definite" in this report and my maximum on the total of all counts. The information on Asian elephants is taken largely from Blake and Hedges 2004; Stiles and Martin 2002 refers to the severe declines of wild elephants in parts of Asia. On culling: for an intelligent review of the issue in all its complexity, see Owen-Smith et al. 2006. For information on the porcine zona pellucida (PZP) birth control vaccine, see Delsink et al. 2006. For sensible assessments of contraception as one option for wildlife management, see Kerley and Shrader 2007 and Kirkpatrick 2007; O'Connell 2007, pp. 83–84, also provides a brief and informal review of the subject. Martin's first

quotation ("knock a few elephants on the head") is from Chadwick 1992, p. 439. Payne 1998, pp. 194–205, reviews Martin's culling philosophy and plans; I have made use of her account, as well as those of Poole 1996 and Chadwick 1992. Douglas-Hamilton and Douglas-Hamilton 1975, p. 433, is my source on the culling operations of Ian Parker; Chadwick 1992 provides the material on Adrian Read. For discussions of elephant psychopathologies associated with culling and other sorts of trauma (such as poaching and translocations), see Bradshaw and Schore 2007; Bradshaw et al. 2005; Owens and Owens 2005; Slotow, Balfour, and Howison 2001; Slotow and van Dyk 2001; and Slowtow et al. 2000. The second Martin quotation ("we understand about infrasonic communication") comes from Chadwick 1992, p. 433; the third quotation ("engine that is driving") is from Payne 1998, p. 202.

SECTION 9 My account of slaughtering elephants for a ruling party feast in Zimbabwe is based on Karimakwenda 2007. The story of a planeload of ivory to China is from Dzamara 2007, which is also the source for information on the surge in poaching along the Zambezi River. The sad account of an elephant from Zimbabwe being swept over Victoria Falls, including the quotations, comes from Nordland 2007. For the statistics supporting a "negative reflection" between people and elephants, see Blake et al. 2007; Blanc et al. 2007, p. 7; and Laurance et al. 2006.

The ivory trade has dictated most aspects of elephant conservation for several decades. When poaching reached record levels in Africa during the 1980s, the international demand for ivory was identified as the main reason for the decline in elephant populations on the continent. In East Africa, in particular Kenya, improved management of the national parks and surrounding areas since then has helped a few savanna elephant populations to bounce back.

The story is different in Central Africa, home to the forest elephant species. During the 1980s, ivory was the major incentive for elephant poaching in this part of the continent, with President Sese Seko Mobutu of Zaire, now the Democratic Republic of Congo, leading the way. Mobutu used his presidential jet to fly tons of ivory from his forest hideaway at Gbadolite directly to China. Even today most of the ivory confiscated internationally comes from forest elephants of the central region. Indeed, in the past three decades, elephant poaching in Central Africa does not seem to have declined. Since there are fewer elephants living in the more accessible areas, poachers today are moving deeper into the once-forbidding forests of the Congo Basin. This is possible because the forests are being opened up, mainly by European and Asian loggers, who are bulldozing roads in order to harvest tropical hardwoods for European and Asian consumers.

A recent study by scientists working in Central Africa shows an interesting pattern in the killing of forest elephants. All of the elephant carcasses located by the surveyors were found no more

than 45 kilometers (28 miles) from an accessible road or navigable river. Since small quantities of ivory can easily be transported much farther than 45 kilometers, these findings suggest that hunters are pursuing something else; this hunting pattern points to the transport of elephant meat. Although the flesh can be smoked, which keeps it from spoiling for several months, its bulk makes it a lot harder to carry than ivory. If the meat has a significant value, poachers will be more motivated to go through the trouble of getting it out of the forest to sell it. So the pattern of poaching ultimately reflects the transport of meat, which is both valuable and hard to carry.

I believe that the trade in elephant meat has become the main incentive behind elephant poaching in Central Africa, where more elephants are killed annually than in all of eastern and southern Africa. There are at least two reasons for the comparatively recent shift in focus, from ivory to meat, in the elephant poaching economy of Central Africa.

First, elephants may simply have smaller tusks today than they had a generation ago. The tusks of forest elephants have always been smaller and harder than those of their savanna counterparts. During the ivory-poaching frenzy of the 1980s, hunters concentrated on killing the bigger tuskers, since they brought the highest profits per animal. This resulted in a gene pool with fewer large-tusked adults, which may now be reflected in the population. A few years ago I interviewed a hunter who had killed a forest elephant the day before and was taking the meat and ivory

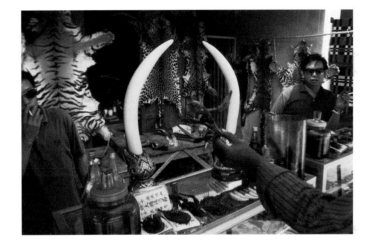

to the market. He showed me the ivory: two tusks weighing only about 2 kilograms (2.5 pounds) each. He told me the tusks were from a male from a herd of six. When I asked him why he had shot the smallest, he responded defensively, "It was not the smallest but the biggest." I've included a photograph here to show what a 2-kilo tusk looks like.

So the ivory from forest elephants could be getting less available because fewer older adults are alive and also, possibly, because of genetic changes. What the hunter told me next illustrates a second reason poaching in Central Africa may be shifting from ivory to meat. Along with the comparatively small amount of ivory, the hunter's sons were transporting five baskets, weighing about 50 kilograms each, of smoked meat. They had come

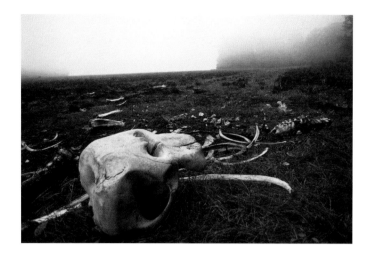

in southeastern Cameroon. The elephant had small tusks, and the hunters declared that while the ivory would bring them only around $40, the bullet for the elephant-caliber rifle they used cost $20. Why would anybody trudge for hours through the forest, evading rangers, and then sell the booty for such a small profit? The crew that interviewed these hunters most likely also filmed the gory butchering of the carcass, the smoking of the meat, and the packing for transportation. But the meat was not mentioned or shown in this documentary.

In Yaoundé, the capital of Cameroon, this same team filmed a conservationist crawling around a shipping container with a toothbrush, trying to find slivers of ivory to prove that a Chinese resident had exported tons of it in a hidden compartment. It struck me as absurd that while the merest traces of ivory were being chased down with a toothbrush in one part of Cameroon, poachers in another part of the country, who were selling both ivory and meat, were not afraid of openly admitting and even bragging about their crimes on camera.

A last piece of information in this context. The previously mentioned study refers to the various survey teams having found fifty-three "confirmed elephant poaching camps" and forty-one carcasses during reconnaissance walks. The authors note that "the tusks had been removed from all poached carcasses, though due to the level of decay it was not possible to determine whether they had been poached primarily for the ivory or for the meat." Although it is disappointing that the surveyors failed to learn much from the decaying remains of the elephants, the most troubling fact is that they failed to note or count the remains of any meat-smoking tables. At a poaching camp, there are tables set up on which meat is cured. These tables disintegrate along with every other organic substance in a tropical forest, but they do so comparatively slowly. Counting the number of smoking tables at a camp would help determine whether the elephants had been slaughtered for their ivory or for their meat. Information on the smoking tables would add to our knowledge about the comparative importance of meat versus ivory, and to what extent the ivory is becoming a secondary, rather than a primary, stimulus for elephant poaching throughout most of Central Africa.

I believe that both the conservation community and most of the conservation media are far too content to go with the ivory story. It's a sexier tale, after all, and it allows us to focus our blame on a

north, crossing a river to move from their base in the Democratic Republic of Congo to the Central African Republic (CAR), to sell their wares in a small town not far from the border. They told me that Sudanese traders in the town would buy the ivory for around $10 per kilogram, and thus they hoped to reap a total of $40 for the ivory. In comparison, the five baskets of meat would sell for about $250. What aspect of the market is most likely to have motivated the poacher to kill the elephant, butcher and smoke the carcass, transport the pieces across the border, and risk the possibility of having to pay a bribe or getting arrested? Undoubtedly the value of the meat.

In spring 2007, Dale Peterson and I, along with journalists Anthony Mitchell and Andreas Gehriger, traveled through the CAR, where we compared ivory and meat prices. Despite tales that raw ivory was selling in China for many hundreds of dollars per kilogram, in northern Congo and southern CAR the price remained at $15 to $20 per kilo. However, smoked elephant meat was selling for around $8 per kilo in the big city of Bangui. This is a considerable price, given that a large elephant could yield up to 500 kilos of smoked meat.

These are the facts as I see them, and my conclusion is simple: meat, not ivory, is the commodity that most excites the professional elephant killer in Central Africa. This is an important shift, and yet the conservation media seem to be missing it completely.

A recent film produced by a U.K.-based broadcaster for *Animal Planet* shows a group of hunters who had just killed an elephant

distant and rather vague "ivory mafia" in Asia rather than on particular poachers, lax law enforcement officers, and meat traders in Africa. The ivory story is also a simpler one to tell, and perhaps easier to hear. But the consumption of all kinds of wild animal meat in Central Africa has become profoundly commercialized during the past several years. This commercialization has, in turn, caused the consumption of game meat—including elephant meat—to explode in scope and impact. The uncontrolled nature of the commercial meat trade is now the most important threat to forest elephants, and it needs to be publicized, understood, and addressed by individuals, organizations, and governments.

For many years, meetings of the CITES (Convention on International Trade in Endangered Species of Flora and Fauna) members have been dominated by the ivory debate. Should stockpiles be sold or not, and to whom? Most of the elephant conservation debate is taken up with that controversy—which in my opinion distracts us from the real issue. I am convinced that even if we were able to end all trade in ivory tomorrow, it would do little to stop the poaching of the remaining Central African forest elephants.

My suggestion is to spend more time and resources on law enforcement. To start with, the hunters who killed the elephant documented in the *Animal Planet* film should be arrested, tried, and sent to prison. This would serve as a real deterrent to other poachers. At present, however, poachers are rarely brought to justice. The problem is poor governance, a general lawlessness in rural areas, and officials who regard the illegal and unsustainable looting of natural resources as one of the only ways to make a good living. Less time and money should be spent endlessly discussing the ivory issue and sending CITES and Interpol officials to inspect containers in far-off locations around the world. More resources should be directed to equipping and training law enforcement agencies. Local enforcement efforts must then be backed up by some real political will from the countries concerned.

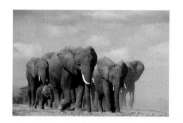

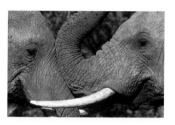

TITLE PAGE AMBOSELI NATIONAL PARK, KENYA. An elephant herd crossing Lake Amboseli on its way to the swamps. Lens: 800 mm (f5.6).

TABLE OF CONTENTS SAMBURU NATIONAL RESERVE, KENYA. Two teenagers greet each other. Lens: 80-200 mm (f2.8).

NOTES ON
THE PHOTOGRAPHS

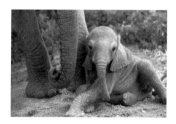

PAGE 3 AMBOSELI. Young calves often lie down to rest, leaning against their mother's legs. This very young calf is watching the photographer. Lens: 80-200 mm (f2.8).

PAGE 4 SAMBURU. The relationship between mother and calf is not easy to document with still photographs. This image begins a sequence that shows a mother very gently waking and raising her calf with a light prod from a rear foot. Lens: 300 mm (f2.8).

PAGE 5 SAMBURU. Second in the sequence. Lens: 300 mm (f2.8).

PAGE 5 SAMBURU. Third in the sequence. Lens: 300 mm (f2.8).

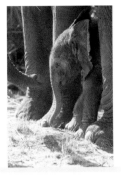

PAGE 7 SAMBURU. Fourth in the sequence, with the young calf standing now and being examined by a sniffing adult. Lens: 300 mm (f2.8).

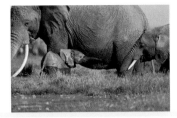

PAGE 10 AMBOSELI. The elephants move into the swamps in the morning and stay until afternoon. Midday light produces harsh shadows and dull contrast; this photo, taken in midafternoon, begins to show detail. Lens: 80-200 mm (f2.8).

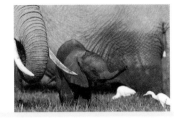

PAGE 12 AMBOSELI. Another picture taken as they leave the swamps. The young calf has probably begun to smell the photographer. Lens: 80-200 mm (f2.8).

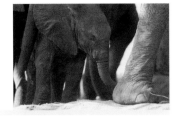

PAGE 13 SAMBURU. Contrasting texture of young and old. A young calf typically enjoys the safety defined by the four posts of a mother's legs. Lens: 800 mm (f5.6).

PAGE 14 SAMBURU. Suckling at mother's breast requires raising the trunk up and out of the way. Lens: 800 mm (f5.6).

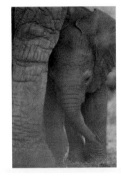

PAGE 15 SAMBURU. Physical contact with a mother is very important. This young calf was touching his mother's leg every few seconds. Lens: 800 mm (f5.6).

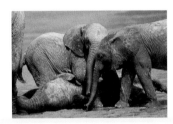

PAGE 16 SAMBURU. Three muddy young elephants play at the Ewaso Nyiro River, a prime spot for elephant photography. Lens: 800 mm (f5.6).

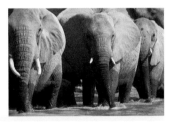

PAGE 19 SAMBURU. Three mature elephants cross a river side by side. Lens: 800 mm (f5.6).

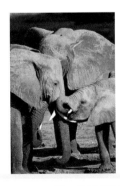

PAGE 20 SAMBURU. When the Ewaso Nyiro River dries up, the elephants dig wells in the still-wet sand of the riverbed and drink out of them. The angularity of the elephant's head on the left clearly identifies a female. Lens: 800 mm (f5.6).

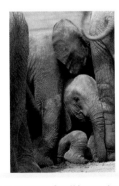

PAGE 21 SAMBURU. One thing an elephant has to put up with is life in a crowd. Lens: 800 mm (f5.6).

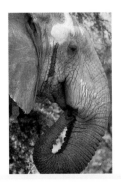

PAGE 22 SAMBURU. An elephant rests in the shade of an acacia tree during the midday heat. In males, the draining of fluids from the temporal gland, between the eye and ear, is a sign of musth. Among females, it's a sign of emotional excitement. This individual is a female. Lens: 300 mm (f2.8).

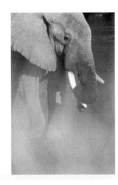

PAGE 23 SAMBURU. Shooting through some foliage with a long lens produces the blurred effect. Lens: 800 mm (f5.6).

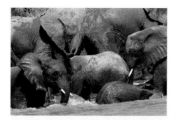

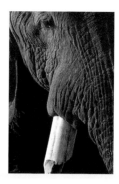

PAGE 24 SAMBURU. After they reach the water and have taken their first drink, the elephants start wallowing and splashing. The calves are often first to enter the water and roll around. Lens: 800 mm (f5.6).

PAGE 26 SAMBURU. Individual made hazy by the dust he has been tossing. Lens: 800 mm (f5.6).

PAGE 27 SAMBURU. Another self-dusting shot, taken while the subject stood under a tree during the midday rest period. This elephant's floppy ear may be the result of an injury. Lens: 80–200 mm (f2.8).

PAGE 28 AMBOSELI. This close-up of Dionysius, one of Kenya's biggest elephants (now deceased), was taken while the photographer was shooting stills as part of a National Geographic IMAX team. Park management had given the team permission for off-road driving, which enabled the photographer to approach within 30 to 40 meters of this magnificent, broken-tusked old male. Lens: 800 mm (f5.6).

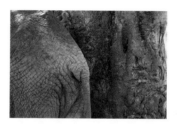

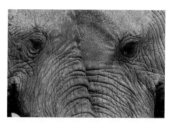

PAGE 28 AMBOSELI. A long lens allows one to penetrate into the forest of legs and trunks, which often yields interesting compositions. Lens: 800 mm (f5.6).

PAGE 29 SAMBURU. Many of the big shade trees by the river at Samburu have been partially debarked by elephants. Lens: 300 mm (f2.8).

PAGE 30 SAMBURU. Elephants feed on all parts of young trees, and strip and eat the bark of older trees, which usually kills them. Lens: 800 mm (f5.6).

PAGE 32 SAMBURU. These two females are comfortable with each other and express that comfort by leaning their heads together. Lens: 800 mm (f5.6).

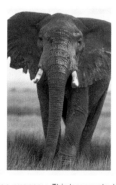

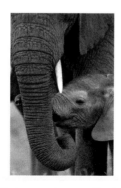

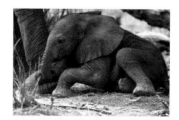

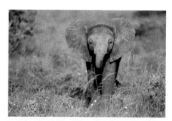

PAGE 36 AMBOSELI. This large male, tinted with dark earth tones, has just come out of the swamps and is headed toward the hills. Ready to cross a road but prevented from doing so by the photographer, he shows his irritation by raising his head and spreading his ears. This was taken from a distance of 4 to 5 meters. Lens: 80–200 mm (f2.8).

PAGE 37 SAMBURU. A young calf seeks maternal reassurance by touching and smelling. Both are tinted by the red dust of Samburu. Lens: 800 mm (f5.6).

PAGE 38 SAMBURU. This youngster, about to get up after having had a quick nap between mother's legs, is tinted by the same red dust. Lens: 800 mm (f5.6).

PAGE 41 SAMBURU. This young calf with outstretched ears threatens the photographer's car. This picture was taken at around 4:00 in the afternoon, and the youngster's family has left the river—thus the fresh signs of mud splashing—and is headed toward the hills. Lens: 300 mm (f2.8).

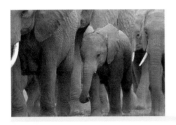

PAGE 43 AMBOSELI. This study in gray, with touches of ocher, was taken in the late afternoon, as the family group left the swamps. At Amboseli, it is possible to drive ahead on the roads to reach a spot where the moving herd will cross, and then shoot with a long lens right into the group as it moves your way. Lens: 800 mm (f5.6).

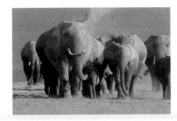

PAGE 44 AMBOSELI. Sometimes the elephants just meander along, casually feeding and self-dusting along the way. The blue background is not sky but earth: the foothills and base of Mount Kilimanjaro. Lens: 800 mm (f5.6).

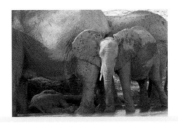

PAGE 47 SAMBURU. A comparatively close-up shot (from 6 to 7 meters) of a family group at a rainy-season mudhole. Notice the elephant who is nearly completely submerged in mud, in the lower left. Lens: 80-200 mm (f2.8).

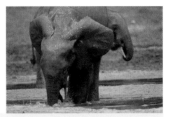

PAGE 48 DZANGA-SANGHA RESERVE, CENTRAL AFRICAN REPUBLIC. This forest elephant, marked with mustard yellow splashes from previous contact with a different mud, reaches deep into the waterhole at Dzanga-Sangha baï to suck up mineral-rich waters from the bottom. Lens: 300 mm (f2.8) with doubling adapter (600 mm at f5.6).

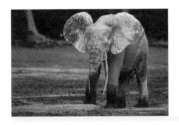

PAGE 49 DZANGA-SANGHA. This forest elephant shows a Jackson Pollock effect, acquired by self-spraying with very light-colored clay. African forest elephants have smaller, thinner, more downward-pointing tusks, rounder ears, and a smaller and somewhat rounder body than savanna elephants. Lens: 300 mm (f2.8) with doubling adapter (600 mm at f5.6).

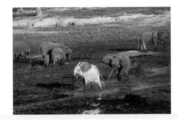

PAGE 50 DZANGA-SANGHA. One of these forest elephants has acquired a creamy color from a recent wallow. The high-water mark on her trunk shows how deeply she has recently reached into the water in pursuit of that mineral-rich muck at the bottom. Lens: 300 mm (f2.8) with doubling adapter (600 mm at f5.6).

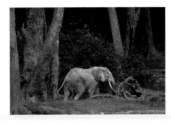

PAGE 53 DZANGA-SANGHA. This large forest elephant male with a partial erection has recently sprayed himself with creamy-white clay. Lens: 300 mm (f2.8) with doubling adapter (600 mm at f5.6).

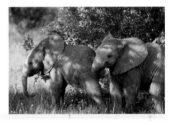

PAGE 54 SAMBURU. Two frisky youngsters, posed side by side in the dappled late-afternoon sunlight, are ready to play. Lens: 300 mm (f2.8).

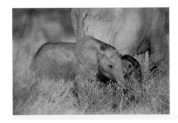

PAGE 56 SAMBURU. A very young calf sidles up to a slightly older sibling. The brittle brown vegetation identifies this as Samburu during the dry season; the yellowish light indicates a midmorning sun. Lens: 800 mm (f5.6).

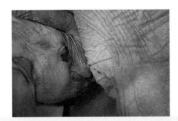

PAGE 58 SAMBURU. This suckling youngster and her mother are tinted with orange hues from the rising sun. Lens: 800 mm (f5.6).

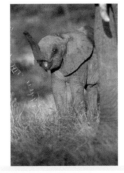

PAGE 59 SAMBURU. This young elephant, trumpeting and wide-eyed, appears to be in an emotionally excited state—reacting, possibly, to the photographer or to another elephant. The photograph was taken as the late-afternoon sun moved lower in the sky. Lens: 800 mm (f5.6).

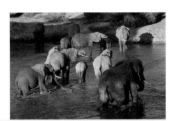

PAGE 60 SAMBURU. Ordinarily, family groups cross the Ewaso Nyiro River around the middle of the day. This particular crossing took place in the early morning, when the light was good for contrast and detail. Lens: 80-200 mm (f2.8).

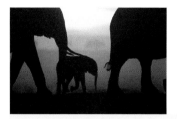

PAGE 62 AMBOSELI. This photograph of elephants silhouetted by the setting sun was taken on Amboseli's open plain. Lens: 800 mm (f5.6).

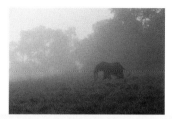

PAGE 67 WONGA-WONGUÉ RESERVE, GABON. This photograph was taken during the misty moments following daybreak. Lens: 80-200 mm (f2.8).

PAGE 68 WONGA-WONGUÉ. At the time this photograph was taken, Wonga-Wongué, once used by the president of Gabon as a private hunting reserve, was imperfectly protected, and this large male survivor acted fearful when we encountered him. Climbing a steep grassy hill in midmorning, he is headed for the comparative safety of the forest. Lens: 80-200 mm (f2.8).

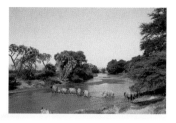

PAGE 70 SAMBURU. A family group crosses the Ewaso Nyiro River in midafternoon. Lens: 80-200 mm (f2.8).

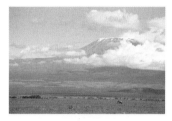

PAGE 72 AMBOSELI. A lone bull walks through Amboseli's grassy plain, with snow-capped Mount Kilimanjaro as the backdrop. Lens: 80-200 mm (f2.8).

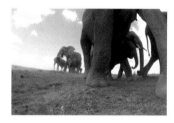

PAGE 74 AMBOSELI. With permission from park authorities, the photographer was able to place his camera on the ground and then use a remote triggering device to photograph this group from a ground-level perspective. The elephants appear frightened, possibly as an unanticipated consequence of this unusual photographic approach. Lens: 16 mm (f2.8).

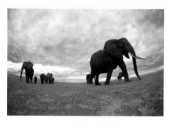

PAGE 76 AMBOSELI. This was taken approximately an hour after the previous shot, in the same general area and of the same elephants, as the sun begins to set. Again, the elephants in the foreground appear frightened. Lens: 16 mm (f2.8).

PAGE 78 MASAI MARA NATIONAL RESERVE, KENYA. The elephant picked this isolated acacia tree to get some shade in the midday sun. The photographer moved his camera close to the ground to create this sky-and-cloud-dominated composition. Lens: 300 mm (f2.8).

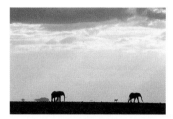

PAGE 80 AMBOSELI. This one was taken at midday, showing the spreading plain of Amboseli. The small creature between the elephants is a zebra. Lens: 800 mm (f5.6).

PAGE 82 AMBOSELI. Part of Amboseli is a dry, ancient, alkaline lake bed. It's unusual for a herd of elephants to cross the lake bed during the hottest part of the day, but this one did—and the photographer was able to capture a mirage effect caused by the intense heat distortions of the air. Lens: 800 mm (f5.6).

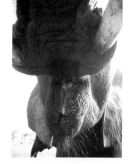

PAGE 86 OL JOGI CONSERVANCY, KENYA. This close-up of an elephant mouth was taken at a private game ranch. Lens: 60 mm (f4).

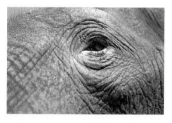

PAGE 87 OL JOGI. This close-up of an eye was taken under the same circumstances. Lens: 60 mm (f4).

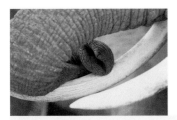

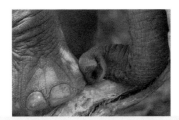

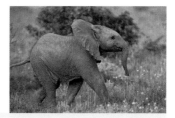

PAGE 89 SAMBURU. This composition, a trunk tip curled over a tusk, was shot while this elephant was relaxing in the company of a family group resting soporifically in the shade of acacia trees at midday. Lens: 300 mm (f2.8).

PAGE 90 SAMBURU. Another image taken during midday rest in the shade. When the muscles in a trunk relax, it lengthens enough that the tip will rest on the ground. Lens: 300 mm (f2.8).

PAGE 91 SAMBURU. A third study taken during the midday rest period. Lens: 80–200 mm (f2.8).

PAGE 94 SAMBURU. This frisky juvenile prancing through the grass is about to charge a playmate. Lens: 80–200 mm (f2.8).

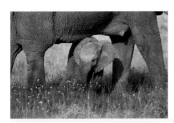

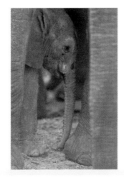

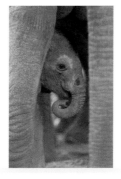

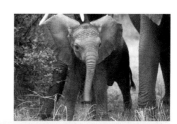

PAGE 96 SAMBURU. A mother and her calf enjoy the rich grass at the end of the rainy season. Lens: 80–200 mm (f2.8).

PAGE 98 SAMBURU. This composition, a young elephant framed by legs, reflects natural behavior: a calf protected by his mother's presence and stance. Lens: 800 mm (f5.6).

PAGE 99 SAMBURU. Second in the sequence. Lens: 800 mm (f5.6).

PAGE 100 SAMBURU. A very young calf momentarily faces the photographer. Lens: 800 mm (f5.6).

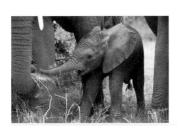

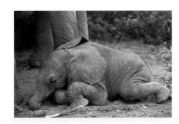

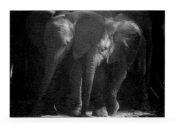

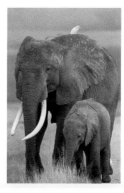

PAGE 101 SAMBURU. Second in the sequence. The calf may be studying the feeding technique of his mother. Lens: 800 mm (f5.6).

PAGE 102 SAMBURU. Utmost repose. Lens: 800 mm (f5.6).

PAGE 104 SAMBURU. These two adolescents were photographed through a thin film of dust, which produced a monochromatic effect. Lens: 800 mm (f5.6).

PAGE 106 AMBOSELI. Mother and youngster seem to be posing for the photographer at the edge of the Amboseli swamps, with the blue of Mount Kilimanjaro in the background. Lens: 800 mm (f5.6).

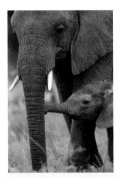

PAGE 107 SAMBURU. Trunks are important tools for emotional communication. Here the youngster seeks attention. Lens: 800 mm (f5.6).

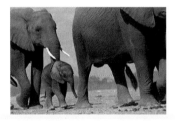

PAGE 108 AMBOSELI. To capture this portrait of a young calf walking between two adult females in a family group, the photographer positioned himself low to the ground, crouching just outside his car. Lens: 800 mm (f5.6).

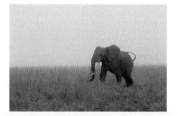

PAGE 110 WONGA-WONGUÉ. An old bull forest elephant stands in the morning mists, showing alarm with raised tail and spread ears. Lens: 300 mm (f2.8).

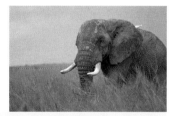

PAGE 113 AMBOSELI. This crusty old bull is coming back from a midday excursion into the swamps. Lens: 800 mm (f5.6).

260

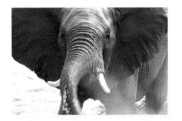

PAGE 114 SAMBURU. With outspread ears and a shake of the head, an adult female expresses mild irritation at the proximity of the photographer. Lens: 80-200 mm (f2.8).

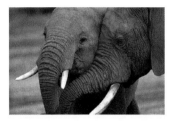

PAGE 115 SAMBURU. Two females snuggle in a friendly fashion. Lens: 800 mm (f5.6).

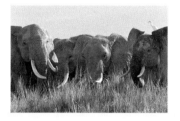

PAGE 116 AMBOSELI. The adult females of a family group strike a formidable pose. The photograph was taken from a distance of 10 meters. Lens: 300 mm (f2.8).

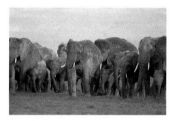

PAGE 118 AMBOSELI. An Amboseli herd, on the move, appears to pause and pose for a family portrait. Lens: 800 mm (f5.6).

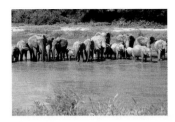

PAGE 120 SAMBURU. A large group has stopped to drink, a prelude to crossing the river. Lens: 80-200 mm (f2.8).

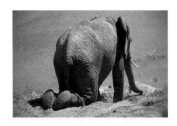

PAGE 124 SAMBURU. Getting down a steep, muddy river bank sometimes requires an awkward-looking, knee-sliding approach. Lens: 300 mm (f2.8).

PAGE 125 SAMBURU. During the dry season, elephants will dig wells in the river sand to get water. Lens: 800 mm (f5.6).

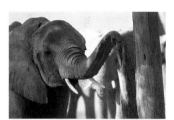

PAGE 126 SAMBURU. An elephant's trunk tip can serve as a grasping hand with power and fine precision. Lens: 300 mm (f2.8).

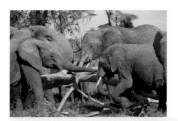

PAGE 127 OL PEJETA CONSERVANCY, KENYA. Stripping away the bark as an edible treat, this group destroyed an entire fever acacia tree in a single afternoon. Lens: 80–200 mm (f2.8).

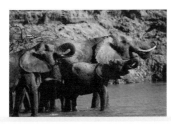

PAGE 128 SAMBURU. Upon reaching the river, a family group's first impulse is to drink deeply. Lens: 800 mm (f5.6).

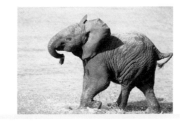

PAGE 130 SAMBURU. After drinking comes play. This teenager seems to enjoy splashing. Lens: 800 mm (f5.6).

PAGE 131 SAMBURU. Older elephants enjoy the water as well and are sometimes inclined to take a full bath. Lens: 800 mm (f5.6).

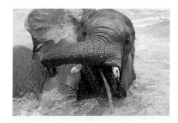

PAGE 131 SAMBURU. Getting back up from a lying-down position can require some awkward shifting of weight. Lens: 800 mm (f5.6).

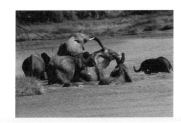

PAGE 132 SAMBURU. An adolescent briefly displays dominance during a playful time in the water. Lens: 800 mm (f5.6).

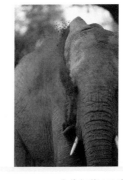

PAGE 134 SAMBURU. Self-dusting soothes and protects an elephant's skin from damage by sun, insects, and other irritants. Lens: 800 mm (f5.6).

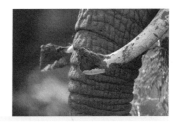

PAGE 135 SAMBURU. Tusks can be used as digging tools. Lens: 800 mm (f5.6).

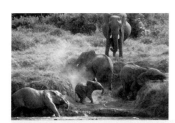

PAGE 137 SAMBURU. While the matriarch looks on, these elephants dust and wallow in the river bank mud during the wet season. Lens: 800 mm (f5.6).

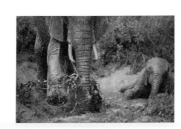

PAGE 138 SAMBURU. Mud Adventure, Part 1. Mudholes can be great fun for elephants. Lens: 80–200 mm (f2.8).

PAGE 140 SAMBURU. Mud Adventure, Part 2. Youngsters seem to enjoy mudholes even more than adults do. Lens: 300 mm (f2.8).

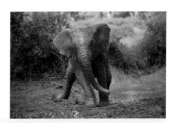

PAGE 141 SAMBURU. Mud Adventure, Part 3. Swaggering in the mud. Lens: 80–200 mm (f2.8).

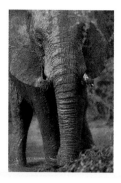

PAGE 142 SAMBURU. Mud Adventure, Part 4. Wet and muddy all over, including the tusk tips. Lens: 300 (f2.8).

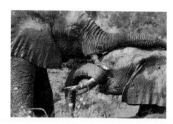

PAGE 143 SAMBURU. Mud Adventure, Part 5. Mudholes and social interaction go together. Lens: 300 mm (f2.8).

PAGE 144 SAMBURU. Itchy-Scratchy, Part 1. It's rare to find a tree of the right height to scratch an itch behind the ear. Lens: 300 mm (f2.8).

PAGE 145 AMBOSELI. Itchy-Scratchy, Part 2. This termite mound offers the ideal rubbing opportunity in an otherwise flat environment. Lens: 300 mm (f2.8).

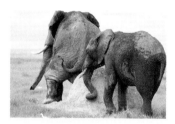

PAGE 145 AMBOSELI. Itchy-Scratchy, Part 3. Every part of the body is capable of itching and needing a scratching. Lens: 300 mm (f2.8).

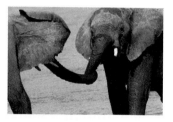

PAGE 146 SAMBURU. This elephant trunk shake is either a friendly greeting or the preamble to more serious wrestling. Note the veination at the back of the ear: this is important to elephants as part of their cooling system and important to researchers as a way of identifying individual elephants. Lens: 800 mm (f5.6).

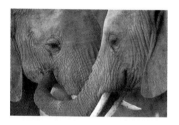

PAGE 148 SAMBURU. Touching trunk tip to mouth provides information about individual identity as well as recent foods; it seems often to be a friendly greeting. Lens: 800 mm (f5.6).

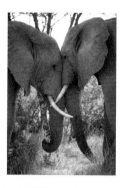

PAGE 149 SAMBURU. This friendly posture, head against head, shows two individuals who are very comfortable with each other. Lens: 80-200 mm (f2.8).

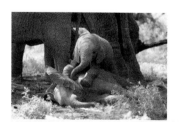

PAGE 150 SAMBURU. Roly-poly play. The wet season, with its burst of nutritious vegetation, means more energy and more play. Lens: 800 mm (f5.6).

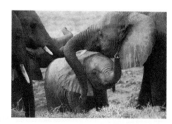

PAGE 152 SAMBURU. This mother provides a comforting embrace with her trunk. Lens: 800 mm (f5.6).

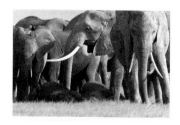

PAGE 154 AMBOSELI. Lunchtime rest period is different for adults and youngsters. For adults, lying down is a difficult undertaking, done only during the darkest hours of the night. During sleepy times of the day, adults doze standing up while the more nimble youngsters flop to the ground. Lens: 800 mm (f5.6).

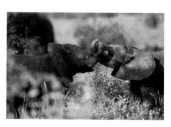

PAGE 156 SAMBURU. Two youngsters trunk wrestle, a playful act with dominance implications. Lens: 800 mm (f5.6).

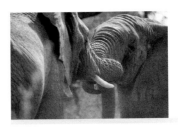

PAGE 157 SAMBURU. Two males in a standoff, resting between bouts of play wrestling. Lens: 800 mm (f5.6).

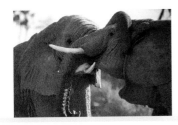

PAGE 158 SAMBURU. The clacking of ivory on ivory is a distinctive noise that accompanies elephant wrestling. Lens: 800 mm (f5.6).

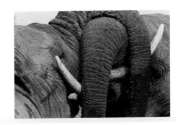

PAGE 159 SAMBURU. Elephant tussles occur at varying intensities, ranging from play to dangerous aggression. This mad intertwining of trunks and tusks may suggest a high level of aggression, but the trunks are relaxed and draped. Lens: 800 mm (f5.6).

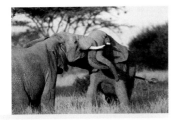

PAGE 160 SAMBURU. Throwing one's weight around is an important aspect of the contest for dominance; these two bulls are engaged in a serious shoving match. Lens: 800 mm (f5.6).

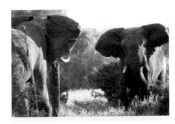

PAGE 162 SAMBURU. Two bulls in conflict over sexual access to a fertile female are poised for a head-on collision. Lens: 800 mm (f5.6).

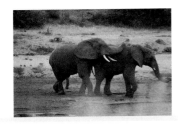

PAGE 164 SAMBURU. Teenagers engage in sexual play. Lens: 800 mm (f5.6).

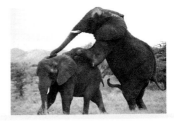

PAGE 165 OL PEJETA. A male attempts to mount. The S-shape of his erect penis is ideal for penetrating the female's forward-located vaginal opening. Lens: 300 mm (f2.8).

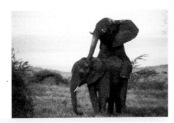

PAGE 165 OL PEJETA. Success. Lens: 300 mm (f2.8).

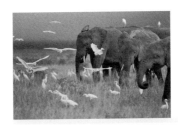

PAGE 168 AMBOSELI. Cattle egrets take advantage of the elephants' tendency to disturb insects hidden in the grass. Lens: 300 mm (f2.8).

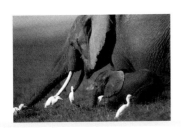

PAGE 170 AMBOSELI. Elephants with egrets. Lens: 300 mm (f2.8).

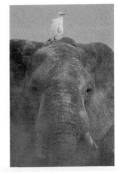

PAGE 171 AMBOSELI. Elephants tolerate egrets in exchange for fewer insects on the skin. Lens 800 mm (f5.6).

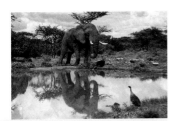

PAGE 172 SAMBURU. This large bull, fresh from a mud bath, eyes a guinea fowl. Lens: 80–200 mm (f2.8).

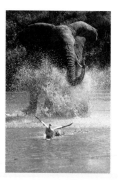

PAGE 173 SAMBURU. Chasing an Egyptian goose can be fun, especially when combined with splashing. Lens: 80-200 mm (f2.8).

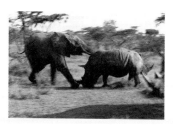

PAGE 174 OL PEJETA. White rhino and elephant challenge each other near a water hole. Lens: 80-200 mm (f2.8).

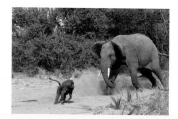

PAGE 175 SAMBURU. Baboons and teenage elephants regularly interact, as in this playful chase. Lens: 80-200 mm (f2.8).

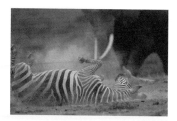

PAGE 176 AMBOSELI. The zebra, rolling in dust, is watched by a passing elephant. Lens: 800 mm (f5.6).

PAGE 178 DZANGA-SANGHA. A teenage forest elephant playfully chases two forest buffalo. Lens: 300 mm (f2.8) with doubling adapter (600 mm at f5.6).

PAGE 180 DZANGA-SANGHA. Forest elephants, sitatunga, and buffalo peacefully share this forest mineral lick and mudhole in Central Africa. Note the elephant skull in the foreground. Lens: 80-200 mm (f2.8).

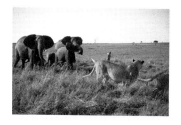

PAGE 182 MASAI MARA. Elephants chase off a pride of lions. Lens: 300 mm (f2.8).

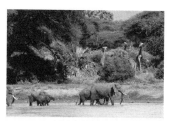

PAGE 184 SAMBURU. Reticulated giraffes coming down to the river are held off by a passing group of elephants. Lens: 300 mm (f2.8).

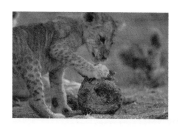

PAGE 186 SAMBURU. This lion cub, backed up by two or three siblings (out of focus), seems to be playing with a piece of elephant dung. Lens: 800 mm (f5.6).

PAGE 187 AMBOSELI. Fresh elephant dung contains nutritious tidbits. Lens: 800 mm (f5.6).

PAGE 187 SAMBURU. This Van der Decken hornbill picks apart elephant dung in search of insects. Lens: 300 mm (f2.8).

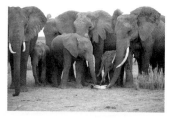

PAGE 190 AMBOSELI. This family group has stopped to examine the evidence of a passage: a broken fragment of tusk. Lens: 300 mm (f2.8).

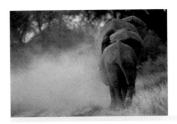

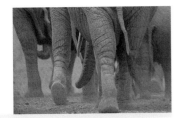

PAGE 193 SAMBURU. Three generations in recessional passage. Lens: 300 mm (f2.8).

PAGE 194 SAMBURU. Rear view of a departing group. Lens: 800 mm (f5.6).

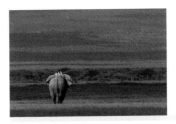

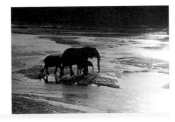

PAGE 196 AMBOSELI. A big bull leaves the swamps in midafternoon, headed in the direction of Mount Kilimanjaro and taking a few passengers with him. Lens: 800 mm (f5.6).

PAGE 197 SAMBURU. A family group crosses the Ewaso Nyiro River. Lens: 80-200 mm (f8.0)

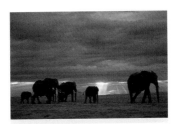

PAGE 198 AMBOSELI. Late afternoon: a family group passes through the plains after a day in the swamps. Lens: 80-200 mm (f2.8).

REFERENCES

Adamson, George. 1968. *A Lifetime with Lions.* Garden City, NY: Doubleday.

Aelian. 1958, 1959. *On the Characteristics of Animals.* Volumes 1–3, books 1–17. Translated by A. F. Scholfield. Cambridge, MA: Harvard University Press.

Alexander, Shana. 2000. *The Astonishing Elephant.* New York: Random House.

Alter, Stephen. 2004. *Elephas Maximus: A Portrait of the Indian Elephant.* New York: Harcourt.

Archie, E., et al. 2007. "Behavioural Inbreeding Avoidance in Wild African Elephants." *Molecular Ecology* 16: 4138–4148.

Aristotle. 1965, 1970. *Historia Animalium.* Volumes 1–2, books 1–6. Translated by A. L. Peck. Cambridge, MA: Harvard University Press.

———. 1991. *Historia Animalium.* Volume 3, books 7–10. Translated by D. M. Balme. Cambridge, MA: Harvard University Press.

Arrian. 1958. *The Campaigns of Alexander.* Translated by Aubrey de Sélincourt. New York: Penguin.

Barnum, Phineas Taylor, 1875. *Struggles and Triumphs; or, Forty Years' Recollections of P. T. Barnum.* Buffalo: Courier.

———. 1888. *Life of P. T. Barnum.* Buffalo: Courier.

Bartlett, A. D. 1899. *Wild Animals in Captivity, Being an Account of the Habits, Food, Management, and Treatment of the Beasts and Birds at the "Zoo," with Remembrances and Anecdotes.* London: Chapman and Hall.

Bates, Lucy A., et al. 2007. "Elephants Classify Human Ethnic Groups by Odor and Garment Color." *Current Biology* 17 (November 20): 1–5.

Bedini, Silvio A. 1997. *The Pope's Elephant: An Elephant's Journey from Deep in India to the Heart of Rome.* New York: Penguin Books.

Bigwood, J. M. 1993. "Aristotle and the Elephant Again." *American Journal of Philology* 114, no. 4 (Winter): 537–555.

Blake, Stephen, and Simon Hedges. 2004. "Sinking the Flagship: The Case of Forest Elephants in Asia and Africa." *Conservation Biology* 18, no. 5 (October): 1191–1202.

Blake, Stephen, et al. 2007. "Forest Elephant Crisis in the Congo Basin." *PLoS Biology* 5, no. 4 (April): 1–9.

Blanc, J. J., et al. 2007. *African Elephant Status Report: An Update from the African Elephant Database.* Occasional Paper of the IUCN Species Survival Commission no. 33. Downloadable from www.iucn.org/themes/ssc/sgs/afesg/aed/aesr2007.html.

Bouley, D. M., et al. 2007. "The Distribution, Density and Three-Dimensional Histomorphology of Pacinian Corpuscles in the Foot of the Asian Elephant *(Elephas maximus)* and Their Potential Role in Seismic Communication." *Journal of Anatomy* 211: 428–435.

Bradshaw, G. A., and Allan N. Schore. 2007. "How Elephants Are Opening Doors: Developmental Neuroethology, Attachment and Social Context." *Ethology* 113: 426–436.

Bradshaw, G. A., et al. 2005. "Elephant Breakdown." *Nature* 433 (February 24): 807.

Brahic, Catherine. 2007. "Conservation Group Sees Need for Elephant Cull." *New Scientist,* February 26. Online at http://environment.newscientist.com/article/dn11258.

Brown, Robert L., editor. 1991. *Ganesh: Studies of an Asian God.* Albany: SUNY Press.

Buss, Irven O. 1961. "Some Observations on Food Habits and Behavior of the African Elephant." *Journal of Wildlife Management* 25: 131–148.

Carrington, Richard. 1958. *Elephants: A Short Account of Their Natural History, Evolution, and Influence on Mankind.* London: Chatto and Windus.

Chadwick, Douglas H. 1992. *The Fate of the Elephant.* San Francisco: Sierra Club Books.

Colbert, Edwin H. 1996. "Henry Fairfield Osborn and the Proboscidea." In *The Proboscidea: Evolution and Palaeoecology of Elephants and Their Relatives,* edited by Jeheskel Shoshani and Pascal Tassy, xxiii–xxvii. Oxford: Oxford University Press.

Conniff, Richard. 1987. "When the Music in Our Parlors Brought Death to Darkest Africa." *Audubon* 89, no. 4: 77–93.

Cumming, Roualeyn Gordon. 1857. *Among Lions, Elephants, and Other Wild Animals of South Africa.* New York: Derby and Jackson.

De Beer, Gavin. 1956. *Alps and Elephants.* New York: E. P. Dutton.

Delsink, A. K., et al. 2006. "Regulation of a Small Discrete African Elephant Population through Immunocontraception in the Makalali Conservancy, Limpopo, South Africa." *South African Journal of Science* 102 (September/October): 403–405.

Donne, John. 1967. *Complete Poetry and Selected Prose.* Edited by John Hayward. London: Nonesuch Press.

Douglas-Hamilton, Iain, and Oria Douglas-Hamilton. 1975. *Among the Elephants.* New York: Viking Press.

Dzamara, Itai. 2007. "Illicit Ivory Barter Deal Exposed." *The Zimbabwean,* June 26. Online at www.bushdrums.com/news/index.php?shownews=1070.

Eltringham, S. 1982. *Elephants.* Dorset: Blandford Press.

Furniss, Charlie. 2006. "On the Tusks of a Dilemma." *Geographical* (November 1): 47–57. Downloadable from www.encyclopedia.com/doc/1G1-156203892.html.

Gale, U Toke. 1974. *Burmese Timber Elephant.* Rangoon, Burma: Trade.

Gröning, Karl, and Martin Saller. 1998. *Elephants: A Cultural and Natural History.* Cologne: Köneman.

Guy, Peter R. 1971. "The Daily Food Intake of the African Elephant, *Loxodonta africana* Blumenbach, in Rhodesia." *Arnoldia Rhodesia* 7: 1–8.

Hart, B. L., and L. A. Hart. 1994. "Fly Switching by Asian Elephants: Tool Use to Control Parasites." *Animal Behaviour* 48, no. 1: 35–45.

Haynes, Gary. 1991. *Mammoths, Mastodonts, and Elephants: Biology, Behavior, and the Fossil Record.* Cambridge: Cambridge University Press.

Hollister-Smith, Julie A., et al. 2007. "Age, Musth and Paternity Success in Wild Male African Elephants, *Loxodonta africana.*" *Animal Behaviour* 74, no. 2: 287–296.

Jolly, W. P. 1976. *Jumbo.* London: Constable.

Karimakwenda, Tererai. 2007. "Zimbabwe Accused of Trading Ivory for Military Hardware from China." *SW Radio Africa,* June 26. Online at www.swradioafrica.com/news260607/ivory260607.htm.

Kaufman, Marc. 2007. "Wildlife Experts Fear for African Elephants: 23,000 Killed Last Year." *Washington Post,* February 26.

Kerley, Graham I. H., and Adrian M. Shrader. 2007. "Elephant Contraception: Silver Bullet or a Potentially Bitter Pill?" *South African Journal of Science* 103 (May/June): 181–182.

Kirkpatrick, Jay F. 2007. "Measuring the Effects of Wildlife Contraception: The Argument for Comparing Apples and Oranges." *Reproduction, Fertility and Development* 19: 548–552.

Kistler, John M. 2006. *War Elephants.* Westport, CT: Praeger.

Laurance, William F., et al. 2006. "Impacts of Roads and Hunting on Central African Rainforest Mammals." *Conservation Biology* 20, no. 4: 1251–1261.

Laws, Richard M. 1966. "Age Criteria for the African Elephant, *Loxodonta africana.*" *East African Wildlife Journal* 4: 1–37.

Laws, Richard M., I. S. C. Parker, and R. C. B. Johnstone. 1975. *Elephants and Their Habitats: The Ecology of Elephants in North Bunyoro, Uganda.* Oxford: Clarendon Press.

Leakey, Richard, and Virginia Morell. 2001. *Wildlife Wars: My Fight to Save Africa's Natural Treasures.* New York: St. Martin's Press.

Lister, Adrian, and Paul Bahn. 1994. *Mammoths.* New York: Macmillan.

Loder, Natasha. 2007. "Arresting Evidence." *Conservation* 8, no. 3 (July–September). Downloadable from http://conbio.org/CIP/article30711.cfm.

Martin, Esmond. 2001. "The Great White Gold Rush." *BBC History,* August, 30–32.

Mayor, Adrienne. 2000. *The First Fossil Hunters: Paleontology in Greek and Roman Times.* Princeton, NJ: Princeton University Press.

McComb, Karen, Lucy Baker, and Cynthia Moss. 2005. "African Elephants Show High Levels of Interest in the Skulls and Ivory of Their Own Species." *Biology Letters* 2 (October): 26–28.

McComb, Karen, et al. 2000. "Unusually Extensive Networks of Vocal Recognition in African Elephants." *Animal Behavior* 59, no. 6 (June): 1103–1109.

McComb, Karen, et al. 2001. "Matriarchs as Repositories of Social Knowledge in African Elephants." *Science* 292, no. 5516 (April 20): 491–494.

McKay, George M. 1973. "Behavior and Ecology of the Asiatic Elephant in Southeastern Ceylon." *Smithsonian Contributions to Zoology* 125: 1–113.

Meredith, Martin. 2001. *Africa's Elephant: A Biography.* London: Hodder & Stroughton.

Moore, Jim. 2007. "Phenotype Matching and Inbreeding Avoidance in African Elephants." *Molecular Ecology* 16, no. 21 (November): 4421–4423.

Morell, Virginia. 2007. "Elephants Take Center Ring at CITES." *Science* 316, no. 5832 (June 22): 1678–1679.

Moss, Cynthia. 1988. *Elephant Memories: Thirteen Years in the Life of an Elephant Family.* Chicago: University of Chicago Press.

Mpinganjira, Ernest. 2007. "Ivory Trade Ban to Test Regional Unity." *East African Standard,* May 27.

Nordland, Rod. 2007. "The Good Friday Elephant." *Newsweek,* April 13. Online at www.newsweek.com/id/35399.

O'Connell, Caitlin. 2007. *The Elephant's Secret Sense: The Hidden Life of the Wild Herds of Africa.* New York: Free Press.

Osborn, Henry Fairfield. 1936. *Proboscidea: A Monograph on the Discovery, Evolution, Migration and Extinction of the Mastodonts and Elephants of the World.* Volume 1. New York: American Museum Press.

Owens, Delia, and Mark Owens. 1992. *The Eye of the Elephant.* Boston: Houghton Mifflin.

———. 2005. "Comeback Kids." *Natural History,* July/August, 22–25.

Owen-Smith, N., et al. 2006. "A Scientific Perspective on the Management of Elephants in the Kruger National Park and Elsewhere." *South African Journal of Science* 102 (September/October): 389–394.

Payne, Katy. 1998. *Silent Thunder: In the Presence of Elephants.* New York: Simon and Schuster.

———. 2003. "Sources of Social Complexity in the Three Elephant Species." In *Animal Social Complexity: Intelligence, Culture, and Individualized Societies,* edited by Frans B. M. de Waal and Peter L. Tyack, 57–85. Cambridge, MA: Harvard University Press.

Payne, Katy, William R. Langbauer, and Elizabeth M. Thomas. 1986. "Infrasonic Calls of the Asian Elephant *(Elephas maximus).*" *Behavioural Ecology and Sociobiology* 18: 297–301.

Perry, John S. 1953. "The Reproduction of the African Elephant, *Loxodonta africana.*" *Philosophical Transactions of the Royal Society of London,* series B, 237: 93–147.

———. 1964. "The Structure and Development of the Reproductive Organs of the Female African Elephant." *Philosophical Transactions of the Royal Society of London,* series B, 248: 35–51.

Pliny. 1956. *Natural History.* Volume 3, books 8–11. Translated by H. Rackham. Cambridge, MA: Harvard University Press.

Plotnik, Joshua M., Frans B. M. de Waal, and Diana Reiss. 2006. "Self-Recognition in an Asian Elephant." *Proceedings of the National Academy of Sciences* 103 (November 7): 17053–17057.

Poole, Joyce. 1996. *Coming of Age with Elephants: A Memoir.* New York: Hyperion.

———. 1997. *Elephants.* Stillwater, MN: Voyageur Press.

Rasmussen, H. B., et al. 2008. "Age- and Tactic-Related Paternity Success in Male African Elephants." *Behavioral Ecology* 19, no. 1: 9–15.

Rensch, B. 1957. "The Intelligence of Elephants." *Scientific American* 196 (February): 44–49.

Rich, Tracey, and Andy Rouse. 2004. *Elephants.* Rickmansworth, UK: Evans Mitchell Books.

Romm, James S. 1989. "Aristotle's Elephant and the Myth of Alexander's Scientific Patronage." *American Journal of Philology,* 110, no. 4 (Winter): 566–575.

Rubenstein, Dustin R., et al. 2006. "Pleistocene Park: Does Re-wilding North America Represent Sound Conservation for the 21st Century?" *Biological Conservation* 132: 232–238.

Ryan, Myrtle, and Peta Thornycroft. 2007. "Jumbos Mourn Black Rhino Killed by Poachers." *Independent Online,* Nov. 18. Online at www.iol.co.za/index.php?set_id=1&click_id=143&art_id=vn20071118084613595C384523.

Sanderson, Ivan T. 1962. *The Dynasty of Abu: A History and Natural History of the Elephants*

and Their Relatives, Past and Present. New York: Alfred A. Knopf.

Schaller, George B. 1967. The Deer and the Tiger: A Study of Wildlife in India. Chicago: University of Chicago Press.

Schulte, Bruce Alexander, et al. 2007. "Honest Signalling through Chemicals by Elephants with Applications for Care and Conservation." Applied Animal Behaviour Science 102: 344–363.

Scigliano, Eric. 2002. Love, War, and Circuses: The Age-Old Relationship between Elephants and Humans. Boston: Houghton Mifflin.

Scott, W. B. 1887. "American Elephant Myths." Scribner's Magazine 1, no. 4 (April): 469–478.

Scullard, H. H. 1974. Elephants in the Greek and Roman World. Ithaca, NY: Cornell University Press.

Short, Jeff. 1981. "Diet and Feeding Behavior of the Forest Elephant." Mammalia 45: 177–185.

Shoshani, Jeheskel, and J. F. Eisenberg. 1982. "Elephas maximus." Mammalian Species 182 (June 18): 1–8.

Shoshani, Jeheskel, and Pascal Tassy. 1996. "Summary, Conclusions, and a Glimpse into the Future." In The Proboscidea: Evolution and Palaeoecology of Elephants and Their Relatives, edited by Jeheskel Shoshani and Pascal Tassy, 335–348. Oxford: Oxford University Press.

Sikes, Sylvia K. 1971. The Natural History of the African Elephant. New York: American Elsevier Publishing.

Slowtow, Rob, Dave Balfour, and Owen Howison. 2001. "Killing of Black and White Rhinoceroses by African Elephants in Hluhluwe-Umfolozi Park, South Africa." Pachyderm 31 (July–December): 14–20.

Slowtow, Rob, and G. van Dyk. 2001. "Role of Delinquent 'Orphan' Male Elephants in High Mortality of White Rhinoceros in Pilanesberg National Park, South Africa." Koedoe 44, no. 1: 85–94.

Slowtow, Rob, et al. 2000. "Older Bull Elephants Control Young Males." Nature 408 (Nov. 23): 425–426.

Stiles, Daniel, and Esmond Bradley Martin. 2002. "From Tusks to Trinkets." BBC Wildlife, March, 32–37.

Sukumar, Raman. 1990. "Ecology of the Asian Elephant in Southern India: II. Feeding Habits and Crop Raiding Patterns." Journal of Tropical Ecology 6, no. 1: 33–53.

———. 2003. The Living Elephants: Evolutionary Ecology, Behavior, and Conservation. Oxford: Oxford University Press.

Topsell, Edward. 1607. Historie of Foure-Footed Beastes. London: W. Iaggard.

Toynbee, J. M. C. 1973. Animals in Greek and Roman Life. Ithaca, NY: Cornell University Press.

Turner, Myles. 1987. My Serengeti Years: The Memoirs of an African Game Warden. New York: W. W. Norton.

Wallace, Irving. 1959. The Fabulous Showman: The Life and Times of P. T. Barnum. New York: Alfred A. Knopf.

Watson, Lyall. 2002. Elephantoms: Tracking the Elephant. New York: W. W. Norton.

Weissengruber, G. E., et al. 2006. "The Structure of the Cushions in the Feet of African Elephants (Loxodonta africana)." Journal of Anatomy 209, no. 6 (December): 781–792.

White, Lee J. T., Caroline E. G. Tutin, and Michel Fernandez. 1993. "Group Composition and Diet of Forest Elephants, Loxodonta africana cyclotis Matschie 1900, in the Lopé Reserve, Gabon." African Journal of Ecology 31, no. 3 (September): 181–199.

White, T. H., editor and translator. 1984. The Book of Beasts: Being a Translation from a Latin Bestiary of the Twelfth Century. New York: Dover.

Williams, J. H. 1960. Elephant Bill. New York: Viking.

Wilson, Derek, and Peter Ayerst. 1976. White Gold: The Story of African Ivory. New York: Taplinger.

ACKNOWLEDGMENTS

This book began as a large collection of elephant photographs taken by award-winning wildlife photographer and photojournalist Karl Ammann during the past twenty-five years. Sheila Levine, our first editor at University of California Press, brightly imagined that the best of those photographs, presented in a certain way and supported with a certain kind of text, might make the book you now have. Karl and I are particularly grateful to Sheila for her vision and early encouragement. We should also acknowledge three important others for their support during the early part of the project: Marc Bekoff, Melissa Groo, and Richard Wrangham.

The middle part involved travel. I had traveled in Africa with Karl before, and during one of those earlier trips we encountered elephants. He took pictures. I watched. But when we went to Africa in spring 2007, we more methodically sought out the elephants. He photographed some more and I watched some more and this time took notes. We also, as a prologue and preparation for the African trip, visited a government-run timber operation using elephants in the mountains of northwestern Burma, where we were able to experience tamed, working elephants up close. For their assistance, companionship, and contributions during the Burmese part of our journey, we wish to thank Myo Min Aung, Soe Min Aung, Ko Gyi, San Lwin, U Tun Nyan, and Sai Win.

The African portion of our travels required, for starters, spending time in a small plane flown by a Christian missionary who happened to combine personal grace and fluency in a number of obscure African languages with the highest competence in flying and fixing a plane. Thank you, Ron Pontier. Thanks also to a second missionary, Wendy Atkins, who welcomed us with positive spirits and hospitality during our time in Zemio, in the Central African Republic. We are also grateful to Akakpio Sadrac for his assistance during our stay in Zemio. Our goal in the Central African Republic was actually two-fold. We were first looking to photograph and write about the forest elephants coming to the open air and mineral-rich wallows of Dzanga-Sangha baï, in the southwestern tip of the country, but we also intended to document some of the threats to forest elephants, including the ongoing illegal trade in ivory and elephant meat. Joining us in our research on and documentation of that trade were two men intent on spreading the story through their own media to a larger audience: Andreas Gehriger, a video journalist from Switzerland, and Anthony Mitchell, an Associated Press correspondent based in Nairobi. Both proved to be excellent companions as we followed a trail of evidence through a rural maze and into the big urban markets in Bangui, capital of the Central African Republic.

In Bangui, Lewis Alexis Mbolinani made our lives more rational in fundamental ways, as did Junior Ngaerosset. Josiane Dwili and Stephanie Magba also provided important assistance in Bangui, for which we are thankful. At Dzanga-Sangha, we were welcomed by Jean-Baptiste Gomina, manager of the Doli Lodge, which is supported by Germany's World Wide Fund for Nature (WWF); we were then set up and settled in through the kind efforts of Mattias Heinze. Others at Doli, including Erica Cochrane and Cyril Pelissier, provided good company and useful information. From our working base at Doli, Clement Balambi and Gilbert Tanchiko brought us farther into the forest, down a road and along a muddy trail, through a clear river and a seething cloud of butterflies, and out to the elephants, while Andrea Turkalo, who has watched them for so many years, consented to interviews. She is one of this world's real heroes.

Our travels in East Africa, especially to see the savanna elephants of Samburu and Amboseli, were more straightforward but equally exciting, and we should thank, for their company, help, and input in Amboseli, Joseph ole Ntalamia, Sapota Serengeti, and Moses ole Sipanta. Kathy Ammann was an elegant hostess and friend during my times at the Ammann home, and she also enlivened our stay at Samburu. Others in Kenya, including the elephant expert Iain Douglas-Hamilton, the geneticist Nick Georgiadis, and the ivory trade expert Esmond Bradley Martin, generously provided information in the form of comments, papers, and interviews.

Following the joint travel came the lonely task of writing. In that, I was fortunate to have the occasional company and steady guidance of a real expert, Katy Payne, whose writings and work I so admire. My second editor at University of California Press, Jennifer Wapner, should be thanked for her exceptional competence, responsiveness, and tolerance, while my third editor, Dore Brown, will be remembered fondly for her unusual focus, exacting intelligence, and pleasant presence on the telephone. I'm also grateful to Madeleine Adams, Juliana Froggatt, and Genevieve Thurston for their astute editorial suggestions and perceptive questions that pushed me to clarify important points. Closer to home, I must thank my family, Wyn, Britt, and Bayne, for, as ever, their encouragement and smart comments. Wyn deserves double thanks for her role as my first and most trusted reader.

I have saved for last the tragic part of these acknowledgments, which is also an explanation of the book's dedication to Anthony Mitchell, the journalist who joined us in Bangui and traveled with us from there to Dzanga-Sangha and back. Along with his personal effects, notebook, and tape recorder, Anthony brought along his passion for British football and a formidable, nonstop sense of humor. He was a great person to travel with, and it will always be a source of regret—of grief, actually—that Anthony, logistically unable to accompany us on our return journey to East Africa, was forced instead to buckle himself into a Kenya Airlines commercial flight bound from Douala to Nairobi. His plane rose into the chaos of a tropical thunderstorm and failed to come back whole. The world is not the same.

INDEX